# Charlie Russell Roundup

# Charlie Russell Roundup

ESSAYS ON AMERICA'S
FAVORITE COWBOY ARTIST

EDITED BY Brian W. Dippie

MONTANA
HISTORICAL
SOCIETY
PRESS

Helena

COVER IMAGE Charles M. Russell, *Charles M. Russell and His Friends*, 1922, oil on canvas, MHS Museum, Helena, Mackay Collection

COVER DESIGN Kathryn Fehlig
BOOK DESIGN Arrow Graphics, Missoula, Montana
TYPESET IN Stempel Garamond
PRINTED BY BookCrafters, Chelsea, Michigan

© 1999 by Montana Historical Society Press,
P.O. Box 201201, Helena, Montana 59620-1201

99  00  01  02  03  04      9  8  7  6  5  4  3  2  1

LIBRARY OF CONGRESS CATALOGING-IN-PUBLICATION DATA

  Charlie Russell roundup : essays on Montana's favorite cowboy artist /
edited by Brian W. Dippie.
    p.  cm.
    Includes index.
ISBN 0-917298-47-0 (paper : alk. paper). — ISBN 0-917298-46-2 (hard : alk. paper)
    1. Russell, Charles M. (Charles Marion), 1864–1926—Criticism and interpretation.
2. West (U.S.)—In art.   3. Cowboys in art.   I. Dippie, Brian W.
N6537.R88C53 1999
709'.2—dc21
[B]
                                                                  98-56-386
                                                                     CIP

*For Joe and Florence O'Connor*

This book was made possible with partial funding from the Montana Historical Society Foundation and the Bair Trust.

# Contents

PART TWO. REMEMBERING RUSSELL    71

# Illustrations

## TEXT ILLUSTRATIONS

# Note on Editorial Procedures

Selections are reprinted as published; only obvious typographical errors and misspellings of proper names have been corrected. The notes have been standardized and the following abbreviations are used throughout.

CMR: Charles Marion Russell

NCR: Nancy C. Russell

Britzman Collection: the Helen E. and Homer E. Britzman Collection, the Taylor Museum for Southwestern Studies of the Colorado Springs Fine Arts Center, Colorado Springs, Colorado

CMR Museum: C. M. Russell Museum, Great Falls, Montana

De Yong Papers, Great Falls: Joe De Yong Papers, C. M. Russell Museum, Great Falls, Montana

De Yong Papers, Oklahoma City: Joe De Yong Papers, National Cowboy Hall of Fame and Western Heritage Center, Oklahoma City, Oklahoma

Dobie Collection: C. M. Russell Miscellaneous Material, J. Frank Dobie Collection, Harry Ransom Humanities Research Center, University of Texas at Austin, Texas

*GFT:* Great Falls (Montana) *Tribune*

MHS: Montana Historical Society Archives, Helena, Montana

*Montana: Montana Magazine of History* (1951–55); *Montana The Magazine of Western History* (1955–present)

Rankin Papers: James Brownlee Rankin Research Collection, Charles M. Russell, 1910–62, Manuscript Collection 162, Montana Historical Society Archives, Helena, Montana

# Introduction

CHARLIE RUSSELL'S STORY has been told so often that it has attained the sheen of well-worn leather, and all the trappings of myth. *Charlie Russell Roundup* contains many of the best of the stories about Russell, drawn principally from the files of *Montana The Magazine of Western History* which, beginning with its second issue in April 1951, when it was still known as *The Montana Magazine of History*, began featuring his art. (Indeed, before the year was out, the magazine had carried a prescient review dismissing Ramon Adams and Homer Britzman's pioneering biography of Russell as rampant hero-worship, and a color reproduction [its first] of *Waiting for a Chinook* [FIG. 2], accompanied by this disclaimer: "Incidentally, in case you're wondering why we feature so much Russell in this magazine, there are two reasons: First, nothing is more typically Montana than a Russell; second, our printer has only Russell cuts in stock.")[1]

Excuse-making ended with the Montana Historical Society's move into a building of its own in 1952 and the acquisition that December of the great Malcolm Mackay Russell collection.[2] The next year *Montana*, the society's journal, abandoned the traditional format of historical quarterlies—long on text and notes and short on pictures and pizzazz—for a larger, slick paper format, thereby opening the door even wider to art—and art meant Charlie Russell. "Something New Will Be Added," the Autumn 1953 issue announced. Beginning with the next issue, "and from there out," we "will make more and more usage of the superb work of Montana's most famous Cowboy Artist." Covers "will sparkle" with Russell reproductions, and "inside the covers, at every opportunity, we shall

I

utilize those rare talents . . . which captured the frontier flavor of Montana's formative years better than it can ever again be done by brush or pen."

*Montana* was as good as its word: Russell paintings appeared on every cover but one in the 1950s. Not every reader was happy. In a letter published in the Winter 1961 issue, western author Dorothy M. Johnson wrote bluntly, "I am tired of Charlie Russell pictures on the magazine, so there." But, Wallace Beery, Jr., replied, Russell art "is what lifts a fine magazine into the unique class, especially to the out of state readers," and the editor obviously agreed since it graced every cover for the next sixteen consecutive issues.[3] *Montana*'s covers still regularly "sparkle" with Russell reproductions, and over the years the magazine has published much of the best in reminiscent and scholarly writing on the artist and his art. *Charlie Russell Roundup* draws heavily on this rich harvest; indeed, while it is primarily a tribute to Charlie Russell, the *Roundup* is also a tribute to the long and fruitful partnership between Russell and the Montana Historical Society.

Why? Why this love affair with a man whose own love affair with Montana ended seventy-two years ago? The answer seems obvious. Russell may have died in 1926, but his art lives on, still speaking in the present tense, still wooing new converts every year. "You may lose a sweetheart, but you won't forget her," he said of the Old West, and his art assures that others will remember with him.[4] Through it his name has become synonymous with his adopted state: "Nothing is more typically Montana than a Russell."

∼

CHARLES MARION RUSSELL (1864–1926) was the soul of consistency. He said he was devoted to the West of his youth, and he was. He said that progress had not improved the world, and he meant it. He said he preferred the old days to modern times, and he did. Beneath his casual, even gruff exterior ran deep and abiding loyalties. Everything around him changed, but despite recent attempts to qualify this simple proposition, he did not. Of course he lived in a city, traveled the world, went to motion pictures, rode in automobiles,

gawked at airplanes, and read the newspaper. But emotionally he stood still.[5] A portrait made shortly before his death by Edward S. Curtis, renown as a photographer of the old-time Indian, conveys the imperturbable calm that defined Russell [FIG. 1]. Things passed him by and eventually caught up to him again, still standing where he always stood, still lamenting a lost world with no fences around the yearning heart. By the time of his death he had come to seem not so much "eccentric" (to use his word) as mystically wise, kin to the Indian patriarch shown in one of his last models, *Secrets of the Night*, listening intently to an owl perched on his shoulder imparting nature's wisdom. Neoprimitivism was fashionable in an age grown leery of the price of industrial progress. "Let Americans turn to America, and to that very America which has been rejected and almost annihilated," D. H. Lawrence had advised from Florence in 1920:

> They must pick up the life-thread where the mysterious Red race let it fall. They must catch the pulse of the life which Cortes and Columbus murdered. There lies the real continuity not between Europe and the new States, but between the murdered Red America and the seething White America. . . .
>
> To your tents, O America. Listen to your own, don't listen to Europe.[6]

By never changing, by staying true to himself and his own values, Russell, the least progressive of men, had become astonishingly up to date.

The selections in *Charlie Russell Roundup* provide a wealth of detail about the man, his work, and his enduring legend. It would seem impossible to restore novelty to a story so often told. In fact, more Russell source material is available today than ever before, much of it previously untapped. Newspaper accounts and reminiscences, long the staple of Russell scholarship, have been substantially augmented in the last few years by a bonanza of primary sources—the Russell estate papers and the Joe De Yong papers, to name the most important—and they offer a fragmentary but revealing set of fresh insights into Russell, his relationship with his wife Nancy, and the realities of making a living as an artist. A sample follows.

# Boy Dreamer and Neophyte Rip-Snorter

Susan, Charlie Russell's only sister, was nearly five when he was born in St. Louis on March 19, 1864, the fourth of seven children. "I do not remember him in his baby-hood," she wrote Nancy after his death in Great Falls in 1926,

> but when he was three or four years old, he was a very cute, tow-headed youngster, healthy & good natured. By the time he was eight or ten he afforded much amusement to the family, as he always saw things in a funny light & would call forth many a laugh when he told us about anything he had seen, or described any "show" to which he had been taken. He was always a great mimic. About this time he began to take scraps of wax, left from the wax flowers with which I was afflicting my friends & long suffering relatives, on all anniversary occasions. From these scraps of wax he formed tiny animals which were so natural that Father purchased beeswax for him. . . . Charlie inherited a love for horses & had been drawing pictures of them in all positions, "frontwards & backwards," as he himself expressed it. He always carried a chunk of wax in his pocket & modelled almost incessantly, attracting much attention from grown-ups as well as children. The pupils at school were highly diverted, but the teachers were not quite so appreciative, when they discovered the cause of said diversion & also that blank pages of books, margins &c were covered with drawings of animals in all sorts of exciting positions, a story in themselves, & much more interesting to most of the students than history & arithmetic. When Chas. was twelve years old, he made a bas-relief in clay on a large slate   the subject was a knight in armor, on horse-back. Father had a plaster cast made of this, & sent it to the St. Louis Fair where it took a blue ribbon. The next year he sent a similiar cast of a horse & rider jumping a fence. Again he won a prize. He began to use color in his pictures & showed remarkably close observation of his subjects. He yielded to persuasion & entered the Washington University Art School—but objected to going back to first principles, drawing cubes &c so he gave it up after a lesson or two. Wherever he went his work attracted attention. It was not displayed in any way except on the two occasions already mentioned, (at

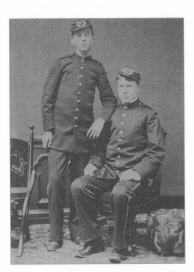

Archie Douglass and C. M. Russell at Burlington College, New Jersey, early 1880. MHS Photo Archives, Helena

the St. Louis Fair). When he was not drawing or modelling he was riding his beloved pony "Gyp"—almost always without a saddle & going like the wind. Charles always loved the West as he knew it from stories & he was probably dreaming thereof as he rode at breakneck speed about the country in the neighborhood of our old home, "Oak Hill."[7]

And so rode the beloved family rebel who bucked convention and yearned to break free: headstrong, tenderhearted, and maybe bruised by a world intent on pounding a square-pegged dreamer into convention's round hole. Nancy would always see some tears behind his laughter. He might relate his school days with winning humor, but, she insisted, "the confinement always was a horror to Chas. The teachers could not bother with him to find out what he realy could do and becaus he could not be made to study out of books he was punished a lot."[8] He just had to get away, and though his family was prosperous and expectations accordingly high, his restlessness won out. Just before his sixteenth birthday, in 1880, he was permitted to go west to work for awhile on a sheep ranch in Montana's Judith Basin. His career as a sheep herder proved brief, but Montana lasted him a lifetime.

## The Likable, Lazy Kid from Missouri Meets His Destiny

THE RUSSELL LEGEND tells of a hard-riding, hard-drinking, adventuresome youth who roamed unescorted in a dangerous land. But John R. Barrows, a Judith Basin acquaintance of Kid Russell, as he was known, tartly put that nonsense to rest. Russell did live with a professional hunter, Jake Hoover, for a few years (see "A Slice of My Early Life") before hiring on to herd horses on a cattle drive in

1882. But far from being "a restless pioneer," Barrows wrote, Russell was "of that type which adapts itself to surrounding conditions and makes the best of it":

> I have more than once considered the effect of environment upon Russell's career and my own. We were dumped down within twenty miles of each other, of the same age, and with similar back ground. Charley holed up with Jakey Hoover and Lying Babcock, while I put in at least half of each year at home with my family. My work with the postoffice and express business was interesting and kept me out of mischief. We had a wealth of reading matter in the best maga-zines and two daily papers with a backlog of standard fiction, thru the Lakeside Library. It is not probable that there were two individu-als in Montana Territory that were more nearly alike than Charley Russell and myself in the beginning of our frontier experiences. I was supposed to have talent with my pencil, Charley certainly had talent as a story teller. I felt the urge to write, while Charley devoted most of his spare time to the development of his artistic side. We faced our educational short comings in different ways, because of our dif-ferent environments. If Charley wanted to express an idea and was not quite sure of his grammar, he cut the Gordian knot, by resorting to some flagrantly ungrammatical twist. If he did not have clothing suited to the occasion, he defied all conventions and wore his spurs! In a similar situation I was corrected or criticized by my father, my great Aunt Helen (who was a very precise old maid) or by other members of the family. I never quite forgot that we were people of quality. That slight touch of snobbishness was very useful to me, but it deprived me of a great deal of local color.

As for Russell's hell-raising cowboy career in the wide-open Judith Basin, "the Judith roundup was a tame affair," Barrows scoffed. "It was dominated by eastern cattlemen and . . . the roundup as a whole was characterized as a bunch of 'pumpkin rollers,' or 'corn husk-ers,' or 'straight legs,' and the use of cots and mattresses by some of the elders, caused the roundup to be called a 'feather bed roundup.' They had no trouble either with Indians or outlaws."[9]

Though Charlie romanticized the cowboy in his writing and his art, he cannot be blamed for others romanticizing him. In 1905 he brushed aside a complimentary poem about his bronc-busting skills.

It was "well ment," he told its author, "but would hardly go as historical as the first bronk I forked thruw me so high that the boys caught him before I hit the ground an when I lit it jared my memory so I will never forget and al tho I have ridden maney years I never reached fame as a broncho buster."[10] Russell likely would have relished his friend Billy Shaules' judgment that he was "the laziest man I ever saw."[11] He hated physical labor; the fun was in the telling and the showing, not the doing. "Sawing wood, digging ditches and working in disagreeable occupations would not appeal to one of Russell's temperament," an interviewer observed in 1917. "He is a great story-teller and was fond of the cowboy life and the cowboy pranks."[12] Thus a contemporary assessment of Russell, offered in 1886 when he was a working cowboy and before fame found him, is particularly revealing:

> There is an erratic genius out here by the name of Charley Russell who draws pictures that have a striking resemblance to the things he tries to represent. It is said his father is rich & would do anything for him if he would try to be somebody. He (Charley) says most folks come out here for their health, but he came out for his father's health. I guess he has a good enough opinion of his own abilities, but he is too lazy to work. There is only one thing that he will do & that is to go with the roundup & be night herder for the horses & that would be the last thing in the world that I would do. You see in the roundup there are 50 or 60 men & they have 4 or 5 horses apiece so that when one gets tired they can take another, & at night they are all turned loose in a drove & 2 or 3 men have to watch them & keep them from running away and he will do that & stick to them rain or (moon) shine. In the winter he stays round where he can find a chance & folks like to have him well enough for he is witty & is willing to draw some pictures for them, but if they want him to chop a little wood or do a few chores he picks up his traps & goes some where else.[13]

By conventional standards, Russell *was* lazy. But even his critics acknowledged that he did his job as a night herder. He worked most roundups spring and fall from 1882 to 1893, wrangling horses and cattle. And he happened to be right about his artistic abilities. Russell had sketched and modeled from the time he arrived in Montana, and after his little watercolor *Waiting for a Chinook* (see "The Story Behind

Charlie Russell's Masterpiece: 'Waiting for a Chinook' ") attracted national attention in 1887, the local papers began reporting his comings and goings. He was on his way to lasting fame as the "Cowboy Artist."

Years later, a friend was visiting in Russell's Great Falls studio when Nancy swept in and reprimanded Charlie for not taking the ashes out of the fireplace. This was probably her way of telling him to get back to work. "After she left," the friend recalled, Charlie "spread out his hands—evidently admiring his long refined-looking fingers— and said: 'They wont carry out ashes & paint both.'"[14]

## That Storied "Winter" with the Bloods

IN LATE MAY 1888 Russell crossed the border into Alberta, Canada, accompanied by two young men he had met in Helena, Phil Weinard and B. J. "Long Green" Stillwell. Weinard had married on the six- teenth hoping to take his bride by carriage to a job awaiting him on a

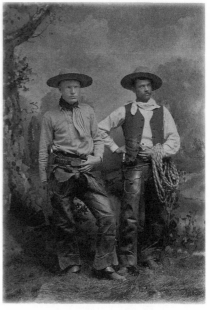

Charles M. Russell and Wallace Stairley, July 1887, photographed by R. H. Beckwith, Helena.
MHS PHOTO ARCHIVES, HELENA

ranch south of Calgary. Russell and Stillwell were to escort the newly- weds, but a last-minute change of plans put her on the train instead, leaving the three men to ride north by themselves. They were sixteen days on the trail before they reached their destination. Weinard set his friends up in a shack on a ranch owned by Charles D. M. Blunt about five miles west of the town of High River Crossing. And so, on June 6, Russell began his storied "winter" among the Blood Indians. Neither he nor Stillwell was inclined to look for work, finding that fishing, hunting, and loafing were enough to fill their days. "I have reached my stoping place," Russell wrote a friend back in Montana. "I am s[t]aying at a cattle ranch on high rive   I am not doing aney thing now as I got

here to late for the roundup I like the county pritty well so far there is lots of Indians here they visit us nearly every day."[15] The Stoney, Sarcee, and Blackfoot reserves were in close proximity to the north, while the Bloods and Piegans often passed through High River on visits from their reserves to the south. Their presence inspired Russell and left a permanent impression on his art.

But with summer winding down, and the prospect of work in the fall and a bitter northern winter looming, the two bachelors suddenly packed up and headed south. On September 21 the Helena *Herald* reported Russell back in town talking "seriously" about leaving for Europe to study art; instead, the next spring he followed the herds north from the Judith Basin to the Milk River country where he would round out his cowboy days in the vicinity of Chinook. His career decision was made for him. "I have tirde [tried] several times to make a living painting but could not mak it stick and had to go back to the range," he wrote a cowboy friend in 1889. "I expect I will have to ride till the end of my days but I would rather be a poor cow puncher than a poor artist."[16]

In their rush to leave Alberta in 1888, Russell and Stillwell had not paused for a courtesy call on the Weinards—nor to return the borrowed horse and saddle Stillwell was using. Instead, they made a beeline for the border. Once home, Stillwell, sheepishly styling himself "your horse thief friend," contacted Weinard to offer compensation.[17] There is no evidence he ever paid a penny. But time had lent a golden glow to memory, and theft had become a boyish prank, when Stillwell wrote Russell in 1915 to reminisce about their lazy summer together in Alberta:

> i was just talking of high river with a man that lives on highriver and it brout back memories of other days a bout 30 years a go when you and i was froginet through that country will you ever forget them days i am sure i never will we dam near starved to death well not quite that bad but they looked bat[d] at times but still we got through all ok. we had a lot of experince that i never regeted i dont know howabout you but i often think of those days do you rember the big fish we caught in willow creek i caught him with a hook and you waded in and stabed him with a knife i think that was the bigest fish i ever caught and then when we was at spuorers [Harry Spurrier's] place you rember we went

out an snaired a bnnch of suckers those wer days of real sport and
then on high river you rember how we nsedto [used to] catch
trout That was when we was at blunts place on high river well i
wont bother you with any more nonsense but will close

Showing how the world changed, in 1915 "Long Green" Stillwell,
Old West gambler and one-time horse thief, had been Ritzville,
Washington's night marshal for seven years.[18]

## Meeting His Match

RUSSELL WAS READY for a change himself by 1896. He had quit
cowboying for good after the 1893 roundup and located in Great Falls
to pursue his art full time. Maybe being a poor artist was better than
being a poor cowboy after all. He was going on thirty, and already
much of the range he had ridden was fenced in. Old cronies were get-
ting married and settling down. His own first love had ended in disap-
pointment, and polite society's impression that he was aimless and
worthless perhaps troubled him more than he let on. But the same
floating itinerant element he had favored in Utica and Helena and Chi-
nook beckoned in Great Falls, and Russell's long bachelor spree con-
tinued. Even after he opted for the small-town quiet of Cascade twenty-
five miles to the southwest he found progress slow. When John Bar-
rows, now a Helena attorney, encountered him there the next year
Charlie was uncharacteristically glum. "He was getting nowhere, the
range cattle business was dead, and perhaps he looked upon me as a
success." If it was a change of direction Russell needed, it was about to
burst upon him in the form of a young woman with ambition enough
for two. Barrows was "one old man" who appreciated what Nancy
Cooper—Mame, as she was affectionately called—meant to Charlie
Russell: singlehandedly she "made a success out of a frustrated life."[19]

Charlie met Nancy at a propitious moment. In February 1895 he
had visited his ailing mother in St. Louis. She died four months later.
With two brothers already dead, mortality was erasing Russell's St.
Louis connection even as progress eliminated the open-range life
he cherished in Montana. No wonder he felt discouraged about his

prospects. That October, Charlie found himself in Cascade, the guest of his old friends Ben and Lela Roberts. Nancy loved to repeat the story of their first meeting. She was, as she put it, staying with the Robertses at the time. In fact, she was working for Mrs. Roberts, who had taken her in after her mother died in Helena and Nancy was virtually abandoned by her stepfather at the age of sixteen. She and the three Roberts children had been told that Russell would be dropping by. Nancy and Mrs. Roberts were setting the table when

we heard voices, that of Mr. Roberts and the stranger. They were coming near the back door. There was a jingle of spur-rowels, on the steps, then a call "Leila, here's Charlie!" and Mrs. Roberts went to meet them.

They came in and we were introduced in that clean, spacious kitchen. The table was covered with a red and white cloth, a wood fire was burning in the cook stove, the biscuits were ready to be put into the oven, and supper was to be served in fifteen minutes.

Our cowboy guest took his Stetson off of a very erect, blonde head and said, "I'm glad to meet you", and shook hands with all of us, even the baby. Then, taking off his spurs, he said, "I'd like to wash". . . .

There was something different about this man. He took off his coat, a double-breasted blue serge, hung it on a chair-back, turned very square shoulders and straight back to me and walked over to the wash-bench. He was very little above average height and weight. His high-heeled riding boots covered small arched feet, his riding breeches were snug-fitting of heavy blue army cloth. In fact, they were Northwest Mounted Police pants, I learned later. They were held up by a wonderful bright colored French half-breed sash that clung just above the hip bones. The sash was wound around twice, the ends twisted and turned into a queer flat knot, the long fringe tucked into his hip pocket, & a gray flannel shirt unbuttoned at the throat with a neck tie hanging loosely. . . . His face, with its square jaw and chin, large mouth, tightly closed firm lips, the under protruding slightly beyond the short upper, straight nose, high cheek bones, gray-blue deep-set eyes that seemed to see everything . . . In time I came to know that he could not see wrong in anybody. He never believed anyone did a bad act intentionally, it was always an accident.

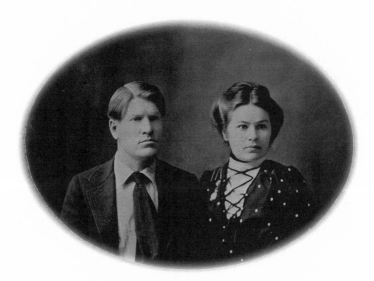

Charles M. Russell and Nancy Cooper Russell, 1896, portrait by the
Elite Studio, Great Falls. MHS Photo Archives, Helena

His hands were good-sized, perfectly shaped with slender
long fingers. He loved jewelry and always wore three or four
rings. They would not have been Charlie's hands any other way.
... When he talked he used them a lot to emphasize what he was
saying, much as an Indian would do.

While he washed, I watched him as closely as possible with-
out being observed. When he was drying his face, there seemed
to be a chance to take a good look, from boots up. [B]y the time
my eyes reached his head, he was drying one side of his face and
peeking out of one corner of the towel at me. He laughed and I
almost dropped the plate of fried ham. "Are the potatoes burn-
ing and Nancy will you please get the quince preserves in the
cellar way?" Mrs. Roberts saved me in my great confusion by
asking me to do the things I knew I should do. . . .

At the supper table in the soft light of the coal oil lamp, he
talked. We could see the play of laughing wrinkles on that In-
dian-like face. He looked like a blond Indian and had us fasci-
nated with his stories of real life.

The courtship began that night; a year later, on September 9 at
eight o'clock in the evening, Charlie and Nancy were married in the
Robertses' living room. Charlie was all slicked up and Nancy was

wearing a blue wedding dress Mrs. Roberts had made up for her from material purchased on a shopping excursion together in Helena. Life was simple then. "There were just nine people present at our wedding," Nancy recalled, "and Charlie had only $15.00. He gave $10.00 to the preacher who tied the knot and $5.00 to the fellows around town to keep them from chivareeing us. I made the wedding cake and Charlie froze the ice cream." After the refreshments, the Russells began their "journey through life in what Charlie called 'double-harness'" by walking hand in hand to their matrimonial home, a one-room 12-by-24-foot shack behind the Robertses' house.[20]

Nancy did not remain a simple housewife long. By the late 1890s, in conjunction with Charlie's businessman father with whom she discovered a special affinity, she was managing her husband's artistic career. A 1905 commission was typical. Charles A. Magrath of Lethbridge wanted Russell to paint an oil for him showing a local battle fought in 1870 between Blackfeet and Crees. A contact in Great Falls approached Russell and reported back that

> he seemed favorably disposed . . . as the subject is exactly in his line. As I think I told you before, he is a peculiar genius and takes great streaks, acting upon sudden impulse as the fancy moves him. He . . . is going to visit . . . [the area] in May, so I suggested that he go on to Lethbridge at that time, look over the scene of the battle and see you. His wife goes with him, and you would do well to see her, as she has great influence over him. She was much attracted by the proposed subject, and is most anxious that Charlie should undertake the Commission.

That clinched the deal. The finished painting was delivered four months later.[21] In marrying, Charlie Russell had acquired both a wife and a business partner.

## Unworldy Naifs on the Brink of Fame

IN 1897 CHARLIE AND NANCY moved from Cascade to Great Falls seeking greater exposure for his art. Even with family help they were struggling financially. But in 1900, with money inherited from Charlie's mother, they purchased a double lot in a good area of town and built

the modest two-story house where they would live until his death. The log cabin studio on the adjoining lot was Nancy's idea, but after it was finished in 1903, Charlie made it his domain—studio, museum, and gathering place for cronies to share a smoke and swap stories.

The Russells were becoming fixtures in Great Falls, but Charlie's work was little known outside Montana, and the larger world remained a mystery. In late February 1903 they boarded a train bound for the Hudson Bay Company post of Fort Edmonton, five hundred miles to the north. Alberta called. It was there in 1888 that Charlie had discovered an empathy with Indians, and its recent history was romantically enticing. William Bleasdell Cameron, who signed Russell to an illustrating contract with *Field and Stream* in 1897 (see, "The Old West Lives through Russell's Brush"), doubtless regaled him at the time with tales of his near escape from death at Frog Lake (due east of Edmonton) and his subsequent captivity among the Crees in 1885. An Indian captive just twelve years before![22] And if Indian wars were only a memory even in Alberta by 1903, the Klondike gold rush was still a fresh sensation. The North lured those who wanted one last spree on a remote frontier. As Robert W. Service wrote,

Thank God! there is always a Land of Beyond
For us who are true to the trail;
A vision to seek, a beckoning peak,
A farness that never will fail.[23]

From reports Charlie had read in the papers, barroom gossip picked up at downtown hangouts like the Mint and the Silver Dollar, and photographs of Klondikers setting off by dog team, he had convinced himself that when he and Nancy reached Fort Edmonton they would be magically transported back in time. Full of anticipation, then, they stepped off the train only to find a prospering city. Fort Edmonton was not a fort at all, let alone the "primitive fur trading post" Russell had come to see. There were no dog teams to inspect, though obliging Edmontonians hitched one up so Charlie could envision the reality—which he subsequently did, in wax and watercolor. But Edmonton was a letdown, and after four nights in the Grandview Hotel and an interview with the local press in which Charlie voiced

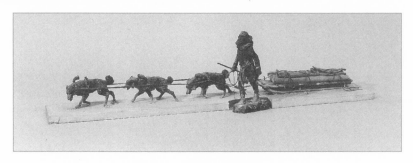

Charles M. Russell, *Transport to the Northern Lights*, ca. 1903–5, mixed media.
MHS MUSEUM, HELENA, GIFT OF THE SONS AND DAUGHTERS OF MONTANA PIONEERS

his disappointment, the Russells reboarded the train and headed straight home. So much for the dream of going north to yesterday.[24]

The Russells would never become worldly by most standards, but within a decade of the Edmonton trek they were regulars in New York and had visited Florida, Mexico, California, Canada's three prairie provinces, and England, with a side trip to Paris, was on the horizon. However, a busy exhibition schedule and sunbelt vacations never replaced Charlie's yearning for the wild, the primitive, the uncivilized. He still dreamed of a "Land of Beyond" as he poured over the pages of *National Geographic* looking for pictures of primitive types in faraway places. At the St. Louis World's Fair in 1904 he headed, fittingly, to Arrow Head Lake on the western extremity of the fairgrounds, where the living ethnological exhibits were located—Navajos in hogans, Wichitas in grass lodges, Kwakiutls in a longhouse, Pawnees in an earthen lodge, Sioux in their tepees, as well as Pygmies, Patagonians, and Ainu. The point of it all was lost on Russell. He was supposed to be impressed by the contrast between these vestiges of outmoded savagery and America's progressive civilization, but he ignored the pavilions celebrating educational and industrial advancement to wander the "Philippine Reservation" and sketch Igorots from Luzon dancing in their loin clothes. "These folks are verry primitive forging there own weapons an weaving there own cloth," he wrote a friend in Great Falls. "They are verry small but well bult pople an judging from the way they handle the spere or assiga if they ever lern to handle the new gun Uncle Sam is liable to have trouble corraling em their sirtenely a snakey looking artical."[25] When Russell visited the Don Luis Terrazas ranch in Mexico in 1906 he was properly impressed by the vaqueros resplendent in

their sombreros and silver, and a few of the Navajos he saw in Arizona in 1916 still in their traditional costume made the entire trip worthwhile. "I am glad I wint and I whish I knew those people and there past If I savyed the south west like you," he told his fellow artist Edward Borein, "Id shure paint Navys."[26]

The old-time Indian was "the mos picturesque man in the world," Charlie Russell insisted, and Indians who still looked "Indian" were a requirement for his art. Beginning in 1906 the Russells spent every summer at Bull Head Lodge, their cabin at the foot of Lake McDonald in what is now Glacier National Park, surrounded by trees and mountains and wildlife, and with Blackfeet to the east and Flatheads to the south. These Flatheads are the real thing, Charlie wrote: "I belive there is mor old time dressed indians in that reservation than aney of them I never saw a short haired Flat head."[27] Just as modern "bib overall" cowboys with caps were not real cowboys, Indians in white men's garb were not real either—real, that is, in terms of Russell's art. "Judgin from what I saw Im twenty years late," he wrote about his Arizona trip. "The scool teachers beet me to it. those wisdom bringers surtenly wipe all the picture out of nature."[28] He always knew exactly what he was doing in excluding the present from his work. His was a timeless, changeless West, devoid of the very boosters and businessmen who were his patrons. But Charlie recognized a common bond. His patrons might spend their days in their law offices or on Wall Street making money, but at core they were "nature loving regular men" eager to exchange their three-piece suits for hunting shirts and riding breeches, and their desks for horses and rifles and the chance to live the strenuous life out in the high lonesome for a few weeks each year.[29] He had to sympathize. He was a Walter Mitty, too: Kid Russell trapped inside the body of a famous artist who still wore boots, a Stetson, and a sash as proud badges of who he really was.

## The Bashful Celebrity at Home

IN 1917 RUSSELL turned fifty-three. He had quit drinking nine years before, and was an artist of international stature whose major paintings commanded as much as three thousand dollars. He had it made,

and his acquaintances included film stars and millionaires; everyone enjoyed his company. But Charlie Russell was still a homebody, a private man who hated to be stared at or fawned over, preferred dining with family, and was happiest puttering around Great Falls, trading yarns with old cronies downtown, taking in movies and plays, visiting with the neighbors. First up in the morning, he made the fires, cooked breakfast, and carried a tray up to Nancy who liked to dine in bed. He repaired to the studio, she rose, dusted, made the beds, and did the washing when she was between helping girls (demanding of those around her, she ran through several). Russell came in for lunch, then went his way and Nancy hers for the afternoon. She prepared the evening meal; Charlie did the dishes. For him, it was a simple, satisfying routine. As his birthday approached in March 1917, a household guest reported,

> a little bit of a kid came to the front door at noon—He was red headed & named Riley. Russell went to the door & the Kid said I want to see Mr. Russell, & R said well Mrs. R is in there the Kid said No! *Mr.* Russell. He was about five years old awful cute—Had a box of ginger camels & popcorn balls as a birthday present—They had never seen him before—He was bashful & R was as embarrased as he was—Had the Kid come in & showed him models & such. He said his mother made those cookies & the pop-corn balls to—Mrs R. nearly died watching them—Both were rattled—[30]

For all his fame, Russell remained "real as a toad-stool," Frank Linderman wrote, and "simple as a little boy."[31]

## Star Struck in Hollywood

CHARLIE RUSSELL'S FONDNESS for the movies—especially Westerns, which he knew to be mostly moonshine—has puzzled some who view him as a rockhard realist. But Russell was consistent: his mode may have been realism, but his message was storybook romance. He welcomed Western movies as he welcomed all allies to the Old West's cause. Paint, prose, poetry, and celluloid kept its memory alive. Westerns took outrageous liberties with fact, but they reached a vast audience, and

while Russell loved to spoof their absurdities, he never mocked their appeal. Good friends like William S. Hart, Harry Carey, and Will Rogers were advancing the banner, and stars of the magnitude of Douglas Fairbanks, Jr., might yet be recruits to the ranks. "Heres to history and romance," he wrote Fairbanks after they met in 1921. "You and your kind Douglass, men and women, . . . make folkes of history and story bookes live and breath again." In a follow-up letter he pitched his cause:

> I have seen you under many names and you have worn them all well—an actor of action always—And now since you have back tracked the grass grown trails of history and romance I know that D'Artagnans name will fit you as well as his clothes.
>
> But Doug dont forget our old west. The old time cow man right now is as much history as Richard The Lion Harted or any of those gents that packed a long blade and had their cloths made by a blacksmith. You and others have done the west and showed it well but theres lots of it left, from Mexico north to the Great Slave lakes the west was a big home for the adventurer—good or bad—he had to be a regular man and in skin and leather men were almost as fancy and picturesque as the steel clad fighters of the old world The west had some fighters, long haired Wild Bill Hickok with a cap and ball Colts could have made a correll full of King Arthurs men climb a tree.[32]

Russell's movie addiction led him to write a screenplay of his own for Will Rogers. "Duce Bowman" told the story of Dannie, a young boy effectively orphaned by the death of his mother and the cruel indifference of his father. Adopted by Duce Bowman, a "white Indian," he is entrusted to the comforting care of a young woman while Duce, who has already engaged in a shoot out, faces suspicion as a robber, is proved innocent, and rides off—only to return and wed the girl. "I was down to his camp a couple of weeks ago," a packer says of Duce:

> "He struck a pay streak. I guess you know he tied up to Old Man Sims' girl. It sure looked homelike—him and her and little Dannie." . . .
>
> "Which one turned him good?" asked one of the packers. "Little Dannie or the girl?"

"Damned if I know. But, when I ride up, she's readin' a little book to him—I think it's the Bible."[33]

Charlie provided detailed costume notes to accompany the script—the appearance of realism (as in his art) verifying a storybook romance whose biographical parallels suggest how completely he had absorbed himself in his creation.

## The Nancy and Charlie Waltz

NANCY IMPOSED HERSELF between Charlie and others. There was no path to him except through her. This infuriated some old-timers who remembered the affable, easygoing Kid Russell of cowboy days. If you were socially acceptable or could offer something that might advance his career—indeed, if you had the means to buy one of his paintings—Nancy granted access. If not, you were simply unwelcome in their home. She held a tight leash: family and social friends were always well-treated, but even they considered her a slave driver.[34]

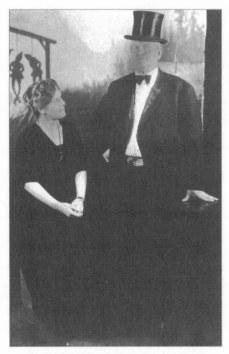

Charles and Nancy Russell, ca. 1925–26.
BRITZMAN COLLECTION, COLORADO SPRINGS
FINE ARTS CENTER

Joe De Yong, a devoted admirer who came to study at Russell's side, was admitted into the inner circle in January 1916 (see "Modest Son of the Old West"). A boyish twenty-one, he was deaf and Nancy fussed over him, showering him with motherly advice. She was perhaps too preoccupied by business to mother a child of her own. Nevertheless, on December 3 that year the Russells filled a hole in their lives by adopting a three-

month-old baby boy. They named him Jack Cooper Russell, after Nancy's father.[35] The new addition tied them down in Great Falls for a spell which, to borrow one of Charlie's sayings, suited his taste to an All Spice.[36] De Yong now had a set role. On his extended stays with the Russells he baby-sat Jack, did chores for The Chief and Wise Woman, as he called them, and endured the periodic atmospheric changes on the home front. Nancy had "no more system than a dish full of noodles or spagetti," he complained. "She could accomplish three times the amount she does with less energy if shed schedule herself— It would be worth your life to suggest it tho." Sometimes he was frustrated by it all—by Nancy's histrionic "blow ups" and Charlie's moody silences. But he never doubted that they were a match. He accepted them as a couple, and appreciated the particular balance they had achieved in their marriage. She was, he agreed, "the pivot the whole bunch swings on."[37] Charlie and Nancy trotted in double-harness to the end—two very different people bonded by love.

Others were not so sure. Con Price, the closest friend Russell had among his old cowboy compadres, when pressed, said simply, "As to him loveing Nancy, I know he did once, very Dearly, when she was an innocent little girl, But I think later in life he pitied her for her social ambitions."[38] Still, Price resented the prying questions of J. Frank Dobie, who wanted the lowdown on the Russells for a proposed biography (see "The Conservatism of Charles M. Russell"). "I told him, they were both sleeping in Great Falls their final Sleep, and that I would prefer to let them rest in peace."[39]

The echoes of old battles distorted recollections. But Bertha M. Bower, a longtime acquaintance with a novelist's power of observation, provided a revealing contemporary analysis of one late movement in the Charlie and Nancy waltz. "Your curiosity shall be appeased—as far as is compatible with my Good Words Club pledge," she wrote Nancy's half-sister on July 25, 1924, from Las Vegas, where on June 15 she had hosted the Russells passing through en route to Montana after a fifth successive winter vacation in California:

> Mame is living in the same old strained determination to help God run the world. With more enlightened eyes I studied her here, and feel that her heart is all for everybody (Mame included)

and [she] is striving to be a real efficiency expert without understanding the First Principles of life. With this general diagnose of her case I will proceed to give you the case as it stood on the surface.

As you know, we planned a picnic at Nob Hill; a supper there, at the right time for a view of the sunset which is said to be marvellous. As it was the night before full moon, we counted on letting Charlie watch the moon rise over the five states and the Colorado river. So many Vegas people had left for the summer, however, that our party dwindled to two cars by Sunday—a fortunate circumstance.

. . . we left here at the proper hour for arriving in Searchlight about noon. Mame had written that they would leave L.A. Saturday, and would stop at Ludlow, so we called noon plenty early to catch them in Searchlight. But you know Mame. We had just crossed the dry lake, out here, when we met them buzzing down that long, sandy slope, Mame in the front seat beside the driver with a green veil over her face, and Charlie tucked back among the grips etc. I suppose he was perfectly comfortable, but he looked *tucked*, if you get my meaning.

Mame had a terrific headache—"Oh, let me get into the *sha-ade!*" she implored. When I said picnic she threw up both hands in horror. "*Picnic*??? Oh, my Lord! We've been out in this *horr*-ible glare since *day*-light. *Plee*-ase let us get into the shade! You folks go on and have your picnic, but let *us* get in out of this *horr*-ible hot, blinding sun. I want to be nice and have you love us, but really—there's a limit to what we can *stand*." There followed a laugh. A Mame laugh.

Charlie said, "You folks go on and have your picnic. We'll wait for you at the hotel."

We said, "Picnic nothing! We'll turn back and head off the others—" and that is what we proceeded to do. Of course, our whole bunch was mad. All except me, and I called myself a bad name for having forgotten that one mustn't plan things for Mame Russell. It isn't done, my dear. A mile down the road I began to laugh, and the dicky birds from there on were ever and anon startled by my wild chortling.

Of course it never occurred to Mame to lower the shades in that big sedan and sit back out of the glare. Instead she must perch in the front seat, stare at the desert and curse the sun.

We met the other car, made the proper apologies, and convoyed the Cadillac to the Nevada hotel, where I had engaged rooms, ice water galore, electric fan and whatever else they had that was nice.

I put Bud [Cowan, her husband] in their car and beat it on ahead so that I could phone the hotel to have everything cold, but I did not get out and go over and shake hands with Mame; not then. I stayed in our car and let her stay in hers.

Bud had a good visit in the lobby with Charlie. Mame went to bed and puked. (Excuse me.) She wouldn't let Jack out of the room . . . and the child persisted in breathing occasionally, which made it worse for the child. Charlie couldn't do a thing for Mame, and she wouldn't have him near her, nor let him go on off somewhere.

That was the state of affairs when, about four in the afternoon, I drove up to the hotel to see her.

I did feel sorry for the poor, blind lady who won't see. I cuddled her in sheer pity for the blindness . . . Charles I eased out, and Jack. Then I called Ilee, my faithful "efficiency expert" and told her to round up the bunch and go on down to Doolittle's with our poor picnic supper, and when everything was ready to come back for Mame and me.

. . . Mame told me her troubles, decided she would get up, brushed her long, beautiful hair and powdered her nose, got into a cool dress and became human, all within the space of an hour. So "Everything passed off pleasantly." She went to Doolittle's, and everybody was nice to her and she was once more a queen. Charlie managed to say to me afterwards, "God, I sure was glad when you come and got Mame out of that hot room! She wouldn't do it for me—but now she's all right. I can't do nothin' with her, though. Never was so glad of anything in my life!" I patted him on the arm . . .

That's all there was to it. They came, tarried tumultuously and went. The desert swallowed them—and I'm glad they arrived home all right. I know I helped Mame, and by that means Charlie also. I wish she might learn how to go at life, but until she does learn she will go on being "edgy" and hurried and worried and insincere. It's her eagerness for life and her driving energy and ambition that are wearing her and everyone else to ribbons. She doesn't know how to go at it, is all.[40]

# The Legacy

CHARLES MARION RUSSELL died on October 24, 1926. Jack had just celebrated his tenth birthday, and Charlie and Nancy their thirtieth anniversary. Russell was sixty-two and a half years old and at the peak of his reputation, but he had been experiencing poor health since 1923. Thus his end was not unexpected. Great Falls paid homage to its most famous citizen. City schools and public offices and businesses closed for his funeral on October 27, and people lined the route of the cortege to Highland Cemetery. Horses pulled the hearse that carried him to his grave. Floral tributes from Will Rogers and others affirmed Russell's national stature. But with the Cowboy Artist dead and buried, chances were his fame would also turn to dust. Nancy made it literally her business to ensure this did not happen. She marketed his sculptures, which were a renewable source of income, and the unsold paintings she had on hand, which were not. So she became a dealer in other people's Russells as well as her own—and other artists' work, having learned that a commission for a sale was good money whatever its source. Nancy had a list of clients eager to buy Russell paintings at prices set high to reflect the fact there could be no more—the avidity of collectors matching Nancy's own shrewd evaluation of the artist's worth until the Depression terminated the twenties and the bullish market for Russells.

Nancy did not tarry in Great Falls; within two months of Charlie's death, she and Jack had moved to Pasadena where she had a house already under construction next to her father's. Nancy lived out her days a Californian. But she knew that Montanans would have to tend the Russell flame. Consequently, she followed up on Charlie's wish that his studio and its contents be given to the city of Great Falls. Typically, she added conditions—it must be maintained as a permanent memorial—and on her way to Lake McDonald the next summer she stopped in Great Falls long enough to have Joe De Yong inventory the studio collection and pack it away in mouse- and moth-proof containers. This served notice to the city that the gift would be rescinded unless her conditions were met. Under pressure (the clause "time is the essence" figured prominently in the formal agreement Nancy's lawyers drew up), concerned citizens created a

Russell Memorial Committee with a mandate to raise funds to purchase the adjoining Russell properties (three lots, including their home). In the end, Charlie's gift was rolled into Nancy's asking price of $20,000, and the deed transferring title signed on August 3, 1928, ran eight legal-size pages replete with a threatening proviso. Only Nancy could have turned a simple goodwill gesture into such a fertile breeding ground for ill will.[41]

The Russell Memorial was just one of the projects Nancy advanced in the 1920s. A collection of Charlie's writings, contracted with a New York publisher before his death, appeared in 1927 as *Trails Plowed Under* and attracted favorable reviews. Using her resulting clout, Nancy pushed a biography that she had commissioned from Great Falls journalist Dan R. Conway. "A Child of the Frontier: Memoirs of Charles M. Russell (The Cowboy Artist)"— overblown, repetitious, and pretentious—was never published, but Conway did place a few articles in the Great Falls *Leader*, and Nancy subsequently dabbled at a biography of her own, which remained unfinished at the time of her death. Friends weighed in with tributes to Russell, and a few appeared in print, notably Will Rogers' moving introduction to *Trails Plowed Under*. But what would happen when silence followed the initial rush of sympathy? Nancy saved the day with another project, a collection of Russell's illustrated letters. Published in 1929 and again prefaced by Will Rogers, *Good Medicine* was a stroke of genius. It kept Russell before the public as a living presence, charming, funny, warmhearted, and lyrical. That same year the state of Montana resolved to formally honor Russell by placing his statue in Statuary Hall in the Capitol Building in Washington, D.C. Nancy was a more than interested spectator, intervening directly to derail the committee's selection in 1931 (a seated figure by Jessie Lincoln—see "C. M. Russell—The White Indian"), thereby delaying the installation of a Russell statue until 1959— another homegrown tribute gone awry![42]

Through the 1930s Nancy kept active promoting the Russell name and guarding his legacy while raising a son on her own and experiencing a series of emotional and physical reverses. She was pretty much an invalid by 1938, but managed to preserve intact the Russell estate collection of business and personal papers, sketches

and drafts, and paintings and bronzes. She worried about the future and (having feuded with Great Falls) wanted the collection housed in any appropriate institute as a memorial to her husband. Remembering the halcyon days of the twenties, however, she always set her price too high, and the collection was still in her possession when she died on May 24, 1940.[43]

Charles M. Russell's last will and testament consisted of a single, hand-written page, two sentences long, dated November 8, 1924: "I Charles M Russell Do here by Devise and bequath all of my real and pursonal property to my wife Nancy C Russell I am not providing for my Son Jack C Russell because I know my wife will provide for all his needs." In contrast, Nancy's will, dated June 18, 1934, ran twelve typed, foolscap pages. Three codicils (April 5, 1938, March 23 and October 14, 1939) and a trust agreement (September 14, 1939) added another nine pages to the document.[44] Nothing better expressed the Russells' different takes on life than their manner of departing it. Nancy left behind a litigious and exacting legacy; Charlie Russell simply folded up his tent and stole away, leaving Mame to take care of business.

The Russell estate collection—more formally, the Helen E. and Homer E. Britzman Collection at the Taylor Museum for Southwestern Studies of the Colorado Springs Fine Arts Center—has only recently become available to scholars. Much of the original collection was dispersed after Nancy's death—the art sold off, the papers vetted, some key files gone astray. Nevertheless, the estate collection remains a matchless resource that has already revolutionized the study of Charles M. Russell and his art. While paying homage to the old, then, *Charlie Russell Roundup* salutes a new age in Russell scholarship.

~

## Acknowledgements

First, I want to thank Charles E. Rankin, editor of *Montana The Magazine of Western History* and director of publications at the Montana Historical Society. *Charlie Russell Roundup* was his idea. That it is now a reality and we are still on cordial terms is testament

to his persistence, patience, and good humor. He has allowed me a long leash, and I have extended it more than once.

I also want to acknowledge Rick Stewart, Director of the Amon Carter Museum in Fort Worth, who, by his encouragement and enthusiasm, has served as the hub of the wheel in the recent revolution in Russell scholarship. His *Charles M. Russell, Sculptor* (1994) will stand as one of its monuments. Even when I've been engaged on other topics, coworkers in the Russell vineyard—Patricia M. Burnham, Raphael Cristy, Elizabeth A. Dear, Hugh A. Dempsey, Peter H. Hassrick, Steve Shelton, John Taliaferro—have kept me up-to-date and involved. Collector friends like Joe and Tim O'Connor, Kirke, Helen and Doug Nelson, and Wiley Buchanan III, and those with different research agendas whose studies cross Russell's trail like Kate B. Anderson, Seward E. Beacom, Jim Brust, Paul Fees, Stephen L. Good, Sally and Bob Hatfield, Paul Hutton, James D. McLaird, and Dave Walter, have all made working on Russell a continuing pleasure. I am especially indebted to those contributors to *Montana* who have granted permission to reprint their articles. Their efforts are the foundation upon which this book rests.

On the home front, I am as indebted as ever to good supportive friends like Charles Cowan, Dorothy and Werner Liedtke, Joy McBride, Angus, Arlene and Jesse McLaren, Gary Pargee, Ron Peppin, and Judy and Ron Pollard. It is not entirely thrilling living with a historian, and Donna, Blake and Scott, who have been doing it for so long—and Melanie, who is new to the game—have my gratitude and love.

Finally, should any sharp-eyed reader spot errors in *Charlie Russell Roundup*, please keep in mind that venerable *Montana* tradition and *blame the printer*.

## NOTES

1. Review by Peter Meloy, *Montana*, 1 (July 1951), 49; "The Last of Five Thousand or Waiting for a Chinook," *Montana*, 1 (October 1951), 3.

2. Vivian A. Paladin, *C. M. Russell: The Mackay Collection* (Helena, Mont., 1979).

3. Dorothy M. Johnson, letter, *Montana*, 11 (Winter 1961), 67; Noah Beery, Jr., letter, *Montana*, 11 (Spring 1961), 63. Johnson was defending Margot Lib-

erty, who opened the controversy with a letter deploring the "adolescent hero worship" of Russell evident in *Montana* (10 [Spring 1960], 63), and received a salvo from readers who mostly disagreed (*Montana*, 10 [Summer 1960], 78–79).

4. Dedication to Charles M. Russell, *Good Medicine: The Illustrated Letters of Charles M. Russell* (Garden City, N.Y., 1929), vii.

5. For challenges to the "conventional" view that Russell "lived his modern-day life in a frontier way, refusing to go along with the modernization of a 'West that has passed,'" see William H. Truettner and Alexander Nemerov, "What You See Is Not Necessarily What You Get: New Meanings in Images of the Old West," *Montana*, 42 (Summer 1992), 75–76, elaborated in Alexander Nemerov, "Projecting the Future: Film and Race in the Art of Charles Russell," *American Art*, 8 (Winter 1994), 70–89. The argument, in a nutshell, is that "Russell was in fact much more reconciled to modern life than the myth of the cowboy artist allows." But what does "reconciled" mean? Russell's *allegiance* remained, unambiguously, to the past rather than to the present. To assert otherwise is simply wrong. Of course he lived until 1926. Yes, he went to movies, was star struck in the presence of Douglas Fairbanks and Mary Pickford, and even tried his hand at a movie script. Yes, he lived on a "good" street in Great Falls, hobnobbed with the wealthy, and rode in automobiles (including those driven by Nancy or a chauffeur). Of course he kept up with the news, and was a knee-jerk patriot during World War I. Yes, he knew about flappers, and though professing to be shocked by modern apparel saw Nancy and the rest of the world garbed in it. He could do an acceptable fox-trot himself, and was aware of modern art. He just happened not to like it. And that is the point. Charlie Russell was not dead, but his allegiance was to another time and place.

Take modern art, for example. Russell noted it, discussed it, and dismissed it. His artist friends were illustrators by and large, and it was their kind of art he cared about—art faithful to his own brand of realism and his own taste for outdoor subject matter. He read newspapers and the popular magazines of the day, and had favorite columnists like the humorist Irvin S. Cobb. But his taste in fiction ran to adventure stories and historical romances, and in nonfiction to western history and travel accounts about exotic peoples in faraway lands. These were preferences consistent with his lifelong interests. He liked to say that Nancy looked to the future and he looked to the past. Every letter he ever wrote advanced this sentiment. The old days were better. Automobiles, for example, had no souls; horses did. Those who in the 1920s thought wild horses should be exterminated as health hazards had short memories; it was not that long ago that horses were the universal means of transportation—and human companions—and Russell passionately defended their right to exist. Why, in the age of the automobile? Because—again, unambiguously—he was devoted to the past and doubted that progress had made the world better. He rode in cars, but never drove one (unlike his cowboy pal Pete Van) and often said that he preferred to take the streetcar once his horse-riding days were over. He never flew in an airplane (unlike his friend Will Rogers), hated to go faster than a steady lope, and felt unsafe crossing a busy street, especially as age hobbled him. We *know* this to be true. Joe De Yong watched him fuss and fret

and hesitate trying to cross a Los Angeles street in 1924, and told his mother that had he not taken Russell's arm and pulled him out of harm's way Russell would have been hit while he dithered.

Was it all an act? Was Charles Marion Russell actually a modern sophisticate who, at night, shoved his Stetson and boots into a closet along with the sash and the rest of his cowboy costume, slipped on a silk robe, flipped over the western art and photos of old cowboys that decorated his walls to expose the Picasso prints beneath, brushed aside his sack of Bull Durham and fixin's, stuck a Camel into a cigarette holder, and settled into a Louis XIV chair to sip a fine Bordeaux and whip through the Sunday crossword puzzle before studying the stock reports, all the while smirking at a world that had bought his rustic act? There is a mountain of evidence to support the conventional view that Russell was exactly what he appeared to be and none to support a novel view to the contrary. There is not a shred of evidence that Russell gave a fig about business—unlike Frederic Remington, for example, who kept an eagle eye on his bank balance and his stock portfolio. Business was, literally, Nancy's affair. Charlie said so and she said so. Their friends said so. He knew old cowboys who invested in everything from apple orchards and movie theaters to wheat farms and Los Angeles real estate. Russell's one investment in land was a ranch below the Alberta border, where he could periodically drop in on his cowboy friend and partner Con Price and play at old times. It proved not much of an investment—nostalgia paid better in paint and bronze than beef. But it should silence those who doubt Russell's allegiances.

6. D. H. Lawrence, "America, Listen to Your Own," *New Republic*, 25 (December 15, 1920), 69–70.

7. Susan Portis to NCR, ca. 1929, Britzman Collection. In a note to Joe De Yong, Russell touched on similar themes: "When I was a little kid Girls ust to make wax flowers I would steel wax and mak toy hosses green and red ones I never been with out one sinc . . . my father got me a poney when I was 8 I lived in the country Oak hill south of Tower Grove Park then it was a pritty country . . . I was away at scool [at 13] Burlington New Jersey going to be a pirat then I changed my mind was going to be a trapper." CMR to Joe De Yong, undated note, ca. 1916, De Yong Papers, Great Falls.

8. NCR, notes towards "'Back-Tracking in Memory': The Life of Charles M. Russell, Artist," Britzman Collection.

9. John R. Barrows to James B. Rankin, April 27, 3, 1938 (and, for elaboration of his comments, April 20, 1938), Rankin Papers.

10. CMR to [Lin B Hess (?)], ca. 1902, Favell Museum of Western Art and Artifacts, Klamath Falls, Oregon.

11. Billy Shaules, quoted in John R. Barrows to James B. Rankin, May 17, 1938, Rankin Papers.

12. Al. J. Noyes, *In the Land of Chinook; or The Story of Blaine County* (Helena, Mont., 1917), 122.

13. Clark B. Shipman to Rebecca Shipman, March 17, 1886, Shipman Family Papers, MHS. Years later Silas B. Gray (typescript, October 9, 1935, p. 27,

SC 766, MHS) remembered an incident in the spring of 1881 when Kid Russell hooked up with a small party heading back to the Judith Basin after purchasing a new wagon in Fort Benton. Russell had a saddle and blankets but was horseless, so he needed a ride. "The first night out we were camped close to water, I looked after the mules while [Johnnie] Allen looked after the other team," Gray recalled:

[N. S.] True and Uncle Billy were preparing supper, Russell sat smoking a cigarette, True asked the Kid to get a bucket of water for supper, but the Kid kept on with his smoke regardless, a few minutes passed, when True asked him again, still the Kid did not move, then True got hot, walked over to the Kid, an said by God you get that water or you dont get any supper. I knew that settled the water question, as far as the Kid was concerned, for he was just as stubborn as True, we had supper, but not the Kid, no coments were made we had Breakfast but the Kid did not partake, we had dinner, but the Kid smoked instead, supper time we were home. The Kid ate somewhere else, and perhaps he learned a good lesson, for it is sure bad taste, to be a drone around camp. If each one does a little it tends to make things more pleasant for all.

Eliza Walker, who knew Russell in the same period, summed matters up: "Charley was ever a stranger to work." Eliza Walker to Rankin, January 6, 1937, Rankin Papers.

14. J. Frank Dobie, notes of an interview with Wallis Huidekoper, July 1, 1947, Dobie Collection.

15. CMR to Ben R. Roberts, [mid-June 1888], in Brian W. Dippie, ed., *Charles M. Russell, Word Painter: Letters 1887–1926* (Fort Worth, Tex., 1993), 14.

16. CMR to Friend Pony [William W. "Pony Bill" Davis], May 14 [1889], in ibid., 16–17.

17. B. J. Stillwell to Phil Weinard, March 20, 1889, copy with the Weinard file, Rankin Papers.

18. B. J. Stillwell to CMR, February 8, 1915, studio files, CMR Museum. It is likely that the person Stillwell met from High River was Weinard himself, since about this time Russell also received a letter from Weinard to which he replied on June 23, 1915. See Dippie, ed., *Word Painter*, 218.

19. John R. Barrows to James B. Rankin, March 9, 1938 (enclosing a short item on Russell he had published in the Great Falls [Mont.] *Tribune*, January 3, 1934); Barrows to Rankin, April 20, 3, 1938, Rankin Papers.

20. NCR, "'Back-Tracking in Memory': The Life of Charles M. Russell, Artist," unpublished ms., Britzman Collection; and Harold McCracken, *The Charles M. Russell Book: The Life and Work of the Cowboy Artist* (Garden City, N.Y., 1957), 170–71 (quoting the recollections of the Robertses' middle child, Hebe Sheridan).

21. Cecil P. L. Fowler to Charles A. Magrath, April 9, 1905; NCR to Magrath, July 13, 1905, Magrath Collection, Glenbow Museum, Calgary.

Russell's painting *The Battle of Belly River* (or *The Last Great Indian Battle*) breaks the convention Russell followed in his art of containing the action within the pictorial space and providing generous margins on all sides; here, figures enter into the picture, drawing the viewer's eye to the action—an illustrative ploy indicating the influence of Russell's New York illustrator friends. Magrath's commission led to a second the next year, a fine oil painting of a Blackfoot family on the move that has been variously titled *Indian Chief and Family* and *When the Plains Were His*. See Alex Johnston interview with Hugh Dempsey, 1989, courtesy of Hugh Dempsey, Calgary; and Brian W. Dippie, "Charles M. Russell: The Artist in His Prime" in *Charles M. Russell: The Artist in His Heyday, 1903–1926* (Santa Fe, N.M., 1995), 18–20, reproduction on page 45.

22. William Bleasdell Cameron, "Chas. M. Russell," *Western Field and Stream*, 2 (August 1897), 101; "The Old West Lives through Russell's Brush," *Canadian Cattlemen*, 13 (January 1950), 11, 26; "Russell's Oils Eye-Opener to the East," ibid. (February 1950), 26–27, 34; "Russell's Great Gift of Humor," ibid. (March 1950), 5, 8–9; "Charlie Russell Comes Home," ibid. (April 1950), 10, 43, 46–47. For Cameron's memoirs of his captivity, see *The War Trail of Big Bear* (London, U.K., 1926).

23. Robert W. Service, "The Land of Beyond," *Rhymes of a Rolling Stone* (Toronto, 1912), 31.

24. Calgary *Herald*, February 21, 1903; Edmonton *Bulletin*, February 21, 1903; "An Artist Visitor," Edmonton *Bulletin*, February 25, 1903. I am grateful to Mr. Hugh Dempsey, Calgary, for these references. This expedition to Edmonton left its trace in Russell's studio collection, which included a miniature toboggan, a dog-sled model (from Caspar Whitney), and a pair of snowshoes. He continued to seek knowledge about dog sleds from Whitney and the artist Will Crawford and discussed his Edmonton experience with Harry Stanford and Joe De Yong. The idea of making a trip farther north, up the Mackenzie River, continued to intrigue him, and in 1911–12 he actively considered the possibility.

25. CMR to Albert J. Trigg, January 29, 1905, in Dippie, ed., *Word Painter*, 65–66. See Charles M. Harvey, "The Last Race Rally of Indians," *World's Work*, 8 (May 1904), 4809; W. J. McGee, "Strange Races of Men," ibid., 8 (August 1904), 5187; and Robert W. Rydell, *All the World's a Fair: Visions of Empire at American International Expositions, 1876–1916* (Chicago, Ill., 1984), chap. 6.

26. CMR to Robert Stuart, January 16, 1907, and to Edward Borein, February 13, 1918, in Dippie, ed., *Word Painter*, 78–79, 247. In a letter to Joseph G. Scheuerle [February 1918], ibid., 248, Russell expressed his loyalty to Montana. Arizona, he wrote, "is a great country wild and makes good picture stuff. the Indians are not as good as there northern brothrs eather in looks ore dress but a bunch of Navajoes mounted in there country of red sand makes a good picture."

27. CMR to Joe De Yong, undated note, ca. 1916, De Yong Papers, Great Falls.

28. CMR to Edward Borein, February 13, 1918, and, for a classic Russell letter on modern cowboys, CMR to Walter Coburn, November 27, 1924, in Dippie, ed., *Word Painter*, 247, 359.

29. CMR to Will James, May 12, 1920, in *Good Medicine*, 68.

30. Joe De Yong to his parents, Saturday morning [May 5, 1917], Friday morning [March 16, 1917], De Yong Papers, Oklahoma City.

31. Frank B. Linderman to Frederic F. Van de Water, November 8, 1931, Frank Bird Linderman Collection, Maureen and Mike Mansfield Library, University of Montana, Missoula.

32. CMR to Douglas Fairbanks, April 27, 1921, courtesy of Stephen Good, Rosenstock Arts, Denver; and CMR to Fairbanks [June 15] 1921, in Dippie, ed., *Word Painter*, 313.

33. CMR, "Duce Bowman (Featuring Bill Rogers.)," typescript drafts, Britzman Collection.

34. James B. Rankin to his mother, August 11, 1937, Rankin Papers.

35. Joe De Yong to his parents, Sunday night [December 10, 1916], De Yong Papers, Oklahoma City.

36. CMR to Frank B. Linderman, January 18, 1919, in Dippie, ed., *Word Painter*, 269.

37. Joe De Yong to his parents, December 9 [1922], Wednesday morning [April 26, 1917], Friday [March 1918], De Yong Papers, Oklahoma City.

38. Con Price to J. Frank Dobie, August 9, 1946, Dobie Collection.

39. Con Price to Homer E. Britzman, August 19, 1946, Britzman Collection; Dobie paid Price twenty dollars for his recollections.

40. B. M. Bower to Jeanne [Ella] Ironside, July 25, 1924, Jeanne Ironside Papers, SC 344, MHS. According to Bower's granddaughter, who is writing her biography, Bower for most of her adult life "tried to move and work in The Positive as part of a belief system that included Christian Science and later a more extreme view of All This that was supertranscendant." (Kate Baird Anderson to the author, November 11, 1995.) Bower's beliefs are evident in her account of "rescuing" Nancy from herself.

41. Daniel R. Conway to NCR, September 2, 1927; Deed and Agreement (August 3, 1928), Britzman Collection. Nancy did want to stress the fact that the studio and its contents were a gift nevertheless—see NCR to I. E. Church, May 1, 1928, to Fred A. Fligman, June 14, 1928, and her draft letter of instructions, July 30, 1928, Britzman Collection.

42. Montana Session Laws, 21st Legislative Assembly, House Joint Memorial No. 3 (March 1, 1929), typescript copy, Charles M. Russell Research Materials, microfilm reel 3, MHS; Sid A. Willis to NCR, April 26, 1929, enclosing a copy of *House Concurrent Resolution 1*, 71st Cong., 1st sess. (April 15, 1929), Britzman Collection; and *Acceptance of the Statue of Charles M. Russell Presented by the State of Montana* (Washington, D.C., 1959). For Nancy's involvement in the competition (she championed a Los Angeles sculptor at the expense of the committee's selection), see NCR to Willis, May 6, 1929, Calvin E. Hubbard to NCR, April 6, 1931, and Governor J. E. Erickson to NCR, May 1, 1931, Britzman Collection. It should be added that the second competition, in 1957, stirred up a controversy all its own—see Joe De Yong, "Protege of Charlie Russell Criticizes Model of Hall of Fame Statue," *GFT*, (*Montana Parade*),

September 16, 1956, and H. McDonald Clark, "Charlie Russell Again Sparks Montana," *Spokesman-Review* (Spokane, Wash.), September 1, 1957. The controversy illustrates Frank Dobie's contention that "no other state of the Union is so shadowed by the figure of a single individual as Montana is shadowed by Charlie Russell." *GFT*, August 20, 1954.

43. For the story of one negotiation over the Russell Collection conducted in the last year of Nancy's life, see Joe Williams, *Woolaroc* (Bartlesville, Okla., 1991), 118–23. A month before she died, Nancy asked $250,000 for her Russell art; Frank Phillips would not go above $100,000, so the sale fell through. Less than six months after she died, the entire collection was appraised at $3,569. A second appraisal (April 14, 1941) raised that figure to $24,670. Thus, the sale of the collection in May 1941 at $40,000 was above estimate, though hardly in line with Nancy's asking price.

44. Copies of both wills are in the Studio files, CMR Museum.

# PART ONE

~

# Russell in the Press

Long before he became a national figure, Charlie Russell was a local celebrity. Montana papers began following his comings and goings after his small watercolor *Waiting for a Chinook* [FIG. 2] caught the public's imagination in 1887 and earned him the sobriquet "the Cowboy Artist." Russell was no publicity hound, but he was newsworthy. And he frequented the same establishments reporters did—saloons, cigar stores, and the like—where his latest paintings were often on public display, providing fodder for the local press. These early reports are an essential source for Russell's rise to prominence; two are reprinted here: "A Diamond in the Rough" from the Helena *Weekly Herald* for May 26, 1887, and "Life on the Range" from the Helena *Daily Independent* for July 1, 1887.

Many gaps remain in the Russell record; he was a rolling stone, and exactly where he went, who he rode for, and what he was doing prior to his marriage in 1896 are often matters of conjecture. Newspaper research is already making it clear that he returned to St. Louis more frequently than previously supposed, and that simple fact counters the impression that he was estranged from his family. It was only in 1989 that Hugh Dempsey (see "Tracking C. M. Russell in Canada, 1888–1889"), drawing on reminiscences and contemporary newspaper accounts, corrected the record by proving that Russell's legendary winter with the Blood Indians in southern Alberta was actually a four-month summer's excursion that ended in early September 1888; reprinted here is "The Cowboy Artist" from the Helena *Daily Herald* for September 21, 1888 reporting his return to Montana. Similar problems in the Russell chronology will be clarified by further newspaper research. When, for example, did he participate in his last roundup? The fall of 1892 or 1893? Did he accompany a cattle car to Chicago afterwards and visit the fairgrounds at the World's Columbian Exposition? Russell's later interviews are not very helpful in answering such questions, but contemporary newspaper reports offer tantalizing clues. Two pertinent items, reprinted

here, are a notice from the Livingston *Post* for June 30, 1892, and "Our Cowboy Artist" from the Great Falls *Tribune* for April 28, 1893.

Russell always believed that he was born in 1865 rather than in 1864, and this one-year discrepancy skewed chronology in all of his published interviews. If he said he did something when he was sixteen or twenty-five, his assumption that he was born in 1865 must be kept in mind. He was frank about such lapses, telling an interviewer in 1917 that he could never remember "the month or date" he married, and he ended an unusually long autobiographical letter to Guy Weadick in 1922 with the admission, "Guy I am not a historian and this is the best I can do."[1] Nevertheless, Russell's reminiscences are invaluable for understanding his reputation. An autobiographical letter published in the Butte *Inter Mountain* on January 1, 1903, as "Russell, the Cowboy Artist, and His Work" proved particularly influential. Picked up by the Great Falls *Tribune* and the Denver *Republican*, it became the basis for the standard Russell biography in the press.[2]

Newspaper stories also chart Russell's rise to national prominence. Comparisons were routinely drawn between his work and that of Frederic Remington, as in the example reprinted here, "Cowboy Artist St. Louis' Lion," from the Helena *Daily Independent* for May 13, 1901. The Montana press initially relished Russell's growing fame while stressing his loyalty to Montana and friends back home. "Prefers Ulm to New York as Place of Residence," published in the Great Falls *Tribune* for February 16, 1904, mixed rivalry and pride. Once the Russells began traveling regularly and spending longer periods away from Great Falls, the tone grew shriller and the tug-of-war over his allegiance was on. Russell never entertained any doubts himself, but Nancy's attraction to California was undeniable and the rumor of a permanent move prompted a small classic in the Great Falls *Tribune* for February 17, 1923, "Russell Scorns Film Cowboy and Santa Barbara Climate, But City Claims Him as Son."[3]

Planted feature stories and interviews were key cogs in the Russell publicity machine. Nancy turned the crank. No press account failed to mention her primary role in Charlie's life, and after his death she kept his name before the public with books and exhibitions. Nancy even contemplated writing a full-length biography. In preparation,

she jotted down such highlights of their years together as meetings with presidents and royalty, their trip to England and Paris, and this revealing note: "first one mans show in N.Y. Arthur Hoeber getting a page in the N Y times."[4] Russell's exhibition "The West That Has Passed" at the Folsom Galleries in New York in April 1911 was a major breakthrough in his career; so was the well-illustrated article "Cowboy Vividly Paints the Passing Life of the Plains" in the Sunday *Times* for March 19. Such advance publicity was critical to success. Hoeber, himself an associate of the National Academy of Design, was a committed advocate for American art; he was also a gun for hire, and Nancy paid him twenty-five dollars for his services in getting Charlie into the *Times*. Hoeber promised to do more to broadcast Russell's reputation, and with access to periodicals like *World's Work* and *The Mentor* proved as good as his word.[5]

Art was exactly what Nancy called it—a business—and she was expert at her end of it. In 1916 she wrote a friend in Chicago for help:

> Yes, a cry from Montana. Maybe you'd say a Call from the Wild, anyhow I need help in Chicago. We will be there the first of Feb. and have an exhibition of paintings and bronze at Thurber's Gallery that month.
>
> I don't know any newspaper people that are strong enough to get the proper notices and we Darsent buy advertising. That's a bad move for an artist, just like a doctor you know. So I thought maybe you'd know just the person to start Chas. off right in your city. We need a first class press agent. Could you recommend one? If so have him write to me. Time is mighty short.[6]

With press agents involved, there was nothing spontaneous about Russell's newspaper appearances. Since he was a reluctant star, shy around strangers, and laconic about his work, canned biographical material predominated. But reporters who persevered sometimes managed to draw him out, and when he got going, he was quotable, as the two examples reprinted here attest: "Russell, Noted Cowboy Painter, Leaves Past for Minneapolis," from the Minneapolis *Tribune* for December 9, 1919, and "'Just Kinda Natural to Draw Pictures, I Guess,' Says Cowboy Artist in Denver to Exhibit Work," from the *Rocky Mountain News* for November 27, 1921.

This section ends with a tribute to Russell that appeared in Will Rogers' nationally syndicated column in 1924. At the time of the Teapot Dome scandal, in which the secretary of the interior was implicated in shady dealings in oil leases, Rogers had fun with the notion that Russell, a personal friend, was the only pure man in oil. Rogers' column provides a witty take on the standard newspaper version of the life and legend of the Cowboy Artist. And Nancy gets her due.

## Notes

1. Al. J. Noyes, *In the Land of Chinook; or The Story of Blaine County* (Helena, Mont., 1917), 121; CMR to Guy Weadick [ca. July to August 1922], in Brian W. Dippie, ed., *Charles M. Russell, Word Painter: Letters 1887–1926* (Fort Worth, Tex., 1993), 323. Noyes' interview with Russell is especially valuable because by focusing on his cowboy days in Chinook, it drew specific responses from Russell and is rich in anecdotes.

2. See, for example, [Arthur Chapman], "Russell, the West's Cowboy Artist," *Outing,* 45 (December 1904), 269–72.

3. See Brian W. Dippie, "Charlie Russell Meets California," *Montana,* 34 (Summer 1984), 62–79.

4. NCR, notes towards "'Back-Tracking in Memory': The Life of Charles M. Russell, Artist," Britzman Collection.

5. Arthur Hoeber, "Concerning Our Ignorance of American Art," *Forum,* 39 (January 1908), 352–61; Hoeber to CMR, March 25, 1911, Britzman Collection; Arthur Hoeber, "The Painter of the West That Has Passed: The Work of Charles M. Russell, Hunter, Cowboy, and Artist, the Painter of the Cattle and Indian Days," *World's Work,* 22 (July 1911), 14,626–35; and Hoeber, "Painters of Western Life," *Mentor,* 2 (ser. no. 85) (June 15, 1915), 1–11.

6. NCR to C. Barnes, January 15, 1916, Britzman Collection.

# A Diamond in the Rough

Helena *Weekly Herald*, May 26, 1887

∼

WITHIN TWELVE MONTHS past the fame of an amateur devotee of the brush and pencil has arisen in Montana, and, nurtured by true genius within the confines of a cattle ranch, has burst its bounds and spread abroad over the Territory.

Seven years ago a boy of fourteen years left his home in St Louis and came to Montana, going to the Judith Basin, where he got employment on a cattle ranch and has remained ever since. With the lapse of years and growth to manhood the young fellow developed into an expert cow boy until now he can ride the range and throw a lasso with the most adept of his class. But a spark of artistic genius, implanted in his soul, soon made itself visible and called his energies into the cultivation of talent as well as muscle. A strong imitative talent and ability for sculpture and painting soon asserted themselves and the young cow boy employed his leisure hours in moulding figures out of plastic materials and in transferring to canvass and paper representations of the rude scenes surrounding his life. Without a master, never having taken a lesson in drawing or painting, with nothing to guide his pencil but the genius within him, C. M. Russell became celebrated in the neighborhood as a painter. His pictures soon found their way to the centers of population, until now his works in oil and water colors, evolved amid the rough surroundings of a cattle ranch, adorn the offices and homes of wealthy citizens in Montana's principal towns.

Mr. Russell's forte lies in depicting animated scenes. His subjects are all drawn from the scenes familiar to his Montana life, and the faithfulness with which he portrays with the pencil incidents of life on the range is surprising. One of his well known works is entitled "Waiting for a Chinook," and represents a lone steer, "the last

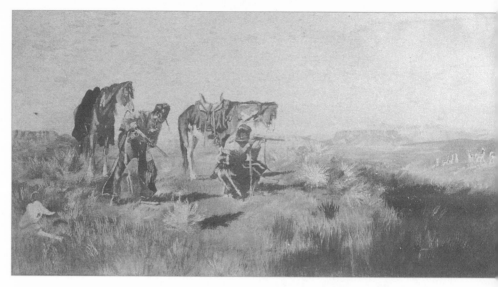

Charles M. Russell, *Antelope Hunt*, oil on canvas, ca. 1887.

of five thousand," standing up to his knees in snow upon a bleak prairie, after a hard winter [FIG. 2]. The exhausted animal, worn to skin and bone, with a worried look in his eyes, is most realistically drawn. This picture has been photographed and copies have been sent to all parts of the country.

His latest work, an oil painting now on exhibition at Calkins & Featherly's, represents two Indians about to shoot at a band of antelope. The scene is taken from the Bad Lands, and is an apt representation of that barren district. In the foreground are two Indian bucks, with painted faces and gaudy blankets. One has dropped upon his knee, and with rifle to shoulder aims at one of the antelope seen in the distance. The other stands stooping behind him, with gun in readiness to take the second shot. Beside the pair are their respective cayuses, hard looking Indian "plugs," caparisoned with ropes for bridles and that mysterious compound of dirty blanket and worn out saddle tree known as an Indian saddle. The live figures are excellently drawn, not the slightest detail in attire of the Indians, their peculiar attitudes or the characteristics of their cayuses being omitted [*Antelope Hunt*]. This painting, as well as several of his former works, has been purchased by Mr. T. W. Markley, of Washington, father of A. W. Markley, of Helena.

Mr. Russell is now in Helena, industriously plying his brush. He has had an offer from Mr. Markley to go to Philadelphia, enter an art school and cultivate his marvellous talent. All who know the young artist and see in his abilities the promise of a bright career for their possessor, hope he will accept Mr. Markley's proposition and go East to perfect the wonderful faculties with which he is endowed.

# Life on the Range

Helena *Daily Independent*, July 1, 1887

∾

ANOTHER PICTURE BY C. M. Russell, the "Cowboy Artist," is on exhibition in Calkins & Featherly's. As the *Independent* has said before, every picture by this natural artist is better than the last, and the remark applies with peculiar force to this latest production. The subject is a round-up scene [*Branding Cattle—A Refractory Cow*]. The central group consists of a wild-eyed and vicious looking cow that has just been branded "O. H.," and with the rope still on her hind leg is running amuck over the prairie, while the cowboy at the other end of the rope has thrown his horse back on its haunches in an attempt to hold her. In the direction in which she is running with her head down in a vicious way are two other mounted cowboys, each with its lariat raised and ready to throw. The whole group is instinct with life and is finished in every detail, even to the "slicker" tied behind one of the saddles and the faint dust rising from among the grass behind the hoofs of the flying animals. In the rear is the herd that is being rounded up, with the moving herders and in the distance rises a range of mountains. The coloring thoughout is very effective, and the picture exhibits much more delicacy of finish and attention to artistic grouping and detail than any former production of his brush. In the front is the buffalo skull which he puts in all his pictures, and which he says is his trade mark. Russell, who is the cowboy in every tone, gesture and movement, is truly the artist of the prairies—the camp and the range. He is a Montana development,

Charles M. Russell, *Branding Cattle—A Refractory Cow*, 1887, oil painting.
From Harold McCracken, *The C. M. Russell Book* (Garden City, NY., 1957), 67.

and if he ever attains the eminence in art that the *Independent* believes him capable of after some study, Montana will still claim him, and expect to see that buffalo skull crop out once in a while.

# The Cowboy Artist

Helena *Daily Herald*, September 21, 1888

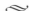

C. M. Russell, the cowboy artist, has returned to Helena after several months' absence on the range, where he no doubt secured subjects for more of his characteristic paintings. Mr. Russell, we understand, is seriously considering the propriety of going to Europe to perfect his talents in the noted art schools of the old world. It is said his friends have perfected arrangements to give him the best of advantages under the best masters of Italy, and that he will soon leave for that artistic land. Under such cultivation Mr. Russell's exceptional talents would doubtless bring their fortunate possessor name and fame as an artist.

# Untitled note

Livingston *Post*, June 30, 1892

C. M. Russell, the cowboy artist, who has made his headquarters at Chinook for several months past, has, we are informed, decided to forsake the round-up for a season and devote his attention to the art of which he is a famous master, says the River press [Fort Benton]. With two saddle horses, one of which he has owned seven and the other ten years, and with which he has ever refused to part, Russell has started across the country for Yellowstone Park, where he intends spending the summer in sketching scenes, which he will afterward produce on canvass as only Russell can. The principal points of interest on his route will also be sketched.

# Our Cowboy Artist

Great Falls *Tribune*, April 28, 1893 (from the Anaconda *Standard*)

About six years ago a striking engraving made from a pen sketch appeared in one of the great London illustrated papers, which attracted wide-spread attention, and was pronounced by critics to be the production of the crude hand of a new master in the world of art, and who also predicted for its author a career of success and fame. The sketch was entitled "Waiting for a Chinook, the Last of 5,000," and was a realistic and pathetic representation of a lone Texas steer, reduced by starvation and exposure to a sorrowful skeleton, while through thick, falling snow cast wildly about by the blizzard, the gaunt outlines of a wolf could be dimly seen in the gray distance [FIG. 2].

It was a graphic portrayal of the horrors witnessed upon the great cattle ranges during the arctic winter of 1886–7 and was the work of C. M. Russell, an uninstructed cowboy, who rode the northern

"circuit" and was unknown to fame. Just about the same time two or three paintings were exhibited in some of the store windows in Helena, which gave startling evidences of a surprising genius.

They were also the work of Russell, and were characteristic and animated scenes of western life in which the cowboy, the Indian, the hunter, and the freighter, and the wondrous landscape of the mountains and plains were drawn and colored with an artistic realism which was a revelation and indicated a high degree of creative power.

The coloring for an untaught hand was marvelous, but the most remarkable feature of the studies was the exquisite fidelity of detail with which the features and picturesque figures of the Indian and those of his sometimes scarcely less wild allies of Saxon blood, were drawn.

The landscapes were photographic reproductions of the snow-wreathed and purple mountains, and the grand monotony of the plains, and the skies while sometimes boldly tinted, were always wondrous reflections for sunrise or sunset dyes, and the soft twilight shades and sombre shadows of night. The artist was sought out and an effort made to persuade him to go to the art centers of Europe and receive instruction in technique, but though money was freely offered him for this purpose he would not accept it, preferring to remain and continue his work as he had begun it, unaided and untaught amid the familiar surroundings of his life.

Russell has at the present time an atelier at Great Falls, where he pursues his work in the independent fashion he affects. He has recently been producing some remarkable representations of Mexican life, and they are classed among his best work.

He has caught the spirit of the semi-barbarous life of the Spanish-American race, and portrays it with his usual vigor and truth. He still retains the habits of his cowboy days, and keeps two ponies, which he rides with grace, dexterity and skill. He is unassuming in manner and dress, and extremely modest in demeanor, depreciating any praise of his work.

Russell is said to be a native of Philadelphia and to have come from a wealthy family. His tastes led him early to adopt the wild life of the range and he rode for many months with the herds, winter and summer. The remarkable genius he possesses was unsuspected by

himself until accidentally developed. The first effort of his brush was in more than one sense a masterpiece.

It is fortunate that peculiar aboriginal and other distinctive types of the wild went which are fast disappearing should have found a hand to so nobly preserve them, and Russell, a young man still, will immortalize himself.

# Russell, the Cowboy Artist, and His Work

Butte *Inter Mountain*, January 1, 1903

⌁

FOR THE FIRST TIME in his career, Charles M. Russell, the cowboy artist, has written an article for a newspaper. Mr. Russell was requested to prepare for the holiday Inter Mountain a sketch of his life, since no absolutely correct biography of this strange genius ever was published. After some persuasion he consented, and here is the story just as he wrote it:

I was born in St. Louis, Mo., in 1865, and came to Montana 23 years ago next month, coming by way of the Utah Northern and stage to Helena, where Pike Miller, the man I came with, outfitted, buying a wagon and four horses. We pulled out for the Judith Basin, where he had a sheep ranch.

I did not stay with Miller long as the sheep and I did not get along at all well, so we split up and I don't think Pike missed me much, as I was considered pretty ornery. I soon took up with a hunter and trapper, Jake Hoover. This life suited me. We had six horses, a saddle horse apiece and pack animals. Two of them belonged to me. One of these, a pinto, I bought in 1881, is at this minute eating hay in my corral. He has a good stable but seems to prefer being outside, so I turn him loose. He has his choice.

He is not worth much now, but I don't think he owes me anything. We were kids together. I have ridden and packed him thousands of miles. We have always been together. People who

know me know him. We don't exactly talk, but we sure savy one another.

Well, I lived with Jake about two years. In 1882 I returned to St. Louis and stayed about four weeks, bringing back a cousin of mine, Jim Fulkison [Fulkerson], who died of mountain fever at Billings two weeks after we arrived.

When I pulled out I had four bits in my pockets and 200 miles between me and Hoover. Things looked mighty rocky. There was still quite a little snow, as it was early in April, but after riding about 15 miles I struck a cow outfit coming in to receive 1,000 dougies for the 12, Z and V outfit up in the basin.

The boss, John Cabler, hired me to night wrangle horses. We were about a month on the trail and turned loose on Ross Fork; where we met the Judith roundup. They had just fired their night herder and Cabler gave me a good recommend, so I took the herd.

It was a lucky thing no one knew me or I'd never got the job. Old man True was asking who I was. Ed Older said: "I think it's Kid Russell."

"Who's Kid Russell?"

"Why," says Ed, "it's that kid that drawed S. S. Hobson's ranch."

"'Well,' says True, "if that's that buckskin kid, I'm bettin we'll be afoot in the morning." So you see what kind of a rep. I had. I was considered worthless and was spoken of as "that ornery Kid Russell," but not among cowmen.

I held their bunch and at that time they had 300 saddle horses. That same fall old True hired me to night-herd his beef, and for 11 years I sung to their horses and cattle.

In 1888 I went to the Northwest Territory and stayed about six months with the Blood Indians. In the spring of 1889 I went back to the Judith, taking my old place wrangling. The captain was Horis Cruster [Horace Brewster], the same man who hired me in 1882 on Ross Fork.

The Judith country was getting pretty well settled and sheep had the range, so the cow men decided to move. All that summer and the next we trailed the cattle north to Milk river. In the fall of 1891 I received a letter from Charley Green, better known as "Pretty Charley," a bartender who was in Great Falls, saying that if I would come to that camp I could make $75 a month and grub. It looked good, so I saddled my gray and packed Monty, my pinto, and pulled my freight for said burg.

When I arrived I was introduced to Mr. G., who pulled a contract as long as a stake rope for me to sign. Everything I drew, modeled or painted was to be his, and it was for a year. I balked. Then he wanted me to paint from 6 in the morning till 6 at night, but I argued that there was some difference in painting and sawing wood, so we split up and I went to work for myself.

I put in with a bunch of cow punchers, a roundup cook and a prize fighter out of work and we rented a two-by-four on the south side. The feed was very short at times, but we wintered. Next spring I went back to Milk river and once more took to the range. In the fall I returned to Great Falls, took up the paint brush and have never "sung to them" since.

I went to Cascade in the fall of '95 and was married to Nancy Cooper in '96.

She took me for better or worse, and I will leave it to her which she got. We moved to Great Falls in '97 and have lived there ever since.

Several papers have given me writeups, and though they were very kind and gave me much flattery, in many ways they were incorrect, so I have written you a few facts.

Yours sincerely. C. W. RUSSELL

# Cowboy Artist St. Louis' Lion

Helena *Daily Independent*, May 13, 1901

A FEW WEEKS AGO Charles M. Russell, the "Cowboy Artist," who lives at Great Falls, went to St. Louis to visit relatives. The work of Russell is highly appreciated in Montana, because the people who live here know it is true to nature, but they are familiar with the scenes he paints, many of them having witnessed them scores of times, so there is no real novelty about them. But with the easterners it is different. The life and "go" in the Russell pictures strike them forcibly, and now they have the painter with them and are lionizing him.

All of the St. Louis papers have printed more or less about the artist, and some of them have illustrated their stories with reproductions

of some of his pictures. One of the most interesting stories about Russell is printed by the St. Louis Post Dispatch, and it is interesting because it tells how Russell made his first hit for public attention by a sketch he made for Louis Kaufman, of this city. This is the story told by the Post Dispatch:

"Charles Marion Russell, a cowboy artist whose pictures of frontier types are winning fame for him in the world's art centers, has returned to his boyhood home in St. Louis after 23 years of adventure in the west.

"A painter who discovered his life work and a wife through the medium of blood-and-thunder dime novels, whose inspiration has been the color and romance of a vagabondage among Indians, hunters, trappers and cowboys, and who, loving nature, has set up his atèlier in the lap of the mother of his fancy—that is Russell.

"Accompanied by Mrs. Russell, whom he met and loved at first blush, five years ago, at Cascade, Mont., as Miss Mamie Cooper, a former Kentucky girl, he is visiting his father, Charles S. Russell, president of the Parker-Russell Mining & Manufacturing company, and his sister, Mrs. Thomas G. Portis, at their residence, 3512 Franklin avenue, before departing for his adopted home at Great Falls, Mont.

"It is there in a pleasant home within the sound of the great cataracts of the Missouri, living the memories of his wild days, that Mr. Russell 'paints for a living,' as he expresses it, and entertains his former friends, Sleeping Thunder, a young Blackfeet brave, and Buffalo Colt, a Cree warrior, who visit their paleface chum at the passing of the moon. Their heads have served as models for many of the painter's best moods. The Russell ranch is the halfway house for any old acquaintance of the plains or mountains.

"Remington is the idealist of the new western art culture. Russell is its realist. He knows his Indians, his plainsmen, his broncho and cayuse and his cattle. All the finish his art shows has come to him intuitively during the progress of its natural development. His gift is purely negative. Not one hour was ever spent in a studio.

"His studies have been made in the saddle while punching cattle for 11 years on the ranges of Montana, in the cabin of the trapper or when he lived among the Blackfeet Indians. He says that it was during these fragmentary moments that his artistic senses were quickened and his nature assimilated the color and atmosphere of his surroundings.

"He is modest about his powers and feels that he is only beginning, although his fine Indian heads and severely simple studies of horses and cattle and frontiersmen have already found their way into the homes of the most cultured people of the western cities.

"Russell says that he took his cue from Horace Greeley's advice and went west and grew up with the country, but he saddles the responsibility of the venture on the Lasso Lukes and Calamity Janes who fired his imagination from between the lines of Col. Ned Buntline's border fiction.

"A long time ago, when he was a callow youth, drawing pictures in the leaves of his books at Washington university, St. Louis, and at Burlington college, N. J., he confessed that he was reading 'Dare Devil Dick, the Gentleman Road Agent,' when he ought to have been preparing the lesson for the morrow. He caught the rolling stone habit and it stuck to him.

"The artist's first realization of his power dawned when in an idle moment, while snowed in among the Montana cattle ranges, he painted in cheap water colors a miniature which has since been copied all over the world. He called it 'A Hard Winter.' A lone steer is perishing from starvation and exposure amid a bleak hurricane of drifting whiteness [FIG. 2]. Mr. Russell talks in an interesting way about it.

"He was wintering and waiting for the chinook, the warm winds, at the Quarter Circle-Block range along the Judith river and Arrow creek in Montana. Communication was cut off between the ranch and Helena, where the cattle bosses kept to their warm hotels. Kauffman, the principal owner of 75,000 head of cattle on the range, sent a message into the wilderness by a carrier on snow shoes. He inquired how things looked.

"While the foreman, Jesse Phelps, sat himself down, 'pen in hand,' to tell him that the herd was melting away with every icy blast, Cowboy Russell got out his sorry little box of water colors and drew a picture of the situation. It was the lone steer, bearing the 'R' brand. He tossed it over to Phelps with the remark, 'Put that in the letter.'

"Phelps repled that he would not write a letter: he would send the picture. This rough tribute to Russell's art was the beginning of a career.

"Kauffman exhibited his strange answer in the Montana capital. A young woman who knew art saw the picture. It touched her nature. She carried it east. It was recognized as something true. 'A Hard

Winter' caught the popular fancy and Cowboy Russell heard from his idle hour.

"Mr. Russell left St. Louis in 1879 in the company of Willis Miller, the son of an old resident of the city. Miller was 25 years of age and Russell was only 13. They made their way to what was then the terminus of the Union Pacific railway at Green River, Wyo., and staged several hundred miles from that point to Helena, Mont., which they found feverish with gold seekers, road agents and vigilantes.

"The two tenderfeet outfitted with saddle horses and pack animals and with their grub stake pulled out for Judith basin, then a vast, untenanted range. They built their cabin and began prospecting. Things went up the spout and Russell 'pulled his freight.'

"That is to say, he fell in with Jake Hoover, a trapper who had been in the west so long that he had bunions on his feet. Two years were spent on the south fork of the Judith with this newfound partner. Russell tended his horses, cooked and sketched.

"Then the cattlemen began to find the range good along the Judith and Russell turned cowboy. He learned to ride and shoot and throw a lariat in the round-up. He punched cattle 11 years and amused himself and his associates by his caricatures.

"The summer of 1887 was spent on the Blackfeet reservation in the British possessions, where studies were made of Indian life. The artist relates his experiences.

" 'I lived among the tribe as one of them. Black Eagle, one of the chiefs, was a good friend of mine, but I ran with Sleeping Thunder, a young buck about 22 years of age, who was very bright. The Indians considered me a sort of medicine man because of my ability to put them on paper. I wore moccasins during this life, but otherwise clung to the white man's garments. The time was passed in hunting and fishing. It was a valuable experience. The Blackfeet are very proficient in the sign language, which I acquired.'

"The Portis residence fairly pulsates with the breath of the painter's inspiration. There is a young Indian maiden reclining after the fashion of the houris of the harem on a divan in a gaily-decorated tepee. Her arm, which is thrown carelessly over her jet hair, reveals a wealth of physical perfection. Another, an Indian scout on the warpath, mounted on a cayuse that has been reined back on his haunches, and

a rifle carried ready in the hollow of his arm, is full of alertness and majesty and conveys a good idea of the artist's touch. The coloring is potent with the mystic distances of the west. There are heads of chiefs and bucks in wildest border array.

"Mr. Russell began to paint in oil in 1893, after taking up his residence at Great Falls. He works rapidly and without much preparation. The subject decided, the painter sits before his easel and lays off his preliminary sketch with the freedom of a cartoonist. Then he takes a walk alone and memorizes the features of some face and figure that he has met. The development of the picture is then made at leisure.

"The man who may rival Remington and some day surpass the world's best animal painters possesses an individuality born of a close communion with the breath of life as realized in the far reaches of the west. He is cast in powerful mold. There is an amplitude of shoulders that tempts womankind to admire. There is a leonine head closely cropped and well set upon a neck like a Dorian column. The face glows with perfect health. It is frank and inviting. It is a face full of power as well. The features are large and suggest the strength and more of the nobility that he has stolen from his Indian friends and transferred to canvas. Deep-set, penetrating blue-gray eyes have a direct gaze. The nose is slightly aqualine and the mouth is firm, the lips long and tightly closed. A square, massive chin bespeaks decision. Mr. Russell is 36 years old."

# Prefers Ulm to New York as Place of Residence

Great Falls *Tribune*, February 16, 1904

~

CHARLEY RUSSELL, "the cowboy artist," and Mrs. Russell returned yesterday afternoon from a visit of four months in the east, and incidentally it may be said that Charley Russell is the happiest man in Great Falls.

"Glad to get back? Well, I should say I am. Say, my advice, to anybody that does not love home, is to just go down and live in New

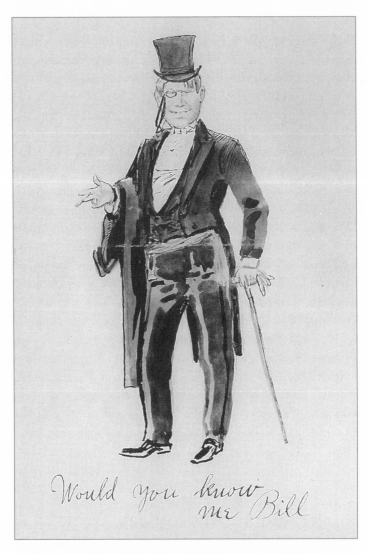

Charles M. Russell, *Would You Know Me Bill*, 1905, pen and ink, watercolor, graphite. MHS Museum, Helena, Elks Club Collection

York for a while. He'll sure love home then," he replied to a question.

During their absence Mr. and Mrs. Russell went to St. Louis where they stayed several months with Mr. Russell's father. They then went to New York at the solicitation of John N. Marchand, an illustrator of western life, whom Russell met here last summer, while Marchand was visiting Wallace Coburn.

Russell's reappearance on the streets yesterday was a glad sight to his scores of friends and he was kept busy shaking hands and saying, "Howdy," to the many who pressed around him to welcome him back. His "harness," as he speaks of his clothing, afforded his friends considerable amusement, for he was dressed in the latest Fifth avenue cut of a Tuxedo overcoat, and he was mildly guyed about wearing corsets. Aside from that he is the same, old "Charley" and his comments and stories on the east kept his auditors in a roar of merriment.

"Yes, I had a fine time," he said. "Everybody was mighty nice to me. As nice as they could be. But the east is not the west. Give me the choice of spending the rest of my life in either New York or Ulm and I would take Ulm. From St. Louis, where we spent Christmas with my family, we went to New York, where I met a lot of artists and illustrators. They are a mighty fine lot of fellows and they treated me out of sight. I worked in the same studio with Marchand, Albert Leving and Will Crawford, and they were particularly kind to me.

"I practically did no work in St. Louis, beyond submitting four pictures to the hanging committee of the World's fair art gallery. I have not been notified yet whether any of them will be hung, and I am rather doubtful that they will be. In New York I did considerable work and more than 'broke even' on expenses. I did some illustrations for Scribner's, Outing, McClure's and Leslie's magazines, and some of it will be published in a short time. I also did some sculptoring, and sold a statuette of a cowboy on a bucking broncho to a firm which will reproduce it in bronze. My friend, Marchand, took me around and introduced me to the art editors of the big publishing houses, which was might fine for me. Many of the editors promised me work in the future in illustrating western stories.

"While there I met Alfred Henry Lewis, the author of 'Wolfville Stories,' Ernest Thompson Seton, the author; Schreyvoygell [Charles Schreyvogel], a painter of American army pictures, Casper [Caspar] Whitney, the editor of Outing, and a noted hunter, 'Bat' Masterson, the famous gun fighter and sheriff and now prize fight referee. That newspaper talk about my being 'lionized' by the smart set is all nonsense, though I did meet the man who leads or bosses the smart set at a dinner, but I don't remember his name. I also ran across William

Hart, the actor, who played the leading part in 'The Christian' here last year. He and I went down to Rockaway beach together, where I got my first sight of the ocean, and tried eating freshly dug clams. My limit was two. I also saw Senator [Paris] Gibson, Theo. Gibson and H. O Chowen in New York.

"New York is all right, but not for me. It's too big and there are too many tall tepees. I'd rather live in a place where I know somebody and where everybody is Somebody. Here everybody is somebody, but down there you've got to be a millionaire to be anybody.

"The minute you get west of Chicago you can notice the difference in people. You begin to strike westerners again. If you go into a smoking car east of Chicago, sit down beside a man and start talking to him by saying, 'This [is] a fine country through here,' he'll mumble 'yes' and look the other way. You can't get anything out of 'em. I guess they're afraid you'll spring a shell game on 'em or try to sell 'em a gold brick.

"And the style in those New York saloons. The bartenders won't drink with you even. Now I like to have the bartender drink with me occasionally, out of the same bottle, just to be sure I ain't gettin' poison. They won't even take your money over the bar. Instead they give you a check with the price of your drink on it, and you walk yourself sober tryin' to find the cashier to pay for it.

"You can live better here in Great Falls for the same money than you can in New York. I'll bet I didn't have a good potato while I was there. I don't know what they do with 'em—evaporate 'em I guess. Of course I didn't stay at the Waldorf-Astoria. I went in there once and looked around and got out without leavin' any of my clothes behind, or havin' a chattel mortgage tacked onto me. You've got to be rated in Rockefeller's class to camp around that lodge very long.

"They say no matter where you come from, if you walk on Fifth avenue for an hour you'll meet somebody that you know, and I guess it's so. One day I was kicking around the studio and Marchand sprung that sayin' on me. I said I didn't believe it and he said, "Well, you go out and try it.' I did and I hadn't been on Fifth avenue an hour when I met Judge DuBose, who used to be down at Fort Benton. He was down there from Alaska. Well, we had a good time talking about Montana.

"There's a whole lot of people down there in New York that has got too much to eat and there's a whole lot more who haven't got enough to eat. I remember one night while I was out walking with Marchand, I saw a line of men two or three blocks long stretching up the street. I asked Marchand what the show was, and he said they were poor devils without anything to eat and coffee and sandwiches were bein' given out to them at the other end of the line. It was a tough sight. I'd rather take my chances in this country, where a fellow can make a stand-off occasionally."

# Russell Scorns Film Cowboy and Santa Barbara Climate, But City Claims Him as Son

Great Falls *Tribune*, February 17, 1923

～

SANTA BARBARA LIKES "Charlie" Russell.

In fact, when the great western artist, who is wintering there, sells one of his paintings to the Prince of Wales for $10,000, the famous California resort—ever alert for new advertising values—is quite willing to adopt "Charlie" as a native son.

As an afterthought to the description of additional glory that has come to the great artist at Santa Barbara, new[s] dispatches concede that Russell was "formerly of Great Falls, Mont."

But that "formerly," in the words of Andy Gump, is the bunk—

"Charlie" not only was, but IS, of Great Falls, Montana—"Charlie" himself being authority for his preference.

And, not only that, but if Santa Barbara knew what "Charlie" thinks of that particular resort, it might expend less energy in attempting to claim him as a native son.

"Their sunshine," says the artist is like "near-beer. It looks good, that's all."

And now he adds a few choice insults to those already extended.

In these last he makes the following pertinent observation anent the movie profession:

"There's lots of movie folks here; often their horses are the best actors." The remark is the conclusion of a description of the variety of cow punchers that abound in Santa Barbara, and is contained in a letter to his friend, "Bill" Ellot [Elliot] of Great Falls.

Captioned by a vivid drawing of a movie cow puncher, the letter reads:

"There's lots of punchers like this one in this country. Some different from the kind you worked with in the old days. This one never slept where he could see the stars. He can rope and ride, but he never smelt burning cow hair and hide in his life. He buys his sunburn in a drugstore, sleeps on springs and his chuck wagon is a cafeteria.

"The horse he rides is a top that never smelled dust, heard a bell or pawed snow."

Besides the picture sold to the Prince of Wales, Douglas Fairbanks, the actor, also purchased one of Russell's paintings for the sum of $10,000.

# Cowboy Vividly Paints the Passing Life of the Plains

[by Arthur Hoeber]
New York *Times*, Magazine Section, March 19, 1911

~

"KID" RUSSELL, or, to be formal, "Charley" Russell, or, to be ridiculously formal, Charles M. Russell, cowpuncher that was, painter and sculptor that is, has come to town from Montana for his first "one-man exhibition." He has brought with him a score of the paintings and bronze groups of Indians and cowboys and wolves and buffaloes that are making him famous. Also he has brought along plenty of brawn and sinew, and the indescribable gait of the man who lives in the saddle, and a weather-beaten face that speaks eloquently of the "range," and a pair of boots that start somewhere near his knees and run to the tip of his toes without a solitary buttonhole

or aperture of any sort. Nothing but boots like those for footwear, opines "Charley" Russell. "Only wore one pair of shoes in my life." His exhibition will be held at the Folsom Galleries on April 12. He will array there his "Medicine Man," of which his wife and artist friends are exceedingly proud—(Russell himself is proud of none of his works)—and his "Disputed Trail" and "The Wagon Boss" and—well, another painting for which the Russell description is "a bunch of Indians just lookin' for trouble," answers better than any conventional label. It shows a group of red men painted in the gayest colors, squatted on a ridge, their horses quietly cropping the grass beside the trail, their eyes riveted on a lovely valley stretched out beneath them, dotted with paleface settlements—saying nothing, not moving a limb, just squatting there—"lookin' for trouble."

Cowpunchers and redskins—lonely trails—wolves—gun play, simple and compound—bony, wise-looking horses—gaudy trappings and blankets and feathers—buffaloes—that is all you will see at the Russell exhibition. For this new artist out of the West thinks of nothing else, sees nothing else. All his life has been spent on the "range" or in log-cabin studios. The trips he makes to the East only make him keener to get back there. "Me stay in the city?"—you ought to hear him say that. It's rough on the city.

He has never studied art. All that he knows has come to him from himself. For eleven years he was a cowpuncher, way back in the West of the eighties and nineties; a "night herder," guarding the horses of his comrades against thieving bands of Indians, with no companions but silent stars and howling wolves.

He took up that night job simply and solely to have a few hours of daylight for his sketching. Those were precious hours! Then he used to drop from the saddle, whip out of his sock a meagre supply of colors and brushes and set to work to sketch, sketch like mad, before the sunlight forsook him.

That was his school. As for sculpture, he took his first lesson when, as a little boy, he got the first piece of wax he had ever seen between his fingers.

He has been modeling ever since. At a theatre, if he is bored, he picks some wax out of his pocket and shapes it into something. If you sit at a table with him and look under it, you will see his fingers

restlessly working over a seemingly formless lump. Presently up will come his hand and on the table before you will be a life-like figure in wax or clay—probably a bear or a horse or a redskin warrior.

"He made a portrait—yes, Sir, a real breathing portrait!—of my dog while he was telling me an after-dinner story," declares one of Russell's friends here.

"Wait a minute—it is not true that Russell never went to art school. He attended one in St. Louis. The instructor set him to drawing a human foot from a model. Russell drew it. The instructor came by and, without a word, rubbed out the young student's work. Russell drew it again. Again the instructor rubbed it out. Russell put on his hat and went away. Next morning he hit the trail for Montana.

In Montana he has been ever since—not in the pushing young State of to-day, but a Dreamland Montana, the mysterious mountain-land that has melted away never to return, the Montana peopled by huge herds of buffaloes and roving bands of Indians, and dotted with the bones of murdered and scalped palefaces.

That is where Russell still lives. When he first knew Montana, it was in its dying struggle against civilization. He saw the gradual taming of the wild "cow" towns, and the last sounds of unbridled revelry and the whistling of the last bullets that flew in bloody brawls. Driven by unquenchable thirst to know the real West before it vanished forever, he lived month after month among savage Indians, eating their meat and winning their confidence, learning their ways, their beliefs, their speech, learning, even, that mysterious sign language which makes brothers of Sioux and Cree and Blackfoot.

"If I had my way I'd put steam out of business!" In those rough words, rapped out beneath scowling brows, "Kid" Russell, Westerner of the past, throws down the gauntlet to the present.

"Gee, I'm glad I wasn't born a day later than I was!" he often sighs. And then, without losing time, he grabs brush and colors, vaults on his horse, streaks out of the far-away Montana town where he lives, and in an hour or so is sitting contentedly by the trail-side, conjuring up the yesterdays that he loves, while his horse grazes patiently, little knowing that he has become an artist's model.

"I was born in 1865 in St. Louis. When I was 15 my father took me to Montana. I worked as a cowpuncher for eleven years. Then I

decided to be an artist. It didn't work. I had to go back to cowpunching. That was in the Fall of '92—no, '93—no, '92. Then I started painting again. Been painting ever since."

That's how Russell talks when he is interviewed. He is hopeless. "It's—it's mighty hard to know what to say," he grunts, taking off his big cowboy hat, scratching his head, and looking uneasily at the questioner's pencil. He doesn't really get started till a question is fired at him regarding the value of art training abroad. Then:

"I can't see how a Dutchman or a Frenchman can teach me to paint things in my own country!" he blurts out.

"Oh, I always made a bluff at painting," he explains, when pressed for information as to the beginnings of his career. "I used to sketch the other boys on the range and, their horses and the Indians all the time. Those fellows are good critics, let me tell you, especially as to little things. A cowpuncher or an Indian tells you right away if there's anything wrong about the clothes or saddles or colors used in a picture of the West.

"But I couldn't get any of them to pose for me. They don't like it. 'Why the devil should I sit there like a fool!' cowpunchers used to ask me.

"As for the Indians, they'd just get up and walk away without a word. The most I could get them to do for me was to sit just for a few minutes. There was one young Indian boy who used to be so kind as to take off his shirt and pose a bit when I was up against some difficulty in reproducing a human figure. But he'd soon put the shirt on again and go away.

"I live in Great Falls, Mont. I paint in a log cabin. I also have a country place on a lake. I paint a good deal in the open air."

He was getting hopeless again. "Aren't you about the only artist in your part of the country?" he was asked. That question alarmed Russell very much.

"Look here, don't go and say I'm the only cowboy artist," he expostulated. "Why, there's another one in Wyoming, and another in Coloraydo, and—" But there he got stuck; he couldn't remember many more readily.

So he plunged, with huge relief, into anecdotes utterly irrelevant to the interview, and the interviewer pocketed his pencil in despair,

and a pair of Russell's friends, realizing the situation, gently but firmly eliminated the big Westerner entirely from the interview, and started in themselves to tell about the picturesque career which the artist himself seemed entirely incapable of divulging.

They told of his life with the Indians of British Columbia, when he was six months without seeing a white man. The Blackfeet Indians called Russell "The Antelope" on account of his mane of tawny hair. They also spoke of him as the "picture-maker." He donned Indian costume, wore moccasins, ate what his hosts ate, and, before he hit the trail again for civilization, was looked upon by them as a brother.

Once he fell in with a squad of the Northwest Mounted Police and traveled with them. One night, when they were camped in the midst of a wilderness, a footsore Indian limped into camp asking for food. One of the policemen, a young fellow inclined to be over-fresh, was very disagreeable to the newcomer.

Russell expostulated, but the policeman, growing nettled, renewed his rude treatment of the Indian, and when the latter again asked for some supper, deliberately kicked him in the ribs. The Indian simply glowered and drew away. Russell then invited him to share his repast, which the Indian did without a word. At dawn he left the camp.

"My boy," said Russell to the young policeman, "I wouldn't ride around here much alone." But the youth scoffed at the warning.

Four days later he was found dead beside the trail. Shortly after that the survivors of the police squad awoke one morning to find that all their belongings had been stolen during the night. Only Russell's kit had been left untouched.

One of the artist's particular friends is Young Boy, brother of a Cree chieftain. At irregular intervals Young Boy drops in as if from the sky at the artist's Great Falls studio.

"Lend me ten dollars," he grunts. The artist hands him the money. "Pay it back in three moons," grunts the red man. And he vanishes. Three months later, without fail, he is back to return the money.

At times he is not so explicit. "Pay back in three—six moons—year, maybe." But his white friend lends him the cash just the same and, sure enough, Young Boy brings it back.

At first Russell used to communicate with this youth in the intricate sign language which he learned during his long stay among the Blackfeet Indians. Young Boy, being a Cree, knew no Blackfoot, and received all advances made in English with a face utterly blank. So Russell did what he could with signs.

One day, when the artist was busy painting a picture, Young Boy walked into his studio and examined the work critically.

"Say, how much money will you get for that?" he inquired in perfect English.

The artist turned on him in amazement.

"Why under heaven didn't you let me know you could talk English instead of making me get gray hairs trying to speak sign language?" he asked heatedly. The Indian never twitched a muscle.

"Me want know what kind of man you first," he replied solemnly.

Another great friend of Russell's is an Indian chief who is over 100 years old and is known by the poetic name of "Bill Jones." Once Russell painted his portrait and presented it to Bill.

Many years elapsed before the two met again. Then, one day, Russell came upon an Indian encampment and was welcomed cordially by the aged chieftain. Disappearing into his tent, Bill Jones dug up a roll of blankets and other accoutrements and, unrolling them carefully one by one, finally produced from the innermost fold of the bundle the portrait which Russell had painted of him.

"Still got," he grunted pleasantly.

Indians, as a rule, have names far more picturesque than Bill Jones, names which actually connote something. In fact, they look down on the white man's methods of nomenclature.

"What your name?" a redskin asked Russell, when the artist was living the life of a savage.

"Charley Russell," was the reply.

The red man pondered.

"What 'Charley' mean?" he inquired.

"Mean? Why, I don't know."

"What Russell mean?"

"I don't know."

The Indian grunted disdainfully and puffed at his pipe.

"White man read heap books, know heap things," he observed, "but don't know own name."

Far, indeed, are those scenes from "Charley" Russell just now, as he dodges trolley cars and other wild things on his way from his apartment to the studios of fellow artists, there to talk seriously about the coming exhibition; also to receive congratulations on account of the letter he has just received from the Director of the American section at the coming exhibition at Rome asking that he send across the ocean his bronze group of a bear and her cubs which he calls "The Lunch Hour."

That is by no means the first Russell group to make the transatlantic voyage. Out in Montana the artist knew a number of Englishmen, members of a syndicate that was working a sapphire mine, who took a great fancy to his paintings and bronze reproductions of the Wild West. Several of the directors of the syndicate bought specimens of his work and took them away to London.

When you ask what Russell's views on art are both he and his friends are stumped. He doesn't like impressionism. "It's smeary," he declares. Independent as he is, he likes to look over the shoulders of his artist friends here in New York, while they are at work, and get ideas from what he sees. But not too many. For inspiration he sticks resolutely to Montana.

"I'm afraid of losing my grip of the whole thing," he explains. So vividly does he feel and know what he depicts that his work never fully satisfies him. When he models things, they look good to him in wax; cast in bronze, however, they often appear to have lost some of their reality and become disappointing. And the artist mourns accordingly.

But, in the eyes of others, Russell's work has plenty of reality. His keen observation in the days when cowpunchers abounded on the "range," and when Indians carried lance and bows and arrows, and wore blanket leggins obtained from Hudson Bay traders, has not been wasted.

Not long ago, in a magazine, a writer who spent years taking photographs in the Far West pointed out wherein Russell's depictions of bucking broncos differed from Frederick [Frederic] Remington's, and maintained that the Russell brand of bronco was

the truer to life. And there is the following anecdote which Russell's friends delight to tell as a further illustration of one way Russell's work is looked upon by Far Western connoisseurs.

Somebody once wrote to Andy Adams, author of "The Log of a Cowboy," asking exactly how cowpunchers dressed in the early eighties.

"Ask Charley Russell," Adams replied. "If he painted a naked cowpuncher swimming across a river you'd know it was a cow-puncher."

# Russell, Noted Cowboy Painter, Leaves Past for Minneapolis

Minneapolis *Tribune*, December 9, 1919

～

CHARLES M. RUSSELL of Great Falls, Montana, recognized by many critics as America's greatest Western painter, has come out of that part of the early Eighties, and earlier, when great herds of buffaloes and cattle covered the grassy ranges of Montana, and blanketed Indians were everywhere in evidence, long enough to accompany 16 of his canvases to Minneapolis this week.

With a broad-brimmed hat set far back on his head, and a soft flannel collar open at the throat, Mr. Russell strolled into the Hotel Radisson lobby yesterday afternoon, with that unmistakable gait of the genuine cow-puncher. Not even the cigarette he deftly rolled for himself could make him altogether at home.

"I'm not much on cities," he confessed. "I went up to the round-up in Calgary last July, when they entertained the Prince of Wales, and I haven't been beyond my backyard in Great Falls since."

His eyes roamed aimlessly past guests in the lobby straight to the Indian decorations on the walls.

"Who did those?" he asked suddenly. "They're good."

The interviewer confessed ignorance, as did several loungers and

the clerk. When the manager was consulted, A. Thomas of New York city was found to be the artist.

"I didn't know these Minnesota Indians, said the artist, "They're different from the ones I knew in Montana. But I guess the artist knew them."

He fell silent, and only in reply to repeated questions disclosed the story of his trip 40 years ago, upward from Missouri over the old Union Pacific trail into the Montana cattle country. He was 15 years old then, and for three years he hunted and trapped through the wild country, making friends of cattlemen and Indians. Then he became a cow-puncher, and remained one until he turned entirely to painting in 1896.

"It's a good thing I took to painting," he said, "because there isn't much call for cow-punching any more."

Asked about his artistic education, he smiled, "I'm not that kind," he said. "I never had a lesson—just painted. After I got known a little, other artists came to see me, and I watched them paint. I learned something from that."

He has few friends among artists today, the Western painter said. "I'm just a cow-puncher, and I don't have the education," he said. "I wouldn't know what to talk to them about."

Asked where he gets models for his pictures, all of which have subjects of the early pioneer days in Montana, the artist said he used no models. "I live back there in those days nearly all the time," he explained. "I don't have any trouble seeing my pictures."

On hundreds of canvases the Montana cow-puncher has put down authentic pictures of the Montana days now rapidly being forgotten, and before he finishes he hopes to set down a complete picture of the life and events with which few people are now familiar.

Sixteen of his best canvases are on exhibition at the Minneapolis Institute of Arts this week. Asked whether he would be at the galleries, the artist shook his head, embarrassed at the thought. "I won't be there much," he said. "But my wife will—and she knows more about my pictures than I do myself."

# 'Just Kinda Natural to Draw Pictures, I Guess,' Says Cowboy Artist in Denver to Exhibit Work

*Rocky Mountain News* (Denver), November 27, 1921

≈

CHARLES M. RUSSELL, acclaimed the greatest living painter of Western subjects, and himself a picture of the old West, arrived in Denver yesterday, with a group of his canvases, which will be exhibited in the Brown Palace hotel this week.

Russell is a unique figure in the world of art. Coming west when a boy 14 years old, he saw Montana in the wild days, when Indians dressed in breech clouts instead of frock coats, and when every man carried his own law on his hip.

"It was just kind of natural for me to draw pictures, I guess," Mr. Russell said yesterday afternoon. "I don't remember when I wasn't scratching around with a pencil.

"First picture I made with paint was up in Montana. I was working with a cattle outfit and when winter came 'round was wintering in Great Falls. That's my home now. Well, there was a saloonkeeper wanted a picture in colors to hang up on his wall, so I made it for him. Didn't have anything else to do. Painted it with house paint, because I didn't have anything else and didn't know about other paints, either.

"This was a picture of a round-up with the post there. It's around Great Falls there somewhere now. Anybody'd know it was somebody's first picture. Where there was a white tent I painted her all white, and where there was a black horse I painted him all black—humph!

"Art schools are good. Never went to one myself, tho. Never had money and had to work for a living.

"If you never studied drawing figures how do you paint them accurately?"

Mr. Russell rolled a brown paper cigarette and crossed his legs—trousers pulled carefully over polished cowpuncher boots.

"Humph—" said he, "some fellows say I can't!

"Oh, I don't know," he continued. " I like to stick a lot of action in my pictures—maybe that's one way to cover up inaccurate drawing."

Mr. Russell laughed.

"You know I get a laugh out of some of these novels and moving pictures," he said. "Cowpunchers and Indians and automobiles all mixed up. Oh, I guess it's all right. You've got to romance a lot to make money these days. If you don't do anything but tell the truth in stories and paintings, it's nothing but plain history, and nobody cares anything about buying history except a few old fellows like me.

"I reckon I'm kind of old-fashioned. I like things natural. Guess that's why I like Bill Rogers in the movies. I know Bill, and he's a regular feller, too.

"Just for myself, I don't care much for this new way of painting—it's too broad and rough. I know it must be good or they wouldn't make a success, but it goes over my head.

"But, you know, I can't get over thinking things ought to be painted out. Take this old boy Thomas Moran that painted the Grand canon and things. Lot of these folks laugh at him now, but, by golly, when you look at his pictures, the old hills are right there.

"You know this fellow Maxfield Parrish? Well, I think he's the greatest artist in the world. He paints things out, but, oh, the colors! He's got imagination and he sees things clear that other artists only dream about. I've learned a lot from that man.

"Lots of people say he paints too vivid. They don't know. Say, did you ever go out in these hills in Montana or New Mexico or Colorado in Indian summer, did you? Well, if you can see color you know there's not fine enough colors in the tubes to exaggerate them.

"Lots of people sneer at commercial artists. Well, I do commercial work myself, and illustrators are commercial, aren't they? I believe the finest artists in America do commercial work. Parrish himself will do soap advertisements and make masterpieces of them if the company comes thru with his price. I think that's all right.

"Have I moved down to Pasadena? I should say not. Great Falls is my home. I like it up there. I like all this western country, but it

kind of seems to me that Montana is the best part of it. The hills up there seem more friendly-like to a fellow. There is some real wild country up there yet, too—just as wild as when God made it."

Mr. Russell's canvasses are rated as among the highest priced of any American artist. Critics declare he is equal to Frederic Remington in many of his western paintings. . . .

# Will Rogers

Los Angeles *Examiner*, April 27, 1924
[McNaught Syndicate, Inc.]

∽

A FEW WEEKS AGO I engaged in a good-natured debate before a very large audience with Los Angeles' most able and popular Preacher on the question, "Resolved. That Cowboys have been more beneficial to Civilization than Preachers." I hope you won't all think me Egotistical when I say that I won, not on account of me or my Flowery Argument, but simply because I was lucky enough to have the Cowboy side. Of course, he, out of good sportsmanship, presented his Preacher side, but he had so little to Work on that it practically went to me by Default.

Now, in that Debate I enumerated the deeds of all our Valiant Buckaroos, from Theodore Roosevelt down. But there is one I failed to mention. If, as the saying goes, "it's the things that we have done that are Remembered after we are gone that really amount to Anything," well, I have a Cowboy friend who is doing Things today that will live longer with People who know and appreciate Art and Beauty and Genius, than anything any Cowpuncher ever did.

Think of a 40-dollar a month Cowhand, who never had a Lesson in his life, taking a little Paint Brush, a few daubs of Paint and producing Scenes of our West, which are fast passing, that have sold (not only one, but three of them) to England's Future King (if they will just keep him off a Horse), and which will Hang for Generations to come to Ancestral Halls (if Ramsay MacDonald don't object), along with Rembrandts, Whistlers.

It is Charles M. Russell of Great Falls, Montana. He went west from his home in St. Louis at the age of 15, and landed by Stage Coach in Montana in 1880, and has lived there Ever Since.

A lot of these Birds go west to some Dude Ranch, or Tourist Camp, stay 8 months, and then either write Stories or Paint Pictures of the west, and say, "I know, for I have been right over that very Country." Charlie says he don't know nothing but Montana, and he don't paint anything but Montana.

He gained his first local fame in Montana, in the winter of '86 and '87. It was a Terrible Cold Winter. He was working for a Cow Outfit and they had been snowed in all winter and the cattle had about all died. The Owner finally got word through to ask the Boss how Everything was. The Boss wrote him a Letter telling him the bad News. Then Charlie, who was just one of the Hands, drew a Picture of one old lone Cow in a Blizzard. She was surrounded by a pack of Wolves, and he had under it "The last of the 10 Thousand, or Waiting for a Chinook [FIG. 2]." A Chinook, by the way, is one of those Warm Winds which come in that Country which melt the Snow and it feels warm like Summer, and the stock has a Chance to get something to Eat.

Well, when the Boss saw that Picture, just painted on the back of an old Envelope, He said, "Why write him a letter? Just send him this! It will tell him more than I can write." And that is held in Montana today as one of the most famous of Russell's Paintings.

He used to paint a Picture, bring it in and Sell it if he could for a few Dollars and, if not, give it over the Bar for a round of Drinks for himself and Friends. For in those days Charlie was a pretty Wild kind of a Hand. So, as a consequence, the Silver Dollar Saloon housed many a Russell Masterpiece, and it became Noted.

Then Charlie got to riding up to Cascade, a little mining Town, and it was Noised Around that there was a School Teacher up there that must be Sitting for a Portrait. They were not Sure until they Heard that he had given her his favorite Horse. Then "Old Yank," a Character, Miner, Stage-Coach Driver, and all around Town Philosopher, said: "Charlie sure is going to marry that Gal. Now, I hear he give her his Horse and he will have to Marry her to get him Back."

He got not only the Horse back but a Wife, and not only a Wife but a Manager. The last Russell Painting had gone over the Bar. She said: "You paint these things. I will attend to the Distribution end of this Enterprize. She enlarged his Market from what had been purely local Consumption to one which embraced two Continents.

When the Prince of Wales was in Canada, Charlie was out to Mr. Lane's Ranch when the Prince was. So the Boss was catching out their Horses when Mr. Lane said to the Boss, "Now, Fleming, put the Prince on a Gentle Horse. You know there will be enough to pay if we kill a King on this Ranch."

The first one of his Pictures which Brought a big Price naturally attracted a lot of News in the Home Paper. One of the Cowpunchers on reading it went to Charlie and said, "Charlie what is it that makes them Pictures cost so much? Is it the Brush or the Paint?"

He is the only Painter of Western Pictures in the World that a Cowboy can't Criticize. Every little piece of Leather or Rope is just where it would be. Eddie Borein, the greatest Etcher of Western Subjects we have, is also a great Painter himself, and a Real Ex Cowpuncher. He says Russell is "The Master." So you see in these times of Scandal, it is a real Pleasure to point out to some of you some one who is IN OIL, and still remains Pure.

Now every Story should point a Moral and this one is: If you are going to Paint (or do anything else) know what you are Painting about, and if you are going to Marry, marry somebody that can manage you RIGHT.

So here is to an Old 40-Dollar-A-Month Cowpuncher, whose work will live for Centuries. Maybe longer than that. Maybe as long as the Republican Party is under Suspicion.

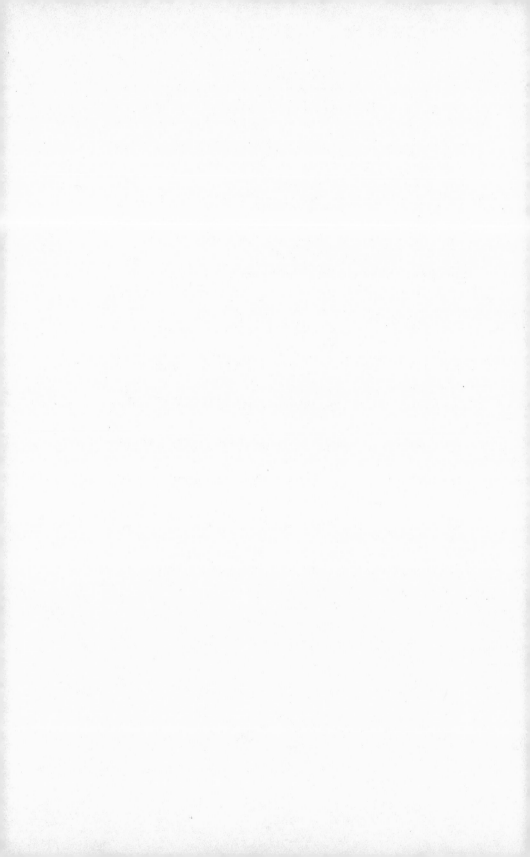

PART TWO

~

# Remembering Russell

R EMINISCENCES ORDER EXPERIENCE, making the past conform to subsequent reality. In recollection, whatever happened was always bound to happen. Since Kid Russell went on to fame as the Cowboy Artist, it was apparent early on that he had a capacity for greatness. Reminiscences involve a burrowing back in time to find evidence for future developments—self-fulfilled prophecies, in short. Scientists have concluded that, "in the formation of a memory, current beliefs about past events are more important that what actually happened."[1] Granting this, reminiscences can still be magical. Random events are patterned and made coherent. A story emerges. Thus memory creates a more interesting reality. The Russell legend is a case in point. A product of contemporary observations and careful publicity, it was nurtured each step of the way by fond recollection.

Several of Russell's cowboy contemporaries told their stories in print. Friends like Teddy Blue Abbott and Con Price and acquaintances like Tommy Tucker, Kid Crawford, and Bob Kennon added more or less to Russell lore.[2] Russell also made guest appearances in the autobiographies of the Montana writer Frank Bird Linderman, the cowboy movie idol William S. Hart, the Western artist Will James, the humorist Irvin S. Cobb, the Scottish painter John Young-Hunter, the Western novelist Walt Coburn, and the actor Harry Carey, Jr.[3] An essay by Linderman published a few months after Russell's death, a tribute by Cobb first published in 1934, and a fond recollection by William B. Cameron of meeting the newlywed Russells in Cascade in 1897 are reprinted here.[4]

No one enjoyed a better opportunity for sustained, intimate observation of the Russells than Charlie's nephew Austin Russell, who lived with them or near them from 1908 to 1916. After Nancy's death in 1940 Austin began work on a book eventually published in 1956 as *C.M.R.: Charles M. Russell, Cowboy Artist.*[5] It is a revealing account of life with Nancy as well as Charlie. Austin knew the one other individual who might have written an equally intimate memoir of the Russells in their later years, Joe De Yong. Beginning in 1916 De Yong was a regular guest in the Russells' home and at Bull Head

Lodge, and in 1924 he accompanied them on an extended vacation in Southern California. De Yong tried often to put his memories into publishable form, but apart from a few short essays (including "Modest Son of the Old West," reprinted here), he was frustrated by false starts in his search for a single beginning point. Instead, he wrote and re-wrote, circling his materials, unable to marshal them to a conclusion. He left Russell scholars many manuscript fragments, however, and something far more precious—detailed, journal-like letters to his parents recounting everyday life with Nancy, Charlie, and Jack. Uninfluenced by the tricks of memory, they record simple facts and immediate impressions. To read De Yong's letters is to step back in time and become a member of the Russell household.

*Montana* in the 1950s published several recollections of Russell. Wallis Huidekoper's account of the origins of *Waiting for a Chinook* [FIG. 2] adds an authoritative voice to the discussion of one of the most publicized episodes in Russell's career.[6] Carter V. Rubottom, whose father owned the Como Company where Russell bought his art supplies and had his pictures framed, recalls a picnic in 1898 involving the Russells and several of their Great Falls friends at a time when Charlie and Nancy were a young couple and fame was still on the horizon. George Coffee's "Home Is the Hunter" touchingly portrays a gentled, late life Russell who in the 1920s still enjoyed the camaraderie of fall hunts each year, but took no part in the killing.

Since acquiring the astonishing James B. Rankin collection in 1983, the Montana Historical Society has become the unofficial repository of Russell reminiscences. Rankin, a Princeton-educated teacher disaffected with modern life, and especially with what he considered the decadence of modern art, in 1936 began advertising in newspapers across the West for any recollections of Russell and any information about his art. Hoping to compile a Russell *catalogue raisonné* and, eventually, to write the artist's biography, he followed up every lead, prompting John Barrows to remark, "You have doubtless been told that you are indefatigable."[7] Vivian A. Paladin's 1984 essay "Charlie Russell's Friends" provides a fine sampler of the treasures Rankin unearthed. Repetition and the obscuring distance of the years smoothed reality's rougher edges; collectively, such reminiscences *are* the Russell legend.[8]

# NOTES

1. Carol Travis, "Beware the Incest-Survivor Machine," *New York Times Book Review*, January 3, 1993, 16.

2. E. C. Abbott and Helena Huntington Smith, *We Pointed Them North: Recollections of a Cowpuncher* (New York, 1939); Con Price, *Memories of Old Montana* (Hollywood, Calif., 1945); Con Price, *Trails I Rode* (Pasadena, Calif., 1947); Patrick T. Tucker, *Riding the High Country*, ed. Grace Stone Coates (Caldwell, Idaho, 1933) (a novel, really, more than a reminiscence); Thomas Edgar Crawford, *The West of the Texas Kid, 1881–1910: Recollections of Thomas Edgar Crawford, Cowboy, Gun Fighter, Rancher, Hunter, Miner*, ed. Jeff C. Dykes (Norman, Okla., 1962); Bob Kennon, *From the Pecos to the Powder: A Cowboy's Autobiography*, ed. Ramon F. Adams (Norman, Okla., 1965).

3. Frank B. Linderman, *Montana Adventure: The Recollections of Frank B. Linderman*, ed. H. G. Merriam (Lincoln, Nebr., 1968); William S. Hart, *My Life East and West* (Boston, Mass., 1929); Will James, *Lone Cowboy: My Life Story* (New York, 1930); Irvin S. Cobb, *Exit Laughing* (Indianapolis, Ind., 1941); John Young-Hunter, *Reviewing the Years* (New York, 1963); Walt Coburn, *Walt Coburn, Western Word Wrangler: An Autobiography* (Flagstaff, Ariz., 1973); Harry Carey, Jr., *Company of Heroes: My Life as an Actor in the John Ford Stock Company* (Metuchen, N.J., 1994). Linderman also wrote a warm, book-length reminiscence of his friend that was supplemented with the tart recollections of his three daughters and published as *Recollections of Charley Russell* (Norman, Okla., 1963).

4. For information on Linderman and Cobb and their relationship with Russell, see Brian W. Dippie, ed., *Charles M. Russell, Word Painter: Letters 1887–1926* (Fort Worth, Tex., 1993), 117–18, 275–76. For William B. Cameron's immediate impressions of the Russells, see his "Chas. M. Russell," *Western Field and Stream*, 2 (August 1897), 101.

5. Austin Russell, *C.M.R.: Charles M. Russell, Cowboy Artist* (New York, 1956). For the story behind the book, see Austin Russell to Joe De Yong, 1941–42, August 30, 1948, March 21, 1953, February 25, 1956–April 26, 1957, De Yong Papers, Oklahoma City.

6. See Dippie, *Word Painter*, 13, 411, for sources on *Waiting for a Chinook*. Huidekoper's revealing thoughts on the Russells are recorded in "J. Frank Dobie's Notes of an Interview," July 1, 1947, Dobie Collection.

7. See "New York Resident Cataloging Works of Charles Russell," November 15, 1936, and "Russell Art Being Listed by Biographer," August 26, 1937, *GFT*; John R. Barrows to James B. Rankin, July 8, 1938, Rankin Papers.

8. The last attempt at gathering reminiscences of Russell was published in 1973; see Forest Crossen, *Charlie Russell—Friend*, vol. 9 of *Western Yesterdays* (Fort Collins, Colo., 1973). Time has caught up with memory; almost the last significant living link to Charles M. Russell was severed in 1996 with the death of his son Jack Cooper Russell seventy years after his own.

# Charles Russell—Cowboy Artist

Frank B. Linderman

~

Ask any old plainsman or mountaineer, "Who has painted the best pictures of the West, especially the Northwest?"

"Charley Russell," he will answer, without the least hesitation or qualification.

"What about Remington?"

"Good," he will say. "Mighty good, especially when he painted regular soldiers. But he couldn't paint with Charley Russell. Remington didn't know, and couldn't feel the West as Charley did, because he wasn't part of it. Charley lived here since he was a kid. He saw life in the Northwest early, and he loved it even more than we did. But now he's gone, and there can never be another Charley Russell. It sure hurt me when he laid 'em down, partner."

The passing of Charles Russell, the cowboy artist, saddened not only the old plainsmen and mountaineers, but everybody in the Northwest, since all knew and loved him. He was a boy of fifteen when he came to Montana to begin life for himself. He was sixty-two when he passed to the Shadow Hills at his home in Great Falls, on October 24, leaving behind him a wealth of wonderful stories told in pigment and bronze.

Russell's coming to the Northwest seems inspired. The very moment of his advent to the plains was propitious. The old life was already passing, and there had been none to write its history. Its characters, trappers and traders, touched the country so lightly that they left little to testify to the occupancy, and almost nothing of their history. They were nomads, not builders; and they drifted out of the picture before advancing civilization. They hoped always to keep ahead of it, and, in love with the wilderness, they deliberately

strengthened popular belief that the Northwest was uninhabitable by the peaceably inclined whenever they could, so that its endless plains, high mountains, and dense forests, peopled with tribes of hostile Indians, set up their own barriers against settlement for more than a generation after the expedition of Lewis and Clark.

There had been but little change on the plains when Russell came. The gold stampedes westward to the Rockies in the sixties had not affected them, because, in its greed for the gold, civilization had literally jumped over the plains to the mountains, and in their gulches had set up its cities, with no thought for the vast country that remained wilderness between its outposts east and west. And there was little in common between the gregarious miner and the solitary plainsman, anyway. Greed led many to the mines. Perhaps none came to the mountains primarily to build or to permanently settle; all hoped to enrich themselves, and go away. But long before the exciting discovery of gold on Grasshopper Creek, in the mountains of Montana, trappers and traders had established themselves on the great plains eastward, and if hope of gain in the fur trade had been responsible for their coming, these men soon learned to love adventure more, and stayed for the love of the game. Their posts were small and far apart, and these were the establishments of substantial corporations retaining scores of engagés, hunters, and hangers-on. The free trappers were men who roamed the plains and mountains at their own sweet will, sold their furs at the posts, or carried them down the Missouri River to St. Louis, if they pleased. Copying the Indian in many of his ways, they were the most picturesque of all plainsmen, and the most hardy and daring. Their lives were filled to the brim with blood-stirring adventure, warfare, hardships that seemed only to wed them closer to the wilds, and a freedom that made them men apart from those in any settlement. Their customs, apparel, and even their language, fashioned by requirement and experience, were as much their own as the great plains themselves. Russell came in time to know them all.

THE COWMAN, coming up the trails from Texas with his herds, only added romance to the great grass country of the Northwest. Freighters with their bull teams and skinners with mules, taking cargoes in

wagon-trains from Fort Benton, on the Missouri River, to the mines in the mountains, were not settlers. Even the scattered cow ranches were mostly only headquarters for cow outfits. They were not regular homes where there were women and children. A pan of milk in a cabin in those days did not forecast the establishment of a dairy. It merely testified that a venturesome cow-hand had had a fight with a cow, and that the cow had lost. Nobody on the plains missed civilization. Nobody wished it to come to him there. So the plains were unsettled—Montana a Territory—when Charley Russell came to them from St. Louis, a boy of fifteen.

Cut off from the influence of family, and full of filtered romance unshaded by the serious side of frontier life, which seemed always to be secondary and evanescent in its higher light of adventure, he fell easily into the ways of the people of the plains, and never forgot them. At the age of fifteen, more impressionable than ordinary boys because of his inherent art and natural love for primitive life, he began to know the Indian, the trapper, the trader, and the cowman; the latter, then rapidly becoming master of the plains, especially attracted him, and he became a cowboy.

His knowledge of the customs, apparel, and life of both white men and Indians of those days was perfect, and he was almost fanatical in his attention to detail in his paintings, which he began in the eighties and continued to the last day of his life. His "Waiting for a Chinook," a pen drawing of a cow, already reduced to a skeleton, standing humped up in a snow-drift on the plains, while a wolf near by confidently waited for starvation to save him even the possibility of a battle, was first to command wide attention [FIG. 2]. It was sent to Kaufman & Stadler in Helena, Montana, to acquaint them of conditions at their ranch during the terrible winter of 1886–7. The picture, done hurriedly to save writing a letter, and without proper materials, created much comment, and perhaps there was not a cowman in all the Northwest who was not familiar with its harrowing details. Those were days that threatened the cattle industry, but Charley Russell, for the amusement of himself and fellows, modeled animals, carved the butts of six-shooters, stocks of rifles, painted pictures on the cabin doors, and told stories to the delight of the hands fortunate enough to be employed with him

during the awful winter of '86–7, when tens of thousands of cattle perished on the northern ranges.

RUSSELL'S PHILOSOPHY of life was gathered from old plainsmen and mountaineers, both white and red. Their aphorisms never failed him as a source of deep wisdom, and their humor, so often embellished by his own and repeated in his inimitable manner, was the joy-cup of his life that remained full to the last, because of his own magical replenishments. He had no peer in the Northwest as a teller of stories, and with his face as straight as that of the chiseled Sphinx he could keep a group of friends convulsed with laughter for hours without once faltering, except to roll an occasional cigarette, and then his art held his audience breathless until he resumed.

I have never known a simpler, a more humble man, than Charley Russell. He hated the counterfeit of anything, and could not pose. He avoided strangers, and, shy as a little girl, sought his own kind whenever they were near. Unique among them, possessing great talent that was as naturally his own as the blood in his veins, he was unbelievably modest of his attainments. "I couldn't help but be a painter," he would say whenever compliments approached flattery. Writing of himself, he has said: "I'm old-fashioned and peculiar in my dress. I am eccentric (that's a polite way of saying I'm crazy). I believe in luck, and have had lots of it. To have talent is no credit to its owner, for what a man can't help he should get neither credit nor blame—it's not his fault. I'm an illustrator. There are lots better ones, but some worse. Any man that can make a living doing what he likes to do is lucky, and I'm that. Any time I cash in now, I win."

Once he told me, rather shamefully, of a "crooked deal" he had made in the early days of his art. He was flat broke when a stranger from Boston who was in town buying cattle asked him to paint two pictures. When they were finished, Russell carried them to the hotel where his patron was stopping, and said, "Here's your pictures, partner." The man was delighted. "How much are they, Mr. Russell?" he asked, reaching for his wallet. "He was a plumb stranger, and I thought I'd hit him good and hard, because none of the boys had any money. Grass hadn't even started on the ranges, and our saddles

were in soak," confided Russell, "so I said, 'Fifty dollars.' And I'm a common liar if the fellow didn't dig out a hundred dollars and hand 'em over. He thought I meant fifty dollars *apiece*, you see. I got crooked as a coyote's hind leg right away. I didn't say a word. I just bought the fellow a drink, and kept the rest. He don't know to this day how bad he beat himself." To-day those pictures are worth many times the amount the purchaser paid for them in this "crooked deal."

THE LIFE RUSSELL painted was a life of action. His horses are alive. His buffalo, his Indians, his plainsmen, are not merely set upon his canvases; their action stirs one until he wishes earnestly that he might have lived on the plains with them. Even his bronzes are so full of lively action that they seem fairly to move. He seldom painted still objects. I remember that once when I carried to him a commission to paint a picture for the Montana Club at Helena [*When the Land Belonged to God*, FIG. 6], I was requested to ask him to paint us something "that was not going like the wind." He loved action. Even his illustrated letters are full of it, and whenever they are in evidence there is always a group of people gathered round them, eager to see more.

Quickly and easily impressed by speech or action, with a heart as tender as a child's, Russell felt keenly every cruelty practiced upon man or beast. I have seen him rescue a badgered mouse from a tormenting cat and carry it a hundred yards to safety, all the way commenting on cat creation in a manner wonderful to hear. "But I reckon God made them," he ended, excusing even the offending cat. He shunned all modern things, always ready to set the gauge of the past disparagingly against the present. Once at Lake McDonald we were walking near his summer home when we discovered that several hens that had been raised by an incubator and a small chick that had been hatched in the old-fashioned way were following us. Russell stopped to drive them back. At this, one of the hens picked viciously at the toes of the little chick, and it ran to us for protection. "Did you see that?" asked Russell, throwing a small stick at the chick-eating hen. "Get out!" he said, disgustedly, stamping his foot. "Git, you unnatural hussy! *Your* mother was a *lamp*!"

CHARLES RUSSELL sorrowed over the passing of the old-time Northwest, and to his last day never quite forgave the seeming wantonness of the destruction which attended its settlement. There can never be another Charley Russell, any more than there can be another new Northwest; and if the men of the old days who have left us have kindled their fires in the Shadow Hills, then Russell has found them, and is happy there.

# Fortunate Friendship

Irving S. Cobb

BECAUSE I VALUED his friendship as one of the biggest things that ever came into my life and because his memory to me will always be a most dear and precious treasure, it is difficult to write of Charley Russell without over-indulging myself in superlatives.

Now that he is dead the world is finding out what some had found out while he was alive—namely, that Charley Russell was one of the greatest creative craftsmen of his race and times, and certainly was the aptest delineator of the most dramatic, the most picturesque—and also, the most entirely vanished phases of Americanism that our country since the Civil War has produced. Suppose there should come up a man of his genius and his scope of power; a man with an eye like his to see and appraise, and a hand like his to fix color and background upon canvas with paints or build into the enduring bronze authentic figure of beast or man—which isn't probable, because no state within a century is likely to produce two Charley Russells—that man still would fall short seeing that the scene has changed, that the Old West has become the New West, that the range riders, the red warriors, the buttes and the settings drawn by Charley's brush and set into the modeler's clay by Charley's fingers either have gone altogether or very soon will altogether be gone.

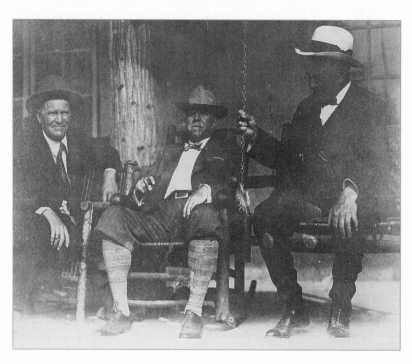

Charles M. Russell, Irvin Cobb, and David Hilger at Lake McDonald, summer 1925.
MHS Photo Archives, Helena

So much for the artist. Of the spirit of the man, the essence of him, the soul of him, I could write a book and yet not say the half of what I'd like to say. A keen but gentle philosophy; a gorgeous darting wit which tickled but never stung; a charity for all mankind which was deep as the Montana basins he loved and as broad as the Montana plains he had ridden; a keenness of mental vision which enabled him to look past the surface of things to the true inwardness of things; a memory for storing up the folklore, the humor and the tragedy of bygone days in cowtown or bunk house or mining camp; and with this an ability to so deftly and so accurately describe it all—stage, actors, language and plot—that, listening to his story telling you realized here also was a supreme word painter and you marvelled that one man could possess in such degree two gifts so closely related and yet so wide apart; a lover of natural things and of genuine things; a lover of friendships and of children and of horses and dogs—yes and under-dogs; a genius whose culture came not of books but out of the heart of a born gentleman; a man who

could be proud of his talent without being conceited over it; a creature as free from guile, vanity, selfishness and affectation as any I ever knew—that was your Charley Russell and if my affection qualifies me to claim a share in the great heritage, my Charley Russell.

If I were charged with the choosing of the two figures most amply qualified to represent the state of Montana in our national hall of fame at our national capitol, I should choose not some strutting political leader whose very name like his personality and his policies and his state craft, if any, will by succeeding generations inevitably be forgotten; neither some captain of industry however brilliant his developing touch might have been, since any human institution is but the lengthening shadow of some individual just as the individual very often is but the overgrown child of the institution; nor yet some military commander whose record was written with the blood of dead soldiers and whose repute most surely would turn to dust as the bones of those dead likewise become dust—no, none of these would I choose.

One of my choices would be the statue of one of those heroic pathfinders who hacked a future commonwealth out of a ramping wilderness and made a road for the white man's civilization to follow over and sowed the seeds for the fruitage which is today yours and which hereafter will be your children's and your children's children. And for my other choice I'd take the homely shape of dear Charley Russell—not that he needs any monument to perpetuate his greatness, because he fashioned his own monuments; monuments which will forever testify to his skill and forever will perpetuate the romantic splendors of Montana's bygone days—but because in thus honoring his memory you'd be honoring that son of yours who was most original of any, most creative of any, most versatile of any, most typical of any and, I claim, most lovable of any; and because you'd be honoring that immortal part of you which was and is the best of you and because you'd be honoring yourselves.

And if there were but one statue to be set up instead of two, if one niche were to be left vacant until a form worthy to fill it had arisen against the Montana skyline, I'd still cast my vote for Charley Russell, Montana's old master—because I tell you the mould out of which he came has by the hand of the Great Potter been broken and we shall not soon look upon his like again.

# The Old West Lives Through Russell's Brush *and* Russell's Oils Eye-Opener to the East

William Bleasdell Cameron

~

ON A BRIGHT MAY DAY in 1897 I walked into the lobby of Butte's principal hotel—to find myself staring at some pictures on the walls, pictures which, in brilliance of coloring and execution, topped anything of the kind—touching the pioneer period—I had ever before seen. In vivid and revealing action, they were compositions illustrative of the fast-disappearing lawless West and the picturesque characters who made up its population—Indians, cowpokes, trappers, prospectors, traders, Chinese, gamblers and "bad" men generally.

But, studying these masterly creations, the thing that most impressed me was their fidelity to truth—the sureness evident in all the work of the artist. Here was no bungling or timidity. On the contrary, he had woven in the very fabric of his canvasses the impress of his own striking and original individuality. They were largely reflections of his own wild young life and experiences (as I learned later), following his arrival on the frontier at the age of 16 from his native Missouri. Moreover, they somehow conveyed to the arrested observer a sense of the hidden joy and satisfaction that the expression in color of his genius brought to their creator.

For some minutes I found it hard to turn from contemplation of these magnificent canvasses and go to the desk for some information about the artist.

"Name's Russell," said the clerk. "See Schatzlein, hardware, around the corner; friend of Russell. He'll give you the dope on the paintbrush juggler."

I found [Charles] Schatzlein friendly and communicative. He seemed pleased over my interest in Russell. And when he showed me his superb collection of Russell pieces, my enthusiasm hit a new

pitch. I determined then and there that if persuasion could accomplish it, the artist would before long be doing work for "Field and Stream." I learned, too, a good deal about the painter. He was shy and no easy man for a stranger to meet. But once he had met a fellow and decided that he "belonged" in his category of desirables, nothing he could do for him was too much.

As an example of his dislike of being put on exhibition, I was told that Jim Hill, builder and president of the Great Northern Railway, once stopped his special train and left his car with a party of friends to be introduced to the cowboy turned artist whose name had begun to trickle beyond the boundaries of Montana. But they didn't meet Russell. Learning what was afoot, he took to the haymow. And there he remained until the railroad magnate and his guests moved on. As he put it, he was no circus freak to be brought out for a lot of people he didn't know to gape at. Thus I knew that to become acquainted with the man I had come to the tiny village of Cascade to see, I'd have to use some diplomacy.

There was only one large general store in the place. Charlie, I learned, lived in a little one-room building with a lean-to kitchen directly across the road from the store. He had recently married and as a family man I knew he must patronize the store in order that he and his lately-acquired bride should eat. Through the avenue of smokes and other small purchases I scraped acquaintance with the merchant and, through his good will, planned a strategic approach.

I was in the store on the day following my arrival in Cascade when a well set-up young fellow in shirt sleeves, of medium height, with blue eyes, straight blond hair and the unmistakable garb of the cowpuncher walked in. He had a prominent chin, but what particularly attracted my attention were his fingers. They were long, shapely and delicate—a true index to his vocation. His shirt was open at the throat, and in place of suspenders he wore about his waist a brilliantly-hued, variegated, silk-and-wool L'Assomption belt, of the sort once carried in stock by the Hudson's Bay Company, and which I was later to learn was never replaced by anything else.

He bought a package of Bull Durham, the tobacco he always smoked, and some groceries, joked a few minutes with the storekeeper and the latter then turned to me and said:

"Mister Writin' Man, meet Charlie Russell. He paints pictures an' they call him the cowboy artist."

The young fellow gave me a warm handshake and said with a shy smile: "Pleased to meet y'u."

"The pleasure's mutual, I can assure you," I said, "in fact, more than that on my side. I've just come from Butte. I saw some of your pictures there. They were magnificent. I came down to Cascade purposely to meet you, and now that I have I'm more impressed by your marvellous ability than ever. I'm hoping to have a talk with you when you can spare the time."

"Drop around tomorrow, then," he replied. "I'd like to introduce you to Mrs. Russell. We don't often have a chance to talk to people from outside."

At our talk next day I told him I was editing a new sportsman's magazine, "Field and Stream," published at St. Paul, and I believed we might be able to arrange something that would be to the advantage both of himself and the magazine. I would tell him more of my idea later.

I did not wish to give him any particulars until we knew each other better. I was afraid if I tried to rush matters he might back away. I did not wish to lose any favorable opinion of me he might have formed.

But next day I went into particulars. I was on a tour of the Northwest, introducing the new magazine to newsdealers and the public, but when I saw his work I said to myself, "This is it! We need the work of this artist and he needs the publicity we can give him." Furthermore, I told him that, if the publisher agreed, I intended to move "Field and Stream" to New York before the year was out. His work in the magazine would be a great feature for the magazine, while he would benefit from the advertising we could give him. That was where the money was and where the men who had it and liked to adorn their residences with fine pictures were ready to pay for them. With his talent it was a shame that he should be painting such splendid canvasses and selling them locally for just enough to buy his daily bread. Once these men of wealth had seen what he could do with paint, there wouldn't be banks enough to hold all his money. In short, I put it on pretty thick, but I considered his work justified

it. I felt that nothing I might say was too extravagant. And I meant it. Moreover, time has given its estimate of the value of Russell's work. For years his canvasses were selling at ten to fifteen thousand dollars and I recently was told of the refusal by the holder of one of the finest of them of an offer of forty thousand dollars. So I consider I did not overpraise Russell's work, except perhaps in my estimate of the number of banks needed to hold his cash. I may have been a trifle out there.

I proposed to Russell that he paint twelve oils for "Field and Stream" to be used as frontispieces for a year. The magazine had no money, but we would manage somehow to pay him $15.00 each for them. By the end of that time he should be established as the foremost depicter on canvas of the early western scene. I'd hear his decision a month later when I saw him on my return trip to St. Paul.

He asked me one day if I'd like to see him paint and I couldn't say "Yes" fast enough; it was something I'd dreamed about but never hoped to realize. It seemed to astonish the storekeeper, who asked me about it. He thought I must have registered a ten-strike with the cowboy—he'd never known him to do anything like that before. When I went in, Russell was seated on a low stool before his easel. He took out his little bag of Bull Durham and holding the tie string in his teeth rolled himself a cigarette before sitting down to continue painting.

"I'm always curious to see what a picture's goin' to look like when I've finished with it. After that I don't give a hang if I never see it again," he commented.

The half-finished picture was what was later his famous "A Bronc for Breakfast" [*Bronc in Cow Camp*, FIG. 16]. It's early on the frosty morning when a horse objects strongly to a cold saddle placed on his back and has his way of saying so. With his back humped and the loose stirrups flying, he's bucking a hole in the cook's nice breakfast fire, and the 'punchers, cups and tin plates in hand, are trying to beat the flying embers in the race for the safety zone. It's really what you'd call "a spirited picture." Russell seemed to be enjoying himself and he evidently had the scene clearly mapped out in his mind. . . .

Contract between C. M. Russell and *Field and Stream*, September 30, 1897.
MHS Archives, Helena

BACK IN CASCADE, after covering the northern states to the Coast as well as southern British Columbia, Russell met me with smiling and open-handed friendliness. I was more than gratified to learn that—Mrs. Russell agreeing—he had concluded to have his work brought prominently before the public, with added publicity from write-ups, through the medium of "Field and Stream" at the stipulated price of fifteen dollars each painting. I immediately drew up a Contract and Agreement in duplicate, to which Russell affixed his sig-

nature. Under it I wrote my name, "on behalf of myself and for 'Field and Stream'," and Mamie, his wife, signed as witness. The original of this historic document is still in my possession and a photostatic copy accompanies this article.

To say that I was jubilant would be a gross understatement. That I, a stranger to the artist a few weeks before, should have been able to close such a contract with a man I was convinced would before many years be recognized as the most brilliant painter in his field, that of the pioneer West, seemed to me too fantastic. But I held in my hand the document, signed and witnessed, to confirm it, and the pride I felt in the accomplishment of the purpose that had brought me to Cascade was, I think, justifiable. I tried to control my exultation, but it wasn't easy. I wanted to whoop.

At the same time I had not, I believed, been entirely selfish. The benefits I saw resulting from our agreement would be shared by both parties. If it was true that he would receive from his magnificent work a mere trifle, on the other hand, through the pages of "Field and Stream," he would become known to thousands who had never before heard of him or had the chance to put the stamp of authority upon his genius. As a result there would be an immediate and mounting demand for his canvasses and steady rise in their value, until I could envision them taking their place among the other great American works of art. That my belief in the future of Russell's work was well grounded is borne out by the fact that for years before he laid down his brush his larger paintings had been bringing him sums running into five figures. In the winter of 1925, the last year in which he did any painting to speak of, his sales, I understand, amounted to $25,000.

However, I imagine Mrs. Russell was the managing financial partner in the team. She had a keen business sense, something Russell himself lacked. He was too generous. He would willingly expend himself, without compensation, to do a good turn for a friend—in other words, paint him a picture. But I'm inclined to think that, for the valuable residential property they acquired in Great Falls, the credit is due chiefly to Mrs. Russell. . . .

On this second visit, I spent two weeks in Cascade, two of the most enjoyable weeks in my experience. I saw a great deal of the

Russells, and I was always welcome to drop in and discuss the future and listen to Charlie's original comments and highly diverting chatter. I climbed the hill overlooking the village and took a snap showing Russell's tiny cabin in the foreground. I also took pictures of Russell himself, Mamie and his "Monty" horse, a pinto pony of which he was as fond as if it had been a human being. I used to wonder, if he were obliged to part with one or the other, which he would keep, Mamie or Monty. And as a result of these visits at Cascade the friendship between Russell and me took root and grew steadily stronger, until it ended after close on thirty years. A mutual liking had developed between us which pleased him as much as it delighted me.

Russell didn't balk at admitting that, in his earlier days in the West, he had been "a wild young man." I recall his telling me once of a wild night in Great Falls. "I didn't know when or where I bedded down, but I woke in the mornin' with an awful head and I threw up somethin' that looked like a dead mushrat." (They were always "mushrats"—not muskrats—to the old-timers.)

He had sworn off these occasional "busts"—the natural outlet for his exuberant youthful spirits—before I met him, doubtless as the result of his marriage. If he kept liquor in the house I can't recall him ever offering me any, although I was not then an abstainer, or seeing him take a drink himself.

Russell confided to me a number of things. One I remember was the difficulty he found in mixing his paints. I told him that was something he need have little trouble in remedying. There were a dozen good artists in St. Paul, none of whom was capable of turning out such work as he, with his native ability, found no difficulty in doing, but any one of them in a very short time could teach him all he needed to know about mixing colors. I don't know whether or not he ever acted on my suggestion or just continued to make discoveries for himself by the old and well-known rule of trial and error, but I have no doubt that he had learned all he had to know about blending colors long before they ceased to concern him. . . .

# Modest Son of the Old West

Joe De Yong

THE OLD WEST never acclaimed a more loyal, uncommon, or more truly modest son than Charlie Russell. It is indeed Montana's lasting good fortune that Fate should have seen fit to endow this one of the Treasure State's early-day and numerous footloose, "horseback drifters" so that he could eventually record the lusty, colorful life of her amazing frontier period.

To become nationally recognized as the first (and unquestionably, the most gifted) of the few genuine "cowboy artists," was in itself remarkable, for Russell was wholly self-trained. In fact, to those capable of intimately judging the man and his works, it appeared certain now that the slow, always self-reliant, and characteristically stubborn development of Charlie's many-sided creative ability hinged solely upon his having spent his earliest years in such wilderness surroundings. In themselves, these wild, isolated, vast surroundings seemed to spark his romantic and always-original outlook. His advice in later years to at least one hopeful young beginning artist was: "Stick to Mother Nature, she'll never fool you!" And this was one measure of Russell's perceptive greatness.

Fate decreed, too, that Russell be born on the outskirts of St. Louis, Missouri, toward the close of the Civil War. This was at the historic moment when that place was still regarded as the gateway to the Great Plains, the upper Missouri River, and whatever lay beyond the strange Rockies. It is not surprising, therefore, that the constantly-changing, chance-gathered assortment of frontier-types and the riff-raff spawned by the "riverboat era" seen daily along the nearby city's riverfront, helped to make his reckless daydreams of far greater importance than regular attendance at school.

Finally in his mid-teens, repeated truancy and an impossibly poor scholastic record (coupled with endless stubborn opposition to parental authority) resulted in Charlie being reluctantly granted parental permission to "Go West, and grow up with the country!"—as Horace Greely had advised the young men of that time.

So it came about that in the late spring of 1880 there appeared in the remote, almost totally unsettled Judith Basin of central Montana, a pathetically equipped sixteen-year-old. His preparation for life on the frontier soon proved to be largely of a visionary sort. He was almost immediately fired from his first job—that of a lowly sheepherder! Yet luck was with him. Friendless, homeless, and soon hungry he was camping beside the trail without food or shelter, when the passing professional "meat hunter" Jake Hoover, sizing up this forlorn situation, casually took "The Kid" under his wing. Hoover allowed Charlie to help out around camp in return for grub and the sometimes shelter of a cabin roof. This arrangement, in young Russell's eyes, amounted to considerably more than a fair trade; and in time proved to be even more than that. He learned so much from Jake Hoover!

Thus from part-time meat skinner, packer, and camp-tender for Jake Hoover, "Kid" Russell (as he had become known locally) eventually graduated to intermittent periods of work as either horse wrangler, or "night hawk" for the roundup outfits of local cattle ranchers. His life long love of horses helped to fit him for this from the start. It was to cast the die for the balance of his life, since from there on (barring a brief, unsuccessful apprenticeship as a bull whacker) the ways of cowmen, cow ponies, and range cattle became deeply embedded in Russell's complex make-up.

Since roundup work was of a seasonal nature and further hampered on the northern ranges by the long winters (during which all but a select few hands were laid off) Charlie, always of a roving nature anyway, was apt to spend the winter in whatever manner necessity or chance came up with. But wherever he rambled, his "war bag" (either a seamless grain or flour-sack, in which cowpunchers customarily carried their small assortment of personal possessions) invariably included an odd sock. The war bag also unfailingly contained a few tubes of oil-paints, several pans of watercolors, one or

two carefully-husbanded brushes, together with an always-present lump of beeswax for modeling.

Unhurried, not given to worry, with such a few and simple tools, Charlie Russell tirelessly sketched, modeled, or painted whatever caught his eye. In addition, he possessed an instinctive feeling of kinship for Indians that bordered on second-sight. As a result, it is not surprising that he sometimes turned his back on the white man's life in order to share the lodges, meatpots, and ceremonies of the plains tribes who still roamed Northern Montana Territory and the bunchgrass-covered prairies of Southern Canada. His Indian-like cast of countenance, sincerity, and complete lack of any trace of the mercenary, invariably led to his being accepted without question. These associations resulted in Russell mastering the "hand talk," or Indian sign language, and also supplied countless ideas for paintings and models for the rest of his life.

Pathetically misfit as Charlie Russell may have appeared at the time of his arrival in Montana Territory, the once patronizingly-dubbed "Buckskin Kid" gradually developed into a strikingly picturesque individual who was ALL MAN—inside and out! Lighthearted and improvident, ribaldly humorous on occasion, it was Russell's rock-solid honesty and total lack of arrogance, as much as his genial, magnetic qualities that earned him a genuine open handed welcome wherever chance led him. In fact, by the time he met sixteen-year-old Nancy Cooper, whom he was soon to marry, the shaggy-haired, teen-age drifter of the early Eighties had developed into somewhat of a sagebrush celebrity, well known in the cow-camps, and cow-towns east of the Rockies from the Bow River to the Yellowstone.

In the rag-tag, false fronted little outfitting points of that day, the few places open to the happy-go-lucky, homeless element of which Russell had long been a part—saloon, gambling-house, and honky-tonk—were invariably the best lighted, warmest, and most cheerful. As a result (since Charlie was never inclined to drink alone and he had become a semi-public character whose presence amounted to a trade-asset in any place where liquor was sold) he gradually acquired an additional talent; albeit one that promised neither honors nor dividends.

But as is sometimes the case where those marked by genius are concerned, the important forks in Charlie's train through life repeatedly bore indications of his being under the wing of a Guardian Angel; and at no time was such more clearly evident than in his choice of a life-partner and helpmate.

"Wide-open" as his personal life always was, there had been surprisingly few serious romantic entanglements—and none of the nature to complicate or even cast a passing shadow on his brand new marriage.

Marriage saved Russell from the life of a "rounder." Even so, the inescapable problem of how to make enough of a living for two—in face of an almost nonexistent market for his output—became an ever-present one. This situation was more readily recognized by Nancy than by her easy-going cowboy artist husband. In the uncertain months that followed, Charlie's guardian angel must have occasionally nudged someone's elbow. Somehow a few pictures sold, often at ridiculously low prices and usually barely in time to keep the kitchen cupboard from becoming completely bare. In any case, the Russells were soon forced to admit that their financial problem could only be solved in larger, more wide-awake surroundings—particularly at Great Falls, where they finally decided to locate.

Nancy was naturally smart, practical, and she possessed abundant charm. These qualities complemented Charlie's traits in an always helpful manner. In addition, Nancy soon developed business judgment of an extremely shrewd sort, without which (along with her deftly-applied guidance of his more personal affairs) her husband's success might have been considerably postponed, or even radically altered.

In Charlie's earlier struggles to catch the spirit of the half-wild life that was a part of his best days—working outside in wind, cold, and other distractions simply had to be put up with. Even his larger pictures of those first years were painted on a bunkhouse bench, or a temporarily idle poker table. In fact, his first studio was in the back room of a saloon. With the privacy and comfort supplied by the eventual acquirement of his now-celebrated log cabin studio in Great Falls, Charlie speedily increased the size, number and quality of his paintings.

As was to be expected, with greater local success, the Russells were eventually tempted to test their luck in greener pastures. New York finally was decided upon as their target. A decided gamble at best, it was even more so where Nancy herself was concerned, since (aside from a single trip to St. Louis, to meet Charlie's family) she had never been in any big city. The gamble proved an unqualified success, not only due to a number of gratifying sales at high prices, but it also resulted in Charlie gaining the attention of the editors of the foremost book and magazine publishing houses of the day.

With genuine talent, hard work, intelligent management, and undoubted luck, annual exhibitions in New York, Chicago, and Los Angeles followed as a matter of course. These were augmented by a steadily growing number of direct sales to wealthy lovers of things Western, many of whom understood the quality and value of his art. It became obvious that Charlie Russell's star was definitely in the ascendant. This period culminated in his being commissioned to paint the mural, "Lewis and Clark Meeting the Flatheads" [FIG. 12] for the Montana state capitol, in Helena. And this achievement appears to have also marked a further unfolding in Russell's peculiar technical ability, particularly his bold use of color.

Although Russell was extremely simple—in fact, actually limited—in his knowledge of the technicalities of his craft, years of stubborn insistence upon expressing his inner-self in a completely natural manner finally set his work apart from that of every other artist in the field, regardless of their training or standing.

After 1905—with increased facility in all mediums which he turned to for the expression of his seemingly inexhaustible fund of always original subjects bringing the recognition that his work enjoyed—the Russells finally moved in a circle that included Wall Street bankers, Pittsburgh steel magnates, moving picture stars, luminaries of the world of art, writing and the theatre (and as a result of a successful exhibition in London) even members of the English Nobility. In this company, select and strange though it was, the Russells moved with quiet assurance.

Never a blow-hard, and surely with none of the ham actor in

his makeup, Charlie proved to be a born mixer, a raconteur *par-excellence*, and a real humorist of the Will Rogers, Mark Twain, Lincoln mold. He effortlessly became the center of interest in any group in which he found himself. But Russell did not make a habit of "calling his shots," according to the standing or quality of his company. He seemingly possessed the ability to directly and immediately reach the heart of his listeners on any level. And, whether among old friends or total strangers, such people invariably hung on his every word, like so many little kids. When his deadpan, delayed action manner of delivery finally put across a slow-fused "sneaker" their delight was unmistakable—often whole-heartedly explosive!

Blessed with an imagination that bordered on the mystical, coupled with an extremely retentive memory, there now appeared a deepening and refinement of his sometimes-harsh color. This can hardly be regarded as a wholly-personal fault. Absolute realism was an unshakable part of Russell's life code; and since such colors were, in many cases, characteristic of the conditions to be found at certain seasons, in his always clearly-remembered early-day surroundings, it is only natural that the artist embraced them.

Always the unconscious possessor of an ability to convey *mood*—best shown in his quieter subjects—he became noted, principally, for his ability to portray violent action, too. In fact, action became his *forte*! In addition, by a few swift strokes with pen or brush, often seemingly carelessly done—his ability to reproduce "character," or surface-texture (what the Chinese term: "The Spirit of the brush") became evident in the most minute details, and eventually amounted to Russell's personal hallmark.

But eventually, too, in such of his clay and wax models as were intentionally created for casting in bronze (a field in which he became widely known) Russell finally succeeded in capturing and combining the greater number of his most admirable qualities. Here appeared that indescribable *spirit*, such as characterizes the most brilliant performance by an actor or musician of outstanding ability. This intangible "something" is best illustrated by his magnificent bronze, "Spirit of Winter."

In the good years between 1910 and 1926, when Charlie Russell

had developed into a full-fledged personal and artistic success from every possible angle, there was never any doubt about his wife's ability to keep pace with him in any company. Pretty as a young girl (and in the shared building of his success, increasingly self-confident) Nancy actually became beautiful with the passing years. She was graced with a vibrant, rich speaking voice. Then, too, she developed a charming, alert, intelligent and—when called for—apparently straight-from-the-shoulder (yet shrewdly-calculated manner of "diplomatic-manipulation") that always got results. Nancy's ways were entirely foreign to Charlie's; yet they complemented his simple, trusting, unambitious nature. Even today, however, certain top-flight art dealers, accustomed to persuading and over-awing the meek, timid, or the inexperienced among artists—remain firmly convinced that Nancy's gloves, whether suede, buckskin, or velvet, actually contained a pair of brass-knuckles. Actually the credit is all hers. She merely beat them at their own game!

But Nancy's greatest achievement in her husband's behalf was best summed up by his longtime friend Will Rogers, who drawled: "Nancy took an "o" out of Saloon, and made it read salon."

Charles Marion Russell eventually emerged, not only a first rank painter, sculptor and pen-and-ink artist, but a story-teller of professional calibre; a talented humorist and writer; and the concocter of considerable lasting doggerel originally intended to accompany Christmas cards and other messages. As a poet—usually of a semi-humorous sort, his few attempts at serious verse came out as simple and beyond doubt as beautifully as any of his great paintings. In fact, the originality of anything to which Russell turned his brilliant hand is now easily apparent.

But like any wholly self-trained creator, his genius also occasionally reflects uneven periods. Yet the "tops" of Russell's considerable lifetime output speaks for itself in any company where accuracy, documentation, conviction, spirit, emotion, color and craftsmanship—all employed in an understandable manner—play a vital part.

And, beyond this greatness Russell had still another ability—or gift, rather—upon which anyone who ever really knew him placed an even greater value: He was always "above-board," and in all ways "open to the sky." "His lodge," to use an Indian simile,

"had but one door," which always faced the rising sun. Whenever, or wherever he traveled, he rode—since that was ever his way—where he could see, and be seen. There was no hugging of deep coulees by Charlie to avoid being "skylined"; no skulking in the badlands until darkness made safe the crossing of a ridge. And he never had reason to "pull a blanket-sneak" or craftily "brush out" his horse's tracks with a willow branch. Although his was a sometimes carelessly-made trail, particularly during his younger days (since almost anyone can accidentally stumble into a "dobie patch" or bog down at some creek ford) he still left no hurt and no unpaid debts along the way in all his 46 wonderful years in Old Montana.

Perhaps Charlie Russell was almost too kind, too mild, too honest, and far too innately decent to be a full-fledged member of the human race. He never had to stoop to "burning the country behind him." His trail through life was marked boldly by great friendships. While such friends were made without effort or calculation, yet they were at every level of society.

Russell was never inclined to "weigh" a man's position, wealth, or influence. He never intentionally "used" others for his own gain. He would, sometimes, reluctantly and rarely ask a favor for someone else in great need; but not for himself.

And so it is not to be wondered at that Charlie Russell's friends, Red Men, White Men, and Breeds of many mixtures "sided him, clear to the top of the Big Divide." To such friends it wouldn't have made the slightest difference if he had never managed to draw a line. Oddly enough, when in Charlie's company, folks generally *forgot* all about the genius on which his fame was based. The only explanation for this, I believe, may be found in the following (which like so many of his apparently off-hand remarks grows in depth and meaning on every repetition): "*Nobody* is important enough to *feel* important!" That was part of the real greatness of C. M. R.

# The Story Behind Charlie Russell's Masterpiece: "Waiting for a Chinook"

Wallis Huidekoper

◁∾▷

IN A NEAT GLASS CASE in the Charles M. Russell Room of the new State Historical Building in Helena is a very small water color painting, "Waiting for a Chinook" [FIG. 2]. This sketch is not remarkable as an art form (although veterinarians regard the anatomy of the animal as perfect) but it holds an historical place that can not be duplicated. It is the first publicly recognized colored drawing of that great portrayer of western life—the artist of whom Montanans are so proud—Charles Marion Russell.

The writer had the good fortune to own this primitive painting for a period of more than thirty years. But considering self owner-ship as selfish, it was released in order that the people of Montana might have a share in seeing and enjoying it. The authentic story of this picture, of which there have been many distortions, follows:

Russell was sixteen years old when he left home in St. Louis, in 1880, and came by train to Utah and then by stage to Montana Territory via the old gold route and Beaverhead River to Helena. He had visions of a wild and open country; and he found it. There was plenty of excitement. The buffalo had not been annihilated; wolves and all other wild game was abundant; the Indians were still primitive; larger ranch outfits were driving huge trail herds from Texas; gold mining was still operative. Besides the strong, self-willed and well-rooted citizens, a drifting element existed, consisting of trap-pers and traders wolfers and hunters, saloon-and-dive-keepers, gam-blers, wood cutters for river steamers, freighters, cattle rustlers, horse thieves and outlaws. It was a jackpot gathering. Into all this stepped the young man; already enhanced with much worldly knowledge

and a keen sense of observation, backed by an extraordinary ability to sketch and draw. During this period, and later as a cow-puncher, Russell imbibed the atmosphere and spirit of the early west and its unique characters which he afterwards reproduced so wonderfully on paper and canvas.

Charlie's first location in Montana was in the lovely Judith River country. Here, for a couple of years, he herded sheep, cooked, and fraternized with hunters and trappers. Then he started working for the big cow outfits. He remained a cowboy until his marriage in 1896. His wife then took him seriously in hand and put him to work with brush, palette and easel. During his cowboy days Russell never was rated a top hand, preferring to stand guard with beef herds and wrangle saddle horses; so he could loaf, visit, lie around camp and sketch, or model the piece of wax he always carried in his pocket for this purpose.

Montana is capable of producing demoralizing weather. The winter of 1886–7, when livestock interests sustained such heavy losses and a severe financial setback, was one. I do not believe this winter was much more severe than several others, but stockmen were improvident in winter feeding, expecting livestock to sustain themselves through grazing alone. "The Hard Winter" started the middle of November and continued with Arctic severity until the end of February—one hundred days of crusted and lasting snow, piled high and impassable. Grazing was impossible. Cattle perished by the thousands. Some herds were completely wiped out.

During 1886 Russell worked for two cattle owners living in Helena, Stadler and Kaufman, who ran some five thousand head of cattle in the Judith Basin near the present site of Utica post office. Their brand was a Bar R on the right thigh. Their foreman and range manager was Jesse Phelps, a good stockhand who lived on his own ranch, the O. H. Russell apparently spent the greater part of this winter at the O. H. ranch, for he was out of a job and short of money. He was there later in the winter, when Kaufman wrote to Phelps asking about the condition of the cattle. The night this letter was received, Phelps and Russell were seated together at the ranch bunk house table discussing what kind of answer should be sent "K," as they called him. Phelps said "I'll have to write to Louie but I hate to

tell him how tough it is." To which Charlie remarked, "I'll draw you a picture to go with your letter." This he did the next morning, portraying an old cow visible from the ranch window. The work was done on a piece of pasteboard taken from the cover of a collar box and was painted with cheap water colors. When shown to Phelps, he remarked, "Hell, there is no letter needed. That picture tells the story better than I can write it." There was, however, a short note enclosed.

Charlie called the subject "Waiting for a Chinook." It was never named by him "The Last of 5000." Where the secondary caption— thereafter so overused—came from, is not known.

At the time, Louis Stadler and L. E. Kaufman conducted a butcher shop on Edwards Street, on the site of the present Eddy Bakeries plant. Ben Roberts had a harness shop directly across the street, where the Marlow theater now is. Kaufman took the picture over to show it to Roberts, a close friend of Russell's. (Ten years later Russell not only met "the girl" but later married her in Roberts' house in Cascade.)

Roberts wanted the picture badly and Kaufman, considering it of no great value, presented it to him about a year afterwards, probably in 1888. Then, for many years, it lay around Roberts' shop, becoming soiled, fly-blown and bent. In 1913, Roberts, needing money, decided to sell it. The writer was, fortunately, in Helena at that time and was offered the picture for $500. But my answer was "Not interested." I did, however, offer Ben a modest sum which he refused. As he walked away I called to him that I was leaving for my ranch on the seven 'clock train next morning and my offer would still be good.

He was at the train next morning. I paid him by check and took the little painting with me to the Musselshell River Ranch.

On my next trip to Chicago I took "Waiting for a Chinook" to the O'Brien galleries. There it was cleaned, pressed and backed. I had an appropriate frame made but did not put the picture in it then. Later in the year when I went to Great Falls, I showed it to Charlie Russell.

"Well Huide, you have the little old picture," he said. "I am glad, but where did you get it?" I told him the story and, as there was no writing on the drawing, I asked him to write something and sign it.

I wanted it authenticated. "What shall I write?" he asked. "Anything you may think of, Charlie," I replied.

After rolling a cigarette and taking a puff or two, Russell sat down at his table while his wife and I visited. Soon, without looking up, he called out "How do you spell 'real'?" Mrs. Russell immediately answered, "Oh, Charles, R-E-A-L, of course."

So the picture was nicely autographed, with the wording "This is the real thing painted the winter of 1886 at the O. H. Ranch." And it was signed "C. M. Russell" with his buffalo head symbol. Kaufman's signature was afterwards obtained in Helena. I took him out of a solo game to get it, to put the sketch in its present historical form.

"Waiting for a Chinook" hung on the wall of my ranch home for thirty years. On November 17, 1942 I presented it to the Montana Stockgrowers Association, in order that our members, as well as the public, might see and enjoy it. This State Association has since placed it on permanent exhibit in the Russell room of the Historical Society of Montana.

Jesse Phelps died in Helena about 1930. L. E. Kaufman passed away in the same city on March 12, 1933. Louis Stadler lived to the good old age of 92 years. He died Aug. 28, 1941. I always enjoyed visiting with Kaufman, which I did frequently. One day he told me this story:

He had visited the ranch in the Judith Basin during the middle of the winter of 1886 when things were beginning to tighten up and get tough. This particular animal was a Texas brindle cow that used to come to the ranch and hang around the horse barn for protection and to gather such feed as might be thrown out. Phelps said to Kaufman, "Well, 'K,' do you think you will be seeing that cow next spring?" To which Kaufman replied: "You bet I will and she will raise me a nice big bull calf." This was the freezing emaciated animal that Charlie Russell drew and from which he obtained his first recognition as an artist.

The poor old cow, was, indeed, waiting for a chinook.

# I Knew Charles M. Russell

Carter V. Rubottom

MY HOME TOWN of Great Falls was also the home of the famous Montana cowboy artist, Charles Marion Russell. He had drifted into town about the time that Father set up shop there, and they became intimate friends. Mr. Russell bought materials for his paintings from Father's store, The Como Company. Uncle George Gilchrist made up all the canvasses until his death in 1907, and succeeding picture-framers continued to do the same. All the paintings Charley Russell shipped were crated there, usually being placed on view in our show windows first. I have seen as many as eleven wonderful C.M.R. oil paintings in our windows at one time, ready for shipment to some exhibit or buyer, often to distant parts of the world.

In addition to his great creative talent, Mr. Russell was a man of many facets. In 1898, Father planned a trip to the Medicine Springs in Sun River Canyon, about 85 miles west of Great Falls, with the Reverend Moore and his son Stewart. They would travel by wagon part way, but the last ten miles was a packhorse job. (People troubled with rheumatism made the trip in hope of receiving benefit from bathing in the hot springs and drinking the water.) It required much preparation on Father's part to get his outfit together, since he was a "dude" as regards packing. Mr. Russell—so typical of his interest in others—came to our house several evenings to teach Father how to tie the diamond hitch on a pack. Mother had a clothes drying rig in the attic, on which the pack was fastened, and Mr. Russell used this, with considerable amusement on his part, but with very good grace.

I recall vividly another instance of the artist's generosity. One day I was looking through a drawer in the work bench where a number of unsold Como pictures had accumulated. Among the varied collection of prints of old masters and poor calendar art, I dis-

covered an original water color. It pictured, graphically, an evening in the badlands, the moon coming up through leafless willows. In the center, on a large flat rock was the bleeding body of a mule deer buck, while a grizzly bear and mountain lion are fighting over the remains. Outside this central group five gray wolves are waiting for what may be left to eat. The painting, quite obviously, showed the rare talent of C. M. Russell, whose signature it bore.

I asked father if I could have the picture. He said he would have to ask about it. As hardly a week passed when Russell was in town and he did not drop in to swap stories with the boys in The Como back room, it wasn't long until the opportunity arose. I happened to be in the store when he came in. Father showed him the picture. I almost held my breath as I watched. Mr. Russell looked the picture over critically, grunted in his Indian fashion and said, "I never finished this thing. Sure give it to the kid." I promptly hurried into the back room to frame this water color—to me as fine as the greatest works of art. This picture is still my most prized possession.

I recall that the first calendar using a Russell painting was planned by The Como Company. Charley Russell painted a special picture for it. This portrays an Indian, standing on the back of his horse, painting figures on the face of a cliff with red paint. The Ridgeley Printing Company of Great Falls made up the calendars. They also printed some business cards using the same picture. The original painting disappeared shortly afterwards and to my knowledge has never been seen since.

Versatile and generous, Mr. Russell sometimes made window displays during the holidays for his Great Falls storekeeper friends. I recall a wonderful window he once dressed for Frank Webster's grocery on the corner of 3rd St. and Central Ave. Charley painted a background for the display which filled the back of the window space. I watched him do the work in the back room of the Como Co.—a winter scene in the mountains. In the show space he built up his action. He created a park surrounded by tiny evergreen trees. A really accurate miniature log cabin stood on the high ground to the left. In front of the cabin were necessary accessories, including a log with an axe stuck in one end. At the foot of the slope in the right background two whitetail deer, in perfect miniature, were emerging

from the trees. The cabin door—symbolic of Montana hospitality—was open. The wax figure of a man stood in the door, while another man just outside was throwing a cartridge into his Winchester, as they looked excitedly down the slope at the two deer, a buck and a doe. The scene indicated that venison would be on the table for Christmas dinner.

I recall another fine window that Russell designed for Ward's cigar store showing winter in the North country. And because his sympathies were always with the Red Man, this was an Indian camp scene. He put snow covered ground in the show space. On one side stood a buckskin tepee about a foot high. A few inches in front of this was the wax figure of a young Indian woman, holding her baby on its cradle board up beside her head. They were looking toward the park, where the father was coming into sight on his snowshoes, a rifle in one hand and a fine buck deer hung around his neck and shoulders. Another Russell-inspired camp was having venison for Christmas!

Because of his early range life in the Judith Basin cattle empire, Charley Russell kept a saddle horse all his life. He rode into downtown Great Falls nearly every day. Usually he would ride down the alley back of our store and tie up to a power pole, using the lariat he always carried on his heavy Western stock saddle. When he visited Billy Rance's famed saloon, The Silver Dollar, his horse stood behind that emporium. Rance was a close friend as was Sid Willis, who owned The Mint Saloon, across the street. These two men developed fine collections of Russell's works, paintings, models and personal effects. When Billy Rance died, his collection was added to the one in The Mint, and this combined collection for many years was viewed by thousands of admirers.

Along about 1899, some three years after Russell's marriage, a few intimate friends planned a camping trip to the upper waters of the Dearborn River, about seventy-five miles southwest of Great Falls on the east slope of the Rockies. Two separate camps were planned, the party being too large to be handled by one. Mr. and Mrs. Russell, Mr. and Mrs. Trigg and daughter Josephine, Judge and Mrs. Hawkins, Almon LeFebvre and a large negro cook made up one group. Our party consisted of Father, Mother, Miss Coy, Sister Anna and myself.

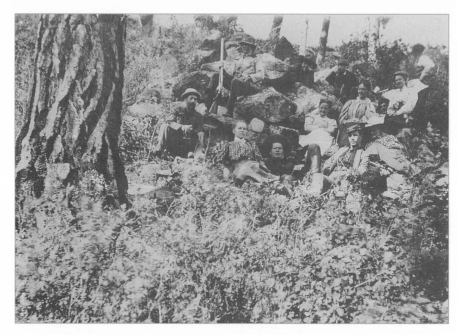

Camping Party on the Dearborn River, 1898. Nancy Russell, Charlie Russell, and Henry "Pike" Webster are in front; behind, left to right, are Frank Webster, Judge S. S. Hawkins, Theodore LeFebvre, Mrs. Frank Webster, Almon LeFebvre, Margaret Trigg, Josephine Trigg, and Jess Smith, the cook. MHS Photo Archives, Helena

The Russell party left ahead of us, going by way of Cascade and Sullivan Valley, to visit at Mrs. Russell's former home. Our party went up Sun River to the old crossing on the Fort Benton–Helena supply road, followed this road south over Bird Tail Divide, meeting the other party at the Dearborn Crossing on the second night out.

The first night we camped about a mile below the old Army post of Fort Shaw, which had been changed to an Indian school. Father jokingly told Sister and me there were a bunch of Indians camped up the river a way and we had better be good and stay close to camp. But we became too frightened, for the stories of Indian killings and scalping had grown to mammoth proportions in these later years—and Father was hard set to dispel his joking threat.

That night Father picketed one horse, but left the other, old Chub, dragging his rope until bedtime, as Chub was not prone to stray. After eating a good fill of grass, Chub went down to the river for a drink. On his way back he passed close to where we sat by the camp fire where Mother was engaged in camp chores. I took a fool notion

to catch the horse by grabbing the rope. As I made a pass at it, Chub started to trot. Father warned me to leave the rope alone, but I did not heed this advice, made another grab, got a good grip, stubbed my toe on a tree root and went headlong, skinning my nose in the dust. I learned a valuable life-long lesson about grabbing a rope fastened to a running horse or cow.

After meeting the other party at the Dearborn Bridge, we all proceeded up the Middle Fork into the mountains. Mr. Russell absolutely would not ride in a wagon. He rode his chestnut saddle horse and led his pack horse, a pinto called Paint, with his belongings lashed to a sawbuck saddle, tied with a neat diamond hitch.

Before reaching the mountains, we passed a small ranch house with a grain field just out of sight of the house. A few turkeys were catching grasshoppers here, not far from the roadside. Russell reached for his Colt which hung at his belt, and said that we needed meat for supper. His wife, Nancy, promptly vetoed this, and with a great show of reluctance, he holstered his gun and rode on. Of course he was only teasing Nancy, in the ribald manner of "ribbing" so common among old-timers of that period.

Several times during that day Mr. Russell rode up beside our wagon, reached in and picked my sister up in one arm and set her before him on his horse, where she road happily, her yellow hair shining in the sun. He loved children.

We pitched our tents beside a clear mountain stream, the two camps within hailing distance of each other. During those pleasurable days everyone was privileged to select the pastimes best suited to their own taste. We kids climbed the hills and fished for trout. The men lounged around camp, talking and smoking with some fishing. The women were well occupied with bustling domestic duties and much visiting. I was surprised to note that Mr. Russell stayed in camp. He did not fish. And even around camp he never walked when he could ride a horse.

Each day a great pile of dead wood was collected near the center of the park for the evening fire. As soon as the sun had set and camp chores were done, the pyre was ignited. Everyone gathered around, reclining on blankets spread on the grass, or sitting on logs. Gay songs and stories of the old frontier days were in order. Father even

popped corn. He would fill the big dish pan with white, crispy popcorn using a wire popper with a long handle, popping it over a bed of glowing coals, his face shaded from the heat with his stetson hat. Mother would douse the pan generously with rich melted butter. And then we all tied into it, two fistedly. I can still remember how delicious it was.

One night we were intrigued when Mr. Russell cut the bottom out of an empty fruit can. He then took some writing paper, picking a piece of charcoal from the edge of the fireplace, and proceeded to draw silhouettes of animals on the paper. He then placed these pictures over one end of the tin can. When held toward the fire so the light would shine through, the ingenious black silhouettes showed up dramatically. We children had a wonderful time guessing the name of each animal. When bedtime came and the party broke up Mother tried to reclaim these pictures, but someone else was either ahead of her or they had been carelessly burned and we never saw them again.

One day, when some wood was needed, the men felled a dry tree close to camp, cutting it into logs. They planned to drag some of it to camp with one of the buggy teams. But Charley Russell wanted to have some sport out of the chores. He suggested dragging a log with his pack horse.

Soon he came into camp, leading Monte, in harness. Several of us gathered around, including the colored cook. Monte's traces were hooked to a single-tree, with a chain passed around the log. But when Mr. Russell tried to start work, old Monte had other ideas about dragging logs. He flatly refused to tighten the tugs. After much urging, he simply gave up and lay flat on his side in the grass. The men sat down on the log to see what Charley would do about it. Every once in a while Monte would raise his head, see the men sitting there on the log, and lay his head back in the grass. Mr. Russell was abashed. The cook nearly split his sides laughing and all of us were amused.

Finally Russell unhitched Monte from the log. The horse promptly got to his feet and followed to camp, where Charley removed the harness and substituted saddle and bridle. Back they came with Mr. Russell confidently on top, taking down his rope. Someone passed the loop around the end of the log, Charley Russell took a dally around the saddle horn, and Monte jerked that log into camp

in jig time. "He wanted us all to know that he was a saddle horse, not a harness drudge," Mr. Russell said, "a cow pony has pride."

One incident of our return trip was amusing. We came to a ranch a short time after leaving our camp. A team and wagon were just leaving the place, accompanied by a small pack of greyhounds.

Many stockmen of that day kept such dogs for chasing grey wolves and coyotes. Along with these aristocrats of dogdom were two small sheep dogs. We stopped a few minutes at the ranch house. Then, when we drove out on the open range, an interesting sight met our eyes. A band of broomtails was grazing there. Evidently the ranchmen did not want them around and the little sheep dogs knew it. They lit out after the horses and it didn't take these broomtails and dogs long to disappear. But what of the lordly greyhounds? Off to one side of the road a small knoll rose above the surrounding prairie. Upon this vantage point sat the hounds with heads up and ears cocked, watching the scene. They were trained for different game. As our ponies trotted along over the prairie road, we kept watch for the little dogs, and met them trotting back with tongues hanging. As they passed us, they looked up as if to say, "See how we handled that case. The lordly greyhounds are only specialists."

One day, near the end of our vacation, two nomadic young men from Helena pulled into camp. They were quite an addition to our nightly gathering around the big fire, as they played the guitar and sang many lively range songs, which pleased C.M.R. We all sang when they started a familiar ballad, but they knew many comical songs that we had never heard—not even Mr. Russell—and they taught us some. I can still hear the youths singing: "With rocks and guns and knives, mad husbands and their wives, would give up half their lives to find and kill O'Grady's goat."

About the time I entered high school, Mrs. Russell's half sister, Ella, came to live with them. Jolly and full of fun, Ella was soon a popular addition to the group I ran with. We visited around from house to house and attended the many dances which, in those days, were not public but were sponsored by families or by the churches. Of course, the Russells entertained, in turn; and we always enjoyed, most, the friendly, interesting evenings at their fascinating home next to the log studio.

But the log studio of the cowboy artist was the exciting place! A large fireplace filled most of the east wall. A skylight in the north slope of the roof afforded the right light for his brilliant, sun-filled paintings. Easy chairs and a simple divan, carelessly placed, invited one to rest. Around the walls, in profusion, hung every item that the early Montana cowboys used: guns, ropes, hats, chaps, saddle, spurs—needed as authentic models for his pictures, except horses and Indians (and these C.M.R. had indelibly inscribed in his fertile brain), photographs of friends, a few small personalized drawings that Charley loved to do—all comprised a cozy mannish room that fit his personality. Here Russell worked or swapped stories with his friends; and he was a master story teller who could fit his tales to his audience, whether in rough cow camps or refined parlor. Few men were his equal as a teller of tales.

About midnight we would walk over to the "Big House" for supper. Here in the neat parlor, so carefully kept by Mrs. Russell, was a large collection of the artist's clay figures. His clay modeling was as wonderful to me as his paintings. Around this room, about four feet from the floor, was the type of wall-moulding, popular at that time and called a "plate rail." On this rail was displayed an amazing collection of figures, ranging from wild turkeys to elephants; from a knight in armor on an armored horse, to a life-like figure of C.M.R. himself on his bay horse. I never tired of looking at these life-like models, many of them so different from those usually associated with frontier art, or a cowboy artist.

On the dinner table was a skillful center-piece painting of a winter scene in the mountains. On the table, a few inches from this picture, was a piece of native rock. On it sat a mountain sheep, of clay. Looking toward the painting sat a log cabin in a canyon, with a light showing in the window. We all enjoyed these rare visits to the Russell home.

Shortly after Father's trip to Medicine Springs, he loaned our horse to Mr. Russell for a trip. There were to be several local men in the party, among them Olaf Seltzer.[19] Father had told Mr. Russell that Chub would buck if spurred in the flanks, so C.M.R. was mindful of the chance to have fun with someone. During the trip, each member of the party took a turn at wrangling horses.

When it came to Olaf Seltzer's turn, he wanted to look the part, so he put on chaps and spurs before he climbed on old Chub to round-up the other horses. Chub, as usual, took his time in getting started. Charley Russell had told Mr. Seltzer to give him the spurs. Olaf followed instructions all right, and Chub piled him, high, wide, and handsome. Afterwards, Mr. Russell never missed a chance to tell this story when he found Mr. Seltzer among a bunch who hadn't heard of the episode. In after years, when I was then riding Chub, Charley often asked me, "How's the old hoss; will he take the spurs?"

The last time I saw the Russell family was at the mountain resort of Lincoln in 1918. Father and Mother were living there then, Father having sold the Como Co. and bought the general store in Lincoln. Their living quarters were attached to the store building.

Father had told Charley Russell much about the Lincoln country and Charley wanted to visit there. So late in August the Russells, with their adopted son, arrived. It was a cloudy afternoon and there had been some rain. Mrs. Russell, who always drove a car, had driven from their summer home on Lake McDonald in Glacier Park, through Kalispell and Missoula, then up the Blackfoot River. The road up the Blackfoot, although in beautiful country, then was one of the roughest in a state saddled with bad roads.

Mr. Russell was in his usual hearty mood, although tired, but Mrs. Russell was worn out. She said that she never would travel that canyon again. We had a good visit in the evening with the Russells and the next day they all gathered at my ranch and enjoyed a ranch dinner. Charley and Dad had a fine time looking over the stock, corrals and barn and recalling old times and old-timers. The Russells left for Great Falls the next day. I do not recall seeing Charles M. Russell again. Father died in 1923 and I was in Great Falls very little after that time. C.M.R. passed away in 1926, mourned by many friends, and Montana and the world lost perhaps the most competent of the great contemporary painters of the Western frontier; and certainly one of this state's most remarkable citizens.

# Home Is the Hunter

George Coffee

~

UNTIL THE FALL OF 1922 I had only a curbstone acquaintance with Charlie Russell. That was good enough because in my youthful ranch days, which were a few generations after Charlie's, you didn't have to sit around the bunkhouse stove many winter evenings without hearing a lot of fascinating stories about "Kid" Russell from some old cowhand who had known him after 1880, when he first hit Montana Territory. He had a lot of grapevine acquaintances like that, particularly numerous in the period before his marriage in 1896.

In the fall of 1922 George Calvert and Jim Hobbins, who were close friends of Russell's, were going along with Johnny Moore and a group of us who were packing in to hunt in the rugged Rockies at the head of Sun River, west of Choteau. Calvert phoned me that he and Hobbins would like to bring the famous Western artist along.

Charlie was in his late 50's then. It had been a long time since "The Kid" had done any hunting from Jake Hoover's isolated cabin over on the South Fork of the Judith—when they hunted mostly for sustenance and not for sport. We knew Charlie was coming this time, just for fun and not to hunt, just as he had been doing for many years.

The trio from "The Falls" called at our house next evening and, as is usual, everybody was checking everybody else for preparedness for a rough mountain trip. Calvert was trying on a new pair of mackinaw pants, which we all saw were much too long. Charlie borrowed a pair of scissors from my wife and gleefully proceeded to whack about a foot of leg off Calvert's pants. When George jacked up his pants by his suspenders they hit him just below the knees. "Too short for a lumberjack, too long for beach combin', and too much exposure for huntin', so you'll have to stay in camp," says Charlie.

Next morning we were on our way from Ken Gleason's ranch on South Fork of the Teton. Toward dark we were strung out on

the trail through heavy timber, horses single file, nearing camp. Charlie was riding behind Hobbins when a pack slipped on the horse ahead of Jim's, whereupon Charlie observed: "The freighthoss took it out on the caboose behind removing a little rawhide from Jim's shin." As soon as Charlie knew Jim's leg wasn't broken and his hurts minor, he says, "Jim, you and Calvert had no business comin' with us young fellers in these mountains. You knew there'd be no white bosomed nurses in our camp to bathe swollen limbs. And sympathy is an awful scarce commodity around this bunch of cannibals."

Our camp was on a little rocky flat alongside the North Fork. As Hobbins described it, it consisted of a "mulligan and bean-tent," where Charlie did most of the cooking, set opposite a "lying-in-tent," with a tarp stretched overhead between, in which Hobbins slept on a cot. The woodpile was at his back and the stars out front. This layout, Hobbins commented, "houses more comedy than Bill Steege ever booked at the Grand Opera House in Great Falls and more solid comfort than the Rainbow Hotel" and he said he meant "solid."

After some of our party had hunted for two or three days we didn't have any camp meat. Johnny Moore saddled a couple horses for Charlie and him to ride hunting when Charlie's attention was called to the fact that no rifle was in the scabbard on his saddle. "Oh hell," Charlie says, "I never take a gun any more when I go huntin," and they rode off. They tracked within smelling distance of a bunch of elk late that day. Moore said they could have caught up and he might have supplied our meat-hungry camp. But Charlie says, "we've got that bunch salted down. Let's leave 'em go and send Calvert and Hobbins out early tomorrow an' see if their readin' Daniel Boone's methods qualified 'em for bein' in our camp." No elk were ever again located.

"We ate packin' house meat for ten days with Armour and Swift savin' face for our gunbearers," said Charlie.

He delighted in cooking meals—at his Bull's Head lodge on Lake McDonald or when camping. He was an excellent cook. One evening, coming in with voracious appetites, we all "waded in" to what Charlie announced was "Chinook stew with squirrel dumplings." After swallowing a few calories we detected Charlie had

dumped half a sack of salt in the bean pot and garnished that course with dried pinecones.

Coming out that trip, we were driven from Ken Gleason's ranch on the South Fork of the Teton River in a big seven-passenger open and unconvertible Pierce Arrow. Calvert and I occupied the two jump seats in front of the back cushion where Russell and Hobbins rode. Snow was falling like big feathers on our shoulders. Calvert and I had taken drinks from a bottle we had left at Gleason's on the way in. (Nobody drank in our camp and neither Charlie or Jim touched liquor in those later days.) Calvert and I struck up a few barber-shop strains as the driver swung pretty fast around curves in the road leading through the foothill jack pines. Charley leaned over and says to Hobbins, "Jim, if this wagon rolls over you know who'll get killed— just you and me. They've got plenty of song birds in Heaven already."

The next fall, 1923, Moore and I packed over the Continental Divide down to the junction of Pentagon Creek and Spotted Bear Fork of the Flathead. Here was a big camp. Horse bells were rattling all over the hillside. As we led the packstring into this camp there stood Charlie at the side of the trail, his thumbs tucked under the old Red River sash he always wore for a belt. He was watching our approach, smiling. "Well, I'll be damned," he says, "here I've come fifty miles hossback thinkin' I'd get clean away from you fellers who didn't exactly approve my cookin' last year on Sun River. Come over an' partake of some of our rations. You both look mighty gant." Close to the trail, on the opposite side from where Charlie stood, a ruddy face appeared from behind the flap of a pup-tent. "That feller over there," says Charlie, "is dyin' of a belly ache. We've picked out his last restin' place under a big boulder up there in the mountain. From the way he's actin' we'll be havin' the buryin' about tomorrow and we'll be needin' a couple of good singers." The face was that of Judge Bollinger of Davenport, Iowa, one of Charlie's closest friends and a companion of his on several trips up the South Fork of the Flathead.

After Charlie passed away Judge Bollinger's tribute to him, written to Nancy, Charlie's wife, recounted one of the phases of his great character—"his loyalty and devotion to his friends." It would seem to Judge Bollinger, as to us all, should we ever return to the mountain settings where days bygone were enriched by Charlie's

presence, the "hoss" bells have a lot less cheerful ring; that the lights and shadows on the reefs have a duller hue than they did when Charlie was there; and that "the Great Spirit" was a little selfish when it called him across "the Great Divide" to the "Sand Hills."

One of my most valued possessions in the form of a New Year greeting, came from Charlie Russell in 1923. It was penned below one of his inimitable water color sketches—a lone rider on the prairie with one hand uplifted in salutation. In prayer-like sincerity he wrote this supplication:

"Here's hoping old sickness don't locate your camp
    And health rides herd on you;
May Dad Time be slow a snuffin' your lamp
    And your trail be smooth plumb thru."

# Charlie Russell's Friends

Vivian A. Paladin

NOT LONG AFTER Charles Marion Russell died in 1926, a young teacher in New York City developed a deep and abiding interest in the life and work of Montana's cowboy artist. James Brownlee Rankin, a native of Denver, Colorado, was teaching at the Collegiate School for Boys in New York City when Russell died, and for the next decade and more, he spent much of his spare time writing letters to people who either had known the artist personally or had collected his works.

From the beginning, Rankin's goal had been to write and publish the definitive biography of Russell as well as to compile an extensive catalogue of the work of the artist he had come to admire so much. The harvest of his research—the voluminous correspondence along with his own letters home to his mother in New

York—came to the Montana Historical Society Archives in 1983 from his wife, Josephine. She had kept the letters since Rankin's death in 1962, and she sent them to the Society to fulfill her husband's wishes.

James B. Rankin was born in Denver, Colorado, on January 21, 1900, the son of the Reverend James Doig Rankin, pastor of the United Presbyterian Church of Denver, and of Daisy Meloy, the daughter of the Reverend William T. Meloy of the United Presbyterian Church of Chicago.[1] Rankin was well educated, first in Denver, later in Chicago, and still later in Europe. He was in Europe when World War I broke out, and he promptly returned home to enroll in Horace Mann School in New York to prepare for study at Princeton. Rankin received his B.A. from Princeton in 1923 and his M.A. from the University of Pennsylvania in 1925.

Throughout his life, Rankin "devoured" books and collected rare and first editions. He was also devoted to art, primarily the work of European and American masters. But when he discovered the work of Charles M. Russell, he found a focus for his interests. While Rankin continued to teach and to share his wide-ranging interests with his students, he began to spend more time seeking out those who could tell him more about Russell's life and work. For several years during the 1930s, Rankin used his summer vacations to personally interview many of Russell's friends who still lived in the West. He also carried on an extensive correspondence with them and with friends he had located elsewhere. His list of informants and his correspondence files grew as he found out all he could about Russell's life and character.

Long after Rankin had gathered all the knowledge and lore his informants could offer about Russell, he continued to correspond with them. Their letters to him are filled with humor, sorrow at the loss of loved ones, and news of day-to-day activities, their own failing health, and some personal problems that were totally unrelated to Russell. Many letters late in 1938 are filled with sympathy for Rankin at the news that his mother had died.

It was in 1940, the year of his fortieth birthday, that Rankin met and married Josephine Poindexter Crenshaw of New York City. They returned to California, where Rankin had moved after his mother's death, and lived in Pasadena, then El Centro, and finally

San Bernardino, where he was a professor of foreign languages, history, and sociology.

According to Josephine Rankin, in a biographical sketch that she wrote about her husband, after Rankin had committed much of his research to manuscript form, he freely shared it with a number of people with whom he had corresponded and who were familiar with his work. In 1948, collector Homer E. Britzman of Pasadena, who published books under the Trail's End Publishing Company imprint, collaborated with western writer Ramon F. Adams to produce *Charles M. Russell the Cowboy Artist, a Biography*.[2] The book contained a list of Russell's works compiled by Karl Yost and was the first serious biographical treatment of the artist. The only mention of Rankin's name is among those who assisted in gathering photographic material for the book. No other biography on Russell was published until 1957, when Austin Russell wrote his memoirs of his famous uncle.[3]

Josephine Rankin does not directly blame the Adams-Britzman book for Rankin's failure to publish his manuscript, but she does tell us this: "Through book friends JBR met other people interested in CMR and confided he was doing a biography of Russell and was urged to show it to several friends(?) . . . Shortly thereafter a book on CMR was published with whole pages 'lifted' from JBR's manuscript which so hurt him he was angry for the first time in his life and burned his own work of years in the incinerator in the back yard in Pasadena . . . A gentle man the shock was too much for him . . ."[4]

Rankin may have destroyed his manuscript about Russell, but he left intact his collection of letters and reminiscences of many people who remembered the cowboy artist and admired his work. His correspondents ranged from such well-known people as Mary Roberts Rinehart, William Allen White, William S. Hart, Irvin S. Cobb, and James Willard Schultz to some of Russell's old cowboy friends who were still alive and lucid during the 1930s, when Rankin was deep into his research.

WITHOUT EXCEPTION, Rankin's informants remembered their friend and the time they spent with him with fondness—and usually with

a chuckle. For example, novelist and playwright Mary Roberts Rinehart wrote: "I knew Mr. Russell very well and knew Mrs. Russell rather less, but over a period of years. They both stayed with me one time at my home in Sewickley [Pennsylvania], and my only clear recollection of that visit is his shouting 'Jesus Christ' every time the car went over thirty miles an hour. He was a grand person, and I can still see him on top of a mountain in the Rockies saying that he was g. d. tired of standing in a cloud up to his waist."[5]

William Allen White, editor and owner of the *Emporia* [Kansas] *Gazette*, also knew Russell after the artist's wrangling days were over. He wrote: ". . . Personally the Russell I knew was a man in his late forties and from then to his middle fifties. He had apparently in his youth lived a hard life in the out-of-doors. He was wholesome and hearty in his personal appearance, had a keen, strong discerning eye, a strong handclasp, and was direct and forthright in all of his relations. He was a 'fellow of infinite wit,' a good story teller who appreciated the shades of character in men and knew life in the rough and so was tolerant and charitable."[6]

Walter Lehman, whose father had owned a store in Utica, Montana, where Russell had spent a lot of time during his cowboying days, cautioned Rankin about making the artist appear too virtuous: "I don't know just how you are going to go about handling Russell's human side but if you can catch his underlying humor and not make the expression of it seem too coarse in the telling it will be fine. After all, men did a lot of rough things in those days and told a lot of things which they knew were not so in order to get a 'raise' out of their victim in front of a saloon crowd and so make him buy the drinks for all hands. Russell was part of his time and so ought not in all honesty to be put on a pedestal of virtue he never assumed. A very remarkable man and well worth your time."[7]

C. J. Ellis had been on a roundup with Russell in 1893 near Big Sandy, Montana, and wrote one of the most comprehensive and interesting letters that Rankin received: "I was 'reping' for the Sun River pool, and Charlie (Cotton Eye) was night wrangling the 'cavey' (horse herd)." Apparently responding to a question about what kind of man Russell was, Ellis wrote: ". . . he was straight as a string, don't think he ever did a man a dirty trick in his life, and if he ever

had an enemy I never met him. He always saw the funny side of any thing that happened and if there was no funny side he made one. He was a good mixer, a good story teller and a wonderful drawer of pictures and modeler of mud. He would have played a practical joke on his grandmother if he had had a chance. He got a kick out of anything that happened as long as no one was injured. He was the most scared fellow I ever saw when there was the least chance of any one getting hurt. If a fellow got throwed off a bucking horse Charlie would actually turn white until the rider got on his feet again and then he would high tail it to get a pencil and paper to draw a comic picture of the happening."[8]

James Willard Schultz, author of numerous books about his experiences on the Blackfeet Indian Reservation, agreed with Ellis's assessment of Russell's character and had a high regard for him. But his appraisal of the artist's wife, Nancy, was quite different: ". . . I became closely acquainted with him soon after he came to Montana, and we had many good times together until he married," Schultz wrote. "After that he was a changed man: his wife completely dominated him; made a slave of him; killed all his joy in life."[9]

What Russell's old friends thought about his wife has been discussed and analyzed at length. The best information we have on this part of his life, however, is that Russell himself had a deep and unwavering affection for Nancy and gave her credit for bringing order and productivity to his life, even though that meant traveling to eastern cities and wintering in California. Unquestionably, she "spoiled some of the fun" of the old days, and Russell, in his own letters to friends had some sardonic things to say about California and left no doubt that he did not like New York or London.

ALTHOUGH RUSSELL's friendships with some of the famous people that he met later in his life meant a great deal to him, he continued to keep in touch with his old friends. I. Finch David of Utica, Montana, knew Russell intimately and furnished Rankin with some of the best material in his collection. He wrote: "You know Russell was peculiar. Some men could see him and talk to him for 10 yrs and not know him. After he had wintered in Cal[ifornia] and formed

a friendship for the late Will Rogers, he was telling me, [']Finch I wish you could see and know him for he is our kind of people. and you would sure like him.['] Well that shows you rather what Russell was like. he was just as friendly and sociable to a man with a dollar as a wealthy man. if you interested him. if not, he just let you a lone. . . ."[10]

Although blind and in failing health, John R. Barrows, author, legislator, and attorney, wrote some remarkable letters to Rankin with the help of his wife, Leslie Foote Barrows. He remembered his old friends, Barrows wrote, with whom he had much in common even though their lives had turned out very differently and their paths had not crossed after the early 1890s.

"It seems to me that you are displaying considerable courage in undertaking the biography of Charley Russell," Barrows wrote, "for you will encounter a great deal of fiction, or perhaps I should say legend, about him. After Charley attained success everybody rushed in to claim something of the reflected glory. . . .

"I met Charley first, in the summer of 1880, when he was on his way to make his first visit to the Judith Basin. I met him only occasionally, for he never worked on the same roundup with me and during the winter hibernations, we were more than twenty miles apart. But the country was thinly peopled, and once in a while Charley would stray over to UBET or I would visit Utica, so that our friendship did not fade. . . .

"We lived in an era of story telling. Long evenings were passed in recounting stories of personal experiences or in relating stories we had heard from others. There was one inflexible rule, the narrator could tell of his misadventures, but was not allowed to tell of his exploits. He could tell about the heroism of others, but was careful to avoid bragging. He did not want to be nicknamed, 'Windy.' Charley was an excellent story-teller: he cultivated a style and a manner of delivery which he found most effective and made that style his ordinary speech. I presume that his formal education was about the same as my own. In his speech he turned his back on any improvement and cultivated the cowboy phrase and manner."[11]

Rankin requested and received a first edition copy of Barrows's book, *Ubet*, published in 1934, and the attorney wrote more about himself and his impressions of Russell: "I want you to pay particu-

lar attention to the 'state of the art' at the time when Charlie's work was seeking recognition. In the 80's we had Harper's, Century, and Scribner's and I saw the first work of Frederick Remington. The Ubet opinion was that his work was very crude. We hooted at it. It improved, of course, but even to the end his cowboys were soldiers in cowboy costume, and apparently his Indians and Chinamen were based on the same model. He must have taken back to his eastern studio a half-leathered saddle of unknown parentage, for it appeared again and again in his pictures. . . .

"As I lie here plucking at the coverlet I want to ask you again to forget your characterization of Charlie Russell as a restless, untamed pioneer. He was an easy-going, friendly, humorous youngster, who followed the line of least resistance. His career was nearly spoiled by his addiction to drink and his undoubted gifts might never have obtained recognition if he had not married the right woman."[12]

Charlie Russell's friendship and ease also extended to children. His old friend Esmundo C. Switzer wrote: "Regarding our old friend Charles M. Russell, I knew him all my life. At Cascade, Montana, in the 80's and early 90's, where my father had a mercantile store and was local judge, Charlie used Father's court room as his studio. He most certainly was a person in a class all by himself, both as a man, a friend and an artist. The last time I had the pleasure of having a visit with him was at his summer home at Lake McDonald in 1923. . . ."

"One of the outstanding things that I remember of my childhood was when Charlie and I were sitting in front of Shepherd & Flynn's mercantile store in Cascade and Charlie took a piece of wax out of his pocket and modeled a perfect Indian figure. . . . When the Indian was taking shape, Charlie said: 'Son, get me a block of wood to set this Siwash on.' So I rustled around and picked up an end cutting of a 2 × 4, got a couple of small nails for him and he drove them into the block and stuck the Indian's feet through the nails, remodeling them to the proper shape. Then he went over to a horse hitched to a post nearby, cut off a piece of his mane, braided it for the Indian's hair, cut a rifle from a piece of wood, put a little piece of calico from his pocket to make a covering for the rifle, and the Indian was complete. While he was doing this I carved on the bottom of the block the initial 'E.' During the Hudson-Fulton celebration

[1907] in New York City, I was a guest at the Metropolitan Museum of Art at Mr. [J. P.] Morgan's private art exhibit and while looking through the cases of curios, etc., I spied this Indian, and immediately recognized it and told those present, including Mr. Morgan, that I could identify that Indian if they would open the case, which they did and sure enough there was the block with my initial carved on it. I believe it was in July or August, 1889, that Charlie made this Indian.

"I have sat by the hour and watched Charlie paint in father's court room and he would sell the paintings for anywhere from one dollar up, whatever he could get for them. . . ."[13]

WHAT OF CHARLIE's famous humor? His own letters to his friends and his *Rawhide Rawlins* books amply demonstrate his sense of humor, and no one, however well they knew him, pretended that they could match his words. The Rankin collection contains some stories about the artist that highlight this inimitable side of Russell and are worth repeating.

"The first picture I ever saw him draw he darn near got the seat of his pants kicked out for doing it," his old range partner, C. J. Ellis, wrote. "Old Bill Bullard, an old flint lock ranahan, one of the toughest old codgers you could imagine, was day wrangling for us when we got down close to Maltey [Malta, Montana]. Bill slipped into town one night and tried to buy all of the whisky in town. He drank all he could hold and rolled the rest in his slicker and came back to camp and got into bed without anyone knowing he had even been out of camp. Next morning when Charlie went to wake Bill up to take his shift at wrangling, Bill was dead to the world and would not stir. Needless to say, the cowboys stole the whisky he had left. When they had consumed it Charlie proceeded to decorate Bill up a bit. He rustled an old buffalo skul with the horns on it and placed Bill's head on it for a pillow. He arranged it so that a horn curved up on each side of Bill's head just above his ears. He then arranged a pair of hairy chaps around his neck like a scarf and called the boys to see his handi-work. It sure was a work of art! Now Old Bill was one of those fellows who would do his shooting first and

ask his questions later. He had an old muzzle loader cap and ball brass handled six shooter with a barrell as long as a hog's leg, with a big flat lock plate highly polished. One of the cow hands, thinking Bill might be peeved when he woke up, sneaked the gun and hid it in the mess box. Charlie was so proud of his work of art, that after the riders had all gone he got out Bill's gun and a shoe awl and drew on the lock plate of the gun the most perfect picture of Bill, with buffalo horns, a hairy neck and chest, that could be drawn, blending Bill's image into the buffalo-head perfectly, and put the gun back into the grub box. When Bill woke up he looked around for his whisky, not finding it he looked for the gun, not finding it he looked for something to eat. By this time he was just about as 'ringy' as a bob tailed bull in fly time and ready to tackle a bull elk bare handed. The first thing Old Bill spied when he raised the grub box lid was his old Boolover [gun] laying there and Charlie's honest endeavor staring him in the face. Bill knew there was no one in camp who could draw a picture like that except Cotton Eye [Charlie]. So he curled his tail over his back and went looking for the kid. As it was day time Charlie was in bed fast asleep when Bill located him. The only reason he didn't get the seat kicked out of his pants was because he didn't have any on.

"This incident is supposed to be the reason Charlie adopted the buffalo bull's skull for his trade mark—Old Bill Bullard always claimed it was anyway, though I don't remember ever having heard Charlie say so. Bill and Charlie became the best of friends later in life. I understand that Old Bill's windies' furnished the material for many of Charlie's pictures after he became an artist."[14]

Finch David recounted another Russell story, except that this time the artist was more victim than perpetrator. "I just thought of a Russell joke," David wrote. "He only had Been out in Mont a few years. his father sent him Money to come home on. he spent the money. But got a pass on [a] cattle train to Chicago. ever one helped to fit him out. A large Man gave him a pr [of] pants, which he tore the seat out of. he had a Buffalo over coat the pride of his life. Well he reached St. Louis [the] last of Aug or early Sept and [it was] very hot [when] he got off [the] train. And had to wear [his] Buffalo over coat to conceal [the] rear end of [his] pants. As he was Broke, he started on foot for his fathers home. As he went he drew a crowd of

Boot Blacks and street idlers. [The] further he went the larger his crowd grew, jeering and laughing at him.

"so he finely took refuge in a livery Barn and wrote a note to his father and sent it C.O.D. By Messenger to his father he says, 'Dear Father, I am here. But I need some clothes. I need a suit of clothes under clothes a shirt shoes and socks. he added I have a hat.'

". . . Before long his father came. he had a 1 horse Buggy. Back of it [was] loaded with clothes. More clothes Russell said than I had in 2 years. so he got home But [he] only staid a few Months and came Back—out here he seemed to think he was lucky to have the hat. he got a great kick out of telling something on him self."[15]

ROBERT E. "BUD" COWAN, who had been a cowboy and roping Champion in Montana before becoming chief of police in Las Vegas, Nevada, had once been married to B. M. Bower, author of *Chip of the Flying U,* which was illustrated by Russell. Cowan shared one story about Russell that "so Help me God it's the truth."

"In 1910," Cowan wrote, "Charley made a trip down into Arazona and Southern Nevada to spend the summer with the Coburn boys who used to be big Stock growers in Montana. While down there, Charley came in contact with the Gila Monster . . . They are a species of lizzard and grow to be as long as 18 or 20 inches. The male species is the prettiest thing you ever saw. On their back are the prettiest patterns and it looks like all bead work in different patterns. And different colors. So when Charley got back from Arazona, he went to work and moulded a Gila Monster in clay and then he painted the pretty beads on it's back and when it was dry you would really think it was the real thing.

"So he went to work and made a glass topped box and put his lizzard in it, and he took it down to the Silver Dollar Saloon, owned by Billy Ranse [Rance], who was a good friend of mine and of Charley. Every evening Billy would put an egg in the box and the Monster was supposed to eat it just before day light in the morning. At any rate, there would be the egg shells in the box next morning. The animal was supposed to sleep all day and eat in the early morning.

"They are also supposed to be very poisonous as to their bite,

and they are also supposed to blow their breath in your face and poison you, but they don't

"Anyway The animal was the talk there in Great Falls and finally it got to the City Council. They finally visited Charley and told him that he would have to kill the thing. I happened to be visiting Charley at the time they sent their walking delegate to tell Charley to kill the thing. Charley said allright, you bring the City Council all down to the Silver Dollar in just an hour and I'll let them all see me kill the poor thing.

"The whole town turned out to see Charley execute the Gila Monster. Charley and I walked into or crowded into the saloon and Charley went back and brought the box out in front of the bar and set it down on the floor, reached in and got hold of the thing and then he took hold of it with both hands and broke it in two right in the middle then handed it to the Mayor. Billy Ranse [Rance] said he took in more than eight hundred dollars over the bar that night.

"There are some of the old City Council that don't like to hear of the Gila Monster yet."[16]

Then there is the story told by Mrs. W. B. Campbell of Buffalo, Alberta, Canada, who wrote that she and her husband had met Charlie and Nancy several times and that they owned a number of Russell's paintings. In an otherwise staid letter, Mrs. Campbell included this gem:

"This is one of Charlie's stories— . . .'We're invited to one of them evenin' dinners back in New York an' I'm the only one there not dressed soup and fish.

" 'I goes in and sits down alongside one of them fellers that's got on a coat what's chopped off 'bout where the tail oughta start. I'm no more'n just eased down when I find I'm sittin' on that shorthorn's hat. I jumps up right pronto an' there's the hat all squashed down flat. I'm plum apologetic, but this fellow says: "Oh, that's all right," and he gives the hat a flip with his thumb. Out she pops all O.K.

"'That's the first damned self-cockin' hat I ever see.'"[17]

THROUGH HIS PERSONAL contacts and correspondence, James Brownlee Rankin got to know something about virtually every facet

of C. M. Russell, man and artist. Most of the elements of Russell's character are in his files—in the letters and reminiscences of Russell's old friends. Those who knew Charlie Russell may not have shared his passion and preference for the "good old days" and his disregard for "civilization," but they did share his ability to look back and remember the good times and the good people. They remembered Charlie Russell as an honest, caring, humorous man—and as a great friend.

## Notes

1. The biographical information on James B. Rankin comes from Josephine Rankin, "James Brownlee Rankin: 1900. . .1962," in the Rankin Papers.

2. Ramon F. Adams and Homer E. Britzman, *Charles M. Russell, the Cowboy Artist: A Biography* (Pasadena, Calif., 1948).

3. Austin Russell, *C.M.R.: Charles M. Russell: Cowboy Artist* (New York, 1957).

4. Rankin, "James Brownlee Rankin," Rankin Papers. Ellipses are the author's.

5. Mary Roberts Rinehart to James B. Rankin, March 19, 1937, Rankin Papers. The transcriptions used here retain original grammar and spelling.

6. W. A. White to Rankin, February 9, 1937, Rankin Papers.

7. Walter Lehman to Rankin, September 4, 1939, Rankin Papers.

8. C. J. Ellis to Rankin, August 16, 1938, Rankin Papers.

9. James Willard Schultz to Rankin, December 18, 1936, Rankin Papers.

10. Finch David to Rankin, March 16, 1938, Rankin Papers.

11. John R. Barrows to Rankin, March 9, 1938, Rankin Papers.

12. Ibid., October 24, 1938.

13. E. C. Switzer to Rankin, October 15, 1939, Rankin Papers.

14. Ellis to Rankin, August 16, 1938, Rankin Papers.

15. David to Rankin, June 5, 1937, Rankin Papers.

16. Bud Cowan to Rankin, June 21, 1937, Rankin Papers.

17. M. S. Campbell to Rankin, May 18, 1937, Rankin Papers.

# PART THREE

~

# Charlie Russell— Ladies' Man

CHARLIE RUSSELL HAS GONE down in legend as a man's man, but as Lady Bird Johnson said of Lyndon, he liked all people and wasn't about to exclude half of humankind. Long before Nancy arrived on the scene, Charlie's response to women had been shaped by family in St. Louis, early crushes on some of the young ladies he met in Montana, and commercial encounters with dance hall girls and prostitutes. Judging from Guy Logsdon's collection of unexpurgated cowboy songs *"The Whorehouse Bells Were Ringing"* (1989), cowboys might well be defined as horny young men. Certainly Russell never sanitized his own lusty youth. "He called a spade a spade," Wallis Huidekoper's wife remembered, "because he did not wish you to be misinformed," and a late-life friend commented that "as rare as Charlie Russell's genius for painting was, his genius for making an open book of his past was remarkable. If confession is rightfully called a bath of the soul, . . . Charlie Russell's soul was certainly well bathed."[1]

Even as a free-spirited bachelor, Russell had a proper regard for good women and good horses, in whatever order. He convinced his skeptical cronies in Great Falls in 1896 that he was serious about settling down by giving his beloved pinto Monte to the future Nancy Russell. Now he *had* to marry her to get his horse back. As a married man, Russell praised the institution. "If the hive was all drones thair d be no huney its the lady bee that fills the combe with sweetniss its the same with humans."[2] But the sentimental tradition erected around the Cowboy Artist should not rob him of his flesh and blood reality. He knew how to behave, and how to misbehave; in polite company, he had the knack of turning blue material snowy white. "I have heard him start a story that I knew wouldn't go over in the Company we were in, But when he got through with it, it would be a Parlor storey, he was a Master at that," Con Price recalled.[3] Ginger Renner's essay, "Charlie and the Ladies in His Life," covers the range of Russell's female friendships, and is especially insightful on the important role native women played in his art.

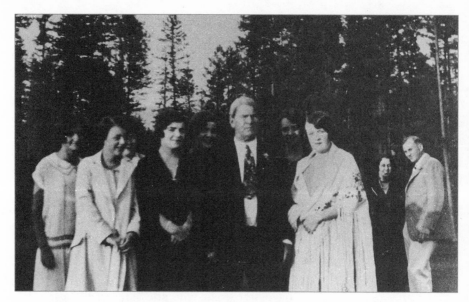

Charles M. Russell, reluctant celebrity, and some of his flapper fans at Con Kelley's lodge, Swan Lake, 1925. Britzman Collection, Colorado Springs Fine Arts Center

Charlie Russell delighted in simple pleasures and maintained a childlike sense of wonder throughout his life. He identified with boys and girls alike. They were drawn to him as a storyteller and an artist who could bring nature's creatures alive with gestures and voice, a lump of wax, or a pencil and a scrap of paper. After the passage of sixty years Elizabeth Greenfield still vividly recalled how Russell's beguiling personality "entered the heart of a child."[4] He also liked adolescents. Touched by a letter he received from Isabel Brown while he was convalescing in 1926, he replied, "to write a letter take[s] time and young folks use a lot of that and whene they use aney of it on me I appreciate it."[5] Verne Linderman, Frank Linderman's college-age middle daughter, moved with her family to a yet unfinished home on the shore of Flathead Lake in the fall of 1917. Charlie Russell showed up shortly after, and, in 1942, when Verne recalled that first winter in the wilderness, he was part of the magic of "The Big Lonesome."[6]

Jessie Lincoln, a sculptor and neighbor of the Russells in Great Falls, especially admired his animal studies. He did a picture of an elk for her husband, and while "only a quick pencil sketch," she noted, "like all of Russell's work it is alive."[7] In "C. M. Russell—

The White Indian," Lincoln, who later married Great Falls' popular mayor Harry B. Mitchell, wrote perceptively of Russell as a fellow artist, never mentioning her own deep disappointment at having her model of Charlie rejected by Nancy for inclusion in the Statuary Hall in Washington. But reading between the lines one can gather her opinion of Nancy.

Helen Mackay knew Nancy both as saleswoman and social friend and voiced no reservations. "We feel so close to you and Charley," she wrote. "You have been two of the greatest Souls that it has been our privilege to know here in this world."[8] Her husband Malcolm, a Wall Street broker with a home in New Jersey and a ranch and his heart in Montana, was Russell's most active patron from 1908 literally until the day the artist died. On November 10, 1926, Nancy returned six thousand dollars "sent in payment for a painting Chas was to do for you—he did not get it started just talked about it—"[9] Mackay's superb Russell collection is the core of the Montana Historical Society collection today. One of Nancy's projects after Charlie's death was compiling a volume of his letters. The title, according to Helen Mackay, was decided in consultation with Malcolm, and "Good Medicine" serves as the title of her memoir as well.

Another of Nancy's projects in the late twenties was a Russell biography. Writing did not come easily to her, and when she was most discouraged, it was Malcolm Mackay who urged her on: "Let me repeat, *Nobody* can ever write a biography of Charley as it should be written, but *YOU*—Just sit down, as if you were conversing with a couple of particularly close friends, and chat along about Charley."[10] In the end the task proved too daunting. But Nancy had already told a little from her side of things in a 1914 address to the Women's Club of Great Falls, published in the *Tribune* as "Close View of Artist Russell." It concludes this section on an appropriate note: Nancy Russell gets the last word because she usually had it, and because she deserves it. As Malcolm Mackay wrote, Charlie Russell "loved his country—the West—as God made it. And through his work, posterity will see something of the beauty he saw, and feel something of the real manhood of the men that rode his ranges. And yes, one thing more, how truly did he reverence Nancy Russell for all she had done for him."[11]

# Notes

1. J. Frank Dobie notes of an interview with the Huidekopers, July 1, 1947, Dobie Collection; James W. Bollinger, *Old Montana and Her Cowboy Artist: A Paper Read Before the Contemporary Club, Davenport, Iowa, January Thirtieth Nineteen Hundred Fifty* (Shenandoah, Iowa, 1963), 24.

2. CMR to NCR, February 6, 1919, in Brian W. Dippie, ed., *Charles M. Russell, Word Painter: Letters 1887–1926* (Fort Worth, Tex., 1993), 271; CMR to Robert P. Thoroughman, April 14, 1920, in ibid., 299; CMR to Eleanor and Selden Rodgers, 1913, in ibid., 178.

3. Con Price to J. Frank Dobie, August 9, 1946, Dobie Collection.

4. Elizabeth Greenfield also published *When Charlie Russell Was A-Wah-Cous: A Tale of Childhood Fact and Fancy* (Helena, Mont., 1975), reflecting her ongoing interest in fleshing out the story of Russell's early years in Montana. See Marguerite Greenfield to Trail's End Publishing Co., November 15, 1948, Britzman Collection.

5. CMR to Isabel Brown, July 30, 1926, in Dippie, ed., *Word Painter*, 402.

6. Verne was less nostalgic in her contribution to "As We Remember Mr. Russell" in Frank Bird Linderman, *Recollections of Charley Russell*, ed. H. G. Merriam (Norman, Okla., 1963), 128–34, but Wilda, the oldest of Linderman's daughters, recalled (ibid., 119) that Verne and Russell shared "perhaps the greatest number of matching facets of their separate natures. Both of them had keen awareness of fashion, of the season's silhouette; for trends of all sorts, the popular as well as the classic; for the comic: the sense of humor of both of them could find expression in cartooning—and *did*—at the expense of all of us, though never unkindly." When Russell died, Verne was the one to write a letter of condolence to Nancy: "Wilda said his going reminded her of a simile in either the Iliad or the Odyssey where the death of a hero was as the fall of a great pine tree. It sent reverberations through all Montana." Verne Linderman to NCR, November 1926, Britzman Collection. For background, see Dippie, ed., *Word Painter*, 246. For an appealing reminiscence of a 1921 visit to Russell's favorite wilderness retreat, Bull Head Lodge, see Dorothy Duncan, as told to Roberta C. Cheney, "The Duncans and Charlie Russell," *True West*, 22 (September–October 1974), 20–22, 38–39.

7. Jessie Lincoln to James B. Rankin, ca. March 17, 1937, Rankin Papers.

8. Helen Mackay to NCR, October 25, 1926, Britzman Collection.

9. NCR to Malcolm S. Mackay, November 10, 1926 (draft), Britzman Collection; see also Mackay's Russell-illustrated memoir, *Cow Range and Hunting Trail* (New York, 1925).

10. Malcolm S. Mackay to NCR, March 28, 1928, Britzman Collection.

11. Ibid., April 22, 1929.

# Charlie and the Ladies in His Life

Ginger K. Renner

∿

"THE EAVNING GARMENTS of a female in this camp wouldent pad a crutch," wrote cowboy artist Charles M. Russell from New York City to his good friend, Bill Rance, back home in Great Falls, Montana.[1] Later, writing from Long Beach, California, to another Montana friend, Charlie remarked, "a man that tyes to a lady down hear after seeing her in bathing aint gambling much."[2]

On yet another occasion, Russell recorded what is probably his ultimate assessment of women: "A woman can go farther on a lipstick than a man can with a Winchester and a side of bacon."[3] A careful analysis of this statement reveals a grudging admiration for the capabilities of women, but the impact of the remark is hardly laudatory.

Pithy, perceptive—sometimes chauvinistic—statements such as these from the pen of the cowboy artist probably added weight to the generally accepted view of Charlie Russell as a "man's man." The repetition of these slightly derogatory phrases led the public to believe that Russell was a man who had limited regard for women.

The general assessment that placed Charles Marion Russell into a masculine milieu was further augmented by his published works of art. Most of these works, the publication of which established his reputation throughout the country, dealt with violent or dramatic action, subjects that not only appealed to men but usually involved them—cowboys roping, a cowboy trying to stay aboard a wildly pitching bronc, Indian warfare and buffalo hunts, hunting big game, and the like. In those few published works in which Indian woman appeared, they usually played only a subordinate role. The public's perception of Russell's masculine orientation was expanded by Russell's own short stories. Of the forty-three of his stories published in *Trails Plowed Under,* only one concerned women, and that

was a one-page satire on "fashions." It was almost unknown that Russell was also turning out a considerable number of paintings that featured Indian women.

An examination of Russell's artistic output reveals over 300 oils, watercolors, drawings, and models that used women as their primary subject. No other artist in the western American genre has ever produced such a body of work.

In consciously, or unconsciously, relegating Russell to a totally masculine orientation, the public has failed to acknowledge or examine the "feminine" side of Charlie's life. Little attention has been paid to the women who influenced, molded, and affected both the man and the artist. Even less investigation has been made into the large number of works he created in which women were the only or the dominant element.

An examination into the influences that women had on Charlie Russell's life should begin with his paternal grandmother, Lucy Bent Russell. The Bent family had played more than supporting roles in the drama of American history. Lucy's grandfather, Silas Bent, was one of those intrepid rebels who had tossed the tea overboard in Boston Harbor, forever changing the history of the world. He went on to command Boston's "Tea Party Regiment" during the Revolutionary War. Lucy's father, also Silas, was appointed Deputy Surveyor for the Louisiana Territory by Secretary of the Treasury Albert Gallatin. In 1809, Governor Meriwether Lewis appointed him Judge of the Court of Common Pleas, and he was one of the signers of the first charter of the town of St. Louis.

Independent-minded, politically astute, with a sense of adventure, and with no small amount of entrepreneurial abilities, the Bents were to make significant marks on the pages of western American history. Their exploits, and those of their associates, were to become a vital part of the Bent-Russell family's folklore, influencing the imaginative mind of young Charles Marion Russell.

Lucy Bent's brothers, Charles and William, established Bent's Fort on the Santa Fe Trail in partnership with Ceran St. Vrain. Bent's Fort, the largest trading and outfitting center in the vast and remote southwest territory, was a unique establishment. The brothers, having been raised in a socially and financially advantaged family, in-

troduced into daily life at the isolated fort many of the social amenities to which they had been accustomed in St. Louis.[4] Bent's Fort enjoyed a reputation for its good food, fine wines, and a highly unlikely asset, a billiard table in a second floor lounge.

Some of the West's most renowned trappers, scouts, and traders worked, at one time or another, for William Bent at the fort. They included Kit Carson, who eventually became Charles Bent's brother-in-law, Jim Beckwourth, Lucian Maxwell, "Old Bill" Williams, and "Uncle Dick" Wooten. Both the myths and the true stories of how these men helped to open the West added to the tantalizing tales that later fueled the fires of Charlie Russell's westward yearnings. The retelling of their adventures probably came about during the annual—and sometimes oftener—trips that William or Charles made back to the States—to St. Louis—to take buffalo robes and to pick up trade goods and supplies.

Lucy Bent had the same kind of independent mind and entrepreneurial capabilities that had carried her ancestors and her remarkable brothers into the pages of history and on their march to the western frontier. In 1826, at the age of twenty-one, Lucy became the wife of James Russell, a widower who was twenty years her senior. Russell had come to St. Louis from Virginia and had purchased 432 acres of land located west of the city limits, where in 1820 he had built a spacious, gracious home named "Oak Hill." At various times called a "plantation," the property resembled a small fiefdom, with orchards, vineyards, meadows, gardens, slaves' quarters, barns for horses and livestock, and most important, an extensive outcropping of coal. A few years before James and Lucy were married, he had begun to supply coal to the city of St. Louis, greatly enhancing the family's economic position.[5]

When James Russell died in 1850, Lucy Bent Russell, aged forty-five, took over the management of the family's extensive business and real estate holdings. Exhibiting some of the same entrepreneurial characteristics that marked the careers of Charles and William Bent, Lucy expanded the family's involvement in business and with the help of her son, Charles Silas, and her son-in-law, George W. Parker, she greatly enhanced the family's financial position.[6] In an age when women were seldom involved in business activities, Lucy actively worked to develop the mining of fireclay from the Oak

Hill property. In a short period of time, the Parker-Russell Company had become the largest operation in the United States devoted to the manufacturing of fireproof materials.[7]

Lucy Bent Russell was the "lodgepole" of a growing family. Her children—Julia, John G., Charles Silas, and Russella Lucy—lived either on or close to Oak Hill. Julia married Trumbull G. Russell (no kin), and John G. and Russella married brother and sister, Pauline and George W. Parker, further complicating, yet tying closer, the extended family.

Charles Silas, Lucy's third child, married Mary Mead, daughter of silversmith Edward Mead, whose reputation for fine work was well established in St. Louis. Following a long honeymoon in the East, Charles Silas and Mary Mead Russell bought a home on Olive Street in St. Louis, but by the time Charles Marion Russell was five they had moved to the Oak Hill property.

It was at Oak Hill, surrounded by the accoutrements of a socially and culturally advantaged family, that Charlie Russell grew up. Sitting at his grandmother's table, Charlie probably heard exciting tales from that remarkable woman about his ancestors, particularly his great-uncles, the Bent brothers, who had left behind the cultured life of the West's gateway city to go farther into the frontier to seek their fortunes.

Charlie's mother, Mary Mead Russell, was a handsome woman, artistically inclined, and, like her mother-in-law, a devoted Episcopalian. She may have brought a commitment to the arts into this family that was already successful in business and investments. She painted well enough to have some of her works included in amateur exhibitions in the St. Louis area. She must have been a source of encouragement and perhaps even instruction to her children. It is quite possible that Mary Mead Russell's involvement in the local art scene had some influence on the inclusion of one of Charlie's paintings in the St. Louis Art Exhibition of 1886.

Mary Russell's children were all exposed to a study of the Bible and the moralistic literature of the period. Many of the ideas and the philosophy of life that Charlie Russell expressed in letters he wrote during his mature years show unmistakable signs of his early indoctrination.

Although it has not yet been found, it is difficult to believe that there was no correspondence between Charles and his parents during the first years he spent in Montana. The family was too closely knit, too committed to one another for them to have not written to each other. The pattern of their lives, in later years, when Charlie and his wife Nancy took in members of both of their families or when they entertained fathers, cousins, brothers, and sisters and other relatives for extended periods, documents deep and continuing familial ties. Limited research of Russell's early years in Montana leads one to believe that he returned home to St. Louis on a regular basis.

A quite remarkable grandmother and a devoted mother left marks on the cowboy artist. He was at home, if not always at ease, in society of all levels, partly because of the principles and ideals taught him by these capable women.

The next woman who came into Charlie's life and made a significant impression on him was a girl from another old and well-established St. Louis family. Laura Edgar, the young woman who was to become Charlie's "first love," was living in the Judith Basin during the summer of 1880 when Russell first rode into that special region.

William B. Edgar, Laura's father, had come west in 1878 to establish a sheep operation. First investing in the Deer Lodge area, he soon decided to move his operations to the newly opened Judith Basin district. In the summer of 1879 he brought his wife and daughter out for the first time. Traveling upriver from Bismarck on the steamer, *The Helena*, they tied up at Fort Benton, where Mrs. Edgar discovered the first of many limitations of life on the Montana frontier. Her fine furniture, carefully shipped with the idea of bringing some of the comforts and refinements of St. Louis life to this remote and unsettled region, was left under a tarp on the Fort Benton docks while the family took an oxen-drawn wagon on the three-day trip to their home in the Judith Basin.[8] There, they lived in a tent while a log cabin was being built on the property, a short distance east of what would become the town of Utica. Just as the first snows came in the fall they were able to move into warmer quarters. It is assumed that they retrieved the furniture from the Fort Benton docks.

In the spring of 1880, Charlie Russell rode into the Judith Basin. He had come to Montana with the blessing of his family who had decided that a summer in the wilds of Montana might bring an end to their young son's romantic dreams of a life "out West." Little did they realize that when Charlie entered the big sky country of Montana he would be going "home."

Charlie's first employment with the Miller-Waite sheep operation was short-lived. By the time he took up residence with hide and meat hunter Jake Hoover, in Pig-Eye Basin, the Edgars were well established in the Judith area.

It is likely that the Russell and Edgar families knew each other in St. Louis. Both families moved in the same social circles and both were involved in mining operations. Charlie and Laura also shared a second cousin, Childs Carr. Whatever the social involvement back home, Charlie apparently was welcomed at the Edgar ranch. Charlie was sixteen that far-ago summer and Laura (Lollie to family and friends) was twelve. They were youngsters in an isolated and primitive land. At some time during the first years that Charlie lived in Montana he was accepted into the Edgar's home, and it was probably during this time that the two young people fell in love.

At the Edgar ranch, Laura watched the young artist work on what must have been his earliest commission. As Laura later wrote:

> It was in our home he did his painting that brought him in real money. It was a large poster for a General Supply house in Helena. It had a central picture of a stage coach with six horses coming down a mountain road. All around were small pictures to show the different articles a cowboy or ranchman might need. Some I remember—a freight train of three covered wagons with 6 or 8 yoke of oxen, a cowboy with elaborate chaps and hat coiling a rope, a farm wagon with work team. There were several others, but I have forgotten. I watched the painting with great interest and well remember Charlie's joy when a letter accepting it arrived containing also a substantial check.[9]

Lollie spent only two winters at the Judith Basin ranch, the first in 1879–1880 and the last in 1885–1886, her father's last year in the sheep business. In other years, she returned with her mother each

fall to St. Louis to attend school. As the love affair developed, Lollie wrote to Charlie from St. Louis, letters that he treasured. Finch David, who as a young man worked with Charlie on the roundups in the Judith, wrote in later years: "He did think a lot of a girl and I think she thought a good deal of him. But the family moved away and they just did not marry. He told me about it one night when we was on herd together."[10]

The importance Lollie had in Charlie's life was substantiated later by Judge James Bollinger of Davenport, Iowa. In 1937, Bollinger, who was Russell's close friend, admirer, and hunting companion, wrote to Nancy Russell, who was acquiring stories from old friends for a biography about Charlie: "Did Charlie tell you how he used to read her [Laura's] letters by cigarette light when he was riding night herd and carried them in his shirt pocket over his heart?" Further correspondence between Nancy and Judge Bollinger indicates that Charlie had told Nancy the same story.[11]

By 1886, when William Edgar gave up on sheep raising and returned with his family to St. Louis, it was evident that the Edgars had taken a firm stand against any further involvement between Laura and Charlie. In the Edgars' eyes, Charlie was an itinerant cowboy with little or no possibility of providing the kind of life they desired for their daughter. Charlie, with some of the stubbornness he was to reveal many times over in his later life, did not give up so easily. Either in 1886 or 1887 he returned to St. Louis, certainly in part to press his plea for Lollie's hand. In 1938, Laura wrote that she had in her possession a photograph of Charlie taken in St. Louis when he was, in her words, "22 or 23."[12] The photo shows Russell dressed in "city clothes," his hair well cut, the tools of his artistic trade at hand. An oil palette is in his left hand, and his watercolor paper and brushes lie on a table beside him. It is apparent that he was presenting a picture of himself as an artist, and a diversified artist, at that—somewhat higher on the social scale than a cowboy. Despite this rather obvious pitch for respectability, the Edgar family remained obdurate.

Years later, Laura wrote that she was married in the spring of 1890 and that "Charlie left St. Louis the week before my wedding." Was he there to make one last plea for her hand? We will never know. But we do know that he vividly remembered her years later.

Bollinger, again in correspondence with Nancy Russell, wrote of the hunting trip they had shared in 1922. Everyone had turned in but Russell, who was restless and not ready to settle down for the night. He spoke aloud to the men bedded down in the hunting cabin: "Who ever says he has forgotten about his first gal, I can't believe him. Some people call it 'puppy love'! [Bollinger indicated the scorn in Russell's voice over that term.] Well, not one of them can forget her—the reason they remember is because she is the nicest thing that ever happened in a young fellow's life. She cannot be forgotten!"[13] Surely a man who would share with his hunting companions the most private and cher-

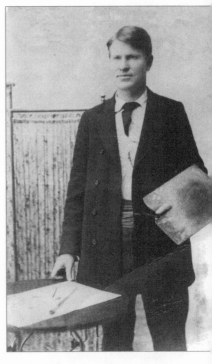

Charles M. Russell, the Cowboy Artist, ca. 1890—the year Laura Edgar married.
MHS Photo Archives, Helena

ished memories of his youth had for many years carried with him the effects of that young and lovely woman.

Between 1889 and 1895, Russell portrayed Lollie in several poses. *Laura's Capture*, an oil done in 1894, is the most "romantic" of the group, encompassing all the terror of the Gothic themes of the Victorian period. A watercolor wash of a woman in English riding clothes standing beside a Thoroughbred on which is a sidesaddle is quite likely also of Laura. *Lollie*, a sentimental watercolor of a young woman dressed in glowing white with a threatening forest behind her, was for many years mistitled Mame, a nickname for Nancy Cooper Russell; but Charlie had painted the piece several years before he met Nancy. Laura Edgar remains with us today—young, virginal, and remote.

It must have been in a genuine state of depression that Charlie turned from the possibility of marrying his first love to accepting, once again, the vagaries of a cowboy's life in Montana. Even that

Charles M. Russell, *Lolly*, ca. 1892, oil on canvas.
MHS Museum, Helena

life, for Charlie at least, had taken a turn for the worse. Homestead-
ers had moved into the Judith Basin, erecting fences and plowing up
the native grasses. Sheep operations were crowding the remaining
free grasslands, and cattlemen had to move farther north into the
Milk River country. No longer would Charlie call the Judith coun-
try "home," the area about which he said, "Nature had surely done
her best. No king of the old times could have claimed a more beau-
tiful and bountiful domain."[14]

Russell lacked a sense of direction. At twenty-six years of age he
vacillated between being an artist and returning to the security of the
spring and fall roundups. When he did not pick up jobs, he drifted
south to spend weeks with Jake Hoover or he holed up with other
out-of-work cowboys, waiting out the long winters. During this pe-
riod of indecision and temporary employment, Russell turned to the
only female companionship available to a drifting cowboy. Many of
his men friends commented in later years on the artist's penchant for
discussing these women, known to us only as "Dutch Lena," "Maggie
Murphy," and "Lil" and "Lou." According to Judge Bollinger, when
Charlie had some money he "split it two ways—wine and women."[15]

Comments from old-time friends, such as Henry Keaton, Finch
David, and Bollinger, indicated that Charlie loved to discuss and
defend the virtues of these women. At a stag dinner party that
Bollinger gave in Russell's honor, the artist publicly defended one
of these women, expressing a genuine respect for her.[16]

One of these women merited such admiration that Charlie gave
her a watercolor entitled *The Kindergarten* (ca. 1890). The painting
depicts the interior of a tipi and a group of children seated on a
buffalo robe, listening to stories from an old Indian man. The piece
is replete with sentimentality and very well may indicate the regard
the artist held for the recipient of this special gift.

Another woman of questionable repute was principally responsible
for Russell having one of the great adventures of his life, one that he
drew upon for thematic material for the rest of his days. Charlie's trip
to Canada during the late spring of 1888, which has been characterized
as a lighthearted, boyish desire to see new country, was actually an
escape from one of Helena's more flamboyant businesswomen,
Josephine Welsh Hankins Hensley, better known as "Chicago Joe."

Chicago Joe started in the hurdy-gurdy, or dance hall, business in Helena during the 1860s. By 1887 she not only owned considerable business property in Helena, but she also presided nightly over a highly successful variety theater, the Coliseum. Chicago Joe had hired a young Canadian, Phil Weinard, to portray an Indian in a one-act play entitled "Montana in '64." Russell, coming off the fall roundup in 1887, became friends with the actor, and the two of them spent much of the winter together. Weinard became romantically involved with Chicago Joe's niece, Mary, and determined to marry her. Chicago Joe, although the prototype of the "tough lady with the heart of gold," nevertheless drew the line at one of her relatives marrying an itinerant actor.

Russell and Weinard, with the help of a gambling friend known as Long Green Stillwell, contrived to slip out most of Mary's clothes and belongings through a back window over a period of several weeks in preparation for a quick, secret wedding and an even quicker departure from town. When the wedding finally took place on May 16, the spring runoffs were so high that Weinard could not chance having his new bride fording the swollen streams on horseback. He sent her by train, entrusted to his family in Minneapolis, and he, Charlie, and Stillwell struck out across country to Alberta. So Charlie's visit to the High River country, where his involvement with and friendship for the Blood Indians led to some of the great works of art he produced in subsequent years, was initially a flight to safety from the ire of a Helena madam, Chicago Joe Hensley.[17]

Charles M. Russell could be called a "late bloomer." He had struck out for the frontier West with a youthful zeal and a taste for adventure, and on the range he had developed a bravado that carried him through many difficult periods; but not until he was approaching thirty years of age did he acquire any genuine maturity. By then, he had determined that becoming an artist was his primary goal in life, and he longed for a female companion of whom he could be proud and who would be accepted by his family. Even in the wild years when he was an itinerant cowboy, Russell knew that his cultural heritage had a claim on him. He wanted a woman with whom he could build the stable life he was finding more and more desirable.

As he said many times himself, Charlie was a lucky man. Never was he luckier than when he met the young, pretty, and unattached

Nancy Cooper. Although she had little education, Nancy was highly motivated. No other woman had the effect on Charlie's life that Nancy did. She was lover, companion, supporter, business manager, a consummately successful public relations expert, a goad, and an understanding friend. She made a comfortable home that allowed him to create a vast body of artwork. Nancy was also capable of entertaining groups of Charlie's friends and companions, often under the most trying of physical circumstances, particularly at Bull Head Lodge in Glacier National Park, where they spent a good part of each summer. She endured when their resources were low and she made him proud with her handsome appearance when times were good. It was Nancy, in large part, who was responsible for creating those good times. Both Charlie and Nancy possessed complex personalities, and they were opposites in many ways; yet, they complemented one another and were, as Charlie said many times, "partners."

They had their problems over the years, as most married couples do, but a letter Charlie wrote to Nancy in 1919 described how he really felt about her: "Dear Mame it's a week tonight you left and it seems like longer to me. I want you to stay til you get all rested. the longer you stay the glader I'l be to see you . . . maybe I'v fallen in love the second time but it's all right if its the same woman and it is." And a week later:

> Dear Mame Its two weeks tomorrow night you left and I hope your rest has made you ten years younger caus you'l need it to stand the hugs you'l get when you meet me. I'l admit it must seem funny after being married over twenty-two years [to] start writing love letters, but it dont seem like I ever wanted you like I do now . . . well I guess I'l bed down. There is one girl I know that I wish was here. Your loving husband.[18]

As always, he signed the letters "C. M. Russell"!

It is difficult to overemphasize Nancy Cooper Russell's importance in the artist's life. One can speculate, of course, about what would have happened had Charlie and Nancy not met and married. Had that been the case, it is doubtful that Russell would have created the prodigious body of artwork he did, a life's work that is truly one of our most cherished national treasures.

Charlie Russell had charisma. He attracted women as well as men, and he enjoyed some remarkable relationships with them. Over the years there were many women who liked, loved, and adored him. One who had a very special relationship with him was Josephine Trigg. "Miss Josephine," as Charlie always addressed her, came into his life when she was a teenager. Their relationship, which over the years made her part of what might be considered Russell's extended family, continued through her brief marriage to W. T. Ridgley and remained a loyal and respectful relationship until the end of Charlie's life.

Josephine played an active part in the artist's life, sharing summer vacations at Bull Head Lodge and spending time with Charlie and Nancy in Southern California. It was Josephine who produced the beautiful calligraphy for Charlie's verses and Christmas cards and for the placecards he painted for dinner parties. They remembered each other on all special occasions with letters and cards; during the last two months of his life Charlie sent her a charming letter, beautifully illustrated in watercolor, for her birthday in August. It was also Josephine who recognized the historical and artistic value of the large body of work Russell created and gave to the Trigg family, protecting it and at her death leaving it to the City of Great Falls so that many could enjoy it.

Charlie Russell was involved with many different kinds of women during his life, but throughout his artistic career he was inspired by many more. By far, the majority of these were Indian women, who offered him infinite variety for his creative moods. He painted them in a straightforward, documentary manner, much as Catlin and Bodmer had done a half century earlier. In *Indian Squaw*, probably painted around 1890, Russell presented a full, frontal view of a young woman, standing on a pegged-down buffalo hide, her fleshing tool in her hand. Less concerned with her personality or character, Russell concentrated on the details of her costume.

The artist also used Indian women as objects of exotic intrigue, such as in the oil, *Keeoma*, done in 1896, where the cowboy artist continued the tradition of Ingres's *Odalisque*. In the intimacy of her skin lodge, bedecked in brilliant fringed and beaded garments, Keeoma languidly stirs the air with an eagle feather fan.

Russell repeatedly portrayed his own romantic dreams through

his subjects. In *Keeoma No. 5*, *Reflextions*, *Lollie*, *Wood Nymph*, and *Meditation*, the women are young, beautiful, pensive, and isolated in the scene [see FIG. 4, *Keeoma #3*].

In the almost classical manner of the Greek earth-mother figures, Russell painted *The Sun Worshipper No. 2* and *Sun Worship in Montana*. Here the women are strong, fecund appearing in their anatomy, and awesome in their ceremonial stance.

Russell treated Indian women with poignant tenderness in such paintings as *Her Heart Is on the Ground* and *Mourning Her Warrior Dead*. The overt grief in these touching scenes is magnified by the lowering skies and the day's-end breeze, sighing around the rocky escarpments that serve as a bier.

In *Indian Maid at Stockade* (oil, 1895 [FIG. 18]), the cowboy artist brought a unique interpretation to a portrait of a tribal beauty. The woman slouches against the silver-grey logs of the fort, flaunting not only her handsomeness, but her ornamentation as well. Russell imbued her with independence, self-assurance, and almost a touch of defiance, making the viewer aware of the woman's sense of self-worth. This is hardly the view of Indian women that most Montanans held when Charlie painted this remarkable portrait in 1895. Russell's interpretation of women in his art was empathetic, usually sensitive, and often complex. Never was that complexity more exemplified than in *Indian Maid at Stockade*.

The majority of Charlie Russell's art depicting Indian women presented them in three situations: in camp, inside tipis, and moving camp. In Russell's paintings of life in an Indian camp, images of domesticity and tranquility dominated. In these scenes he emphasized the matriarchal side of everyday tribal life. Russell almost always portrayed women involved in activities that promote the welfare and comfort of the family and the tribe.

The artist's visits with the Blood Indians in southern Alberta in 1888 gave him first-hand information about these activities, and shortly after he returned to Montana he began a series of paintings, all of which depict one or two Indian women scraping, or fleshing, a pegged-down buffalo hide.

In these paintings, the tipis, in communal arrangement, form a partial background, while children, either singly or in groups, play

quietly nearby. Often, Russell also included a camp dog close at hand and almost invariably the warrior husband, alone or with a male companion, sitting at ease at the entrance of the tipi, smoking and watching the progress being made on the hides. These components, in one compositional form or another, make up *Indian Camp No. 2* [FIG. 15], done probably in 1889, followed by *Indian Camp No. 3, Camp of the Red Men, The Silk Robe, The Robe Fleshers,* and *Indian Camp No. 4,* all painted before 1900.

The variations in Russell's camp scenes are found in his use of different light sources, the placement and numbers of tipis in the scene, the differences in the distance horizons, as well as the different personae in these quiet, familial episodes. There are sufficient varieties in these oils and watercolors to establish each one's individuality. In *The Brave's Return,* an Indian woman straightens up from her work to welcome her husband who has just ridden up to camp. In *Blood Camp on the Belly River,* a handsome woman leaves her tasks to light her husband's pipe.

All of the scenes are marked by a sense of contented silence, with the gentle, rhythmic scraping of the hides being the loudest noise. They are pastoral versions of what Russell saw as an Indian Eden.

It is difficult to separate the realities of daily life in the middle or late nineteenth century Indian camp from Russell's romantic viewpoint. It is also uncertain whether the young artist experienced such a way of life; but considering how many times he recorded it, it was a vision that he greatly admired.

To present a more intimate view of Indian life, Charlie moved inside the tipi, into the fire-circle of these people who were his lifelong friends. He wanted to record and preserve the memory of this way of life through his art. In these paintings of lodge interiors, he portrayed women mothering and sharing the lessons of young children with their husbands or with a grandparent. Russell painted mothers involved in the early training of their sons, a responsibility that others have generally assigned to warrior fathers in the tribe.

*Inside the Lodge* [FIG. 20], a watercolor from 1895, depicts a mother patiently watching her young, naked son trying out a first bow. In *The First Lesson,* the mother helps to guide the boy's arrow, while his father watches with great approval. *After His First Hunt,*

done in 1898, depicts the boy's success, as he stands proudly in the center lodge holding a jackrabbit he has killed, his parents watching with pride. Again, in *Three Generations No. 2,* painted in 1899, the young mother guides the small son's efforts at pulling on the arrow, while the boy's father and a grandparent eagerly watch.

Russell portrayed other activities inside the tipi. Several of his oils and watercolors show Indians grooming themselves and each other. In *Preparing for Ceremonies,* done in 1897, *Indian Beauty Parlor,* a watercolor from 1899, and *Beauty Parlor* [FIG. 3], from 1907, a young and always handsome woman is shown braiding her warrior's long hair. The husband sits at ease, admiring the results in a hand mirror. The woman's skill and pride in his physical beauty are apparent, as is the necessity for his being at his best when he steps outside the protection of the tipi. Other paintings on this theme include *Indian Maiden at Her Toilette* and *Indian Women in the Tipi,* in which young women are engaged in their own adornment, surrounded by the colorful accoutrements of their daily lives.

Russell employed a certain iconography in these intimate and pleasant interior scenes. Bearskins, complete with claws, and painted and decorated buffalo hides provide an exotic, primordial element. Willow backrests introduce an architectural as well as decorative accent to the composition. Russell made a pictorial metaphor out of a small fire, smoldering in the foreground. The fire, the center of the lodge, the source of warmth, and the means of cooking daily meals, represented for Russell the heat and warmth and life-giving sexuality of the young Indian women he painted in the intimacy of their lodges.

In a succession of paintings, Russell depicted a young woman lounging on robes and waiting, perhaps in anticipation of her warrior husband's return. The outcome, as in so many of Russell's paintings, is left to the viewer's imagination. But in the superb oil, *Waiting, But Mad* (ca. 1900, [FIG. 19]), the artist acknowledged that life inside the tipi was not always placid and tranquil; there were tensions as well.

In nineteenth century Romantic art, literature, and even music, the pursuit and capture of young attractive women was a recurring theme. The subject held considerable fascination for Russell, and he used it in a number of works. In *The Proposal No. 1,* a watercolor completed in 1891, the artist placed an Indian couple in a rocky

escarpment overlooking a distant valley. His depiction in these works of the woman's reactions conveys Russell's interpretation of the scene. She is shy and submissive; the young man is protective, confident, and in some instances aggressive. These attitudes continue throughout the series, which includes an oil painted in 1894, *Marriage Ceremony* [FIG. 17], and *At the Spring* and *Waiting*, both watercolors done in 1896 and 1897. Russell continued the courtship theme in *The Proposal No. 2*, painted in 1899, and in *Hiawatha's Wooing*, done in 1903.

Ever the romantic, Russell was not concerned with what might be assumed to be the everyday realities of life for Indians. He conceived of these women in a never-ending summer. It has been said of some parts of the land Russell painted that it had two seasons—winter and August. But ice, snow, wind, and bitter cold had no part in his paintings of women. They lived in the warm glow of a clear, sunny day.

Although Russell's favorite theme was the buffalo hunt—he produced over seventy-five works in oil, watercolor, drawing, and bronze on the subject—his fascination with Indian women moving across the plains was his second favorite [see *Squaw Travois*, FIG. 22]. His oils and watercolors of this event reveal his deep admiration for the resourcefulness, independence, and courage of the Plains Indian women. Repeatedly, Russell presented a young, stalwart woman, like a carved and painted figurehead on the prow of some majestic sailing ship, leading the women of the band across vast, rolling prairies. The tribes' nomadic life required that Indian women be able to take down a twelve-to eighteen-foot tipi, make a carrier out of its lodgepole supports, pack the family's possessions and food, gather up the extra horses, children, and dogs, and strike out across uncharted miles. Russell admired this accomplishment with the same intensity as he did the courage of Indian men riding into a stampeding herd of buffalo.

As early as 1884, Russell painted the primitive *Wanderers of the Plains*, utilizing a composition he employed many times in the following years in many variations and with greatly increasing skill. Russell painted so many scenes on this theme that they have been identified by variations of one title—*Indian Women Moving, Indian Women Moving Camp, Moving Camp*, numbers 1, 2, 3, and 4. Others are more individualized. *The Twins*, for example, shows a

young woman leading a group mounted on horses and carrying a papoose on her back, while another child is slung in a cradleboard hanging from the saddle horn on another horse. In *Thirsty*, the group has stopped at a small waterhole. One woman, off her horse, is offering a cup of water to her child in a cradleboard attached to her saddle. In *Trailing*, a woman, off her horse, points out to her companions a red cloth marker tied to a stick—they are on the right trail. In an oil painted in 1901, *Return from the Hunt No. 2*, Russell pictured the women riding away from the viewer, the travois heavy with meat and hides. A young boy, running along beside the group, holds up a jackrabbit he has killed for his mother to admire. Small as he is, he, too, has contributed to the family's welfare.

In the magnificently composed oil, *In the Wake of the Buffalo Runners* (1911), a young woman, papoose on her back, kneels on her saddle, stretching high to see the action of the hunters in the distance. Her young son, straddling the empty travois, braces himself on the horse's hips, while an older woman gestures excitedly over the action. They will wait, in safety on this ledge, until the dust in the valley settles, signifying the end of the hunt. Then they will move in to skin the great beasts and pack up the meat that will feed the tribe. It is a corporate enterprise: the hunters providing the kill, the women and children attending to the care and utilization of the bounty. Russell reminded us repeatedly that all of the members worked together for the enrichment of the clan.

Time and again Russell expressed his admiration for characteristics he found in the Indians' way of life. This is particularly true in the extensive series he did of women moving camp. In these works, Russell portrayed the generations moving together, holding together; the older members bringing wisdom and experience to the tribe; the younger women, skilled, agile, and fecund, producing and providing for the tribe; the children, protected yet being trained in the ways of the group, offering a promise for its future. In these paintings, Russell emphasized the purposeful existence and the continuing strength of the tribe.

Russell painted more than Indian women; he was also attracted to exotic and colorful women of other races. In *The Spanish Dance* (oil, 1892), three dark-haired beauties with fans and bright shawls provide the principal interest with a young and romantic version of

the artist included in the scene. Perhaps inspired by a visit to Little Egypt's performance at the Columbian Exposition in Chicago in 1893, Russell did two wash drawings of svelte and sloe-eyed girls from the Middle East.

Commissions for book illustrations demanded a great number of paintings featuring white women, but his most forceful pieces, *Mothers Under the Skin* [FIG. 21] and *East Meets West*, juxtapose a white woman against an Indian mother. By and large, the white women do not fare as favorably in Russell's art as do their red sisters.

Throughout the hundreds of works in which Russell concentrated on women, there appears a motif, an artistic icon or device, that is repeated too many times to ignore. For all of Russell's admissions that he was "no better than the next guy" and "had done some sinning in my time," he was a morally straight and very Victorian man. But consummate artist that he was, he enjoyed introducing whatever elements of sensuality he could into his compositions and still not offend his viewers' sensibilities.

The device he resorted to is both subtle and effective—an off-the-shoulder robe, revealing soft flesh and warm curves. In many of the paintings already cited this is a dominant feature, but the artist also used it in *The Bath* (watercolor, 1896) and in *Waiting for Her Brave's Return* (watercolor, 1897). In his masterful oil composition *Lewis and Clark Meeting the Mandan Indians* (1899), Russell has the young woman "upstaging" the explorers by placing her center foreground, so the viewer has to look over her shoulder to the congregation of men in the background. He carried this device over into other media, and the artist never used this motif more effectively than in his splendid bronze, *Piegan Girl*.

Women played some major roles in Charles Marion Russell's life. His stories and letters contain pithy and often satirical comments that reveal a side of his personality that stood in opposition, if not in competition, with women. He wrote from New York to a Great Falls friend, "If clothing is a sign of civilization an paint spelles heathens Judging from she folks here Im among savages."[19] And again from New York he wrote to his dear friend, Albert Trigg, "We took in a Suffereggte meeting the other night an a finer band of Hell raisers I never saw bunched."[20]

Complex character that Russell was, however, he could also be quite poetic about women, saying, "If the hive was all drones there'd be no honey. It's the lady bee that fill the comb with sweetness."[21] And in a letter to old-time ranchman Bob Thoroughman, Charlie reminisced about the "regular" men of the old West—men whose character, courage, and way of life Russell greatly admired. He added, "Some of them had wives mad of the same stuff as thair husbands true unselfish wimen and mothers who shared equely all hardships of the man of thair choice and desurved realy more prase than thair husbands."[22]

Most people are comfortable with the expression "Mother Nature." Charlie carried the feminine personification of places and events, time and experiences to an extraordinary degree. In a letter to his friend Judge Bollinger, he wrote: "[we knew] . . . far off places where young men and old boys shake hands with misery and pleasure. We know both these ladies and wont forget them."[23] Writing to Rube Collins, Russell observed, "The boosters tell me that Haver [sic] has grown to be a good and moral city. She may be lady-like now but when I knew her in her infancy she was anything but a good baby."[24] Newsman Dick Kilroy, Charlie's long-time friend, read in a letter he received from Russell in the summer of 1923: "You need no book to help you remember the west you knew and loved. She was a sweetheart of yours and mine, a wild maid with maney lovers. . . . The West we knew, Dick, is an old woman now but we still love her."[25]

The endowment of these feminine qualities to abstract ideas began in Russell's early years and intensified as the artist grew older. His love affair with all elements of the old West was a viable, throbbing commitment. And to Charlie Russell, all of the old West was female.

Russell was known for the vast number of loyal, loving, and dedicated male friends he treasured throughout his life. Their names are legion—Will Rogers, Will Crawford, Ed Borein, Maynard Dixon, Malcolm Mackay, William S. Hart, Philip R. Goodwin, Con Price, Charles Lummis, Brother Van, and many, many more. It is time to recognize that there were also a great many ladies in the life of the cowboy artist.

# NOTES

1. CMR to Bill Rance, March 1, 1916, in F. G. Renner, *Paper Talk* (Fort Worth, Tex., 1962), 74.

2. CMR to George Speck, May 18, 1923, in ibid., 103.

3. C. M. Russell, *More Rawhides* (Great Falls, Mont., 1925), 13.

4. David Lavender, *Bent's Fort* (Lincoln, Nebr., 1954), 171.

5. Mary Joan Boyer, *The Old Gravois Coal Diggings* (Festus, Mo., 1952), 8–9.

6. Copy of Lucy Bent Russell's will, in the author's possession.

7. Boyer, *Coal Diggings*, 10.

8. Laura E. Whittemore to James B. Rankin, March 31, 1938, James Brownlee Rankin Letters and Notes, 1936–39, typewritten transcript in the author's possession of over seven hundred letters written to Rankin, a New Yorker who was collecting information for a biography of Charles M. Russell during the 1930s. These unpublished letters contained much new evidence about Russell's life. The originals are now in the Rankin Papers.

9. Ibid., March 14, 1938.

10. I. F. (Finch) David to Rankin, March 16, 1937, Rankin Papers.

11. Letters between NCR and Judge J. W. Bollinger, January–February 1937, Rankin Papers.

12. Laura E. Whittemore to Rankin, March 14, 1938, Rankin Papers.

13. Bollinger to NCR, June 15, 1937, Rankin Papers.

14. *GFT*, January 13, 1903.

15. J. W. Bollinger, "Notes on CMR," n.d., Rankin Papers.

16. Ibid.

17. Phil Weinard to Rankin, January 4, 1938, Rankin Papers.

18. CMR to NCR, February 6, 12, 1919, Britzman Collection.

19. CMR to Bill Rance, March 1, 1916, in Renner, *Paper Talk*, 74.

20. CMR to Albert Trigg, April 10, 1911, in ibid., 42.

21. CMR to NCR, February 6, 1919, Britzman Collection.

22. CMR to Robert Thoroughman, April 14, 1920, in Renner, *Paper Talk*, 94.

23. Charles M. Russell, *Good Medicine: The Illustrated Letters of Charles M. Russell* (Garden City, N.Y., 1929), 127.

24. CMR to Rube Collins, n.d., photocopy in author's possession.

25. Renner, *Paper Talk*, 64.

# The Cowboy Artist as Seen in Childhood Memory

Elizabeth Greenfield

~

To follow memory back to the start of the trail can be a surprising experience in perspective. For contrary to what might be supposed, happenings at trail's start sometimes stand out sharper than those at trail's end.

I see by the papers that I can remember back to 1898. Since I was born in 1893, these memories might be questioned. Perhaps the reason I can so well remember might be because the man I recall had a most memorable personality.

In January of 1898 the *Great Falls Leader* ran a story captioned "THE COWBOY ARTIST, A STORY OF THE MEDICINE ARROW," written by a Cascade County man for a magazine. The illustrations are produced from some late paintings of Charley Russell, the artist." But it was not a Cascade County man who wrote the story. It was my mother, Anna A. Nelson, the wife of H. H. Nelson. The magazine was *Sports Afield*, published in Chicago.

One reason my mother wrote the story was because I was so full of it. I told and re-told it as Charlie had told it to me. It was a legend, so Charlie said, about a sad young Indian whose arrows never found their mark. Charlie told it while we were sitting on the sandbar between our ranch home and the Missouri River. We often sat there where a big old willow tree curved overhead and frogs and bright water snakes came to watch us. Charlie could never sit long without telling a tale. Indeed, I would not have let him. Usually he modeled a bit of wax as he talked so that at tale's end there was his leading character sitting on the palm of his hand. No wonder children adored him!

Charlie and his young bride, Nancy, were often at Riverdale, our ranch, since it was about halfway between Cascade and Great Falls—both places the Russells then called home. I think I must have been jealous of Nancy, because I remember trying to get Charlie off on one pretense or another so we could do things alone together—the best of which was sitting under the willow by the river.

The Medicine Arrow story started with a sad young Indian sitting by a river. As Charlie told it, "One evening when his heart was on the ground he sat by the river crying and wondering how he could change his luck." I was fascinated that anyone's heart could be on the ground. Probably it took Charlie a long time to get that story told because I interrupted often for explanations. I wish I could remember all his answers. They were very serious, I'm sure, for he was that way towards me, except of course when he and I collaborated on some preposterous joke on grownups. Even then he would not smile. Deadpan, we both would sometimes pull outlandish hijinks that we enjoyed greatly just between the two of us. This either annoyed or mystified grownups—which was just what we wanted.

After the visit when Charlie told the Medicine Arrow story, my mother got an idea. Why not write it up and get Charlie to illustrate it, then send it to some magazine and perhaps a sale would develop that would help Charlie win the recognition he so badly needed. For in those early years Charlie and Nancy were very hard up. If one of his pictures sold for $10 they felt lucky and ate better for a few days in the little house in Great Falls.

Mother, who was from Boston, had different ideas of art than Charlie, but she decided she would see what she could do to help. So she wrote up the legend in elegant language that was not like Charlie's at all. Charlie painted three pictures. Off it went in the mail, and lo and behold, *Sports Afield* ran it and used one picture as a cover. I don't remember what they paid Charlie, but I do remember wiggling my toes in the river sand with delight as I leaned against the shoulder of my big cowboy friend whose voice droned on and on, making magic for a little girl.

Once Charlie and I were horseback riding together. A little way from our house on the road to Cascade there was a large prairie dog town. As we drew near I remembered a story I could tell Charlie.

This would be a change. It would be true, too. We stopped. Anything was always an excuse to stop awhile. I was so anxious to get on with my story that it came tumbling out.

It was one on Tom Dean, our bookkeeper. Everybody told stories on this English remittance man so out of place on a ranch. He couldn't ride or rope or even herd sheep. But he did keep the ranch books and had complete charge of the furnace. Poor Tom was a long-faced, sad character with a Piccadilly accent and a Court of St. James manner. Even he knew he was an odd ball, which may have been why he got completely and royally drunk whenever he could. I didn't know then that Charlie himself sometimes got drunk. He did, from an excess of conviviality. But Tom's drinking was an act of loneliness. Papa would have no liquor on the ranch, so with his Saturday's pay, Tom would go to Cascade. He had to walk the nine miles because he was deathly afraid of a horse. It was all right going up, but coming back was another matter.

As the men at the bunkhouse told it, they heard a great uproar very early one Sunday morning. It sounded like an Indian scalping a white man. They ran out towards the sound, which came from the direction of the prairie dog town. There was a big bright moon still in the sky but no scalping Indians. Every now and then there would come a horrible string of cuss words, followed by thick threats of vengeance. Then silence. Whereupon some fat, curious prairie dogs would pop out of their holes in the vague early light and rattle off impudent machine—gun chatter. This instantly drew the same bellowed threats.

I couldn't go on for laughing. "Oh Charlie, it was Tom. He was drunk again. He couldn't get all the way home from Cascade and fell down in the prairie dog town and thought the prairie dogs were making fun of him."

I laughed and laughed until I realized Charlie wasn't laughing. He didn't often laugh out loud, but this was different. I remember his frown. After a pause he said something about maybe a person couldn't rightly blame prairie dog critters for mocking a drunk but the men at the bunkhouse ought not to have done it. It came home to me that my hero disapproved in his gentle compassionate way. I was ashamed and told him so. He said: "Oh well, I'll tell one." And

that is the first time I heard why little prairie owls sometimes lived with prairie dogs:

"It seems that long ago there came a time when there were less and less prairie dogs. This was because eagles and hawks and even big owls found they were quicker than fat prairie dogs. While Mr. Prairie Dog and his family were frisking around never looking up for danger, these big birds would swoop down and carry off a prairie dog for a meal. This went on till all of a sudden, there were hardly any prairie dogs. When this came to the attention of the Great Spirit of All Animals, he did something about it. He commanded the littlest owl of all, the tiny grey prairie owl, to live with the prairie dogs and to fly high over their towns, giving a shrill warning sound when he saw birds of prey. In appreciation the prairie dogs stored up seeds for the owls to eat in the winter. And that's why prairie dog towns usually have some little owls around."

When Charlie went home he sent me a picture of a little owl among prairie dogs in the same town where he had told me the story. About the same time Charlie told another story about a big wolf that came down from Canada in the middle of the winter. He only came if the winter was to be very long and very cold. He had a strange howl and when the cowboys heard that long terrible sound they knew they were in for bad weather. Charlie could howl just like that wolf when he put his nose up in the air. He drew me a picture of the wolf in that same prairie dog town, except snow was everywhere and only a big moon and a distant butte stood out besides that stark wild wolf. I had these two pictures in my bedroom and really loved them. A long time after that, when I was in Boston, I wrote mother to send them. She sent the prairie dogs, but said the men had wanted some pictures to put up in the bunkhouse and she must have sent the wolf out there. Anyway, she didn't have it. Often I have wondered who does have that wolf or did he just drift down the years to oblivion like so much of Russell's early friendship art?

After the Russells moved from Cascade to Great Falls in 1897 I sometimes visited them. I remember that the kitchen in their little house had a trap door in the floor leading down to a small dugout cellar. Once Charlie ran out of modeling wax. He rummaged in his pockets and his shelves like a man fresh out of the makings for a

smoke. Then he told me to go down to the cellar and I would find a hole in a side wall. If I scooped way back I would find soft clay and to bring him some. I did so and felt most important as I watched him settle down peacefully, his long slender fingers happy again.

About this time Nancy was getting pretty firm with Charlie. Once when my folks were staying at an apartment we kept at the old Bach Cory Block in Great Falls, I wandered over to the Russells. Nancy said for me to run on home as her husband was busy. She had said that to me before, and I knew she had Charlie locked up until he had done a certain amount of painting. I walked around the house disconsolately; then I heard groans and grunts coming out of the back room.

It was Charlie, and to me it sounded like he was in agony. I got a box and put it under the window. I was sure Nancy was hurting him. What I saw was Charlie with his shirt off, his torso twisted at a leaning angle, one arm raised as though he was gripping a spear. His face was peering intently backward at a mirror on the wall. Before him on his easel was an unfinished buffalo hunt picture. Charlie was just trying to see how the muscles on an Indian's back look when he leans from his pony to plunge his spear into a racing buffalo.

It was about this time that my friend sometimes called on us in the Bach Cory Block. Shortly before Christmas here comes Charlie with a parcel in his hand. He had a present for me and he wasn't going to wait for Christmas. He suggested we go upstairs in the hall and try it out. He said it was one of those new fangled toys Strain's had just got in and it was really a bucker. He took a little key and wound up the little mule that went bucking across the floor. In the long dark hall it was a wonderful sight. Then we heard someone coming up the stairs. I was going to put the mule away but Charlie said no. He started it up again at the end of the hall and we went around the corner. Up the stairs wheezing came a nice old lady, her arms full of parcels. Just as she got to the top, straight at her came this bucking mule. She let out a yell, her parcels clattering down the stairs. It was lucky she didn't too, but she did get down fast to the janitor. We thought we had better get into the Nelson apartment. With the mule in Charlie's pocket, we strolled in just before the old lady and the janitor came up the stairs talking very loudly. Mother stepped into the hall and we followed. The old lady said she didn't

know whether it was a little cat or a big mouse but it jumped like a jack rabbit. Solemnly, we wondered afterwards with Mamma if the old lady could have been a bit cracked.

I wasn't the only little girl with whom Charlie played hi-jinks. Mrs. Thomas Topping lived at Sun River when she was little Lucile Dyas. She told me recently about being at a Fourth of July picnic down by the river. This was before Charlie Russell was married, and Lucile said he didn't stop at anything then. The food hampers were unpacked and the ladies had just settled themselves down for a peaceful bite when Charlie took Lucile by the arm and said, "Come here, kid, I'll show you something." The "something" was a big snake he had modeled out of river clay. It was coiled up like a rattler about to strike, with its mean head waving around on a willow brace. Charlie had put it in the brush near the picnic when nobody was looking. He had a tin can of pebbles which he gave to Lucile. "Listen, kid," he whispered, "if you want to see how fast ladies run, just stand here and shake that can behind your back and yell rattlesnake."

Lucile did. When everybody jumped up she pointed to the snake and shook the can harder. She says she never will forget how high the ladies lifted their skirts or how fast they ran. Lucile grinned. "It wasn't fair; I got spanked, but Charlie didn't."

Another playmate of mine in Cascade was Hebe Roberts. Her folks, the Ben Roberts, took Nancy (who was an orphan) into their home and that was where Charlie met her. Hebe, the widow of Col. Charles L. Sheridan, told just recently about being present at that meeting: "Charlie had stopped by our home, as he often did, about supper time. Nancy, looking as cute as a bug's ear, was bustling around the kitchen getting a fine meal on the table. Mom Rob (Mrs. Roberts) said 'Charlie, I want you to meet a young lady who has just come down from Helena to live with us.' Charlie stood and stared. They both did, didn't even remember to shake hands. Mom said 'Well come on, clean up and let's eat.' Charlie went over to the wash bench. He really worked up a big lather. His face looked like Santa Claus. Then with his hands still up to his face, he opened his fingers wide and peeked through at Nancy. She stood there with a dish in each hand, peeking back at him."

Hebe said even a little girl could see it was love at first sight.

OVER A PERIOD OF YEARS, we received several gift sculptures in plaster from Charlie—one, a wolf with his foot on a bone; a plaque called *Old Man Indian*; a Piegan maiden and a beautiful oil called the *Buffalo Hunt*, painted in 1898. My people probably bought the oil painting. They gave it to me when I was married in 1913. I sold it during the depression to Roy Alley of Butte for $700. It is now in the collection of Fred Renner of Washington, D. C. Of course, I wish it was still mine, but I am not as sorry about that as I am about losing the wolf in the prairie dog town, or about another Russell that is just simply missing!

It was a spur of the moment sketch Charlie did on a piece of cardboard he picked up in the Roberts store at Cascade. It was raining great guns and my father was shipping sheep. Two ornery old ewes escaped and Papa took out after them. He came back with one under each arm. Charlie caught the moment as though he had a camera. Papa and the ewes were both mad-looking and rain poured off his hat as he sloshed through the mud. It was truly a likeness of my big, determined Danish dad. Where is that picture now?

After 1898 we did not see so much of Charlie. His mother died and his father came up from St. Louis. That was about the time the permanent Russell home was built on Fourth Avenue North in Great Falls. I remember a day we spent there when the house was not quite finished. Nancy, especially, was very happy.

Then there came two golden fall days in 1902 when I had Charlie all to myself. I was a big girl—nine years old—so I remember clearly. I'm glad, for that was the last time Charlie and I were kids together. Mama was a great party-giver. Each occasion was bigger and better than the one before. She was known for her originality and it went at a high lope for about two weeks before a New England Harvest Home. This big affair was given on the Island, a beauty spot in the Missouri river a mile or so from the ranch. (The island is now the home of Fred Nickolson, a friend of Mr. Nelson from Denmark and long-time foreman of the Nelson Riverdale ranch). Charlie Russell agreed to do the decorations. This was a fantastic party, as revealed in an account of it carried on the *Great Falls Tribune's* society page of October 12, 1902:

It is impossible to do Mr. and Mrs. H. H. Nelson's "Harvest Home" justice in a short article. About 100 happy people boarded the trains at Great Falls Thursday morning, bound for the Nelson Island two miles from the Nelson home at Riverdale. The Host and Hostess were most wise in the choice of a day—for what is more beautiful than one of our autumn Montana days? And this was perfect.

Carriages and better still, hay racks, met the laughing ones at the train and drove them over to the island, where truly a magical harvest scene greeted them. All felt that they had suddenly been wafted away from Montana to dear old New England. There were the dames and damsels in puritan costumes, becoming caps and colonial gowns.

Assisting Mrs. Nelson were Miss Beth, the quaintest of all, Miss Clark, Mrs. Nelson's niece from Boston and Miss Veazey, all in costume. About the grounds were Mr. and Mrs. A. K. Prescott, Mrs. Henry Seiben of Helena and Mrs. Morony looking after the comfort of guests. As each one turned from the receiving party and passed under the branches of a tree supporting the maze of fish net, into an immense tent, 100 feet long and 50 feet wide, a murmur of satisfaction and pleasure was heard. A table loaded with unique dishes fashioned of squashes, pumpkins and cabbages extended, down the center; even a ball of binder's twine was made to do duty, artistically holding a lot of red apples. Over the tables hung pumpkin baskets, filled to overflowing with luscious bunches of grapes. Hanging from every beam, pillar and post were apples and jack o'lanterns and they really wore "expressions." Here was a jolly Dutch trader smoking a pipe; there a boar's head, with an apple in its mouth. Grinning hydra-headed monsters, made of pumpkins and squashes, claimed attention until someone spied the carved carrots, reposing in straw cornucopias, hanging against the center pillars. One, a head of a Puritan maid, wearing, however, a modern hat (made of squash) and poplar leaves, set the crowd to looking for the artist. Charley Russell was immediately lionized.

Red willow branches, clematis, marsh grasses and everlasting flowers were used in decorating most artistically. Strewn over the sanded floor were sweet fennel. Long low seats, covered with Navajo blankets and ropes, ran the length of the tent. Inside the

tent great rugs were spread here and there, while cozy corners, small tables, with each its old fashioned jug, apples and Indian baskets full of nuts, and Persian and Mexican drapings, completed the picture.

Many wanted kodak views but the objection was made that they would miss the rich coloring, so the guests came away with memory of the richest autumn colors—greens, reds and yellows, making a most beautiful picture. The keg for sweet cider had a most prominent place in a bunch of willows.

There was a scampering in from the tennis, ping pong and games, and the riding ponies and carriage horses gave a sigh of relief when the dinner bell rang. The guests were each supplied with bark plates and the horn of plenty went the rounds. There was cabbage salad served in cabbage majolica, potato salad in potato boats, Boston brown bread sandwiches, tongue, and no one said: "Coffee, what crimes are committed in thy name!" And there were cakes by the score. Yea verily, there was cake.

The strains of Hammills' orchestra were appreciated through the dinner hour and indeed through the five most happy hours.

When train time came and the tally-hos carried the laughing crowd back through the park-like meadow, one and all breathed three cheers for the host and hostess and gazed regretfully at the glimpses of wood and river as they left. . . .

I stayed away from the house during the hectic preparations for the party as much as possible, because my cousin, Helen Clark, had just come from Boston to be my governess and she wanted to start studies. Could I study when Charlie was at the Island? As the news item said, a big pavilion was constructed there. It was roofed over with canvas, camouflaged with boughs of autumn-colored leaves. This roof was supported by big tree trunks down the middle. These pillars were Charlie's art gallery. Great piles of fall vegetables were ready for him. I can see him now, his hat on the back of his head, that stray lock of hair falling almost in his eyes. He sat on a box with several knives handy and the vegetables grew into grotesque and realistic people of every nature, except western, for this was a New England party. As each character was finished, he and I would pick out the best spot and nail it on a post. Then, as he rolled a cigarette, we would argue about what to make next. I held out for

some Gibson girls. Charlie said they weren't Pilgrims. But at last he grabbed up a very large carrot and went to work. A ravishing beauty emerged from that vegetable. A big slab of squash made a slanted picture hat that I trimmed with trailing clematis that looked like a willow plume. We made here a special grass matting background, and, as it turned out, she was the belle of the ball. When the guests arrived they all exclaimed over her beauty.

That day is a blur to me of many happy people, eating, laughing, playing games, dancing or just visiting in the sun. But the two days before the party are my clearest memories of Charlie Russell. I have no pictures to bring these last memories back. The only picture of that party that survived the years is one of my mother's friend, Mrs. Robert S. Ford, in Puritan dress. I do not need a picture. I only have to sit still a bit—as we often sat together—and think of Charlie. Thinking of him is seeing him, for his was a beguiling and honest personality that entered the heart of a child so deeply its warmth still lives.

# The Big Lonesome

Verne Linderman

~

"YOU WILL NOT LIKE IT," warned Sign-Talker, all eager hope that we would not believe him, "when the Big Lonesome is on the trees." By the Big Lonesome, Sign-Talker meant the snow.

But we were young. The thought of spending an entire winter in the woods thrilled us. We did not wish to believe him.

So the cabin was built, of larch logs—tamaracks, they called them in the Flathead country. It occupied the center of the shore of a square bay on Flathead Lake. The wooded slopes came down like sheltering arms from the hills behind the house. There was not a neighbor for miles on either side: only virgin timber back of us, and, before us, the lake, rimmed on the far shore by blue mountains, ten or twelve miles away.

We labored over the Divide from Helena in an early October snowstorm: but, when we arrived in the Flathead country, on the coastal side and at a lower altitude, the weather was still fine. Nights, of course, were frosty, and we felt them, because the mortar was not yet in our cabin. Labor difficulties in the summer had caused delay in getting out the logs and setting up the walls, and they had not long been built. Then logs must settle before they are "chinked."

To keep warm, we built great fires in our enormous fireplace, and Mother hung quilts around a part of the long living-room. Not exactly a stylish decor, and we shouldn't have liked some of our city friends to look in on us. But we were glad when Charley Russell, Montana's cowboy artist, came from Great Falls to be our first visitor.

Almost every year, when Napi was painting the leaves of the moose maples red, Charley and our father, Frank Linderman, who had received his name of Sign-Talker from the Indians, had liked to go hunting. Even now, when they no longer approved of hunting wild game for sport, they still got together. For Charley to live in, we pitched our Thunder Lodge—painted long ago for Sign-Talker by the Blackfeet women, Mrs. Buffalo-Body and Mrs. Running-Rabbit—on the northern point of the bay.

Mornings, Charley would hobble over the trail strewn with frost-wet, yellow larch needles, in his high-heeled cowboy boots, the ends of his red voyageur sash swinging, his breath white in the chill air.

"How! How! Hi-ee! How's the Swiss Family Robinson today?" he would call.

One night, I learned some nature lore. We had gone to bed, each with a heated stone from the fireless cooker wrapped in a Turkish towel to keep us warm. In my room, the moon shone brightly through the cracks between the logs, and I could hear the lake lapping on the cold shore stones. A deer whistling, in fact every sound, was accentuated in the keen air. Almost one could hear the larch needles drop.

Suddenly, *boom, boom, boom!*—and a confused whirring, I held my breath.

We had bought a second-hand machine to pump water from the lake into our water system, and already Sign-Talker had had much trouble with it. I thought he was trying to start the pump; that we were out of water. Several times I almost persuaded myself to get

into a heavy coat and go down to the pumphouse at the water's edge to offer help.

Finally the percussion in the woods ceased, and I concluded thankfully that Sign-Talker had given up. Next morning, fresh and pleased, he inquired: "Who heard the pheasants drumming last night?"

It was almost Thanksgiving when the snow arrived. I remember standing in a grove of young firs northwest of the house, watching "the noiseless work of the sky." Wherever the eye looked, the horizon, and even the middle distance, were blotted out by whirling flakes.

In a town, when you awaken on a snowy morning, it is to the cheerful sound of your neighbor's shovel, scraping the snow from his front walk; the squeak, squeak of the milkman's running footsteps and the tinkle of his bottles; the rasping and chugging, as your neighbor on the other side tries to start the cold engine of his car. Man is digging himself out, is gaining control of the situation.

In the forest, there is not a sound—except, perhaps, of a pine-squirrel *eek! eeking!* from a high limb. If there is a man peeping out from his door, he seems almost as small as the woodpecker surveying the world from a hole in a hollow tree. His footprints to the woodpile seem as unimportant as the rabbit's.

How shall I describe the Big Lonesome as I came to know it? It was trackless whiteness blanketing the steep hills outside our dining room windows on a moonlight night. White mist rising from the bay on below-zero mornings, when we peered from under our blankets. Little featherweight footprints of mice and rabbits stippling the forest covering in mysterious comings and goings, ending suddenly at a hollow log. The broad footpad of a mountain lion's trail at the bottom of the front steps. The groaning of the ice in the bay with the movement of the water and our skating. The long blue shadows. The roseate afterglow on white peaks.

Suddenly a Chinook came. The woods were swept brown and had a fragrance, the juncos were here, and from the island came the gonk of wild geese! And, one March day, robins—at least twenty of them—called back and forth in the tree tops. It was spring!

# C. M. Russell—The White Indian

Jessie Lincoln Mitchell

≈

"DID RUSSELL EVER IMPRESS you as a white Indian?" the noted sculptor, Lorado Taft, adjusting his glasses, asked me after examining my works of the famous Western artist, Charles Marion Russell. "Yes," I replied. "No one could model his face without being struck with the strong resemblance."

Montanans know that Russell had no Indian blood in his veins, that he was born in St. Louis of a genteel family and that not until after he was 15 years old was he granted permission to migrate to the land of his dreams.

But Russell not only had the strong features of the Indian, he had their pronounced characteristics. He was quiet, meditative, and, when he spoke, his voice was low and his words few. But Russell was a blonde, his eyes small and gray-blue, and his light hair coarse and straight as it hung in an unruly lock over his forehead.

He was about five feet eight, with heavy shoulders and neck exaggerated by a goiter. This was not too noticeable, for his shirts were made to order. His hips and legs were slender and his small feet were fitted to expensive cowboy boots. When Charlie spoke, he rarely opened his mouth, but spoke from out of the corner.

I am drawing you a word picture of a man whom I knew, whom I consider the greatest of western painters. I believe the art world is fast reaching that agreement, and his paintings and bronzes are more and more sought after at fabulous sums.

Here was not only a great artist at painting and sculpturing, but an artistic story-teller as well. This was realized by all who heard Charlie, in his droll way, tell a fresh and often arresting story apropos of something being discussed. He never argued but gave his

opinion in his Russell way by telling a story amusingly, yet filled with truth.

There are comparatively few people living today who knew Russell, as I did. Gone are the old Indians he loved, gone are the buffalo, and gone with the soft loping winds of the plains are the lazy, quiet days.

We came to Great Falls, Montana, in 1912, my husband having accepted a position with the Anaconda Copper Mining Company— at that time the backbone of Montana. It was all but impossible to find a house to our liking, so we took "Hobson's choice" until we could find something better. My small daughter and son and I walked the streets the following days in search of a better house.

"Don't be discouraged, Mother," my small daughter finally said, "we'll find something. You know men are not as good at house-hunting as women."

Whereupon we came to a most attractive log cabin building. I stopped short and said, "There! We could make an adorable home out of that." As I hurried to the real estate office, the artistic side of my nature was tingling with anticipation.

With two little kiddies clinging to my hands, I told my story to realtor. He smiled and said, "Have you heard of Charlie Russell, our cowboy painter? Well, that's his studio." Then he looked at me as if he were almost sorry the house was not for us.

"Haven't you seen him since you have been here?"

I shook my head, still thinking of that log cabin.

"Well, you'll know him when you do, for he wears a Stetson on the back of his head, and a red breed sash at his waist. Can't mistake him—there's only one Charlie Russell."

A few days later the street car I was on stopped for a passenger and in stepped a man of medium height—obviously a cowboy dressed in a sombrero and wearing cowboy boots. As he reached for the strap I caught a flash of a scarlet sash. That marked the man! I looked casually away, only to stare again when he was not looking. Yes, that was my first sight of Charles Marion Russell.

Several years later we moved next door to the log cabin and the Russells. This was the beginning of a friendship with a rare and most unique man.

I soon learned that it would be quite impossible to think of Charlie without including Nancy, his wife, for although Charlie was then the great Russell, Nancy was the wagon boss, and since the day they were married, she had taken it upon herself to remodel Charlie-the-cowboy into Russell-the-great-painter. I take my hat off to her, for she did a magnificent job.

Charlie was never cantankerous. If he did not like a person he appeared not to see him. If he did like someone, he went out of his way to be kind and tolerant, and like Will Rogers, he met few men in whom he couldn't find some good.

I think he enjoyed his neighbors, especially our small fry of a son. These two soon sealed their friendship over a dead mother robin. Russell was a great lover of all wild life, and he had helped his mother robin with her nest in the backyard. He and Son were together when they heard the wild cries of the mother bird, and rushing too late to her aid, they found an old alley cat had killed her.

Son stood in awed fascination at the words that rolled from the corner of Mr. Russell's mouth. Then they sat down on the lower step and were quiet. Finally, Son turned to the man next to him and said, "Do you like cats?" This was where I left the scene.

Later when I returned, I saw Son driving the last nail in the box. "What have you there?" I inquired with curiosity, and my young undertaker replied, "This is the cat that killed Mr. Russell's mother robin. I'm burying it."

"Oh, not alive!" I cried. I felt that here was where mercy must season justice. "Quick, off with the top!"

The cat when released gave one frantic bound and the last we saw of it was a streak down the alley such as jets today leave across the sky. This was to mark, however, the beginning of a friendship . . . of a man and a boy.

A few days later, Son received *The Indian Why Stories* by Frank Linderman, illustrated by Charles M. Russell. Son asked Mr. Russell if he would autograph the book, and Charlie replied, "Bring it over. I'll do more than autograph it for you."

And a few days later, Charlie handed Son the book in which he had painted a lovely book-plate and had written to his little friend this poem:

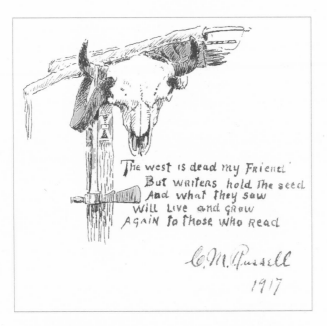

Charles M. Russell, *The West is dead my Friend*, inscription for Edward "Neddy Bay" Lincoln, 1917, pen and ink and watercolor. C. M. Russell Museum, Great Falls, Montana

The West is dead my friend,
But writers hold the seed
And what they sow will live and grow
Again to those who read.
 (signed) C. M. Russell—1917

Some weeks after meeting Russell, we attended a large dance, and to our surprise, there were Mr. and Mrs. Russell. Somehow I never associated this cowboy with dinner jackets and dancing, but there he was and wearing the inevitable scarlet sash and high boots.

We danced one dance, then Charlie said, "I don't like to dance. Do You? Nancy says I have to come for Charity's sake. Is that why you came?"

"Yes," I replied, and we sat down. For the remainder of the evening, Charlie entertained me with his story telling and salty remarks.

"Look at that gal. She ain't got on as much as my grandmother wore when she hopped into bed!"

After knowing Russell better, I often wondered if much of his illiteracy of speech and spelling were not a part of the West he had wholeheartedly adopted, for I have read poems by him without a flaw.

When Charlie was in the mood, he talked and could throw an entire roomful of people into stitches, but when not inclined to tell a story and philosophize, he could sit for an evening and seem absorbed in thoughts far distant.

Once when Russell was having a one-man show of his canvasses in New York, one of the high officials of the Anaconda Company thought he would offer his friends a rare treat by giving a dinner for Russell. He prepared his friends by telling them that they were to hear one of the greatest story tellers and one of the wittiest men he ever knew. Charlie went to the dinner—perhaps Nancy made him— but he was in no frame of mind to enjoy himself. He didn't like New York. He didn't like polished and sophisticated New Yorkers.

The dinner began, the dinner progressed. Charlie sat there unimpressed and silent. With each passing moment his host became more and more frustrated. He struggled in every way to bring Charlie out. Finally, as he was too distraught to do anything but bring the dinner to a close, the many kinds of wine hit Charlie and he turned to his host and drawled, "You know our cows in Montana in the hot August sun is nearer dead than that beef served tonight."

From then until dawn, Charlie told story after story, and the guests went reeling home with laughter, and perhaps with wine.

Not long before Charlie died, he was invited to join The Roundtable Club of Great Falls. He declined by saying they were too high brow for him—his field was painting, not writing. But they would not take no for an answer, telling him that he need not prepare a paper, but for himself they wanted him as a member.

The first night he was present, one of the most brilliant minds in the club had a paper on the German philosopher, Nietzsche. When the masterpiece was finished, Charlie was the first to comment, and my husband said no one that evening opened his mouth except to scream with laughter, for Charlie was at his best. He was among men he liked and there was Nietzsche whom he didn't like.

Dignified ministers and sober doctors threw back their heads and laughed till their faces were crimson. As they left the meeting,

the writer of the paper said, "And to think I spent a year writing that paper, and instead of a Nietzsche night, it was a spontaneous Charlie Russell night!"

I recall we met Charlie at a bridge party one evening. The hostess had divided her party into two groups—those who did not care for cards could enjoy conversation in the study. And there was where we found Charlie. Gradually during the evening, the guests migrated toward the little group where Russell was.

Finally the conversation took up the absorbing topic of the moment—a certain prominent social leader had committed an unpardonable sin and gossip was rampant. One of the group present said, "I think we are too condemning, for she did not know what she was doing. She was intoxicated."

Charlie leaned back in his chair and replied to this in his inimitable manner by telling a story:

"Did you ever hear of the two old Italians who came to Great Falls in the early days? They had a few animals and some circus equipment. That night some cowboys thought they would whoop it up by getting drunk and going to the circus.

"Well, they durned near wrecked that place. They got in amongst the animals and they played havoc. The poor Italians got hold of the judge and brought the cowboys to court.

"The judge said, 'Well, gentlemen, them boys didn't know what they were doing. They was drunk.'

"One little Italian jumped to his feet and screamed, 'Didn't know whata dey wasa doings? Dey kicka da monk! Dey wringa da parriot's neck. But dey NO KICKER DA BEAR!'"

That was all Charlie had to say.

Most people now realize that our Charles Marion Russell was not only a great painter, but a true philosopher. Russell painted action; nothing was static in his pictures save the dim Rockies in the background. As has often been recorded, Russell modestly said, "I am an illustrator." He was, of course, far more than that. No canvas of his needed a title, yet most of his titles were classics. He put on canvas a story the common man could read. As you stand before a Russell picture, you intuitively know what his cowboy is up to, what his Indian is thinking, how scared is his mongrel dog. And

often enveloping such a scene is the glorious sunset, shining through the dust of the western outpost. In his pictures he makes you feel the immensity, the intensity, the vitality and the meaning of his West.

Shortly after living next door to the Russells, I expressed a desire to some time watch Mr. Russell paint. Nancy said, "I would be glad for you to visit the studio and watch him, if you do as a few of his old friends do. Sit quietly and never disturb him." When the time came, she said, "You may go in now if you wish." She unlatched the big, rough studio door, and I entered.

It was a large room filled with the Old West—boots, saddles, spurs, sculpturing, canvasses, paints, and flooding it all was the pungent smell of Indian smoked moccasins.

And why not, for there beyond the painter stood Young Boy, Charlie's favorite model—tall, straight and immobile.

Mr. Russell turned and said, "Come in."

I quietly sat down in the kitchen-like chair he designated and felt much like Alice beyond the mirror. Mr. Russell went quietly on painting and I was relieved. Finally he said, "If you ever want a good model you can have Young Boy. There's no better." With that Young Boy cast his eyes on me, but it was his only gesture of recognition as he stood motionless.

I heard the big clock on the wall tick off the time, but that was the only sound in the studio. I thought how obedient Nancy might think me if she were outside the door.

All at once Russell leaned back in his chair and let his hand—the one holding the brush—rest listlessly on his knee. He sat there some time studying the picture. Then he leaned forward and dipped his brush in scarlet paint and gave one dab to a figure; it sprang into view like magic. Charlie turned and smiled at me. Not a word was spoken. We both felt the satisfaction of the moment.

I recall that I had the rare privilege of watching Charlie paint what was to be one of his last pictures. It was then showing plainly that work was a bit laborious for him. The goiter should have been removed long ago, but Charlie frankly confessed he was "scared of these damn surgeons."

He said to Young Boy, "You go see Mrs. Lincoln sometime. She use you for model."

So often after Charlie died, Young Boy came to the house. He never made his visits known, but entered by the kitchen door unannounced. He seemed grateful for the food given him, and if I were not at home, I always knew of his having been there by the remaining scent of the smoke of the tepee.

We all know that Charlie loved the Indians. This incident happened long before I knew him; but you may have heard that for some six months Russell lived with an old chief of the Blood Indians in Canada and fell in love with his daughter, a lovely young girl named Kee-oh-mee. He painted several pictures of her—"The Water Girl," two or more under her name and others. The Bloods called him "Ah-wah-Cous," which means "antelope."

What happened that winter of 1888–89 in Canada no one seems to know, but Charlie came back to Cascade and there met at the home of one of his old friends a young girl of sixteen, who was living with the Roberts family as a helper. They were both attracted to each other and were soon married. The girl was Nancy Cooper.

This is generally recognized by his biographers as the turning point in Charlie Russell's life; for though Nancy was young and quite alone in the great open spaces of Montana, except for the Roberts family, she became the driving power of Russell's life.

After their marriage, Nancy (who was also known as "Mame") and Charlie came to Great Falls, and here with the help of close friends of Charlie's they procured the house near the Albert Triggs. They spoke of these people as "Father" and "Mother" Trigg. It was these cultured, lovely people, together with the daughter, Miss Josephine, who educated Nancy Russell and encouraged her to go to night school to become one of the most successful agents, secretaries, and business managers all put together that any artist ever had.

Nancy made enemies when she separated Charlie from his old cronies and encouraged him to paint to support them and cautioned him not to barter off his art for a drink across a bar or for just enough for a meal, as he had done so many times.

Charlie loved to paint, and he did it from the earliest knowledge we have of him. But as for setting a rigid—and often high—price on his work, it took Nancy to do that. I recall the first picture Charlie

Russell sold for a startling price—Nancy's price. It was for $15,000! That morning the papers announced it in one inch lettering my husband walked down town with Russell. When he congratulated him, Charlie smiled and mumbled, "Gosh, that's a dead man's price." Little did he know that the dead man's price would bring today four times that amount.

At that time, I could have had one of Russell's bronzes for $35. It sells now at Tiffany's for $1,000! To me it is one of Russell's finest pieces of modeling. It is a mother bear lifting a stone for her cubs to eat the ants beneath it [*Bug Hunters*, FIG. 23].

It is generally known that Charlie always carried a piece of beeswax in his pocket just because he liked to casually model as he whiled away the time talking to old cronies.

One day I was working on a small statue of a cupid when Charlie came in. I said, "Welcome! I need you. What's the matter with this pose?"

Charlie came to the stand where I was working, looked at it gloomily, then sat down and drew the little figure to him. He poked it here and added clay there. Finally the cupid vanished and there stood an Indian. He pushed it back and we stared at each other.

He said, "Who ever told you I could make an angel? I only make Injuns."

When my husband came in, Charlie said, "You know that I've just turned an angel into an Indian? Did you ever hear the story about the Englishman who showed one of your old New Englanders a coin and said, 'The king on this coin made my grandfather a lord!' The old man looked at it and finally drawled, 'Well, see the Injun on this piece? He made my grandfather an angel'!"

Charlie then told of the time he painted a picture of Cascade. He said it was a winter scene and he gave it to one of his old friends, who looked at it for some time, then remarked, "Charlie, you and me knows it gets 45 below zero in that town, but you ain't got a goddam chimney in the whole town!"

"And sure enough," concluded Charlie, "I hadn't painted a durned chimney. Queer how you do things like that."

Charlie painted because he loved that way of life, and he painted with no thoughts of remuneration. He was the one who said, "Any

man that can make a living doing what he likes is lucky, and I'm that. Any time I cash in now, I win."

While in New York exhibiting the last time, Charlie visited another art gallery. One picture, he told me, was the most awful thing he ever saw, but it fascinated him to realize any human mind could conceive such a thing.

"I was standin' studyin' the thing," he said, "When all at once I was conscious that someone had been standin' for some time beside me. When I turned and looked at the fellow, he said, 'What do you think of the picture?'

"I answered, 'I haven't got that far. What I want to know is what is it?'

"The chap replied, 'It's The Inner Man.'

"I said, 'Well, he durn quick needs a doctor.'

"Says the creator of this monstrosity, 'Thank you. I am glad to have your reaction. You are Charles Russell, are you not?'

"'Yeh,' I said. But I was awful busy lookin' at my watch and I added, 'It's lunch time and I'll miss the roundup.'

"He was a hell of a good sport, for he invited me to have lunch with him, so I took it he wasn't too much put out the way I felt about his Inner Man. Later I found out all his mind wasn't so mixed up, for we got to be good friends and the following summer he and his wife visited us at our summer cabin on Lake McDonald. We hit the trail together often, and I sorter feel he's not so mixed up now, for he's gettin' his colors together so as people know what he's sayin'."

We were up to the Russell cabin one summer, and there were animals most of the time about the place. Unafraid they passed by the cabin on their way to the lake for water. They had made a pathway near the house as if they sensed the protection of the place.

The Indians, too, came there, and left the cabin strong with the scent of their smoked elkskins. Outside, the air was pungent with the sweet smell of the pines, for the sun was hot on the trees.

Charlie Russell was loved by everyone who knew him; even the wild things felt that brotherhood. At night, the deer came nosing about the cabin and the trees were full of his feathered friends.

At this time I was much interested in the Lewis and Clark expedition

and that intrepid Indian girl, Sacajawea, who led the little band safely through some of the perilous wilderness.

Russell had just finished drawing a blue sketch of the three of them, Lewis, Clark and Sacajawea, and showed it to me.

The Pioneers of Montana were also at this time interested in placing an heroic statue of Sacajawea at the Gates of the Mountains and so I made a small model of her.

I took it to Charlie for criticism, and I have to laugh when I recall the way he looked when he saw it.

"I don't suppose you ever saw a Mandan or a Shoshone squaw, did you?" And he looked at me with a touch of disappointment. "Well, if one was ever caught with her buckskin skirt up to her knees and her dress off her shoulders like this, the old chief wouldn't look around for a white man to scalp!"

We both laughed while Charlie looked about for a pencil and paper. While he drew me an Indian maiden's dress, he said, "You never depict a squaw without this knife in her belt. They were never without it."

I was amazed at the size of the squaw knife, and Mr. Russell continued, "They used these knives for everything—to kill, to skin, to scrape."

I still have the little drawings he made me of the Mandan's dress and the knife, and my model of Sacajawea was to that extent guided by Russell.

With all Russell's rough life on the plains with the cowboys and his home with the Indians, Charlie himself was not rough, but quiet and gentle. Russell had a great underlying spiritual self. This was not evidenced so much in words as in his life. In his bigness, he was tender and understanding, but his keen gray eyes and his square, firm jaw said plainly, "Thus far and no further."

We knew Frank Linderman, the writer; Johnny Ritch, the clever Montana poet; Sid Willis who owned the Mint Gallery and Saloon where Charlie sold many a painting for a drink and where many tourists stopped to see the collection of Russell's works.

We knew Senator Walsh, George Calvert, who for years bunked with Charlie, and some of the old Indians who loved Charlie. All of these are gone; they were among Charlie's countless friends.

I recall with vividness when Mrs. Russell got her first car. Charlie was passively concerned. He said, "If Mamie wants one of those stink-wagons, she can have it, but I like the smell of horse flesh."

Some way, some how, Nancy inveigled him into trying it out, for I saw them leaving the studio one morning in the auto with Charlie sitting in the rear seat with his feet up on the back of the front seat. He seemed relaxed and quite confident in Nancy's handling of the "stink wagon." That was the only time I ever saw Russell tamed to the times.

Nancy had Charlie's boots made to order of the softest leather. His Stetson was made for him, and his shirts were made to order to cover the goiter. This may sound dapper, together with his turquoise rings and red sash, but no one noticed how fine were the clothes, for Charlie wore them with his cowboy carelessness.

It was in October 1926 when they brought Russell back from Mayo's, where he had been operated upon for the goiter. I think all about the place there was that ominous stillness one feels just before death. So when the news came to us that a great friend of the old West had passed on, we were all the more saddened, but not shocked, for we had been told that Charlie had put off the operation too long.

This was an Indian summer day, the 24th of October, 1926, when the great heart of the West, symbolized in Russell, ceased its struggles.

One of the longest funeral processions ever seen in Montana passed slowly down the avenue to the little Episcopal church and then out to the cemetery. It was not a city's grief, but the whole West's.

Everything was carried out exactly as Charlie had asked. He had said, "I don't want any automobiles at my funeral, and when they lower my bones, do it with my horse's reins."

Later, when we saw the tombstone Mrs. Russell had selected, we found it to be a huge boulder on which his name was carved and just above the name was a small pocket worn in the boulder by the winds and rains. His wife said, "I thought Charlie would like this. It's a good nesting place for one of his feathered friends."

The autumn days have come and gone, the hot Montana sun has relentlessly beaten down upon the grave and the winter snows have been driven off by the welcome Chinook—the old south wind. All of this does not diminish the memory of Charles Marion Russell. But

today the entire world is more conscious of Russell than ever. His paintings and sculpture are so greatly in demand that the public searches for anything that bears his signature of the buffalo skull and "C. M. Russell."

From Russell's grave, one can look off across the great plains and see in the far distance the mountains along the horizon, blue as concord grapes. At eventide, the plains and clouds are golden from the setting sun, and the boulder catches the crimson that floods it all. Beneath this rock sleeps the man of the red sash, and the turquoise rings, and the high-heeled boots.

There have been many notable characters in my life, but none so unique and unforgettable as "the White Indian." One thinks of him in the evening, when the wind stirs the grass and the meadow lark sings her evening song, and the great gold sun sinks behind the jagged Rockies.

# Good Medicine

Helen Raynor Mackay

MY HUSBAND's and my friendship with Charley and Nancy Russell was a most happy one. They would withdraw from the noise and confusion of New York City to our quiet place in Tenafly, New Jersey, every chance they had when they were East. Always Charley's sense of humor and good nature were Good Medicine for his companions.

When we lined a room with logs to make a fitting background for Charley's paintings, the front of the chimney was left unfinished so that when Charley paid us a visit, wet cement could be applied in which he could make drawings, or brands, or Indian hieroglyphics. He had this kind of chimney in his cabin on Lake McDonald. But Charley didn't want to do this, because, he said, he had to work too rapidly and could not make erasures. Instead, he would rather paint for Malcolm Mackay what he termed a "poster" to fit that spot. The "poster" is now hanging in an honored position in the new State Historical Museum in Helena [FIG. 24]. It shows Charley on his

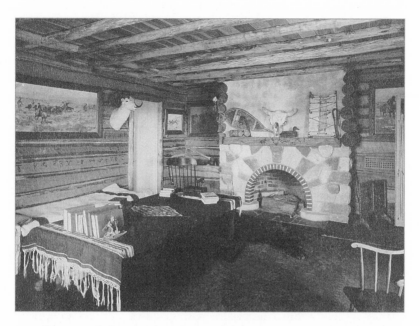

Russell room, Malcolm S. Mackay's home in Tenafly, New Jersey, ca. 1921, before the installation of *Charles M. Russell and His Friends*. MHS Photo Archives, Helena

horse on the brow of a hill in the Missouri River region, near Cascade, Montana. He is motioning down the hill up which ride the cowboys and the Indians he so loved to draw and paint. That first evening in the new Russell Room we sat around the fireplace, which as yet had had no fire, to dedicate it. The squaw of the Medicine Man sat far left, then the Medicine Man, then two Braves, then the owner of the tepee, and finally his squaw next to the fireplace on the right. With great ceremony the squaw of the owner of the tepee made a fire and lighted it. Then the Medicine Man talked to us for over two hours in Indian sign language, with his squaw interpreting. I can never forget the pleasure and the magic of that evening. We were completely transported into the past. Later Charley and my husband heated branding irons and burned as many brands as they could remember all over the logs.

One amusing incident which I always have loved to tell occurred when the Russells were in a small hotel on the East Side. Charley wanted to go out to buy some tobacco. Usually he never ventured out in New York alone, the streets were so confusing. One of his friends made it a point to devote himself to Charley so he could

come and go with no anxiety. But this was late afternoon and there was no one to take him, for Nancy was washing her hair. So Charley went out alone, after much anxious advice from Nancy. He just wanted to cross the street to the drug store to buy some tobacco. Well, Nancy finished washing her hair. When she looked at the clock she was horrified, for over an hour had passed and Charley had not come back! When she was about to call my husband, and the police, and every friend she knew about New York, in walked Charley. He hadn't found the tobacco that he wanted across the street and had gone from one place to another to find the right kind. When it came time to come back, he was lost and didn't know the name of the hotel. But he remembered there was a little hole in the awning over the front door. So he walked up one street and down the next until he came to the door with the little hole in the awning! After that Nancy wrote my husband's name with his home address and sewed it into the pockets of all his coats.

One time when we were looking over his bronzes in the Russell Room, I picked up "The Lunch Hour." It's the little one of the mother bear holding up the rock for the baby bears to get the ants underneath. I said to him,"Which do you like to do the most, the painting or the modeling?" "Oh," he said, "I like the clay, but I don't do it very well." This is just one instance of his extreme modesty, for he had just been given the Prix de Rome for this very same bronze.

Nancy told us of their first trip East. She had saved a portfolio of water colors especially to bring to New York. She'd had to hide them to gather a collection for Charley would give them away. Senator Clark of Montana had expressed the wish to see them and had made an appointment. Before he came, Charley said to his wife, "Mame, how much are you going to ask for these pictures?" "Three hundred and fifty dollars." "You won't get it." When Senator Clark came, looked through the portfolio, and took out the one he wanted, he asked how much it was. Mrs. Russell said, "Three hundred and fifty dollars." When the Senator took out his pen and check book, and wrote out the check without question, the Russells said you could have knocked them over with a feather.

Another instance of his modesty: Years later they had one of their exhibitions in the Grand Central Galleries. One afternoon

Charley was sitting on a big davenport in front of one of his paintings when a very fashionably dressed New York woman came in. Looking around the gallery with her lorgnette, she stopped in front of the painting that Charley was facing and looked at it carefully. Calling the girl in charge, she asked, "How much is this picture?" The girl replied, "Six thousand dollars." The woman gave it another very careful scrutiny through her lorgnette, turned to the girl and said, "It isn't worth it." After she left, Charley went up to the painting, looked it over inch by inch and said, "By God, it isn't!"

On Nancy's first visit to us in New Jersey after Charley's death she was very much pre-occupied with the work she was doing in collecting from Charley's friends some of the many illustrated letters he had written them during the years. She wanted to publish copies of these letters in color and she had not found a suitable title. I can see her and my husband, sitting on the davenport before the fire—a few sentences of conversation and then silence for a long time—each of them seeking for a name for this book which has meant so much to many of Charley's friends and admirers. Finally my husband said, "Nancy, why don't you call it 'Good Medicine'? Charley used that expression so often." So in due time that delightful volume known as "Good Medicine" was published in several editions.

I never saw Charley's wonderful good nature fail him but once. He was usually the life of the party, possessing the evening as we always wanted him to. This time we had invited a well-to-do couple for dinner. We knew they'd be interested to have some of Charley's pictures. Charley didn't open his lips all evening, except to grunt a "yes" or a "no" with his teeth closed. We couldn't make out what the matter was. He had intuitively taken an intense dislike to the man. His intuition was justified, for the man proved dishonest, and landed behind bars not too long after this memorable evening. Charley had an unfailing feeling for what was right and kind, and usually had no dislike for other human beings.

I hope there are a number of people who will enjoy sharing these memories with me, and will see through them all Charley's great spirit.

# Close View of Artist Russell

Nancy Cooper Russell

~

THE WOMEN'S CLUB held an ideal meeting on Monday afternoon. The art section had charge of the program. Mrs. W. W. Conner gave an interesting talk. Her subject was, "How to See Pictures." It was declared by the members a keen delight to review with Mrs. Conner the many old and some new pictures. She talked informally and showed copies of the pictures, to illustrate her points, from Cimabue and Giotto, Velasquez, Botticelli, Bellini, Titian, Peter de Hooch, Durer to the tone pictures of Whistler and the Japanese prints, the audience followed, not wanting to miss one word.

Mrs. Hamilton followed with an able description of Rembrandt's "Night Watch," and then came a charming ending of a most profitable program, the part which the club members cherish as a particularly gracious and happy treat, an account of Great Falls' own artist, Charles Russell's early school days; of his inclination to draw instead of to study, and of his early days in the West from Mrs. Charles Russell. Mrs. Russell had also brought two of his later pictures, which she explained somewhat as questions were plied from the audience.

Mrs. Russell's paper was as follows:

"No man can be a painter without imagination. He must live in his pictures.

"Mr. Russell could paint a picture of life a hundred years before his time, because when he first came west he met old men who had used the flint-lock rifle and they told him stories of their lives and tales that their grandfathers told them. These camp-fire stories that were told this impressionable boy of fifteen, when his mind was like wax, have held until there is an unlimited store of subjects to choose from.

"At this time the Indians still wore skin clothes, were rich in ponies and lived in skin lodges. They were not the half-starved beggars you see today but the most picturesque wild men in the world. And this young man had found the thing God had given him power to do, paint the history of our old west. Nature was his teacher. Animals change very little as years go by, the plains horse is the same now as he was a hundred years ago. Mr. Russell has owned many and studied them. When a child from the time he could safely ride a pony his father gave him one and he has had a horse or horses ever since. He knows the feel of the animal when he falls also how a man hits the ground when thrown because he's been there.

"That is why you feel the life and action in his pictures today. If at this impressionable age he had been forced into school that we think is absolutely necessary for children his life work would have been spoiled as he never could have been a success with books and rules to follow. His teachers thought him hopeless as the most of his time was put in drawing on any blank space in his books, or modeling with a bit of wax for the amusement of his little friends. Only the other day an old school mate of his told me how he would say, 'You get my lesson for me and I'll make you two Indians.' So you can see his school days were not especially happy for either pupil or teacher.

"He had an allowance like his brothers, he also worked at anything a small boy could do to earn more. His bank was a bureau drawer under the paper that covered the bottom. He thought he had almost enough to get west, $60.00, when his mother found the cache and put it in a real bank, where he could not get it. He immediately ran away and was gone three days, sleeping in hay stacks and causing the family no end of worry. But it decided his father; he was to come west at the first opportunity.

"The plans were made and that boy's dreams were going to come true. He was to see the land of his heart's dearest wish where there were Indians, men with long hair, and the old-time picturesque cowmen.

"In the old days men did not read much but were all good story tellers and many of their lives would have made a romance. Although Mr. Russell is a good story teller he is also a good listener and has a remarkable memory for detail. The stories he heard were history

that has never been written and would have been lost had he lacked the ability to put them on canvas. People have said, 'Where do you get all your ideas? I should think you would run out of them.' With him that is impossible, as his great teacher, Nature, and a few silent men developed and strengthened an already wonderful imagination until now there will be days when he lives in that past that was loved and understood when a boy, and there is no limit to the number of pictures he sees in his world. If he lived hundreds of years he would still be unable to paint them all.

"Mr. Russell lives in the past as you all know, and when civilization crowds too close and it is not the season to go to the mountains he takes his coat and hat, his tooth brush in his pocket and goes to Mr. Matheson's ranch near Belt, where the Highwood mountains loom up big and the Belt range make wonderful pictures in the evening sun. At this ranch the artist is a boy, he cooks anything fancy brings to mind or at least he tries, from cake to roasting a chicken, which, by the way, he said was pretty good. When the dishes are washed he will, in nice weather, climb a hay stack and from that elevated place imagine that stretch of country back before the white man came, with Indians and their land alive with game. He goes into what his red brothers would call 'The Great Silence' where nature teaches her child. When he comes back from one of these visits I have seen him start three big pictures within one week. When laying in a composition as a rule Mr. Russell is very silent, he will sit evening after evening with a pencil and scratch pad, working out an idea and scarcely talk at all.

"This in a mild way gives the foundation for this chosen life work and whenever the opportunity presents itself he always goes to see anything that pertains to the old west; for instance when the Canadian government bought the herd of buffalo that were on the Flathead reservation before the land was thrown open to white settlers, the park officials of Canada invited him as their guest for six weeks both summers, while they gathered these brown cattle to take to their new home across the line. This was the best chance in the world to study because there was not only horse and man action, but these wild buffalo that hardly knew what a man looked like were being gradually worked into captivity. It was the last time on

this continent these wild creatures would ever break their hearts against the cunning of man. They were corraled and shipped by train loads.

"Mr. Russell rode as one of the men and in that way saw a great deal that was priceless. The trap was built in a big bend of the Pend'Orreil river with a chute leading down to the water. The wings of the trap were fan-shaped, three miles long on one side and two on the other. Sometimes small bands of wild horses would get into the trap along with the buffalo. Then the men by following would force the frightened animals into the river, and there would be a seething mass of life in the water. They would fight and finally surrender, hopeless. You must know what all this meant to the artist. I think he rejoiced when outwitted by these grass-eaters as he loves to tell how one night they lost over two hundred. The buffalo swam the river again and climbed a cut-bank on the other side. It must have taken a long time but they worked until they made a trail up which they all got away but one lame old cow.

"Nearly every summer Mr. Russell goes to some Indian reservation when it is their festive season. Seeing them in tents and wearing half civilized clothes does not keep his imagination from leaping backwards and picturing them lords of the plains with nothing on but paint, beads and feathers, each mounted on a high-headed war horse, an emblem of savage beauty."

# PART FOUR

~

# Recapturing Russell

INTERPRETIVE AND BIOGRAPHICAL STUDIES

CHARLIE RUSSELL, one of the most beloved westerners of all time, has proven oddly elusive. Many would-be biographers have tackled his story, only to abandon their books along the way. John Taliaferro, author of the first serious Russell biography ever published, the splendidly researched and written *Charles M. Russell: The Life and Legend of America's Cowboy Artist* (1996), traces this intriguing phenomenon in "The Curse of the Buffalo Skull: Seventy Years on the Trail of a Charles M. Russell Biography." Several factors account for the previous failures.

When Nancy Russell died in 1940 she left behind a houseful of Russell documentation—letter files and the like—as well as a sizable collection of memorabilia, sketches, models, and paintings. The market for western art had sagged with the economy during the 1930s—a reality Nancy had steadfastly refused to acknowledge—but the initial appraisal of her estate was still a shock. Russell bronzes were evaluated from $3 to $10; his watercolors from $1 to $20; his major oil paintings, from $125 to $200 (one large canvas was listed at $250, but many smaller ones at $5 to $25).[1] In the aftermath of this debacle, a new appraisal was undertaken, and the estate eventually sold to a four-man partnership for $40,000. In the process, Nancy's correspondence files ended up in the hands of one of the partners, Homer E. Britzman, and until recently have never been fully accessible to scholars. This was a major factor in preventing biographical study in the past.

Another, more pervasive factor was the myth that has grown up around Russell and his artistic legacy. The Russell myth holds that the Cowboy Artist was first and foremost a cowboy—a good old boy who just happened to paint and sculpt. In reality, Russell spent about eleven years on the range and thirty-two years as a professional artist, and while he always exhibited a provincial suspicion of the experimental and avant-garde, he looked—and looked carefully—at those who worked the same patch he did. There was nothing vague about his visual recall. He knew the work of older and

contemporary western artists and could comment tellingly on specifics. He might disdain art schools and art talk and arty types, but he was always eager to improve, and there is no denying the influence that Frederic Remington, for example, as well as the pioneer St. Louis painter Carl Wimar and the wildlife painter Philip R. Goodwin, had on his work.[2]

Russell was a quick study. He learned from observation, and while he remained technically unsophisticated, his art improved dramatically after 1903 when he began making regular visits

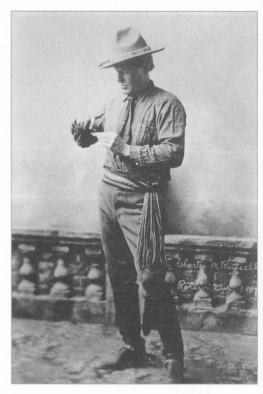

Charles M. Russell, © 1907, by A. O. Gregory.
MHS Photo Archives, Helena

to New York and keeping company with an agreeable "bunch" of experienced illustrators. He treasured their friendship, and they embraced him in return. Russell had discovered something that he lacked in Montana, and his evident pleasure in artistic community suggests the Russell myth's blind spot. It fails to see beyond his cowboy boots and hat to the rings that adorned his fingers and the rakish tilt of his Stetson when he stood before a camera. An artist was posing there as well as a cowboy. Though he never pretended to be a good roper or rider and steered clear of "snuffy" horses, Russell was proud of his cowboy credentials. But he loved the idea of cowboying even more. It appealed to the romantic in him. His artistic fancy responded to the gleam of sunlight on horse jewelry; the whole catalog of cowboy accessories tripped merrily off his tongue. "Chas was always so sencitave to beauty," Nancy wrote. On his annual fall hunts (he did no shooting himself, but relished the outdoor activity), his first order of business was to look for a

little feather to tuck in his hat band.[3] It served as his personal "medicine," and as a little concession to artistic flair—like the colorful sash he always wore in lieu of a belt. (When Russell visited Paris in 1914 he was unimpressed by the miles of pictures in the Louvre, but noted approvingly that some Frenchmen wore sashes.)[4]

Nancy, to the end of her days, disputed the popular notion that Charlie Russell was a crude, hard-drinking cowhand. In 1939 she wrote one of Russell's would-be biographers, J. Frank Dobie, that "in our married life of over thirty years, I never saw him really drunk and during the last nineteen years of his life he never took a drink of hard liquor at all."[5] He was a refined and sensitive man, if not a conventional one, and she longed for others to emphasize the softer qualities in his character. She almost certainly chose Russell's first biographer, Daniel R. Conway, because he was responsible for a short commemorative piece in *Frontier* that struck exactly the note she wanted to hear.[6] Conway, unlike most of the others who tackled the Russell story, actually finished his biography in one three-month burst of activity in 1927. But his book never appeared in print. The very qualities in his prose that attracted Nancy to him—a literary pretension and a straining for emotional effect—were dismissed by Nancy's New York publisher as fulsome and repetitious.[7]

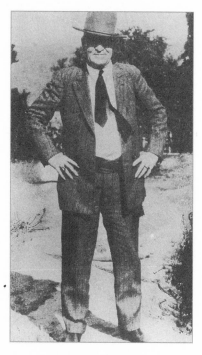

Charles M. Russell, ca. 1923.
MHS Photo Archives, Helena

Subsequently, many biographical studies of Russell appeared in journals and books. Most were long on folklore and description and short on research and analysis. *Montana* has helped battle the trend by publishing some of the best secondary writing about Russell, man and artist. Two cases in point are Hugh A. Dempsey's "Tracking C. M. Russell in Canada, 1888–89," which corrects the old story that Russell spent a winter in Alberta among the Blood Indians, and John C. Ewers's "Charlie Russell's Indians," which

demonstrates how his artistic representations of Indian culture were determined by what he observed in Montana in the eighties and nineties. *Montana* has also featured essays that probe the man behind the legend. J. Frank Dobie, for example, never wrote his Russell biography, but he indicated why he was fascinated by him in "The Conservatism of Charles M. Russell," while Raphael Cristy, in a study of Russell's Indian stories, finds in them a gritty realism harnessed to a lesson about racial tolerance that reveals much about the man.

Finally, *Montana* has featured several heavily illustrated essays focused directly on aspect's of Russell's art. Two are included here: Frederic Renner's "Bad Pennies: A Study of Forgeries of Charles M. Russell Art" and Lee Silliman's "CMR—The Cowboy on Canvas." Renner devoted almost a lifetime of close study to Russell's work. "Bad Pennies" is an invaluable elaboration of an investigation he had begun in "Notes on Copies, Forgeries and Alterations of the Works of Charles M. Russell," an appendix (written in collaboration with Homer E. Britzman) to Karl Yost's pioneering *Charles M. Russell, The Cowboy Artist: A Bibliography* (1948). Silliman focuses directly on Russell's artistry. Russell has been viewed as a literalist whose only goal was realism, and whose gift was the ability to record with faultless precision exactly what he had observed. But his art provides its own rebuttal. His finest paintings expose a romantic streak as broad as all Montana, and his real gift was the power to transform the mundane and transitory into the magical and timeless. He often depicted subjects that antedated his personal experience in Montana. "When my father was a boy St L[ouis] was the starting place for the west," he wrote in 1916. "All the big traders came from there I would like to have lived then."[8] Through his art, he did.

NOTES

1. These figures derive from the appraisal by Leo Green of Green's Art Store, Los Angeles, California, November 1, 1940 (copy courtesy of Rick Stewart).

2. See Brian W. Dippie, "Two Artists from St. Louis: The Wimar-Russell Connection," in *Charles M. Russell: American Artist*, ed. Janice K. Broderick (St. Louis, Mo., 1982), 20–35; Brian W. Dippie, *Looking at Russell* (Fort Worth, Tex., 1987), 6–61; Peter H. Hassrick, *Charles M. Russell* (New York, 1989).

3. NCR, notes towards "'Back-Tracking in Memory': The Life of Charles M.

Russell, Artist," Britzman Collection. Nancy got the anecdote about Charlie and the feather from Olive Lewis, the wife of one of his regular hunting companions.

4. CMR to Joe De Yong, undated note, ca. 1916, De Yong Papers, Great Falls.

5. NCR to J. Frank Dobie, December 2, 1939, Dobie Collection.

6. That obituary, titled "Note on Charlie Russell" and published in *The Frontier*, 7 (November 1926), 24, read as follows:

### Note on Charlie Russell
#### (October 27.)

Charlie Russell, the cowboy artist, died last night.

This afternoon the paper contained a good deal of bosh about him. Tomorrow morning there will be some more of it.

And the tenor of the press comment is that the man was successful because, once, his pictures brought him no money, or at least very little; but that toward the end of his life he did famously because he was getting five thousand—ten thousand—from the Prince of Wales, the Duke of Connaught, and heaven only knows what bargain-driving American oil magnates.

I saw Russell only once. I recall with some shame that I was one of a press convention group that stamped up to the door of his cabin studio at Lake McDonald, and demanded to see the celebrity. Someone who was drunk called, "Yea, Charlie Russell." Then the door was opened.

Russell had been sitting before an easel, under a skylight. The light that made the detail of his picture distinct shone also upon his face. I remember that there were lines in it. He had been painting, and probably he now wanted to go on painting, but he arose and became affable . . . Old Friends, and the drunk man slapping him on the back. . . .

There was another man, a young man, painting beside a window near the far wall of the cabin. He was not noticed until Russell walked suddenly from the group to look over his shoulder. As he looked, the lines went out of his face and there was glowing peace there, and in his eyes.

"Sky too blue, son, you see?" he said to the young man. "Take some blue out. It hurts."

He came back to us. The lines came back, too. He was affable again . . . Old friends . . . and the drunk man slapping him on the back.

7. Dan R. Conway, "A Child of the Frontier: Memoirs of Charles M. Russell (The Cowboy Artist)," typescript, October 19, 1927, SC 1321, MHS. For Conway's understanding of his arrangement with Nancy, see Conway to NCR, September 2, December 1, 1927; and for Doubleday's rejection, Harry E. Maule to Conway, November 23, 1927 (copy), Britzman Collection.

8. CMR note to De Yong, ca. 1916, De Yong Papers, Great Falls. See also Brian W. Dippie, "'I Have Been Improving Right Along': Continuity and Change in the Art of Charles M. Russell," *Montana*, 38 (Summer 1988), 40–57.

# The Curse of the Buffalo Skull:
## Seventy Years on the Trail
## of a Charles M. Russell Biography

John Taliaferro

ON THE NEXT to last day of December 1932, with the Great Depression auguring only bad tidings for the New Year, Dan R. Conway, a washed-up Montana journalist, sent a note to Nancy Russell, widow of Charles M. Russell. "I hesitate to write to you at this time," Conway apologized, "but desperation and almost utter hopelessness force me to measures beyond the bounds of personal pride. For weeks I have been walking the streets much of the time absolutely without food and other requisites of life." Please wouldn't Mrs. Russell help him?[1]

Straits had not always been so dire. Conway and Nancy had come to know one another in the months following her husband's death in October 1926. Conway had been employed as a writer for the Montana Newspaper Association, a Great Falls enterprise that syndicated inserts of mostly historical articles to the state's regional papers. Nancy, with characteristic pragmatism, was rolling up the sleeves of her widow's weeds to tackle life after Charlie. Two months after the funeral, she and ten-year-old son Jack had moved to Pasadena, California. One of her aims was to sell Charlie's Great Falls studio to the city, which would in turn maintain it as a memorial to Montana's acclaimed cowboy artist. Another aim was to commission a Russell biography. Dan Conway left his job at the Montana Newspaper Association for a position as publicist and fundraiser on the Russell Memorial Committee. That winter, Nancy Russell hired him to write her husband's life story.[2]

Nancy and Conway spent most of the summer at Bull Head Lodge, the Russell cabin on Lake McDonald in Glacier National Park. She would reminisce; he would take notes, then go to his room and write. By September he had completed an eighty-thousand-word manuscript, which Nancy sent off to Doubleday, Page & Company, publishers of *Trails Plowed Under*, Russell's collection of Western stories.[3] But despite the success of *Trails Plowed Under* and the immense popularity of Russell and his art, Nancy and Conway had no luck with the biography.

Conway's acute disappointment, given his chronic mental and emotional fragility, was his ruination. He drugged himself with alcohol and evangelism. He made enemies of his allies and became a pariah to editors and publishers. Nancy Russell stomached him longer than most. She listened to his ravings and sent him a few dollars in addition to the agreed-upon $780 plus expenses. But by New Year's 1933 she was past abiding the hangdog pestering of "that poor little man."[4] Her January 9 response to Conway offered perfunctory sympathy but no material assistance. In a matter of weeks, Conway had died in a car crash—whether by accident or suicide is not clear.[5]

Taken on its own, the story of Conway and his manuscript is a cautionary tale of the pitfalls of publishing and hero worship. Yet when seen as the first frame in a snarled serial of fumbled, suppressed, and plagiarized Russell biographies, Conway's failure takes on almost Gothic overtones. When otherwise rational Russellophiles get to talking, someone inevitably jokes about the Curse of the Buffalo Skull, a reference to Russell's logo and the conjectured pall of not-so-good medicine that has clouded seventy years of Russell research and rumination. Even when facetiousness and superstition are discounted, as well they should be, a pattern of controversy and disaster is striking in the annals of Russell scholarship, although of course the blame does not lie with Russell himself.

Nancy Russell had admired earlier profiles that Dan Conway had written of Charlie in the Great Falls *Leader*. "I like the symphathetic way you have of talking about Charlie," she told him before their trip to Lake McDonald. "A person would think you have known him for years." Conway was easily flattered, and just as easily inflated, by his

appointment as official amanuensis. He described his summer's assignment as "the most pleasant one of my whole career."[6]

Neither patron nor scribe had any objectivity toward the project, however, and both were surprised when Doubleday, Page editor Harry Maule promptly rejected the manuscript, which Conway had titled "A Child of the Frontier." Copies of the text survive today, and one need not read further than the overwrought sixth paragraph to grasp the editor's reason:

> And so with the "Cowboy Artist," a separate species, a man of remarkable genius—an outstanding phenomenon, self-taught and yet a dominant master in two fields of art—moderately temperamental, but home-loving and modest, with a heart as big as the stellar spaces, of penetrating sagacity, of keen humor, never banal, never commonplace, never profane, with a keen regard for and adherence to the religious beliefs of his forefathers, with an unparalleled love for and understanding of Nature; and with all of these qualities enveloped in a broad-minded tolerance, the combination of which determined Charles Marion Russell as one of the most unusual characters the Twentieth Century has produced.[7]

If nothing else, Maule was direct in his dismissal. After chiding Conway for the relentless anti-East asides throughout the manuscript, he cut the purple-penned Montanan down to size with his own condescending stroke: "The art of biography is a very specialized one. It is only learned by long experience and bitter struggles. It is in our mind to suggest to you and to Mrs. Russell that you now allow this manuscript to be taken by someone experienced in that very difficult and very tricky field of literature and rewrite the material into a shorter book."[8]

Conway and Nancy chose not to follow Maule's advice. They tried other publishers, including Scribner's, with the same chilly result. Then they tackled revisions on their own. At one point Conway complained to Nancy that he had worn out one typewriter retyping the manuscript and had had to buy a second.[9] Nancy, meanwhile, equipped with no better than an elementary-school education, presumed to act as his editor, a task that had daunted seasoned New York professionals. "I can show you how to make your own

stuff friendlier & breezier in every way and it will still be yours," she coached. "[T]o hell with the High Brows—You are big enough not to have to care for what any gimlet eyed Grammar [sic] shark is going to think."[10]

They got nowhere. Doubleday finally convinced Nancy to set the biography aside in favor of a collection of Charlie's illustrated letters. It was published as *Good Medicine* in 1929.[11]

Although Nancy had written a "Biographical Note" as introduction to *Good Medicine*, she did not abandon the idea of a larger biography. Even before Conway's death in 1933, she had decided to push forward on her own. "My plan is to work [Conway's manuscript] over . . . take out two-thirds of it, try to rub the rest of it into shape then possibly publish it," Nancy wrote to the Great Falls mortician who was trying to settle Conway's affairs.[12] Almost immediately, however, she was upstaged by Patrick T. "Tommy" Tucker, whose ghostwritten memoir, *Riding the High Country*, was published that same year.[13] Tucker had roamed the Montana range with Charlie Russell in the 1880s and described a number of their wilder escapades in his book. The stories were "mostly Fiction," averred Edward C. "Teddy Blue" Abbott, another one of Charlie's cowboy chums (whose 1939 memoir, *We Pointed Them North*, is likewise rich with Russell anecdotes). Nancy was incensed by Tucker's liberties. "[A]nyone who knew Charlie really would not recognize [him] in Tucker's book," she groused. Accordingly, she rededicated herself to publishing a proper version of Russell's life.[14]

Nancy tentatively called her memoir "Back-Tracking in Memory." Snippets survive in her personal papers. The best passages are the most intimate; for example, this account of Charlie and Nancy's first Christmas together, 1896, when they were living in a shack in Cascade:

> Our first Christmas, with no money to spend, and no place to spend it if there had been. . . . We both needed lots of things, and among those we wanted most were warm slippers, as the shack-home of ours was not very warm except in summer, so I bought for Charlie a pair of felt slippers and made a slipper bag out of black broadcloth and worked his initials with red silk on

one side and mine on the other, put the slippers in the case and hung it by his sock which he hung up for Santa Claus. My stocking was in another place to give plenty of room for Santa to get around. At four in the morning, there was no more sleep for us—it was Christmas morning! Our first Christmas, trotting in double harness!

I stepped out and got my stocking and crawled back into bed. I found some nuts, an orange and just the same kind of little hard, bright colored candies we had always had as children, and way down in the toe of my stocking I found a $5.00 bill and one package revealed to me a pair of felt slippers, the exact mates (only smaller) to those I had given my cowboy husband.[15]

Nancy struggled to complete her book, but a heart attack followed by a stroke doomed the project. For four decades she had been Charlie's spin doctor, and now she could not even look after herself. In her years of ill health she had no choice but to suffer the solicitations of one would-be biographer after another. Nancy had little trouble shooing away the lightweights. On March 9, 1936, Maurice Gale, a New York attorney, wrote to her, "I have compiled considerable data in regard to your late husband for the purpose of writing his life history." She declined to assist him, explaining (optimistically) that she was applying all of her material to her own book.[16] She never heard from Gale again. Other necromancers were more persistent, however, most notably James Brownlee Rankin, a New York schoolteacher, and J. Frank Dobie, the esteemed Texas historian and folklorist.[17]

Those who mistook Jim Rankin for a dilettante were sorely mistaken. When he first communicated with Nancy Russell in fall 1936, she was wary of his intent and skeptical of his bona fides. "It has long been my desire to compile a bibliography and check list of the paintings, drawings, and bronzes of Mr. Russell, and later write a biography of this great, outstanding artist," Rankin wrote on October 16. "Before I proceed any further with my work I should like very much to have your personal consent to the undertaking." Nancy responded with equal, but cautious, politeness.[18] Meanwhile, she began inquiring about this out-of-the-blue suitor through friends and collectors Rankin had already contacted about the project. "I don't think Rankin ever met Charlie," she confided to James W. Bollinger, an Iowa judge and former hunting partner of Charlie's (who was preparing his own

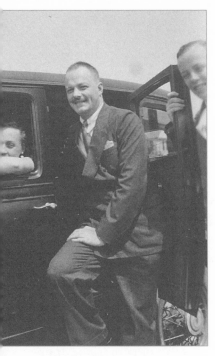

James B. Rankin, n.d.
MHS PHOTO ARCHIVES, HELENA

"Memory Book" on Russell). "I asked him if he had met him but he did not answer my question. . . . Mr. Rankin says that writing biographies is his business. I wonder what he has written."[19]

In fact, Rankin had not published any biographies. Born in Denver in 1900, he was shipped east for school. "As a child I was taken to Europe and educated amidst the art, music, and culture of the old world," Rankin explained to Nancy. After receiving degrees from Princeton and the University of Pennsylvania, he became a schoolteacher in New York. Like so many uprooted westerners, including prominent Russell collectors Malcolm Mackay and Philip Cole, Rankin never got the wide-open spaces out of his blood. "[M]y heart is in the west," he told Nancy. "Charlie Russell's pictures stir in me a part of my nature never to be downed by the veneer called civilization."[20]

When Rankin began his work, nobody, not even Nancy, knew where most of Charlie Russell's art was located. Many of the important pieces had ended up in conspicuous hands (Will Rogers, Douglas Fairbanks, Edward Doheny). But many more pieces belonged to cowboys, saloon keepers, even former prostitutes, whose names and addresses did not appear in any social register. In 1936 Rankin began a letter-writing campaign that would impress today's electronic-mail buffs. He wrote to Indians and ex-presidents. He queried Buckingham Palace (the Prince of Wales had been given a Russell in 1919). He tracked down homesteaders who had once tacked Russell originals to their log walls. In 1937, on his summer break from teaching in New York, he traveled to Montana, toured Russell's old haunts, and conducted many interviews in person. The following summer he traveled west again, including a stopover in St. Louis, Russell's boyhood home.

In many cases Rankin was the first—and last—historian to contact Russell's contemporaries. (Russell would have been seventy-three in 1937.) Sometimes their memories are fuzzy, other times self-servingly embroidered. Among the tailings, however, are some gems. The engraved stationery fairly blushes as an aging Laura Edgar Whittemore confesses to her teenage fling with Charlie in the Judith Basin: "We were both so young & it all happened so long ago. We were thrown together constantly & one year I went back to school [in St. Louis] a little girl in short skirts & hair down my back. The winter changed all that. I came home with my hair put up & my skirts long. Charlie liked the change & told me so. Where we had been comrades before we became sweethearts."[21]

Another Judith Basin resident, Cassandra Phelps, told Rankin of the time Charlie found himself in the midst of an argument over Prohibition. Russell had quit drinking in 1908 but was no proponent of the Volstead Act. Even so, he couldn't keep his lip buttoned when a pompous anti-prohibitionist invoked the Bible story of Christ drinking wine at a wedding in Canaan. "If you're going to make a drunkard out of Jesus Christ," Charlie interjected, no doubt with a wink, "I think you're getting a pretty late start."[22]

In 1939 Rankin moved to Pasadena, California, to be nearer his research. His good manners and above-board intentions dissolved Nancy Russell's initial reservations, and the two became warm friends. Rankin typed a first draft (or perhaps partial first draft) of a biography and made frequent trips to Trail's End, the Russell house, to read the manuscript to Nancy. From her wheelchair she offered corrections and deletions. When Nancy died in May 1940, Rankin served as an honorary pallbearer. That same year he married a young woman from New York, and thereafter his drive to publish his Russell catalog and biography waned dramatically. As late as 1950 he still professed an intent to publish a book. He never did, and his widow reported that he destroyed his manuscript before his death in 1962.[23]

Rankin did not let the torch go out completely, however. On his western tour in 1938 he had stopped off in Austin, Texas, to visit J. Frank Dobie. Dobie taught a course at the University of Texas called "Life and Literature of the Southwest." The story is told that when a pince-nezzed academic suggested that the Southwest had no

literature per se, Dobie shot back, "Well, then I'll teach the life." Dobie was ranch-raised and steeped in oral tradition—much the same as Will Rogers or Charlie Russell. Just as Russell had endeavored to eulogize "Trails Plowed Under" and chronicle "The West That Has Passed" from a Montana perspective, Dobie had set about to preserve the heritage of his native Texas. His books, *The Longhorns, The Mustangs*, and *A Vaquero of the Brush Country*, are the literary equivalents of Russell's paintings, *Jerked Down, Bronc to Breakfast* [FIG. 14], and *Cowboy Camp During the Roundup*.[24]

J. Frank Dobie, n.d.
MHS PHOTO ARCHIVES, HELENA

Dobie and Russell never met, but they were soul mates just the same. They even looked alike: stocky, square-jawed, with a mischievous bang dangling over twinkling blue eyes.

Dobie already had a strong interest in Russell at the time of Rankin's visit. In a 1927 review in the Dallas *Morning News*, he had called *Trails Plowed Under* "the most beautiful book dealing with the West of the present century."[25] In a letter to Rankin before their meeting, he wrote:

> To me [Frederic] Remington is an artist of extraordinary facility and competence in contrast with a burning and powerful genius possessed by Russell. Remington at best was looking in from the outside, while Russell belonged and was painting out of himself. . . . Russell went down to Mexico [in 1906], and he stayed for several months. When he came back, some of his friends asked to see his pictures of Mexico. He replied that a man would have to live down there for years before he could really understand the land and its people. [This] seems to me true to Russell's philosophy of his own art.[26]

Rankin further fanned Dobie's enthusiasm for Russell, and in December 1939 Dobie approached Nancy Russell, vouching that Charlie was "his favorite artist in the whole world and says more to

me than all the rest put together."[27] Dobie paid homage to Russell in *The Longhorns* two years later and from then on saved string toward the day when he would write something more expansive on his Montana idol. What Nancy Russell would never know is that the string Dobie gathered over the years had everything to do with Charlie's "life" and little to do with his cultural contribution, his art.

Throughout the 1940s and 1950s, and even into the early 1960s, whenever Dobie traveled the country to give speeches—usually in summer to escape the Texas heat—he always made a point of looking up old-timers who had known Russell. His notes still bear the sweaty crease from having been stuck in a suit coat pocket after an interview in a hotel lobby or banquet hall. Dobie collected his share of woolly wrangling stories and comical Charlie-in-the-big-city yarns, although one of Dobie's keenest interests seems to have been bawdy. Consider his jotting after an interview with former Montana cowboy W. R. Pontius in St. Paul in 1946. Quoting Pontius (which makes this at least a third-hand anecdote), Dobie wrote: "Sid Willis [proprietor of the Mint Saloon in Great Falls] told me . . . that one night he and Charlie were going home from somewhere and Charlie turned to go into a whorehouse. 'Sid, I've just got to get rid of it in here,' he said, bashfully." Or this recorded after Dobie's interview with Karl Yost, a Russell authority and bibliographer, in Chicago in 1952: "Yost told me that according to talk, not malicious, about 1901 Russell found himself impotent, a result of venereal disease contracted while he lived with an Indian woman. He let Mamie [Nancy's nickname] go her own way and threw himself into painting."[28]

Small wonder Dobie never wrote his book. Such material was too steamy for the professor's readership. And even if Dobie had curbed his prurience, Russell was simply too far removed from Dobie's southwestern bailiwick to command his full attention. At times Dobie insisted he never had intended to write more than a long essay. (Of the several articles he wrote on Russell, the most significant is "The Conservatism of Charles M. Russell," a polite reflection that accompanied a special edition of Russell prints in 1950.) But in 1946 he wrote to a friend, "It grows on me that I should write a book about him. . . . A book not too long about him, packed with stories and profusely illustrated with his own pictures, might

outsell any other picture book on the West." Twelve years later he confided to Michael Kennedy of the Montana Historical Society that he was still actively kicking the book idea around. "I suppose I have 25,000 words written," he acknowledged, "but haven't done anything on it in a long, long time, though materials are all in hand."[29]

Dobie's quest, like Rankin's, ultimately proved quixotic. But as with Rankin, his fieldwork did not go for naught. Dobie's notes are on file at the University of Texas. Moreover, Dobie was instrumental in preserving Rankin's mother lode. Rankin had contacted Dobie in 1955 while in the midst of cleaning out his house in San Bernardino, where he had been teaching college. In September Dobie made a trip to California and spent five days sifting through Rankin's Russell material, describing it as "a jumble in a trunk." With Rankin's consent Dobie shipped a bale of the letters back to Austin, where an assistant painstakingly transformed it into the bound, typewritten, seven-hundred-page "James Brownlee Rankin Collection of Letters and Other Papers Pertaining to Charles M. Russell." Dobie sent the originals, along with one of two bound volumes, back to Rankin in beer cartons. "I may never write the brief book on Charles M. Russell that I have long projected," Dobie wrote in an explanatory preface to the typescript. "Whether I do or not, here is valuable material for a book. . . . Nobody else pursuing a Western theme has ever garnered such a varigated [sic] mass of letters on any subject as James Brownlee Rankin has on Russell. His offering it all to me stands as one of the most generous acts I have known of and the most generous of its kind that I have experienced."[30]

Would that Dobie's graciousness and Rankin's generosity had been endemic throughout the Russell world. The antipodal Russellophile of the day was Homer E. Britzman, known in some contemporary circles as "Homer the Horrible." Britzman worked for the Rio Grande Oil Company in Los Angeles at the time he first met Nancy Russell in 1935. His true passion was collecting western art and artifacts, and when Nancy died, he saw opportunity in the settlement of her estate. On May 14, 1941, a year after Nancy's death, American Airlines president C. R. Smith purchased 32 Russell oils, 39 watercolors, 131 bronzes, 95 plaster objects, and 110 "models, statuettes, and personal effects" for $40,000, although the Russells'

close friend, actor William S. Hart, had previously tendered $50,000 for the same lot. Within minutes of acquiring the collection, Smith sold 14 paintings, 24 watercolors, 85 bronzes, and 110 painted plaster models to Homer Britzman for $20,000. Three weeks later, Britzman paid $7,850 for Nancy's house and most of its remaining contents—everything from fern stands to filing cabinets.[31]

Much of the ill feeling toward Britzman stems from his treatment of the Russell sculpture. Nancy Russell had explicitly intended that a complete set of Russell bronzes—the accepted total is 46—be cast and kept as a single collection. C. R. Smith, to his credit, honored her wish, eventually passing his set to the Amon Carter Museum of Western Art in Fort Worth. Homer Britzman, to his ignominy, did nothing of the kind. He cast multiples from molds that should have been destroyed. He cast bronzes from models that were never intended as bronzes, in many cases altering or damaging the originals.[32] Adding insult to injury, Britzman proudly promoted himself as a conscientious "expert"—a protector of the Russell legacy. More realistically, the fox was in the henhouse. Indeed, he owned it.

Researchers of Russell's life have their own bone to pick with Britzman. From a biographical standpoint, the 1940s and much of the 1950s belonged to Britzman, perforce because he was the laird of Trail's End. Besides selling bronzes Britzman was in the business of selling words. He wrote his own articles on Russell, including one called "Genius in Chaps" and another, "The West in Bronze." He formed his own imprint, Trail's End Publishing. Two of its first books, *Memories of Old Montana* and *Trails I Rode* by Cornelius E. "Con" Price, were spiced with the ex-cowboy's adventures with Charlie Russell.[33] Trail's End's biggest undertaking was a definitive biography of Russell. Britzman attempted to write it himself but in May 1945 admitted to Con Price that he had "died on the vine about seven or eight chapters short of the finish." Next Britzman hired a ghostwriter from Butte, Robert H. "Curley" Fletcher, best known as the author of the song, "Don't Fence Me In." As Price explained to Frank Dobie, "Curley Fletcher never knew Russ, Only writes from Data that Britz gives him."[34]

The "Data" was considerable. Nancy Russell had been a hoarder.

She kept every letter she or Charlie ever received and carbons of nearly every letter she ever wrote. She collected every newspaper mention of Charlie and his art. She filed exhibition catalogs bearing her penciled notations of prices and sales. She even saved the tags from her wedding presents. All of this was left in the house that Britzman bought. "He got some valuable dope there," Con Price wrote to Dobie.[35] Of particular value to Britzman as he undertook his biography were two manuscripts: Dan Conway's "Child of the Frontier," and Nancy's "Back-Tracking in Memory."

When the hard-drinking Fletcher did not deliver, Britzman sought a second ghost. Ramon Adams was a Dallas violinist-turned-lexicographer whose impressive collection of cowboy vocabulary, *Western Words*, had been published in 1944. From the hodgepodge of Russell's, Rankin's, and Britzman's own scribblings, Adams was able to cobble together the semblance of a book. When *Charles M. Russell, The Cowboy Artist* was published in 1948, Britzman's name appeared alongside Adams's on the title page.[36] He should have added Nancy Russell's and Dan Conway's as well. To say that Britzman judiciously excerpted from their manuscripts would be like saying he had merely curated the Russell sculpture collection. No, the larceny was wholesale.

This from Conway's "A Child of the Frontier":

Charley inherited a love for horses, and during these years of happy childhood, when he was not drawing, modeling or listening to frontiersmen's tales, he was riding his beloved pony, "Gyp," almost always without a saddle and going like the wind, his little yellow dog—just plain "dawg"—trailing along behind. As he grew in years, the stronger became his longing for the wilderness, and he was undoubtedly dreaming of the West as he rode at breakneck speed along the roads in the vicinity of Oak Hill.[37]

This from Adams and Britzman:

Charlie inherited his love for horses, and during his happy childhood years, when not drawing, modeling, or listening to frontiersmen's tales, he was riding his beloved pony, going like the wind, his little yellow dog trailing behind. As he grew in years,

the stronger became his longing for the wilderness, and he was undoubtedly dreaming of the West as he rode along the roads around Oak Hill.[38]

This from Nancy Russell's manuscript:

Charlie had one friend, Archie. . . . They made it up to write an excuse saying he was going to visit an Aunt in Kirkwood and would be gone some time. . . . He would take his books, go in each morning with the other children, get out at the corner, then instead of going to school, he would hide his books and go down to the river front or on to the levees to the mule markets. He would talk to the negroes that loaded and unloaded the river boats. He loved to see the fur traders come in and would listen absorbed, and he retained all he heard about the great Northwest. He knew he was going there some day.[39]

Compared with Adams and Britzman:

Charlie had a chum, Archie Douglas, and together they invented an excuse for Charlie to miss school. . . . Archie composed a note to the teacher stating that Charlie was going to visit an aunt for several weeks. . . . Each morning Charlie took his books and rode with the other children to the corner near the school. But instead of going to the classroom, he hid his books and went down to the river front or to the mule barns. Here he talked with Negroes loading and unloading the river boats; here, too, he listened with fascinated interest to the fur traders and the plainsmen ever arriving from and departing to the wilderness. Retaining all he heard of the great Northwest, he knew that nothing less than living in that section would make him completely happy.[40]

Frank Dobie forgave Ramon Adams—"an honest man"—for his participation but not Homer Britzman, whom he decried as "a coarse scoundrel." He panned their book as "bum biography."[41] The kindest thing that could be said for *Charles M. Russell, The Cowboy Artist* is that it celebrated Russell's extraordinary talent and personality. It marked a place. The first Russell biography finally had been published— albeit by an individual of questionable ethics and methodology.

Between Nancy Russell's death and the publication of the Adams and Britzman book, several other Russell manuscripts had lived and died without stirring much dust. In 1942 Marguerite Greenfield of Helena completed "When the West Was Young," a thirty-thousand-word account of "Experiences of Charles Marion Russell, Montana's Cowboy Artist during his early years in the state." It was rejected by Caxton Printers, the well-regarded Idaho publishing firm. In 1954 Frank Dobie received a copy of "Idol of the Cowboys: Russell of Montana, Master Painter of the Old West," a 145-page chronicle written by Basil Rudd, a Billings newspaperman. Dobie could not recommend it for publication, but he did like Rudd's work enough to pay the author fifty dollars for a copy. Dobie would not be guilty of Britzman's impropriety. Nor did he share the killjoy cynicism of Con Price, who had written to Britzman in November 1950: "Got a letter from some Dame in Portland. She is writeing [sic] Charlie Russell's life. What the Hell are they going to do with all those [R]ussell books when they don't know what they are writeing about?"[42]

One person who did know what he was writing about was Austin Russell. Austin was the son of Charlie's older brother Bent, a successful St. Louis engineer. Austin had first come to Montana on family vacations. In 1908 he stayed in Great Falls, taking jobs at the local smelter and with the city streetcar company. Charlie and Nancy, childless until the adoption of Jack Russell in 1916, took the dark-eyed, often brooding Austin under their wing, although he was already in his twenties. It was probably no coincidence that surrogate son Austin moved back to St. Louis the same year baby Jack arrived.

Forty years later, after a long postponement, Austin published *C.M.R.: Charles M. Russell, Cowboy Artist.* He called it a biography, but more accurately it was a memoir—patchy, subjective, and pleasantly tangy. It is Austin's firsthand observations that resonate best today. He describes a young Charlie as "an odd-looking kid, sturdily built, as blonde as a Swede—so blonde that from a distance he seemed to have no eyebrows . . . with fierce blue eyes and a stubborn mouth." He sketches Nancy as "plump and squeezable . . . with nothing whatever to show that she was as smart as a steel trap and as quick as the lash of a whip." And it was Austin who recorded the Russells' deliberations over adopting a child. Charlie argued to

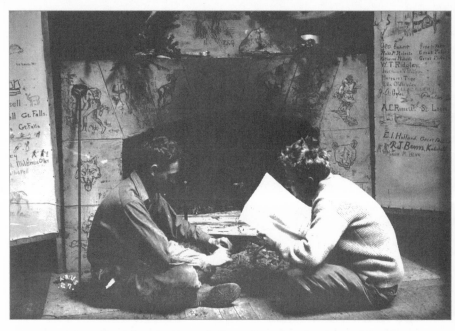

Austin Russell, at left, and Bill Krieghoff in Bull Head Lodge, the Russell's cabin on Lake McDonald, 1912 or 1913. MHS Photo Archives, Helena

Nancy, "'I'm older than you [he was fifty-two in 1916, she thirty-eight] and I'll die first. If we adopt a boy he'll light out across country as soon as he grows up, or go to jail or something; but a girl stays home till she's married, and she'll be company for you.'"[43]

In search of a big name to write an introductory endorsement of his book, Austin wrote to Frank Dobie and A. B. Guthrie, Jr., Montana's Pulitzer Prize–winning author, who was just coming out with his cowboy novel, *These Thousand Hills*. Both declined, and so Austin's book slipped quietly into and out of print. Dobie found it "surprisingly good" and "better written than the one by Ramon Adams and Britzman." Even so, its appearance was eclipsed by two other Russell events—the promise of a Russell motion picture and the publication of a large Russell picture book.[44]

The idea of a movie based on Charlie Russell's life had been around for years. The Great Falls *Tribune* reported in September 1950 that "Hollywood Film Director Byron Haskin, now directing the cavalry epic 'Warpath' at Billings, intends to turn his color cameras on the Charlie Russell saga." The plan vaporized, but in 1954 Universal-International announced that it had developed its own

Russell movie. Written by Borden Chase, who also wrote *Red River* (United Artists, 1948), the script borrowed many of the scenes described in Tommy Tucker's fanciful *Riding the High Country*. Initial press releases hinted that Jimmy Stewart might be cast as Russell. By July 1955 the part had gone to Audie Murphy. The decorated veteran was weary of his fighting roles in Westerns and saw the Russell movie as a chance to go unarmed without entirely deserting the genre. Jesse Hibbs, who had just finished directing Murphy as an avenging gunslinger in *Ride Clear of Diablo* (Universal, 1954), was scheduled to begin in Montana in September, with a budget estimated somewhere between one and three million dollars. But the filming was postponed indefinitely, and Hibbs and Murphy made *To Hell and Back* (Universal International, 1955) instead. Fess Parker, known for his roles as Davy Crockett and Daniel Boone, dug up the Universal script years later, and then abandoned it once more. Audie Murphy never got his wish, dying in a plane crash in 1971.[45]

Those eager to see Charlie Russell on the big screen had to settle for his pictures in a big book. Harold McCracken's *The Charles M. Russell Book: The Life and Work of the Cowboy Artist* was published by Doubleday and Company in 1957. McCracken had published a similar volume on Remington ten years earlier. His Russell book contained thirty-five color plates and scores of black-and-white reproductions.[46] McCracken—who was at the time a consultant to the Buffalo Bill Historical Center in Cody, Wyoming, and soon would become its director—added a lot of substantive detail to the Russell profile. But he also succumbed to the most trail-worn Russell apocrypha about the early years on the Montana range and repeated many of the fictions promulgated by Adams and Britzman. He helped ensure the Leatherstocking version of Russell's two-year stay with mountain man Jake Hoover. And he ratified the myth that Russell had spent the winter of 1887–88 as an adopted member of the Blood Indians of Canada. On balance, McCracken wrote a good Western; he did not write a good Western biography. McCracken's chronology ends just as Russell gets famous, and he has next to nothing to say about the second half of the artist's life, which is equally fascinating.

McCracken's book was considered the authoritative source on Russell until Frederic G. Renner weighed in. Renner had been a

force to be reckoned with in Russelliana for years. He was a Montana native; the family ranch was near Cascade, although Renner was raised in Great Falls. He liked to tell people that his mother and father had been among the small group of guests at the Russells' wedding in 1896. He cherished boyhood memories of slipping out to Charlie's studio to watch Charlie paint while Mrs. Renner called on Mrs. Russell. After college Renner took jobs first with the United States Forest Service, and then with the Soil Conservation Service, living most of his working years in Washington, D. C. He had collected Russell art and ephemera all his life, but after a visit to Nancy Russell in the 1930s, his hobby became a full-blown obsession. By the mid-1950s he purportedly had a record of three thousand Russell works of art. After meeting Renner in Helena in 1954, Frank Dobie noted that he "knows more about Russell than anybody else alive."[47]

Even while he was pursuing his distinguished career with the federal government, Renner made a business out of his Russell expertise as well. He bought and sold Russells, and seldom did a major piece of Russell art change hands without Renner at least stepping in as authenticator. Universal flew him to Hollywood to consult on the proposed movie.[48]

Renner also turned his knowledge to writing, first publishing an article on Russell forgeries, and then fashioning other pieces of a more hagiographic nature. Like Rankin, he nursed the idea of publishing a catalog *raisonné*. Upon his retirement in 1961, he helped curate the first exhibition of Russell illustrated letters at the Amon Carter Museum of Western Art in Fort Worth, Texas, and wrote the introduction to the catalog. In 1966, again under the aegis of the Amon Carter, he published his magnum opus, *Charles M. Russell: Paintings, Drawings, and Sculpture in the Amon Carter Museum*. This was the biggest, most colorful Russell book to date and would stand as a benchmark for more than twenty years.[49]

Renner's appetite for all things having to do with Russell naturally included any extant research on the subject. He was one of the few people who possessed a copy of the Conway manuscript, and in 1962, shortly after Jim Rankin's death, Renner asked Rankin's widow Josephine if she would part with her husband's Russell papers. "Fred Renner wants the material," Josephine wrote to Dobie

in October, "but I wonder if I am to hand it over to him for nothing." A colleague of Renner's had seen Dobie's typescript of the Rankin papers and valued it at five hundred dollars. Dobie wrote back, advising Josephine that the script's index alone was worth that price. Seven years earlier, Dobie urged Jim Rankin to leave his papers to a library, museum, or university, rather than have them dispersed to private collectors. Josephine eventually followed Dobie's suggestion and donated the collection to the Montana Historical Society in 1983. Along the way Fred Renner succeeded in acquiring Rankin's bound typescript of the papers.[50]

*Charles M. Russell: Paintings, Drawings, and Sculpture* documents what is arguably the best collection of Russell art in the world. The Amon Carter Museum owns the C. R. Smith bronzes but also the remarkable Mint Collection. One of the first individuals to assemble a significant group of Russells was Charlie's friend Sid Willis, proprietor of the Mint Saloon in Great Falls. Russell was a regular at the Mint, and over the years Willis turned his watering hole into a virtual museum; the controversial centerpiece was a peep show featuring a painting of a cowboy copulating with an Indian. Amon Carter, the wealthy newspaper publisher, acquired the entire Mint Collection in 1952 for an estimated two hundred thousand dollars, much to the dismay of Montanans.[51]

Renner's book on the Russells gathered in Carter's Fort Worth museum contains more than two hundred reproductions of Russell's work. Each image is accompanied by a paragraph or two of Renner's astute explication. We learn the names of the people and landmarks in each painting, where it was painted, and who its owners were (before Amon Carter). Renner's thirteen-page biographical introduction is further testimony to his learnedness. He knew not to lean on either McCracken or Adams and Britzman. Curiously, however, he gave no credit to Rankin.

On the first page of Renner's introduction, he relates a story of Russell's first venture as a sculptor: "One day, when he was barely four, Charlie wandered away from home and was found following a man with a trained bear on a chain. That night he modeled a small figure of the bear from the mud taken from his shoes." Renner's footnote for this story reads, "Florence M. N. Russell, in private

correspondence dated March 5, 1937, from copy *in possession of the author.*" (Emphasis added.)[52] Florence Russell was Charlie's stepmother; she had married Charlie's father after his mother died and moved to Los Angeles after she herself was widowed. That was where Jim Rankin found her—and it was to Rankin that Florence Russell wrote the letter in question.[53] Considering Rankin's immense amount of detective work, why could Renner not give him at least a footnote? Perhaps the omission can be explained as simply a matter of intellectual property in limbo. Renner's only published acknowledgment of Rankin seems to be a 1971 letter in *Montana The Magazine of Western History*:

> I first crossed Rankin's tracks in Montana in 1937 and 1938 but never met him until about 1960 when I traced him to San Bernardino where he was teaching in the Junior College. During the summers of 1937–38, Rankin interviewed a host of Russell's Montana friends and also corresponded with hundreds of others all over the country. . . . After Rankin's death a few years ago, I obtained copies of this correspondence. . . . Whether Rankin found that he was unable to do justice to the subject or was unable to interest a publisher, I never learned.[54]

Why Renner was unable to do justice to Rankin will never be learned either. Renner died in 1987 and was buried in Highland Cemetery in Great Falls. His grave is immediately behind Charlie and Nancy's—in the spot originally reserved for the Russells' son, Jack.

One of Renner's most ardent detractors was Joe De Yong, who for ten years was virtually a second adopted son to the Russells. De Yong grew up in Oklahoma. In 1913, while riding as an extra in a Tom Mix movie, he came down with spinal meningitis; the illness deafened him permanently. A budding artist, De Yong moved to Montana in 1915, at age twenty, partially to be nearer his hero, Charlie Russell. Russell took a shine to De Yong and invited him to work in the studio. On and off for the next ten years, De Yong lived with the Russells, both in Great Falls and at Glacier Park. Through sign language, shorthand, and demonstration, Russell tried to pass his know-how on to his protégé. Nancy, meanwhile, helped De Yong sell his work. When Jack Russell arrived De Yong stayed on to baby-sit and run errands.

De Yong parlayed his talent and his link to Charlie Russell into

a successful career in Hollywood. He designed sets for *The Plains-man* (Universal, 1966, starring Montanan Gary Cooper), *The Pale-face* (Paramount, 1948, with Bob Hope), and *Shane* (Paramount, 1953, scripted by A. B. Guthrie, Jr.). In the fall of 1926 he had been studying art in Santa Barbara and always regretted being absent when Russell died. For the rest of his life he was scornful of the "human buzzards" who came poking around Russell's art and name. Frank Dobie came away chastened from a 1954 meeting with De Yong. Dobie's interview notes record that De Yong "responded that what he knows about Russell nobody else knows—and nobody else will know until he is ready to release it for a good price. He did not want to give me an anecdote, an observation or anything else."[55]

De Yong himself admitted that he was "not exactly a Boy Scout" when it came to protecting his mentor's name. He slandered other artists who had come under Russell's influence: Charles Beil was as "unfeeling as a meat-grinder"; Olaf Seltzer was a "commonly-regarded blowhard." De Yong harbored special resentment for those whom he felt were trying to get rich from Russell's art. He referred sarcastically to Denver dealer Fred Rosenstock as "our Polish-Jew friend." Idaho dealer Richard Flood had "a peculiarly cheap and sly manner." He shunned Britzman entirely.[56]

De Yong was downright hostile when it came to Fred Renner. In a letter to Montana artist Branson Stevenson in 1957, De Yong re-membered Renner as a kid:

> who occasionally came out to [Russell's] studio, but when he looked me up in Santa Barbara some years later, he was just "an-other guy" as far as I could recall. In any case, he appears to have stuck his nose to the ground and smelled out every possible trace of every "Russell" ever made. . . . I honestly believe him to be the coldest-blooded character I've ever encountered in my whole life; in fact I practically laughed in his face. . . . I said, "Either people have given you some very rough deals in life, or you ex-pect them to, according to the way you keep your guard up!" And the S.O.B. had the grace, at least, to turn a Cinnamon Pink.[57]

Whenever anything was published about Russell, De Yong was quick to pick at the weaknesses. In Renner's article on Russell forgeries,

De Yong spotted "several slips that indicate [Renner] is not the expert he would like to have people in general think." He bashed a 1963 collection of rather sweet reminiscences on Russell written by Charlie's close friend Frank Linderman as "a book in which Russell becomes as defenseless a target as a bale of hay set up on an archery-range."[58]

Tired of all the pretenders, De Yong vowed that he would "sit down and get [the story of Charlie Russell] out of my system."[59] But he could never quite get rolling on his own book. His personal papers are full of false starts and helter-skelter bursts of Russell descriptions. A typical bit: "'Charlie Russell—Sagebrush!'—Gifted, yet unschooled—from choice! Massive of head, direct of eye, and wholly indifferent to the impression he made on qualified critic or chance passer-by . . . possessing a deep, unhurried, self-confident voice. He, Indian-like, often preferred to speak by a toss of the hand . . . Often a ribald mixer; surely never one to preach."[60]

The best De Yong could muster was a couple of articles for western history journals, but even then he whined about how his manuscripts had been handled. "As a writer, I am, admittedly, (so far) down near the bottom of the deck—where I belong," he wrote to an editor. "But—even so, I am convinced that it is my right to object when 'words are put in my mouth.'" He called the whole experience "heart-twisting." De Yong died in 1975, leaving behind only a fraction of the stories that only he could have told about Charlie Russell.[61]

With Joe De Yong's death in 1975, and Fred Renner's in 1987, an epoch in Russell history came to an end. There remained no one who had known Russell or lived in his time to write Russell's story. Dan Conway, Nancy Russell, Jim Rankin, Frank Dobie, and Joe De Yong—none had published a biography. Those who had completed books—Adams and Britzman, Austin Russell, McCracken, and Renner—left something to be desired as shelf mates. Two other books to appear were so slight as to be hardly noticeable. Doris Shannon Garst published a children's book on Russell in 1960, and Mrs. Royal J. Klaue, a schoolteacher who had grown up in the Judith Basin, published a novelized version of Russell's life in 1962 under the pen name Lola Shelton.[62]

Here the bad-medicine thesis would be well served if one could banish the post-1960s commentary on Russell to the ivory towers

of art history or art criticism. But such is emphatically not the case. The recent investigation done under these rubrics marks a new high in Russell biographical scholarship. Let us set the genesis as 1982 with the exhibition, "Charles M. Russell: American Artist," at the Museum of Western Expansion in St. Louis. The catalog for this show presented a collection of consistently smart essays, including one by Brian W. Dippie, professor of history at the University of Victoria, British Columbia. Through the 1980s Dippie continued with lectures, articles, and books that fleshed out Russell's life and boldly delineated his influences; Dippie's most notable titles are *Remington and Russell* and *Looking at Russell*.[63] In what seems an attempt to shoot the messenger, old-school Russell worshippers accused him of blasphemy for suggesting that Russell had appropriated ideas from other artists.[64]

If Dippie has succeeded in stirring the discussion of Russell art to an unprecedented pitch, it is largely because his knowledge of Russell's life is itself unprecedented, at least in the past three decades. Dippie's biggest breakthrough came in 1991 when, working through the Amon Carter Museum, he gained access to Nancy Russell's records. After Homer Britzman's death in 1953, his wife had held onto the Russell estate papers, and then finally bequeathed them to the Colorado Springs Fine Arts Center, where they languished in a basement vault for years. Dippie and the Amon Carter succeeded in exhuming them. The Helen E. and Homer E. Britzman Collection, as this biographical bounty is now called, figures largely in Dippie's 1993 book of Russell's illustrated letters, *Charles M. Russell, Word Painter*, as well as in two other recent books: a lushly illustrated Russell primer written by Peter H. Hassrick, until recently director of the Buffalo Bill Historical Center, and the definitive book on Russell sculpture by Rick Stewart of the Amon Carter Museum.[65]

No one knows precisely how many people have endeavored to write a book about Russell, but a safe guess would be two or three dozen. The number of published books that can loosely be categorized as Russell biographies is no greater than seven, if one counts Joan Stauffer's 1990 book on Nancy Russell, *Behind Every Man*.[66] Against such odds, I set out in 1992 to write a biography that skirted the mistakes and gleaned the wealth of all those who had gone

before. My book, *Charles M. Russell: The Life and Legend of America's Cowboy Artist*, has just been published.[67] If I had known about the Curse of the Buffalo Skull, perhaps I might not have begun; I guarantee that I would never have completed my project without the extraordinary groundwork of Dan Conway, Nancy Russell, Jim Rankin, Austin Russell, Joe De Yong, Fred Renner, Brian Dippie, and even Homer Britzman.[68]

Why another attempt at a Russell biography? It is my opinion that heretofore no one has written a thorough account of Russell's life. Even those who succeeded in their inquiries—for example, Austin Russell and Brian Dippie—did not have pure biography as their final goal. Those who did claim to write biography—Britzman and McCracken—crafted myth instead. These distorters of the Russell story did not depart from reality fatuously or maliciously. Nevertheless, they did a disservice to the complexity of Russell's humanity and in some instances to his achievement. In making Russell larger than life, they made his life less textured; in striving for a broad-brush masterpiece, they blotted out some of Russell's most brilliant and quirky strokes. That said, I hasten to add that the Russell legend they promoted is important in and of itself; it is now as much a part of the record as, say, the provenance of his art or the testimonials of his friends. "Myth is the Mother of Romance," Russell wrote to his neighbor Josephine Trigg, "and I am her oldest son."[69] In my writing, I have made no effort to expunge the myth or denude the romance; indeed I cherish them. Outstanding men deserve good yarns, and their legacies can accommodate them honestly.

My aim from the beginning was simply to reassemble the minutes of Russell's life—including those transcribed by my predecessors—and delineate them from the tall tales that once overruled them. If I claim to have set the record straight, I do not mean to say that my biography is anything more than one man's distillation of the truth. I have arranged the furniture where I believe it belongs, along the way identifying which pieces are faux or flimsy. I have dusted all the gaudy, overstuffed items, although I warn readers to sit in them at their own risk. Of course I have made additions, the value of which will have to be decided by other historians. The most useful thing I've done is to situate Charlie Russell more firmly in the

context of time and place. What was the Montana that inspired him? What was the nation—and art world—that embraced him?

Much work remains in the areas of both interpolation and extrapolation. There are many blanks still to be filled in the Russell chronology, just as there are Russell paintings yet to be discovered and explained. Russell buffs are bent on identifying every campsite and hoofprint of his eleven-year stint as a Montana wrangler. Perhaps then they will shift their energy to the potentially more revealing assignment of tracing Russell on his copious road trips to St. Louis, the East, and California. After all, Russell spent much more time as a gadabout artist than he did as a drifting cowboy, and his itinerary is only now being penciled in. On a larger scale, more could be done to lift Russell above the second-class genres of the West and western art. To my mind, Russell deserves a place next to Walt Whitman, Mark Twain, or any twentieth-century pop star one can name. Like the best our blatant republic has produced, he was part mirror, part anomaly. Yet essays that bring Russell to the fore of American culture are rare. I may be another who has fallen under the spell, but I firmly believe that the more the world knows about Charles M. Russell, the more it will celebrate his greatness.

## NOTES

1. Dan R. Conway to NCR, December 30, 1932, Britzman Collection.

2. *GFT*, June 30, 1927.

3. NCR to Conway, April 2, September 1, 1927, Britzman Collection; Conway to NCR, September 2, September 13, 1927, ibid.; Joe De Yong to J. Frank Dobie, December 7, 1954, Dobie Collection; Charles M. Russell, *Trails Plowed Under* (Garden City, N.Y., 1927).

4. NCR to Conway, November 26, 1927, Britzman Collection.

5. Ibid., January 9, 1933; Wade H. George to NCR, May 31, 1933, Britzman Collection; NCR to De Yong, May 20, 1933, De Yong Papers, Great Falls.

6. NCR to Conway, April 2, 1927; Conway to NCR, September 13, 1927, Britzman Collection.

7. Dan R. Conway, "A Child of the Frontier: Memoirs of Charles M. Russell (The Cowboy Artist)," typescript, October 19, 1927, SC 1321, MHS.

8. Harry Maule to Conway, November 23, 1927, Britzman Collection.

9. Conway to NCR, October 10, 1927, Britzman Collection.

10. NCR to Conway, draft of letter, n.d., Britzman Collection.

11. Charles M. Russell, *Good Medicine: The Illustrated Letters of Charles M. Russell* (Garden City, N.Y., 1929).

12. NCR to George, June 9, 1933, Britzman Collection.

13. Patrick T. Tucker, *Riding the High Country*, ed. Grace Stone Coates (Caldwell, Idaho, 1933).

14. Edward C. "Teddy Blue" Abbott to NCR, March 28, 1934, Rankin Papers. E. C. Abbott and Helena Huntington Smith, *We Pointed Them North: Recollections of a Cowpuncher* (New York, 1939); NCR to James B. Rankin, December 23, 1936, Britzman Collection.

15. NCR, "Christmas 1896," unpublished manuscript, n.d., Britzman Collection.

16. Maurice Gale to NCR, March 9, 1936; NCR to Gale, March 18, 1936, Britzman Collection.

17. James Brownlee Rankin is not directly related to the siblings Jeannette and Wellington Rankin, who also figure prominently in the history of Montana in this century.

18. Rankin to NCR, October 16, 1936; NCR to Rankin, October 19, 1936, Rankin Papers.

19. NCR to James W. Bollinger, December 23, 1936, February 4, 1937, Britzman Collection; James W. Bollinger, *Old Montana and Her Cowboy Artist* (Shenandoah, Iowa, 1963).

20. Preface to index of the Rankin Papers, n.d.; Rankin to NCR, February 21, 1937, draft of letter, Rankin Papers. The Mackay Collection now resides at the Montana Historical Society; the Philip Cole Collection belongs to the Gilcrease Institute of American History and Art, Tulsa, Oklahoma.

21. Laura Edgar Whittemore to Rankin, August 17, 1938, Rankin Papers.

22. Cassandra O. Phelps to Rankin, September 25, 1937, Rankin Papers.

23. Preface to Rankin Papers; Josephine Rankin to Dobie, October 14, 23, 1962, Dobie Collection; Rankin to Dobie, August 11, 1950, Ibid.

24. J. Frank Dobie, *The Longhorns* (Boston, Mass. 1941); J. Frank Dobie, *The Mustangs* (Boston, Mass., 1934); J. Frank Dobie, *A Vaquero of the Brush Country* (Dallas, Tex., 1929).

25. Dallas *Morning News*, October 30, 1927.

26. Dobie to Rankin, May 16, 1938, Dobie Collection. Russell painted several Mexican subjects after his trip, but they do not rank with his best work.

27. Dobie to NCR, December 12, 1939, Dobie Collection.

28. W. R. Pontius to Dobie, August 1946; Dobie notes from interview with Karl Yost, February 16, 1952, Dobie Collection.

29. J. Frank Dobie, "The Conservatism of Charles M. Russell," in *Seven Drawings by Charles M. Russell with an Additional Drawing by Tom Lea*, comp. Carl Hertzog (El Paso, Tex., 1950 [reprinted in this volume]); Dobie to "Raymond," August 4, 1946, Dobie Collection; Dobie to Michael Kennedy, August 28, 1958, ibid.

30. Rankin to Dobie, July 27, September 19, 1955, October 3, 1956; Dobie to Rankin, April 2, 1956; Dobie, "Explanation," bound transcript of "The James Brownlee Rankin Collections of Letters and Other Papers Pertaining to Charles M. Russell," November 22, 1955, Dobie Collection.

31. NCR to Homer E. Britzman, October 14, 1935, Britzman Collection; Nancy C. Russell Estate, California Superior Court Records, Los Angeles County (hereafter NCR Estate Records). The author is grateful to Rick Stewart of the Amon Carter Museum for sharing his research in this area. C. R. Smith commissioned Dobie's essay, "The Conservatism of Charles M. Russell."

32. Rick Stewart, *Charles M. Russell, Sculptor* (Fort Worth, Tex., 1994), 114–25.

33. Homer Britzman, "Genius in Chaps," *Arizona Highways*, 25 (November 1949), 16–29; Homer Britzman and Lonnie Hull, "The West in Bronze," *Westerners Brand Book* (Los Angeles, Calif., 1949), 89–136; Con Price, *Trails I Rode* (Hollywood, Calif., 1947); Con Price, *Memories of Old Montana* (Pasadena, Calif., 1945).

34. Britzman to Con Price, May 22, 1945, Britzman Collection; Price to Dobie, August 9, 1946, Dobie Collection; Price to Pontius, July 10, 1946, ibid.

35. Price to Dobie, August 9, 1946, Dobie Collection.

36. Ramon F. Adams, *Western Words: A Dictionary of the Range, Cow Camp and Trail* (Norman, Okla., 1944); Ramon F. Adams and Homer E. Britzman, *Charles M. Russell, The Cowboy Artist: A Biography* (Pasadena, Calif., 1948). There is some suggestion that Adams and Britzman had access to Rankin's draft as well.

37. Conway, "A Child of the Frontier," MHS.

38. Adams and Britzman, *Charles M. Russell, The Cowboy Artist*, 9.

39. NCR, "Back-Tracking in Memory," unpublished ms., Britzman Collection.

40. Adams and Britzman, *Charles M. Russell, The Cowboy Artist*, 15–16.

41. Dobie to Rankin, September 12, 1950; Dobie notes, December 4, 1954; and Dobie to Basil Rudd, August 25, 1954, Dobie Collection. Another reason for Dobie's grudge was the Britzman family's refusal to give him access to the Russell estate papers.

42. Marguerite Greenfield to Caxton Printers, January 5, 1942, Charles Diggs Greenfield, Jr., Family Papers, MC 166, MHS; J. H. Gipson to Greenfield, January 7, 1942, ibid.; Dobie to Rudd, August 25, September 7, 1954, Dobie Collection; Price to Britzman, November 17, 1950, Britzman Collection.

43. Austin Russell, *C.M.R.: Charles M. Russell, Cowboy Artist* (New York, 1956), 15, 89, 207.

44. Austin Russell to De Yong, December 6, 1956, De Yong Papers, Oklahoma City; Austin Russell to Dobie, February 27, 1956, Dobie Papers; Dobie to Austin Russell, March 14, 1956, ibid.; A. B. Guthrie, Jr., *These Thousand Hills* (Boston, Mass., 1956); Dobie to Rankin, November 5, 1957, Dobie Collection.

45. *GFT*, September 13, 1950, August 26, 1954, July 24, August 2, 1955; Frederic G. Renner to Dobie, September 18, 1954, Dobie Collection; Don Graham, *No Name on the Bullet: A Biography of Audie Murphy* (New York, 1989);

Don Graham, interview with the author, November 8, 1995, Austin, Texas; NCR Estate Records.

46. Harold McCracken, *The Charles M. Russell Book: The Life and Works of the Cowboy Artist* (Garden City, N.Y., 1957); Harold McCracken, *Frederic Remington: Artist of the Old West* (Philadelphia, Penn., 1947).

47. Jeff C. Dykes, "Frederic G. Renner," *American Book Collector*, 12 (November 1961), 5–8; Barbara H. Perlman, "Fred Renner Can 'Smell a Russell'," *Art News*, 80 (December 1981), 98–102; *GFT*, August 20, 1954.

48. Renner to Dobie, October 18, 1954, Dobie Collection.

49. F. G. Renner, "Bad Pennies: A Study of Forgeries of Charles M. Russell Art," *Montana*, 6 (Spring 1956), 1–15 (reprinted in this volume); F. G. Renner, "Rangeland Rembrandt: The Incomparable Charles Marion Russell," ibid., 7 (Autumn 1957), 15–28; [Charles M. Russell], *Paper Talk: Illustrated Letters of Charles M. Russell*, with introduction and comments by Frederic G. Renner (Fort Worth, Tex., 1962); Frederic G. Renner, *Charles M. Russell: Paintings, Drawings, and Sculpture in the Amon Carter Collection* (Austin, Tex., 1966).

50. Dobie, notes from meeting with Renner, Helena, Montana, July 18, 1954, Dobie Collection; Renner to Dobie, February 8, 1963, ibid.; Josephine Rankin to Dobie, October 14, 1962; Dobie to Josephine Rankin, October 21, 1962, ibid.; Ginger Renner, interview with the author, February 3, 1993, Paradise Valley, Arizona.

51. *GFT*, August 27, 1952.

52. Renner, *Charles M. Russell*, 19.

53. Florence M. N. Russell to Rankin, March 5, 1937, Rankin Papers.

54. Frederic G. Renner, letter to the editor, *Montana*, 21 (Summer 1971), 78.

55. De Yong to Branson Stevenson, March 2, 1945, De Yong Papers, Great Falls; Dobie, notes from interview with De Yong, December 3, 1954, Hollywood, California, Dobie Collection.

56. De Yong to "Friend Bill," January 3, 1952, De Yong manuscript, n.d., De Yong Papers, Oklahoma City; De Yong to Stevenson, November 11, 1949; May 16, 1960; September 28, 1962, De Yong Papers, Great Falls.

57. De Yong to Stevenson, September 18, 1956, De Yong Papers, Great Falls.

58. Ibid., September 18, 1956, January 13, 1964; Frank Bird Linderman, *Recollections of Charley Russell* (Norman, Okla., 1963).

59. De Yong to Stevenson, March 2, 1945, De Yong Papers, Great Falls.

60. De Yong, manuscript, n.d.

61. Joe De Yong, "Modest Son of the Old West," *Montana*, 8 (Fall 1958), 90–96; Joe De Yong, "Charlie and Me . . . We Run Together Fine," *Persimmon Hill*, 11 (no. 3/4, 1982), 70–80; Joe De Yong, draft of letter to Michael Kennedy, n.d., De Yong Papers, Oklahoma City.

62. [Doris] Shannon Garst, *Cowboy-Artist: Charles M. Russell* (New York, 1960); Lola Shelton, *Charles Marion Russell: Cowboy, Artist, Friend* (New York, 1962).

63. Brian W. Dippie, "Two Artists from St. Louis: The Wimar-Russell Connection," in *Charles M. Russell: American Artist*, ed. Janice K. Broderick

(St. Louis, Mo., 1982), 20–23; Brian W. Dippie, *Remington and Russell: The Sid Richardson Collection* (Austin, Tex., 1984); Brian W. Dippie, *Looking at Russell* (Fort Worth, Tex., 1987).

64. See Vivian Paladin's review of *Looking at Russell* in the *Western Historical Quarterly*, 20 (February 1989), 68.

65. Brian W. Dippie, ed., *Charles M. Russell, Word Painter: Letters 1887–1926* (Fort Worth, Tex., 1993); Peter H. Hassrick, *Charles M. Russell* (New York, 1989); Stewart, *Charles M. Russell, Sculptor.*

66. Joan Stauffer, *Behind Every Man: The Story of Nancy Cooper Russell* (Tulsa, Okla., 1990).

67. John Taliaferro, *Charles M. Russell: The Life and Legend of America's Cowboy Artist* (New York, 1996).

68. Two important journal articles were also indispensable: Lyle S. Woodcock, "The St. Louis Heritage of Charles Marion Russell," *Gateway Heritage*, 2 (Spring 1982), 2–15; Hugh A. Dempsey, "Tracking C. M. Russell in Canada, 1888–1889," *Montana*, 3 (Summer 1989), 2–15 (reprinted in this volume).

69. CMR to Josephine Trigg, verse accompanying clay sculpture, *Romance*, n.d., CMR Museum, Great Falls.

# Tracking C. M. Russell in Canada, 1888–1889

Hugh A. Dempsey

JUST OVER A CENTURY ago, during the winter of 1888–89, cowboy artist Charles M. Russell experienced six of the most important months of his colorful career. Historians and biographers, however, have never quite succeeded in discovering exactly where Russell lived during those six months or what he did. Something of a legend has grown up about this period in his life, when he supposedly lived with the Blood Indians in Canada, learning about Indian life during the Buffalo Days. Russell left clues about his sojourn in Canada, but many of them have been obscured in the larger legends of his fantastic life. Following those clues and piecing together his whereabouts during the winter of 1888–89, however, is worth the effort

and sheds new light on Russell as artist and as friend of the Indians.

The time that Charlie Russell spent in Canada, as Harold McCracken pointed out, "undoubtedly had a deep and lasting influence upon his attitude toward the Indians and their subjugation by the white man. Some of his finest pictures were drawn from the recollections of that experience."[1] But Russell never said much about those winter months. A few years after Russell's death, his widow, Nancy, wrote that Charlie "became a great friend of a young Indian, named 'Sleeping Thunder.' Through their friendship, the older men of the tribe grew to know Charlie and wanted him to marry one of their women and become one of them."[2] From that description, the legend of Charlie Russell's Canadian experience grew and blossomed under the imaginative hands of each succeeding biographer and writer.

In 1948, Ramon Adams and Homer Britzman described how Russell wintered with the Bloods and learned their customs, habits, and language. He hunted with them, listened to their tales of war, let his hair grown long, and adopted their mode of dress. "Charlie became, in fact, one of the tribe," they wrote.[3] In addition to Sleeping Thunder, one of his close friends was an old warrior named Medicine Whip, who he met on the Bow River.

In 1960, Shannon Garst added the Indian maiden Keeoma to the list of Russell's Blood friends, creating a romantic dialogue in which the artist was invited to marry the girl. The Indians regarded Russell's ability with awe, considering him to possess magical gifts. And when he ran out of paper, Russell painted on hides provided by Keeoma. At last, as Garst described it, "his paint brushes had finally worn out and he was reduced to using the chewed ends of twigs."[4] Two years later, Lola Shelton repeated the stories, with further embellishment, and added an account of Russell making a slow journey home with a bull team that was hauling goods from Canada to Montana.[5] He was just in time for the spring roundup.

I became interested in Charlie Russell during the early 1950s and was fascinated with the story of his winter with Blood Indians. Because my wife is a member of the Blood tribe, I was particularly curious about Keeoma, Sleeping Thunder, and Medicine Whip and wondered if anyone remembered them. Thus began a thirty-year

search for Charlie Russell's elusive friends and an Indian account of his legendary winter.

My first problem was to translate the name Keeoma into English. With the help of my wife and father-in-law, we determined that there were only two Blackfoot words that bore any resemblance to the name. The first was *kee-oh'-mee*, which means "over there," which is a phrase, not a name. The other, *Ah'-kee-oh-ma*, is a man's name meaning "Has A Wife."[6] The name could not be used by a woman. We then spoke with Mrs. Crow Spreading Wings, who was fifteen years old during the winter of 1888–1889. She said there was no such woman as Keeoma.

My father-in-law explained to me that the population of the Blood tribe during the late 1880s was only about two thousand people who were confined to a narrow strip of land on their reservation along the Belly River. Everyone knew everyone else, particularly if they were of the same sex and in the same age group. If Mrs. Crow Spreading Wings said there was no Keeoma, there was no Keeoma.

In 1963, I was put in touch with Fred Renner, who finally solved the mystery of the Indian girl. He wrote: "The first mention of Keeoma is in July, 1897 issue of "Western Field and Stream" in an article by the editor, Bleasdell Cameron, called "Keeoma's Wooing." This was illustrated by Russell's first painting of Keeoma, an Indian girl reclining in a tipi. Although the article does not mention Russell, it is undoubtedly the basis for the legend that she was the Indian girl he knew the winter he spent with the Bloods."[7] So the name Keeoma did not originate from Russell's Canadian winter. Keeoma was a fictional character that Russell had been asked to illustrate for a magazine. Later, Renner proved that the model for the reclining Indian girl was actually Russell's wife Nancy and not some mysterious girl from the past [see *Keeoma #3*, FIG. 4].[8]

But what about Sleeping Thunder? Surely he must have been a Blood chief. That question was also answered with complete unanimity on the Blood Reserve. Not only was there no chief by that name, but Sleeping Thunder was also not a Blood name. There was Thunder Chief, Thunder Robe, and Weasel Thunder, but no Sleeping Thunder. Among Blood Indians, a name is a family possession that is used by an individual during his or her lifetime and is later

passed down to someone from another generation at the appropriate time. My wife's grandfather, for example, was named Flying Chief. When he died in 1935, the name remained in the family but was not used until 1967, when it was given to me in a ceremony.

Because of their customs, all the Blackfoot tribes are very conscious of names and family ownerships. If the name Sleeping Thunder had existed in the 1880s, the elders would have known it. Furthermore, all of the names of the chiefs and members of the tribe were entered on the treaty lists that are preserved in the National Archives in Ottawa. Sleeping Thunder does not appear on those lists for the Bloods, Blackfoot, or Peigans in Canada, nor is the name on the rolls of the Blackfeet Indian Reservation in Montana.

In the end, the name of Sleeping Thunder also proved to be fictional. In 1897 (the same year that William Bleasdell Cameron invented Keeoma), Charlie Russell wrote a story entitled "Early Days on the Buffalo Range," which was published in *Recreation*.[9] In it, Russell described a white boy who traveled with the Blackfoot in 1857 and was befriended by a young Blackfoot named Sleeping Thunder. There was nothing autobiographical about the article; it was simply a piece of fiction that Russell wrote to accompany four of his illustrations.

The earliest reference to Medicine Whip is in 1902, when Russell wrote a letter describing an adventure tale, supposedly told to him by the old warrior. Russell illustrated the story with a sketch of himself sitting with the storyteller on a hot summer's day.[10] Nowhere in his own writings, however, does Russell say that he spent a winter with the warrior. Among all Blackfoot tribes, the word "Medicine" appears frequently in proper names—Medicine Bull, Medicine Wolf, Medicine Pipe Stem—but the name Medicine Whip is not listed on any of the official rolls of the nation. It sounds like a good Blackfoot name, but I have been unable to find any record of it and none of the elders I spoke to had ever heard of it. In fact, the elders I consulted among the Blackfoot, Bloods, and Peigans insisted that the name was not from their tribes. The matter is further complicated by the fact that Russell's descriptions of Medicine Whip are not consistent. In a 1902 letter, Medicine Whip is an aged Blood Indian that Russell met on the Bow River in Canada; in *Trails Plowed*

*Under,* he is a Blood that the artist met in Montana, where Medicine Whip was visiting a niece married to a white man.[11]

Keeoma, Sleeping Thunder, and perhaps Medicine Whip were all fictional characters, but that does not mean that the Canadian trip never occurred. Rather, the trip has been so distorted by imaginative storytellers that it bears little resemblance to the truth. As Phil Weinard wrote in 1938, "Personally, I don't think Charlie knew anything about all this hooey; someone has worked up this propaganda. Don't you pay any attention to the different stories that are printed or spoken about him."[12]

Phil Weinard, left, and Charles M. Russell, dressed as an Indian couple, Helena, February 22, 1888.
MHS Photo Archives, Helena

Charlie Russell's Canadian adventure began in Helena in 1887 when he met Phil Weinard, a cowboy *cum* actor who had just returned from Alberta. Weinard had been working on ranches in the Highwood River area since 1882, and he had met a girl in Helena who he hoped to marry. When the girl's aunt took over the Coliseum Theater in Helena, she wired Weinard, asking him to manage it. Shortly after his arrival, Weinard met Russell and they became good friends.

In the spring of 1888, Weinard arranged to be married and planned to ride overland to Canada's Highwood country while his bride took the train north through Minneapolis. When Russell and cowboy B. J. "Long Green" Stillwell learned about the trek, they asked Weinard if they could join him. Both cowboys were broke, but Weinard was glad of the company. They set out on May 16, 1888, with Russell riding his favorite horse Grey Eagle and using Monte for a packhorse.

The three men camped at Blake's Ranch near Cascade; from there it was an easy ride through northern Montana until they reached the Upper Trail, which led from Sun River to Fort Mcleod. Along

the way, Weinard entertained the two cowboys by teaching them basic words used in the Indian sign language. The trio crossed the border, swam their horses across the St. Mary River near the Mormon town of Cardston, and traveled over the Blood Reserve to the North-West Mounted Police outpost at Standoff. An old Indian guided them safely through the ford on the Belly River, but a mile farther on they had to use a boat to cross the high waters of the Waterton River while their horses swam the stream.

A few hours later, during the ride from Standoff to Fort Macleod, they encountered a North-West Mounted Police patrol that was taking Indian prisoners to the fort. That spring, a number of Blood war parties had set out to raid the Gros Ventres in Montana. When Superintendent Percy R. Neale learned that some of the warriors had returned, he went out to the reserve and arrested Manyfingers, Nice Old Woman, Hollering in the Morning, and White Crane.[13] Neale's squad was taking them to the guard room at Fort Macleod when Russell, Stillwell, and Weinard caught up with them. "Charlie got his first impression of a Mounted Policeman with an Indian handcuffed and under arrest," Weinard later remembered.[14]

Fort Macleod was a thriving frontier town that served as the Mounted Police headquarters and customs office. The three men arrived at night and camped a short distance above the fort, where they found a nice spot under a cottonwood tree. The next morning, Russell experienced a typical brand of western humor. Stillwell had arisen first, as it was his turn to cook, but he was no sooner out of his bedroll when he hollered that breakfast was ready. Russell looked up from under the blankets and said, "What's the great noise about. You haven't got the fire lit."

"Don't need any fire, breakfast's all ready."

When the cowboys looked, he pointed to the mummified body of an Indian child that had fallen from a tree burial and lay in the middle of their camp.[15]

Heavy rains had flooded a number of Canadian rivers that spring, including the Oldman, which flowed past the fort. At first, the ferryman refused to take the cowboys across. They finally talked him into attempting the crossing, but it was such a frightening experience that the ferryman was afraid to make the return trip. Russell

and his friends didn't care; this was the last major river on their four hundred-mile trek.

The travelers followed the Calgary trail north for several miles, then veered off to the west until they reached Walter Skrine's Bar S Ranch on Mosquito Creek. Skrine was away on the spring roundup, and Weinard had agreed to manage the place. After resting for a few days, Weinard took Russell and Stillwell on the last leg of their journey—a twenty-four mile ride to a small ranch five miles west of the village of High River. This neat little group of cabins was nestled in the valley of the Highwood River. The owner, an Englishman named Charles Blunt, had agreed to let the two cowboys use an empty log cabin as their temporary home. An amateur artist, Blunt also gave Russell his small supply of paints and canvasses.

The cabin was made of large cottonwood logs, which were hewed and provided flat facings from twelve to fifteen inches wide. The place may have been crude, but it gave the pair a roof over their heads for the summer. Weinard bought them a stock of supplies from the village and then left the wanderers to fend for themselves.

During that summer, a cowboy friend from Montana visited Charlie and Long Green and found the conditions to be pretty primitive. The men had no lamp, so they had rigged up a dish of grease with a rag sticking out of it for a wick. Their outfit consisted of blankets and a large bear skin. As Russell later recalled, "I had a pritty tough time."[16] To add to their problems, Stillwell was recovering from a broken collarbone, so he stayed close to the cabin.

The cowboy artist had an enjoyable summer, visiting with Blunt and his partner (another Englishman named William "Bar D" Holmes) and watching with amazement how the greenhorn English ranchers looked after their three hundred head of cattle. Russell told his friend Con Price about one of the incidents he had witnessed:

> There was an old retired army captain up in northern Canada who went into the cattle business and had occasion to swim a bunch of cattle across quite a large river. He tried for several days and in different ways to make those cattle cross the stream but couldn't make it work.
>
> So he built some blinds made out of green rawhide strched [sic] on frames and put them on the river bank where the cattle

were to cross and put a man behind each blind. So when the cow-boys drove the cattle to the edge of the river and the captain got his position he gave the command, "Men behind rawhide—charge!" which they did.

Now one can imagine those wild cattle when a lot of men charged in among them on foot. They stampeded and went to the hills and the captain had a hard time gathering them and get-ting them back to the river, and he immediately removed the blinds, as the cattle would not work the regimental way.[17]

According to Billy Henry, who saw Russell frequently that sum-mer, "Charlie spent the whole time fishing and painting. Maybe he did some hunting. I know he moved around the district quite a bit but was not working for anybody."[18] Russell painted at least three oils that summer, the most important being *Canadian Mounted Police Bringing in Red Indian Prisoners* [FIG. 25], based on the scene he had witnessed on his arrival in Canada. He gave the painting to Charles Blunt in gratitude for the use of his cabin.

Weinard also acquired at least two of the paintings Russell pro-duced that summer. One was an oil painting later entitled *Bear at Lake*, the other was called *Solitude*, which was a watercolor of a sylvan scene with a herd of deer. These paintings were found aban-doned in Blunt's cabin after Russell had gone south. Russell also made several sketches on the facings of the logs, including one with his buffalo skull signature.[19]

Russell and Stillwell left Blunt's cabin sometime in September. Weinard was surprised when someone told him that the two cow-boys had left the Highwood country. He had been busy all summer and had seen them only once since their arrival. He assumed that fear of an early winter or the existence of prohibition in Canada may have influenced their departure. The two men rode down to Fort Macleod, retraced their path across the Blood Reserve, and went south to Hel-ena. Russell did not stop on the Blood Reserve. He did not spend the winter of 1888–1889 with the Blood tribe. That is simply a myth that has grown up around the life of the cowboy artist.

Contrary to popular misconceptions, the Bloods were not an isolated people living a primitive life in 1888–1889. They had been on their reserve for eight years, camping along a thirty-mile stretch

of river bottom from Kipp to Big Bend. While some of the Indians had tepees, most lived in cottonwood cabins during the winter. Located among their camps were an Upper Indian Agency and a Lower Indian Agency; Mounted Police outposts at St. Mary's River, Kipp, Standoff, and Big Bend; and an Anglican mission at Big Island, a Methodist mission at Slideout, and a Roman Catholic mission at Standoff. There also were two trading stores at Standoff. Mounted Police patrols made weekly trips through the camps, keeping a wary eye open for whiskey smugglers and stolen horses. If a white man was found in the camps without a permit from the Indian agent, he was immediately thrown off the reserve.

Nearby were the two communities of Fort Macleod and Lethbridge, each of which had a weekly newspaper that regularly reported the comings and goings of people from the reserve. A year earlier, these same papers had given considerable coverage to Russell's rising fame, picking up stories from the Montana press.[20] A celebrity like Russell could not have been on the Blood Reserve without someone reporting it. Also, a careful examination of the daily letter books of the Indian agent, patrol reports from the police detachments, and letters from the missionaries in the area contain no reference to Russell. And when we realize that the artist had not worked all summer and was broke, it is inconceivable that the Bloods would have supported and fed him all winter. The area had been hunted out, the buffalo were gone, and at the onset of winter the rations to the Bloods had been cut by a third, to a pound of beef a day. That winter, the tribe was facing starvation and hardship. We must take seriously the claims by Mrs. Crow Spreading Wings, who was fifteen years old at the time, that no white cowboy artist had spent the winter with the tribe. There is also Phil Weinard's assertion that Russell "never lived with the Indians" during the artist's Canadian trip.[21]

Then there is the story of Russell returning to Montana in the spring of 1889 with a bull train. This might have happened a decade earlier; but when the railway reached Calgary and Lethbridge in the 1880s, the bull team traffic along the Whoop-Up Trail came to an end. As Joel Overholser reported: "With the arrival of the Canadian Pacific in Calgary in 1883 Fort Benton's close ties with Fort Macleod, Calgary . . . and other cities ceased almost like cutting a

skein with scissors. The last important shipments went north in mid-summer of 1883."[22]

There is further evidence that Russell did not spend that winter in Canada. One clue came from Long Green Stillwell, who, on his arrival in Helena, wrote a short letter to Weinard bringing him up to date on events at the new theater. He concluded his letter with the news that "Rusle rote this moring."[23] How could he say this if Russell was not with him in Helena? The final confirmation comes from a reading of the *Helena Weekly Herald* for September 27, 1888, when the cowboy artist was supposedly living in the Indian camps. The newspaper reported that "C. M. Russell, the cowboy artist, has returned to Helena after several months absence on the range, where he no doubt secured subjects for more of his characteristic paintings."[24]

Was the whole story about Russell going to Canada and learning about Indian life a lie? Was the claim of his six months with the Indians nothing but a fabrication? Not at all. This is simply a case of writers and historians misinterpreting the information they had in front of them. I can find no evidence that Charlie Russell ever claimed to have spent the winter with the Bloods. In 1891, he commented: "I went out north a cross the line and lived six months with the Blackfeet"; and in 1903, he reported, "In 1888 I went to the Northwest Territory and stayed about six months with the Blood Indians."[25] In 1917, he told Al Noyes: "My Indian study came from observation and by living with the Blackfeet in Alberta for about six months. I don't know much about them even now; they are a hard people to 'sabe'."[26] Neither did Russell's close friends refer to the winter of 1888–89. Con Price wrote that "Charlie Russell spent one summer in Canada," and Frank Bird Linderman commented that "Charley Russell lived for six months in 1888 with the Bloods, a branch of the Blackfeet Indians living in Alberta."[27]

The confusion seems to have arisen from Russell's remarks in 1903 and from Nancy Russell's claims in *Good Medicine*. Russell told a reporter: "In 1888 I went to the Northwest Territory and stayed about six months with the Blood Indians. In the spring of 1889 I went back to the Judith, taking my old place wrangling."[28] Nancy probably used this article as her source of information when she paraphrased his words almost thirty years later: "In 1888, he

went to the then Northwest Territory and stayed about six months with the Blood Indians." After referring to Sleeping Thunder and Russell's use of sign language, she wrote: "In the Spring of 1889, he went back to Judith to his old job of wrangling."[29] These two references have caused readers to assume that the six months with the Indians occurred in the period immediately before the spring Judith roundup—that is, in the winter of 1888–89.

But Russell's references to his stay in Canada were to the time when he and Stillwell had used Blunt's ranch as their headquarters. Russell had left Helena in May and had returned in September, which is close to six months, at least close enough for a storyteller like Charlie Russell. There were no six months in skin tepees, wearing Indian costumes, learning the native language, and chewing on sticks to make them into paint brushes. Instead, there was a summer when this intelligent and sensitive artist found himself in the perfect place to learn about Indian life while at the same time maintaining something close to a normal lifestyle.

At the time of Russell's visit in the summer of 1888, there were a lot of Indians in the Highwood area. The Blackfoot, with their reserve thirty-five miles east, came to the foothills to hunt or to visit their children in the boarding school at the mouth of the Highwood River. The Sarcee and Stoney Indians, with their reserve a short distance north, also traveled through the area. And the Bloods and Peigans, far to the south, often passed through High River settlement on their way to visit other reserves.

There were so many Indians in the area that local ranchers complained about them. Late in 1887, a settler at High River had asked for a detachment of Mounted Police to be stationed in the settlement "owing to the constant passing to and fro of Indians."[30] In the summer of 1888, a priest reported that a large party of Bloods had camped at his mission while en route to the Blackfoot Sun Dance, and in November he complained that twenty Blackfoot Indians were camped beside the boarding school. Mounted Police patrol reports referred regularly to Indian hunting parties in the district.

For Charlie Russell, one Indian family stood out from all the others. The head of that family, an unofficial chief of the district, was named Apskinas, or The Louse.[31] Russell made particular reference to Apskinas

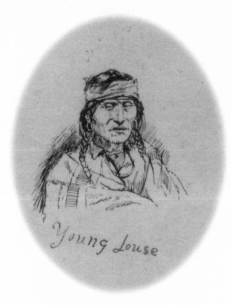

Charles M. Russell, *Young Louse*, ca. 1891,
pen and ink sketch. <span style="font-variant:small-caps">Photograph courtesy MHS Archives, Helena</span>

in a May 10, 1891, letter: "I had a chance to marry Young Louses daughter he is blackfoot Chief It was the only chance I ever had to marry into good famley but I did not like the way my intended cooked dog and broke of our engagement."[32]

Apskinas, The Louse, had been born into the Blood tribe, but he was adopted and raised by Old Sun, a great warrior chief of the Blackfoot nation and one of the two chiefs of his tribe. Old Sun was famous as a medicine man who carried the blonde scalp of a trader in a pouch on his belt. Old Sun and his family were among the most warlike and intransigent of the tribe. When the last buffalo herds were destroyed in 1880, Apskinas chose not to follow his father to the reserve where they would have to live on handouts of beef and flour. Instead, he settled in a permanent camp near the tiny settlement of High River.

Apskinas's choice was a practical one, because his sister Pokimi, or Small, had married O. H. Smith, a one-time trader who had opened a stopping house at the settlement. In fact, there was a rumor that both Apskinas and his sister were the children of a Montana trader. Over the years, Apskinas supported himself as a hunter. He also worked for local ranchers, collected buffalo bones, and generally got along without Indian Department assistance. He was registered as Ticket No. 39 in White Calf Robe's band but was so independent of the authorities that he let his father pick up his annual treaty money.

While Russell was at Blunt's ranch, Apskinas's family consisted of a wife, teenaged daughter, and two young sons, although the boys were put into the Anglican boarding school on the nearby Sarcee Reserve at about the time that Russell arrived in the area. In order to visit the boys without trespassing on the reserve, Apskinas transferred his membership from the Blackfoot Reserve to the Sarcee. The Sarcee Indians called him Eagle Tail Feathers, which became his official name

when he was entered on their rolls with Ticket No. A46. As a result, Apskinas was a Blood Indian, adopted by the Blackfoot, registered as a Sarcee, but living independently in his own camp.

When Russell met Apskinas, he was everything the artist might hope for. He was from a strong warrior tradition, knowledgeable about the customs of his tribe, able to speak passable English, and living in the traditional way. Throughout his life, *Apskinas* lived in a tepee or tent, rejecting the white man's log cabin.

There was also Apskinas's daughter, Pokinaki, or Small Long Woman, who Weinard described as "a very handsome girl."[33] In his letter of 1891, Russell implied there had been a love affair between him and the girl. Weinard, who was away all summer, doubted the artist's claim, believing that only a man of wealth could have arranged such a match. But Weinard did not take into account Russell's charm and his apparent close friendship with the girl's father.

So, the fictional Sleeping Thunder may have been a Blackfoot leader named The Louse, and Russell's Keeoma may have been Small Long Woman. What happened that summer can only be surmised, for the only tangible evidence is the brief comment in Russell's 1891 letter. There can be no doubt, however that the experience and the knowledge he gained left a deep impression on the cowboy artist, which was reflected in his sympathetic paintings for years to come. While at High River, Russell produced a sketch of an Indian wearing a Hudson's Bay blanket and carrying a rifle and whip. And it may have been while he was at Blunt's ranch that he produced a finished oil painting of the same subject, *Portrait of an Indian* [FIG. 5].[34] A member of the family has identified the painting as a portrait of Apskinas, and certainly it is not unlike the only known photograph of The Louse taken many years later.[35]

Two years after Russell left his friends in the fall of 1888, Pokinaki married Jack Big Plume, the son of a Sarcee chief. They had three boys and one girl but, tragically, only one boy lived beyond his teens. Pokinaki died in 1913 at the age of forty-three. Surprisingly, her youngest son, Dick Big Plume, is still alive, and I spoke to him about his mother. He remembered: "My mother understood English but she never went to school. She just worked around High River. I remember her. Everybody who knew her said she was a kind

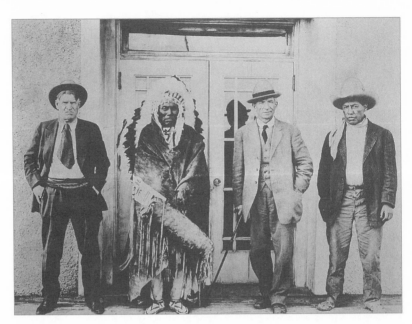

Left to right, C. M. Russell, Big Belly, Phil Weinard, and "Charlie," at the Calgary Stampede, 1919. MHS Photo Archives, Helena

lady. When she got older she was a bit stout but very nice looking."[36]

He knew nothing about any relationship between his mother and Charlie Russell, but he did have something to say about the cowboy artist: "I saw Charlie Russell in 1919 at the last big stampede in Calgary. He believed in Indian medicine so when he was sick he went to Big Belly's tepee. They had all that drumming and singing and they treated him. I was standing outside the tepee when he was being treated."[37] Perhaps it was only a coincidence, but the only known photographs of Russell with Indians at the 1919 Calgary Stampede are with the Sarcees, the smallest tribe there. In two of the photographs, he is posing between the chief, Big Belly, and his wife Maggie, who was also Pokinaki's sister-in-law.

Apskinas lived near High River until about 1910, becoming one of the pioneers of the town. When his wife died, he moved in with his daughter on the Sarcee Reserve, and when she passed away he went to the Blackfoot Reserve in his old age and died there. There is no evidence that he ever saw Charlie Russell again after the memorable summer of 1888.

So, Russell did spend almost six months with the Blackfoot Indians, just as he always said. It was a time for him to see the summer camps, with the sides of the tepees drawn up to let the wind sweep through. He must have seen the medicine bundles hanging on their tripods, the women cooking outside during the heat of the day, and the children half naked as they played games of war. With Apskinas as interpreter, he could have listened to the tales of the past, and he may even have heard stories from the Blackfoot leader himself. Whether or not Medicine Whip ever existed, the adventure Russell recounted could easily have been told to him, as he said, while he was in camp along the Bow River. It was an ideal time for the cowboy artist to watch and to learn, as he moved easily from the homes of local ranchers to the Indian camps. And, as was obvious from his later works, he did learn much that summer.[38]

Charlie Russell did not have to be with the Bloods through the winter of 1888–1889 to learn about Indians, but the obvious question arises: If he wasn't there, where was he? Russell's whereabouts during that winter are best answered by his friend Con Price. As Price explained in his reminiscences, "I first met Charlie Russell in the fall of the year 1888. He was nightherding beef cattle on the Judith Basin and Moccasin Range roundup."[39] The implication is that Russell stopped off briefly in Helena and then traveled to the familiar lands of the Judith Basin. As in previous years, he would have holed up for the winter with some cowboy friends, such as Jake Hoover. With the arrival of spring, he would have joined the other boys on the range. This would partially explain this item in the May 23, 1889, *Fergus County Argus*: "Charlie Russell, the cowboy artist, is once more among the scenes of his earlier triumphs. Charlie has joined the roundup and will as of yore, subdue the erratic bronco and chase the nimble and elusive calf."[40]

When the Minneapolis-based *The Northwest Magazine* sent a reporter through the Judith Basin in the late autumn or early winter of 1888–1889, he visited some of Russell's favorite camping places, including Ubet. When the article appeared in the January 1889 issue, it included a sketch, *On a Montana Cattle Ranch—Roping a Steer*, based on a Russell painting.[41] The reporter might easily have met the artist during that trip.

It is also interesting that a series of sketches, *Ranch Life in the North-West*, jointly produced by Charlie Russell and Jerome H. Smith, appeared in *Frank Leslie's Illustrated Newspaper* on May 18, 1889. The magazine was published in New York, but Helena publisher and businessman Russell B. Harrison purchased an interest in it in March 1889, just weeks after his father had been elected President of the United States. Harrison announced at that time that the West would be better represented in the weekly paper. Smith, who had attended art school in Chicago, was sent west to Montana and may have met Russell so that the two could collaborate on the illustrations and have them ready in time for the May issue. Is it possible that Smith, who was an experienced illustrator, may have shared his technical knowledge with the cowboy artist at that time and given him the first professional training of his career?

Both Russell and Smith were known to have produced illustrated letters. The earliest Russell letter I have seen is reproduced in Brian Dippie's *"Paper Talk,"* and judging from its contents I would date it in the spring of 1890.[42] As for Smith, the only ones of his were produced during the 1930s. But the tradition exists that during the 1920s, when Smith was down on his luck and living in California, Russell grubstaked him until he got a major commission to do some legal scenes for the University of Washington.[43] If this is true, the relationship may have been more than a passing one.

Given the evidence, it is clear that Russell's near-six months among the Indians in Alberta occurred only during the summer of 1888, not the winter of 1888–89. But his whereabouts are still a matter for speculation. If he was not wooing Blood maidens, painting on buckskins, and chewing his own paint brushes, just what was he doing?

N O T E S

1. Harold McCracken, *The Charles M. Russell Book: The Life and Work of the Cowboy Artist* (Garden City, N.Y., 1957), 115.

2. Charles M. Russell, *Good Medicine: The Illustrated Letters of Charles M. Russell* (Garden City, N.Y., 1929), 21.

3. Ramon F. Adams and Homer E. Britzman, *Charles M. Russell, The Cowboy Artist: A Biography* (Pasadena, Calif., 1948), 95.

4. Shannon Garst, *Cowboy-Artist, Charles M. Russell* (New York, 1960), 122.

5. Lola Shelton, *Charles Marion Russell, Cowboy, Artist, Friend* (New York, 1962), 105–6.

6. For example, this name is now held by a young Blackfoot Indian, Jim Turning Robe.

7. Fred Renner to the author, April 5, 1963. Letter in the author's possession.

8. See *Montana*, 22 (Spring 1972), back cover.

9. C. M. Russell, "Early Days on the Buffalo Range," *Recreation*, 6 (April 1897), 227–31.

10. See McCracken, *The Charles M. Russell Book*, 115–16.

11. Charles M. Russell, *Trails Plowed Under* (New York, 1927), 177–86.

12. Phil Weinard to James B. Rankin, October 10, 1938, Rankin Papers. I wish to express my sincere thanks to Bill Lang for bringing this important series of Weinard letters to my attention.

13. Macleod (Alta.) *Gazette*, May 30, 1888.

14. Weinard to Rankin, January 4, 1938, Rankin Papers. Later, when Russell painted the scene, he reduced the number of Indians to three, eliminated the officer, and showed only a sergeant and constable escorting the prisoners.

15. Weinard to Rankin, February 14, 1938, Rankin Papers.

16. Russell to "Friend Charly," May 10, 1891, in Brian W. Dippie, *"Paper Talk": Charlie Russell's American West* (New York, 1979), 20.

17. Con Price, *Memories of Old Montana* (Hollywood, Calif., 1945), 48.

18. Billy Henry, interview with the author, February 19, 1960.

19. Senator D. E. Riley to Rankin, May 2, 1938, Rankin Papers. While Russell was hunting antelope north of the Highwood River with Frank Smith and W. H. Somerton, he etched two scenes on the sides of Somerton's Winchester. One showed a dying buffalo bull with a coyote nearby, and the other was of an Indian, holding his cayuse and gazing mournfully at two buffalo heads in the grass. See Innisfail (Alta.) *Province*, November 4, 1926.

20. See Macleod (Alta.) *Gazette*, August 16, September 27, 1887; Lethbridge *News*, September 21, 1887.

21. Weinard to Rankin, December 19, 1937, Rankin Papers.

22. Joel Overholser, *Fort Benton: World's Innermost Port* (Helena, Mont., 1987), 370.

23. Enclosure, Weinard to Rankin, February 14, 1938, Rankin Papers.

24. *Weekly Herald* (Helena), September 27, 1888. My thanks go to Harold McCracken, who cited this passage in *The Charles M. Russell Book*, 112.

25. Dippie, *"Paper Talk,"* 20; Butte *Inter Mountain*, January 1, 1903 (reprinted in this volume).

26. Al J. Noyes, *In the Land of Chinook; or the Story of Blaine County* (Helena, Mont., 1917), 123.

27. Price, *Memories of Old Montana*, 48; Frank Bird Linderman, *Recollections of Charley Russell* (Norman, Okla., 1963), 52.

28. Butte *Inter Mountain,* January 1, 1903.

29. Russell, *Good Medicine,* 21–22.

30. Patrol report, North-West Mounted Police, October 5, 1887, Royal Canadian Mounted Police Records, RG-10, vol. 1067, National Archives of Canada.

31. More properly, the translation is White Louse, but he was entered in the Agency books simply as The Louse. Local people called him Ab, a contraction of his Indian name.

32. Dippie, *"Paper Talk,"* 20. The name Louse was misread in the handwritten text and printed as Couse. Russell's reference to eating dogs was likely made in jest. The Blackfoot did not eat dogs, a preference that Russell recorded in his later writings.

33. Weinard to Rankin, October 3, 1938, Rankin Papers.

34. The 1884 date that has been ascribed to this painting is obviously wrong. It had to have been done either at the ranch in 1888 or shortly thereafter. Because Weinard had the sketch, it seems likely that it was painted in Canada.

35. Dick Big Plume, interview with the author, March 10, 1989. Big Plume said that it was a picture of his grandfather as a young man.

36. Big Plume, interview with the author, February 5, March 10, 1989.

37. Big Plume, interview with the author, March 10, 1989.

38. There is a question as to whether or not Russell received his Blackfoot name that summer. According to Weinard, "I notice Mrs. Russell says Charlie's Indian name was Antelope (Aua,co's). There must be a mistake. or some Indian played a joke on Charlie. Antelope is a sqaw [sic] name. The winter of 81–2 Red Mike had a Blackfoot woman at Rocky Point on the Missouri River who did the cooking for us, for a time, her name was Antelope . . ." (Weinard to Rankin, July 15, 1932, Rankin Papers). A check of early Indian paysheets and discussions with elders confirm Weinard's statement. The simple names of Antelope (Awakasi) or Antelope Woman (Awakasaki) are women's names. Only when prefixed by an adjective—for example, White Antelope, Running Antelope, and Red Antelope—does Antelope become a masculine name. Perhaps there is truth to the theory that Russell himself shortened the name without realizing its significance. For example, Linderman (*Recollections,* 52) wrote that the Peigans gave Russell the name of Running Antelope (Awakasi-amukan or, literally, Antelope Running). This could easily have been abbreviated simply to Awakasi.

39. Price, *Memories of Old Montana,* 137.

40. Cited in McCracken, *The Charles M. Russell Book,* 127.

41. Illustration accompanying "A Journey in Eastern Montana," *The Northwest Magazine,* 7 (January 1889).

42. Dippie, *"Paper Talk,"* 13.

43. Dale Peterson, East Sound, Washington, interview with the author, February 8, 1989.

# Charlie Russell's Indians

John C. Ewers

❧

DURING HIS LIFETIME Montanans and other Americans came to know Charles Marion Russell as "the Cowboy Artist." He *was* a cowboy and created many striking drawings and paintings of cowboys at work or at play. Even so, a quarter century ago I learned that Charlie Russell was at least as much interested in picturing the Indians of the Great Plains. At that time I had decided to devote the last chapter of a book I was planning, titled *Artists of the Old West*, to Charlie Russell, the cowboy artist who had experienced the passing of the Old West in Montana. At the beginning of my research for this chapter I consulted my friend and fellow founding member of the Potomac Corral of the Westerners, Frederic G. Renner. Fred was the outstanding Russell authority, and he took the time to show me his unique file of photographs of nearly all of Russell's known works. I was surprised to find among them many drawings and paintings of Indian subjects that were new to me. When I commented on this fact, Fred replied, "You know, Jack, Russell pictured more Indians that he did cowboys."

Recent re-examination of Charlie Russell's life and works has impressed me even more strongly with this artist's concern for interpreting Indian history and culture. A number of his earliest-known drawings were of Indian subjects. Several paintings that should be remembered as landmarks in his career portray Indians. Throughout his career he devoted much time and thought to learning the details of Plains Indian life from three kinds of sources: through reading the writings of earlier and contemporary observers of those Indians; through studying sketches and paintings by artists of earlier generations who had pictured Plains Indians from life;

and through repeated personal contacts with members of the tribes of the Northern Plains. Such a background enabled Russell to portray many significant aspects of Indian life in buffalo days and aspects that other artists had overlooked. Even so, there were some gaps in his knowledge and any fair appraisal of his Indian works should mention them.

That Charlie Russell developed a lively interest in Plains Indians as subjects for his art even *before* he went to Montana and met Indians is revealed in a fascinating sketchbook of his drawings, which he executed during the spring of 1880 when he was a fifteen-year-old student at a military school in New Jersey. That was the year after the first publication of Buffalo Bills's autobiography, which carried the subtitle *The Famous Hunter, Scout and Guide*. Like thousands of other schoolboys, young Russell no doubt became an avid reader of that exciting adventure story, and Buffalo Bill became one of his heroes. One of the pencil drawings in the sketchbook pictures a man in western garb, wearing a goatee, and holding a rifle, titled "Buffalow Bill, The American Scout." Other drawings in this sketchbook portray a buckskin-clad frontiersman hunting wild animals and meeting with Indians. Although not labeled as such, he too may have been Charlie Russell's version of Buffalo Bill.

The sketchbook contains a great many horses, but no cows and *no* cowboys. Indians in action or in repose appear in more than half of the drawings. A drawing of an Indian horse race reveals this budding artist's interest in rendering men and animals in swift action; another of an Indian undergoing self-torture shows his early concern for dramatic subject matter.

One drawing entitled *Crow Indian in Ware Dress* is of particular interest, for it shows us that this boy-artist had already discovered one or more of the works of Karl Bodmer, the young Swiss artist who had accompanied German naturalist Prince Maximilian of Wied-Neuwied to the Upper Missouri in 1833–34. Bodmer's realistic watercolors of Indians of that region, carefully executed from life, provided superb illustrations for the German scientist's written account of his observations. An English edition of Maximilian's travels, with engraved illustrations prepared under Bodmer's supervision from his field drawings, appeared in London in 1843.

Young Russell could not have found a more reliable authority on the physical appearance of the Indians of the Upper Missouri a half century before the American boy's time, for the Swiss artist took great pains to portray each Indian and the details of his clothing and accessories with precise accuracy. Unquestionably, Russell adapted his drawing of the Crow warrior from an engraving of Bodmer's portrait from life of the Hidatsa Indian, Pehriska-Ruhpa, as he appeared in full regalia as leader of the Dog Society at Fort Clark during the late winter of 1834. Comparing Russell's Crow warrior with Bodmer's Hidatsa dancer we can see that to the best of his ability young Russell copied the dancer's elaborate feathered head-dress, the porcupine-quilled vertical decorative panels on his leggings, and the keyhole-shaped design on the vamps of his moccasins.[1]

In an undated letter several years later addressed to Charles Reymershoffer, Russell expressed his high opinion of another earlier artist whom he admired because "he knew the Indian." That artist was Charles Wimar who had traveled up the Missouri as far as Fort Benton during the late 1850's and made numerous sketches of both the country and the Indians he had seen along the way. From these field drawings he painted a number of oils portraying Indians hunting buffalo on horseback and participating in elaborate ceremonies. In his letter, Russell ventured the opinion that in Wimar's masterful *Buffalo Hunt* (1861) the Indians pictured must have been Pawnee because of their distinctive hairdresses.[2]

On examination of the large body of drawings and paintings Charlie Russell created over a span of forty-six years we become aware that certain landmark works in his career were Indian subjects. His first painting to be reproduced in a national magazine, *Caught in the Act* [FIG. 26], appeared in *Harper's Weekly* on May 12, 1888. In it he portrayed cowboys confronting a family of destitute Indians butchering a white rancher's steer. It was hardly necessary for the accompanying text to point out that Russell obviously sympathized with the starving Indians, but it did comment: "Anyone acquainted with frontier life will at once appreciate the truthfulness of this picture."

In 1912 Russell was commissioned to paint a huge mural twenty-five feet long and twelve feet high for the chamber of the House of Representatives in the Montana State Capitol. Another landmark work,

it was Russell's interpretation of a dramatic moment in early Montana history *Lewis and Clark Meeting the Indians at Ross' Hole, September 3, 1805* [FIG. 12]. In it Russell combined numerous detailed foreground figures—Flathead Indians on lively horses and members of the Lewis and Clark party on foot—with an awesome panoramic background of mountain landscape. Not only was this Russell's largest painting, but some critics also regard it as his "masterpiece." We should note and remember that it was an Indian subject.

Russell's *Salute to the Robe Trade* (1920), in the Gilcrease Museum in Tulsa, pictures a party of Indians firing their guns in the air as they approach a trading post. This painting was Russell's first to bring as much as $10,000 on the market, a sum Russell termed "dead men's prices." It was an Indian, *not* a cowboy, subject.

At the time of Charlie Russell's death, October 14, 1926, an unfinished painting in his log cabin studio in Great Falls documents that Indians appeared in Russell's last as well as his first known pictures. In it Russell portrayed Father Pierre-Jean DeSmet's first meeting with the Flathead Indians in 1840, an event symbolizing the initiation of direct Christian missionary activity among the Indians of Montana.

Some of Russell's earlier biographers were too inclined to attribute his detailed knowledge of Indian customs to the fact that he spent six months among the Blood Indians of Alberta in 1888. They even suggested that a chief, Sleeping Thunder, had urged Russell to marry a girl of his tribe and inferred that she might have been a young woman named Keeoma. In later years Russell created several pictures of an alluring maiden inside a tipi, titled *Keeoma* [FIG. 4]. But as Fred Renner has pointed out, Keeoma was a fictitious name invented by William Bleasdell Cameron for the Indian heroine of a story Russell illustrated for publication in *Western Field and Stream* in July 1897, nearly a decade after Russell's sojourn among the Blood Indians.[3]

At the time of Russell's extended visit among the Blood Indians in 1888 the lifeways of those Indians had changed markedly since buffalo days. The buffalo had been exterminated in southern Alberta for a decade. Signers of Canadian Treaty No. 7 in 1877, the Blood Indians had settled on a large reservation and were learning to live in log houses when Russell visited them. Some were following their progressive head chief Red Crow in growing crops and raising live-

stock. Others remained dependent primarily on government rations for their subsistence. Russell recognized that the picturesque glory days of buffalo hunting and raiding neighboring tribes were gone. But those days were not so far behind; even middle-aged members of the tribe could remember buffalo days well and could tell many fascinating stories of tribal life.

We know also that Russell maintained personal contacts with Indians of several Montana tribes during the first quarter of this century. Visual proof of this relationship appears in a photograph by Sumner Matteson of Charlie and his wife Nancy among some of their Indian friends on the Fort Belknap Indian Reservation at sun dance time in 1905. Frank Bird Linderman wrote of attending the Cree sun dance in 1912 with Russell when many of Rocky Boy's people briefly resided on the Blackfeet Indian Reservation.[4] My elderly Piegan informants during the 1940s also remembered Russell's visits to their reservation.

I have no doubt that during his friendly contacts with Indians over the years, Russell obtained valuable information on the details of Indian life in buffalo days that helped him with his paintings. Even so, I must insist that he learned a great deal about Indian history and culture from other sources, as in his familiarity with the drawings and paintings of such artists as Bodmer and Wimar, who knew the tribes of this region when buffalo ran. Russell also learned by reading published accounts of Indians and Indian life written by whites who had known them since the time of Lewis and Clark.

One of his writer-observer sources was also his close friend, Frank Bird Linderman, whose books on Indian legends and trickster tales Russell illustrated. The title page of Linderman's popular *Indian Why Stories* (1915) bears a Russell illustration of an Indian storyteller. It refers to the book's illustrator both as "The Cowboy Artist," and by an Indian name. In another place, Linderman wrote of a boat trip he and Russell took down a portion of the Missouri in Montana during which Russell read aloud from a copy of the Lewis and Clark journals he had brought along to help them identify the landmarks mentioned in the writings of those first literate adventurers to ascend that river.[5]

There is not space here to consider individually the hundreds of Russell's works that picture Indians, but we can classify them rather broadly and consider a few representative examples.

Russell attempted to portray Indian life as he observed it in relatively few of his drawings and paintings of Indians. There is no question that this artist found Indian life in buffalo days especially fascinating. He preferred to turn the clock back and to show how Indians lived on the northwestern Great Plains when they were more independent, before the extermination of the great buffalo herds. So Russell's works, though produced *after the buffalo were gone*, tended to have a great deal in common in terms of subject matter with those created by artists who knew these people generations earlier—artists such as George Catlin, Karl Bodmer, and Alfred Jacob Miller during the 1830s, Paul Kane and Father Nicholas Point during the 1840s, and Rudolph Friedrich Kurz, Gustavus Sohon, John Mix Stanley, and Charles Wimar in the 1850s.

Like the paintings of those earlier artists, Russell's works appeal to us as interpretations of some of the basic traits of Plains Indian culture during buffalo days. Anthropologists tell us that reliance on buffalo as their staff of life was the most distinctive characteristic of traditional Plains Indian culture, as contrasted with the culture of Indians of other areas of North America. A goodly number of Russell's paintings—nearly fifty of them—depict the exciting action of the buffalo chase or surround by mounted Indians. They show Indians on swift, well-trained horses riding close to the great, shaggy beasts and shooting them down with well-aimed arrows and strongly drawn bows. This was not a new theme in the art of white men who had known the Plains Indians firsthand. Both Titian Peale and Peter Rindisbacher had pictured mounted Indians hunting buffalo as early as the 1820s, and many other artists had interpreted that action before Russell's time.[6]

Of greater interest to me as an anthropologist is Russell's *Indian Hunters' Return* [FIG. 11], for it reminds me of the verbal descriptions of this rarely pictured aspect of buffalo hunting as told to me by aged Blackfeet Indians who had participated in the hunt as young men. It illustrates clearly the Indians' method of transporting a butchered buffalo back to camp with the heavy burden of the dead animal's parts equally divided on each side of a pack horse. Obviously Russell intended to portray an action in late fall or early winter, after the Indians had gone into camp in a timbered river valley

but before there was too much snow on the ground to prevent the use of horses for buffalo hunting.

Throughout most of the year, the hunting band was the largest residential grouping of Plains Indians. Only during summer did the scattered bands come together to form the great tribal camp circle and to perform the sun dance. Like many other artists, Russell pictured the Indian camp of tipis—the distinctive portable dwellings of the Plains Indians, made of a conical foundation of poles tied together near the tops, covered with buffalo hides, carefully cut, pieced and sewn together. In paintings such as *Indian Camp No. 2* [FIG. 15], Russell showed a close-up of a tipi and placed in the foreground an Indian woman dressing a buffalo hide, while the man of the house sits by smoking his pipe. A large A-shaped frame leaning against the tipi became a very useful drag for carrying household possessions when camp was moved.

More frequently than other artists, Russell pictured the movement of a band of nomadic Plains Indians. It was women's work to take down the family tipi, fold it, and pack it along with all other family belongings, employing soft skin or rawhide containers to transport the various smaller items. Women and children comprised the main body of the procession, along with the elderly and infirm, while the able-bodied men rode at a distance, carrying only their weapons, constantly on the lookout for game and for enemies. *Squaw Travois* [FIG. 22], one of Russell's paintings of a camp on the move, depicts the main body crossing a small stream. Although they crossed these streams without difficulty, crossing a wide and deep river was a much more time-consuming and complicated maneuver, which involved forming the tipi covers into rude cargo vessels that were pulled by swimming horses and men.

Intertribal warfare was another important characteristic of Indian life on the Great Plains in buffalo days. It involved both the conduct of large parties for purposes of taking scalps and gaining revenge upon enemy tribes, and more frequent raids on enemy camps by small parties bent on stealing horses. Russell knew that the Indians themselves kept pictographic records of war actions painted on the inner sides of buffalo robes. Most commonly they sought to record the honors earned by individual warriors in one-on-one combat. Even so, most

Blackfeet and Cree picture-writers render both men and horses in a sort of pictorial shorthand, employing simple stick figures, no details of clothing, and little real action. Russell, on the other hand, pictured Indians warriors in violent and very realistic action, as in the water-color titled *Duel to the Death*, painted in about 1891. But other of his war-related pictures depict parties en route to the enemy or driving home stolen horses from an enemy camp [see *Roping by Moonlight*, FIG. 9].

Not only do Russell's pictures interpret major aspects of Plains Indian life, but some of them also provide insights into little-known details that are rarely or never included in the works of other artists, Indian or white. A water-color executed in 1907 and titled *Beauty Parlor* [FIG. 3], for example, pictures a young Indian woman dressing the hair of her husband, most probably to prepare him for participation in a dance. She wields a long, tubular tool of wood with a gently rounded end to part his hair. A few of these hair parters are preserved in museum collections, some of them with an animal head carved at the handle end. Even so, hair parters were seldom referred to in the literature and few Indians today are aware that their ancestors used such a tool.

Even though other and earlier white artists took an interest in the Indians' own graphic art of picture-writing, Russell may have been the first to visit the site known as Writing-on-Stone in the valley of the Milk River in Canada just north of the Sweetgrass Hills. There unnamed Indians incised and painted numerous figures on the soft sandstone walls. Some of the figures were placed too high above the talus slope for a standing Indian to have painted them. So Charlie Russell offered his own graphic solution as to how Indians had painted these highly placed figures. In a watercolor titled *Friend Pike/America's First Printer*, Russell pictured an Indian standing on the back of his well-trained and patient horse.

In spite of the fact that some of Russell's works reveal remarkable insights into the details of Indian life during buffalo days, such as other white artists may not have known, I find one glaring error in a number of his paintings that shows us that he did have a blind spot in his knowledge. That was his habit of picturing Indian warriors using high-horned, women's wood frame saddles. This shows quite clearly in his painting *Watching the Settlers*.

Evidently Russell did not understand that during buffalo days active young men employed a different form of saddle for hunting buffalo and in warfare. My elderly informants assured me that when they went to war men preferred to ride a pad saddle made of soft skins stuffed with hair, to which they attached stirrups. They preferred this saddle to riding bareback, because with their feet in stirrups they could more easily control their upper body movements forward and back or from side to side while riding at a fast pace.

Russell was not alone among late nineteenth century and early twentieth century artists in this misconception. In his well-known painting *The Smoke Signal* (ca. 1905), Frederic Remington also pictured warriors' use of a high-horned woman's saddle. Even so, a number of earlier white artists had known better. As early as the 1820s, Peter Rindisbacher pictured Indians of the Northern Plains hunting buffalo and riding to war on pad saddles. In 1851 Rudolph Friedrich Kurz, while employed at Fort Union trading post on the Missouri near the present-day eastern border of Montana, correctly rendered the pad saddle in a precise, pencil drawing titled *Saddled Blackfoot Pony*. A Sioux pad saddle collected by George Catlin during the 1830s and a Blackfeet one obtained in the field in 1849 are in the Smithsonian collections.[7]

I would classify another large body of Charlie Russell's drawings and paintings of Indians as primarily of historical significance. Each seeks to interpret an incident in Indian-white relations, and usually with particular whites and at a particular time and place. We have already considered one of these—Russell's interpretation of *Lewis and Clark Meeting the Indians at Ross' Hole*. Many of these historical paintings are unique in seeking to picture the actions from an *Indian* viewpoint.

Another excellent example is the striking watercolor, titled simply *York* [FIG. 10], which the artist himself gave to the Montana Historical Society in 1908. It interprets an episode described in the journals of the Lewis and Clark expedition that occurred during the winter they spent near the Mandan and Hidatsa villages in 1804–5, while on their journey westward to the Pacific. Because they had never seen a man with black skin before, William Clark's slave, York, was a great curiosity to the Indians. At a meeting with the Hidatsa

Indians one of their leaders touched his moistened finger to York's skin expecting that this black color might rub off. It is noteworthy that this Plains Indian attitude toward blacks persisted in the designation of blacks in the languages of several of the Upper Missouri tribes by words that translate "Black White Man."

In this painting Russell again showed his dependence on Karl Bodmer for the detailed construction of the interior of an earthlodge such as both the Mandan and Hidatsa Indians lived in. Surely Russell could not have found a better reference than the engraving of Bodmer's classic *Interior of the Lodge of a Mandan Chief*. Notice also that Bodmer's *Hidatsa Dog Dancer* must have been Russell's model for the young Indian seated between the two leaders of the American expedition. York's appearance must have been derived entirely from Russell's imagination, for no physical description of this man is known to have been published until after Russell's death. And it suggested that York was a fat man, rather than the tall and rangy fellow the artist portrayed.[8]

The Lewis and Clark expedition provided subjects for a number of Russell's historical paintings. Again and again Russell sought to picture their meetings with Indians from the Indians' viewpoint, as if the whites were not explorers of but intruders into the Indian country. Russell's *Indians Discovering Lewis and Clark,* painted as early as 1896, places the Indians in the foreground high above the Missouri River looking down on the explorers' boat approaching from the distance.

We should recognize that when Russell attempted to picture scenes of the Lewis and Clark expedition he was venturing back to a time a quarter century beyond his earliest graphic references to the clothing of the Indians they met on the Upper Missouri. Nor were the explorers' journals as precise as they might have been on this point, particularly in their descriptions of Indian women's dress. In several of his paintings, Russell pictured Sacagawea, the Shoshone wife of expedition interpreter Toussaint Charbonneau. His study sketch for the design and construction of her dress, as he envisioned it, clearly pictures a pattern such as that worn by Indian women on dress occasions in the artist's own time. We know that Blackfeet women wore that pattern of dress as early as 1833, for Bodmer pic-

tured a woman of that tribe wearing one.[9] But it is probable that Indian women of the Upper Missouri tribes did not wear that style of dress in Lewis and Clark's time. Fragmentary descriptions from the writings of white observers around the turn of the century, as well as two dresses collected by Lewis and Clark while at the Mandan and Hidatsa villages now preserved in the Peabody Museum of Archaeology and Ethnology at Harvard, suggest that Sacagawea's dress was more likely a skin slip supported by straps over the shoulders. It would have been more like the one worn by a conservative Plains Cree woman who visited Fort Union in 1851, where she was drawn by Rudolph Friedrich Kurz in his sketchbook.

Of the Russell paintings depicting Indian experiences with cattle introduced into the Great Plains by white men, my favorite is *White Man's Buffalo* [FIG. 27]. Here Russell sought to picture an undated historic event from an Indian viewpoint—some Indians' first sight of cattle. Like the Spanish explorers of the Southern Plains in the sixteenth century who described the buffalo they saw as "humpbacked cattle," Indians looked upon the white men's cattle as a variant of the animal that had been well-known to them. So Russell pictures the Indian on the left with his hands raised to the sides of his head with fingers crooked in the Indians' sign language gesture for "buffalo," while the man on the right covers his face with his hand to suppress his amazement at the sight of this new animal. As a matter of fact, Indians of the Southern Plains, who were the first tribes of the region to see white men's cattle, did speak of them as "striped buffalo" and believed these strange beasts possessed supernatural powers.[10]

Among the paintings Russell created that pictured relations between Christian missionaries and Indians in Montana, one of them had a very personal interest to him, for he knew and held "Brother Van" in great respect. William Wesley Van Orsdel, a young and vigorous Methodist lay preacher from Pennsylvania, traveled west in 1872 to establish a mission among the Blackfeet. He quickly made friends with those Indians who came to know him as "Big Heart," but he soon realized that he could make little progress among them until the morals of some of their white neighbors improved. So Brother Van, as he became widely known in Montana, devoted the rest of his life to founding churches and preaching interracial understanding.

Charlie Russell painted his interpretation of Brother Van hunting buffalo with the Blackfeet in memory of his friend for the Deaconess Hospital in Great Falls, which is within sight of the artist's log cabin studio.[11]

A number of Russell's works picture in very realistic detail dramatic actions in the hostilities between Indians and whites in the American West that took place over a period of more than 330 years. Several of his finest pen-and-ink drawings executed in about 1922 portray well-known and dated conflicts, such as *Coronado Advancing Against a City of Cibolo* in 1540, *John Colter's Race for Life* in 1810, the *Attempted Massacre of the Blackfeet at Fort McKenzie* in 1844 by white fur traders, and *William F. Cody's Fight with Yellowhand* on Warbonnet Creek in 1876.[12]

Unlike his contemporaries Frederic Remington and Charles Schreyvogel, however, Russell attempted relatively few pictures interpreting actions in the Plains Indian Wars between Indians and soldiers during the second half of the nineteenth century. When he did he preferred to picture the action from the Indians' viewpoint, as in *Attack on the Wagon Train* (1904 [FIG. 28]). In this view, Indian warriors on running horses occupy the foreground while the white-topped wagons —the objects of their attack—are in the distance. Earlier white artists had tended to picture Indian attacks on wagon trains—whether emigrant or military—by making the defense of the wagons by the whites the focus of attention.[13]

During the early years of this century, Russell became involved in the campaign spearheaded by his friend Frank Linderman to find a reservation home for the homeless Chippewa and Cree Indians who had sought asylum in Montana after the Riel Rebellion was quelled on the Canadian Plains. This was by no means a popular cause in Montana at that time, for neither whites nor Indians living on reservations expressed much desire to have these so-called renegades settle on lands near them.

It was during this period that Russell drew a powerful pen-and-ink illustration showing his sympathy for these homeless Indians as underprivileged human beings. On the sidewalk in the foreground he drew an Indian woman walking with her baby on her back wrapped in a blanket. She was on her way to the railway station to make a small amount of money by selling the hatrack of polished

F I G. 1   *Charles M. Russell*, 1925, gold tone photograph, by E. S. Curtis.
C. M. RUSSELL MUSEUM, GREAT FALLS, MONTANA

F I G. 2   Charles M. Russell, *Waiting for a Chinook*, 1887, watercolor.
MONTANA STOCKGROWERS' ASSOCIATION, MHS MUSEUM, HELENA

FIG. 3 Charles M. Russell, *Beauty Parlor*, 1907, watercolor.
C. M. RUSSELL MUSEUM, GREAT FALLS, MONTANA

FIG. 4 Charles M. Russell, *Keeoma #3*, 1898, oil on canvas.
MHS MUSEUM, HELENA

F I G. 5    Charles M. Russell, *Portrait of an Indian,* 1884, oil on board.
MHS Museum, Helena, Mackay Collection

F I G. 6    Charles M. Russell, *When the Land Belonged to God,* 1914, oil on canvas.
PURCHASED FROM THE MONTANA CLUB, MHS MUSEUM, HELENA

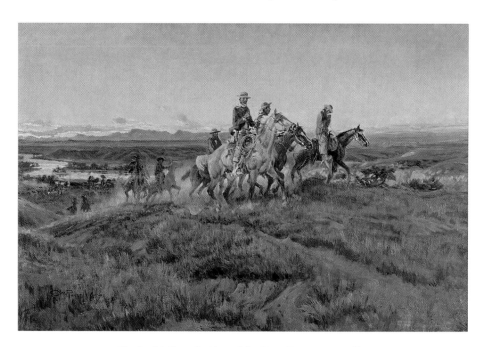

F I G. 7    Charles M. Russell, *Men of the Open Range*, 1923, oil on canvas.
MHS MUSEUM, HELENA, MACKAY COLLECTION

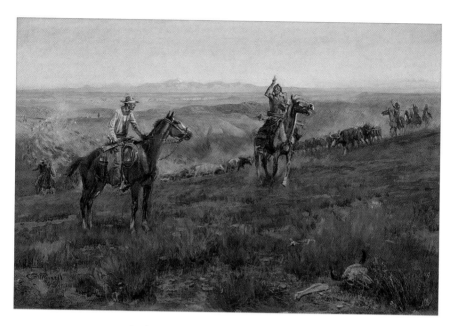

F I G. 8   Charles M. Russell, *Toll Collectors,* 1913, oil on canvas.
MHS MUSEUM, HELENA, MACKAY COLLECTION

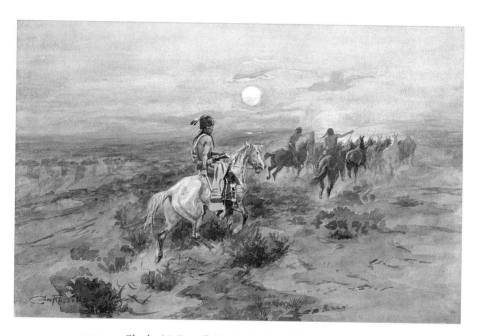

F I G. 9   Charles M. Russell, *Roping by Moonlight,* 1900, watercolor
(gouache technique). MHS MUSEUM, HELENA, GIFT OF MARGARET SIEBEN
AND FAMILY IN MEMORY OF HENRY SIEBEN HIBBARD

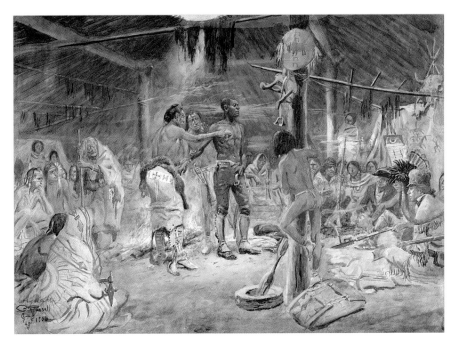

F I G. 1 0   Charles M. Russell, *York,* 1908, watercolor (gouache technique).
MHS MUSEUM, HELENA, GIFT OF THE ARTIST

F I G. 11   Charles M. Russell, *Indian Hunters' Return,* 1900, oil on canvas.
MHS MUSEUM, HELENA, MACKAY COLLECTION

FIG. 12   Charles M. Russell, *Lewis and Clark Meeting the Indians at Ross' Hole,*
1912, oil on canvas. MHS MUSEUM, HELENA

FIG. 13   Charles M. Russell, *Lewis and Clark on the Lower Columbia,* 1905,
watercolor, gouache, and graphite on paper, 1961.195.
AMON CARTER MUSEUM, FORT WORTH, TEXAS

F I G. 1 4   Charles M. Russell, *Bronc to Breakfast*, 1908, watercolor (gouache technique).
MHS MUSEUM, HELENA, MACKAY COLLECTION

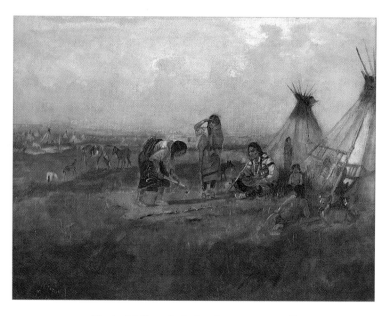

F I G. 1 5   Charles M. Russell, *Indian Camp #2*, 1891, oil on canvas.
MHS MUSEUM, HELENA, MACKAY COLLECTION

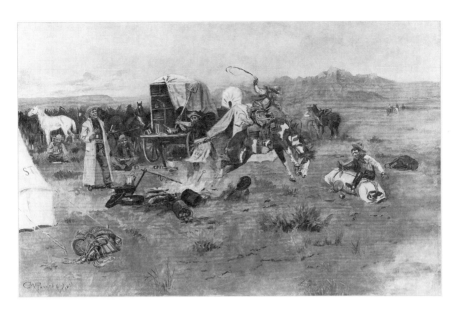

FIG. 16   Charles M. Russell, *Bronc in Cow Camp*, 1897, oil on canvas, 1964.144.
AMON CARTER MUSEUM, FORT WORTH, TEXAS

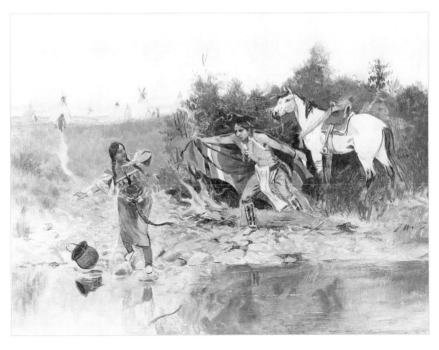

FIG. 17   Charles M. Russell, *The Marriage Ceremony (Indian Love Call)*, 1894, oil on
cardboard. SID RICHARDSON COLLECTION OF WESTERN ART, FORT WORTH, TEXAS

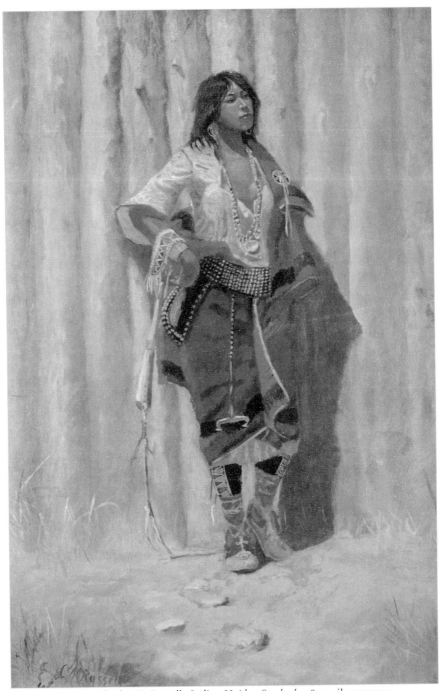

F I G. 1 8   Charles M. Russell, *Indian Maid at Stockade*, 1895, oil on canvas.
FROM *The West and Walter Bimson* (TUCSON, 1971), 143. COURTESY BANC ONE

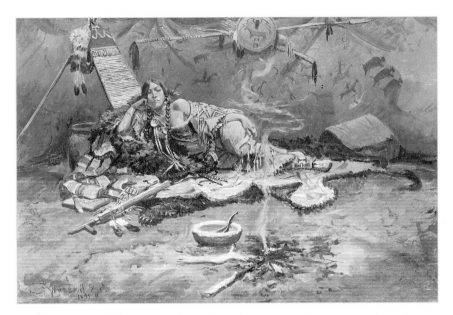

FIG. 19   Charles M. Russell, *Waiting and Mad*, 1899, oil on canvas, 12" ×17¾",
IMA73.104.5. INDIANAPOLIS MUSEUM OF ART, GIFT OF THE HARRISON EITELJORG
GALLERY OF WESTERN ART

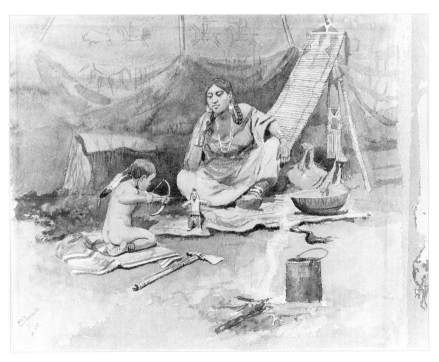

FIG. 20   Charles M. Russell, *Inside the Lodge*, 1893, watercolor.
MHS MUSEUM, HELENA, BEQUEST OF MAUD FORTUNE AND FLORENCE FORTUNE

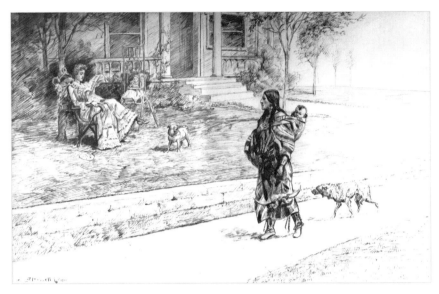

FIG. 21    Charles M. Russell, *Mothers under the Skin*, 1900, pen and ink.
C. M. RUSSELL MUSEUM, GREAT FALLS, MONTANA

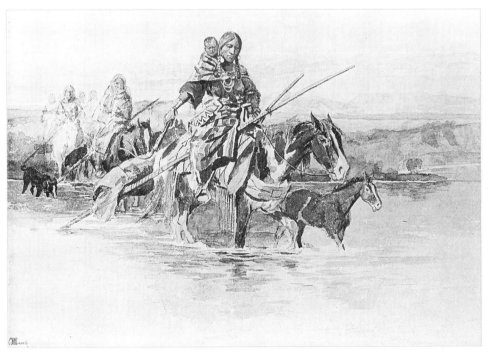

FIG. 22    Charles M. Russell, *Squaw Travois,* 1895, watercolor.
MHS MUSEUM, HELENA, BEQUEST OF MAUD FORTUNE AND FLORENCE FORTUNE

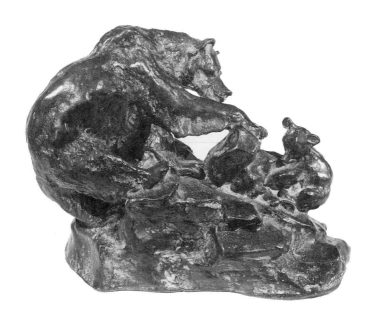

F I G. 2 3   Charles M. Russell, *Bug Hunters*, ca. 1926, bronze.
AMON CARTER MUSEUM, FORT WORTH, TEXAS

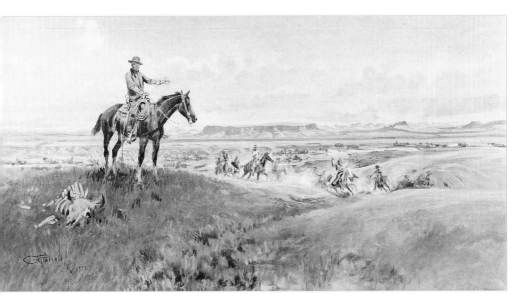

F I G. 2 4   Charles M. Russell, *Charles M. Russell and His Friends*, 1922, oil on canvas.
MHS MUSEUM, HELENA, MACKAY COLLECTION

FIG. 25    Charles M. Russell, *Canadian Mounted Police Bringing in Red Indian Prisoners*,
ca. 1888, oil on canvas, 46 cm. 91.7 cm. THE BEAVERBROOK CANADIAN FOUNDATION,
THE BEAVERBROOK ART GALLERY, FREDERICTON, N.B., CANADA

FIG. 26    Charles M. Russell, *Caught in the Act*, 1888, oil on canvas.
MHS MUSEUM, HELENA, MACKAY COLLECTION

FIG. 27 Charles M. Russell, *White Man's Buffalo,* 1919, oil on canvas, 0137.1622.
FROM THE COLLECTION OF THE GILCREASE MUSEUM, TULSA, OKLAHOMA

FIG. 28 Charles M. Russell, *Attack on the Wagon Train,* 1904, oil on canvas, 0137.902.
FROM THE COLLECTION OF THE GILCREASE MUSEUM, TULSA, OKLAHOMA

F I G. 2 9   Charles M. Russell, *Skunk Wagon*, 1907, watercolor.
Buffalo Bill Historical Center, Cody, Wyoming, gift of Charles Ulrick
and Josephine Bay Foundation, Inc.

F I G. 3 0   Charles M. Russell, *First Wagon Trail*, 1908, pencil, watercolor, and gouache
on paper. Sid Richardson Collection of Western Art, Fort Worth, Texas

buffalo or cattle horns she is carrying to some white train passenger. She is followed by her faithful mongrel dog. This woman contrasts sharply with the fashionably dressed white woman sitting in a chair on the lawn of her home, with her baby resting comfortably in an elaborate cradle and her pedigreed little dog beside her. Russell captioned this telling picture *Mothers Under the Skin* [FIG. 21].

In a less serious vein, but also revealing his awareness of contemporary Indian feelings, Russell humorously interpreted Indian reactions to the white man's new technological wonder, the automobile. He created this picture in 1907, more than a half-century before white Americans began to show concern about emission controls. But he knew that his friends the Blackfeet Indians had dubbed these new-fangled machines "skunk wagons" because of the odor of burning gasoline associated with their operation. Russell pictured an Indian and his wife coming upon a party of whites with a broken-down automobile, and the Indian commenting "White man's skunk wagon no good, heap lame" [FIG. 29]. Because Russell resented the replacement of horses by these mechanical contraptions he readily adopted the Blackfeet name of "skunk wagon" for them in his own writings. The Blackfeet Indians, however, soon came to speak of the means of transportation by a name that translates "goes by itself," a close approximation of "automobile."

That Charlie Russell took an interest in Indians as worthy individuals is revealed in his effort to advise John Clarke, a Blackfeet woodcarver who gained a wide reputation as a sculptor of the wild animals of the Glacier National Park region. In the C. M. Russell Museum there is a letter Russell wrote to John Clarke on May 7, 1918, in which he stated frankly "your work is like mine, many people like to look at it but there are few buyers." Russell proceeded to recommend an art store in Great Falls that handled his own works as a possible outlet for Clarke's and expressed his opinion that John might find it easier modeling his animals than carving them of wood. He also suggested that it might help sales of Clarke's carvings if he placed his Indian name on them.[14]

A deaf-mute since childhood, John Clarke did sign a number of his works with his Blackfeet name of Cutapuis, meaning "The-Man-Who-Talks-Not," but he never gave up wood carving in favor of modeling his very lifelike animals. It is said that Clarke's carving of

a mountain goat furnished the model for the logo of the Great Northern Railway. He established a studio near the entrance to Glacier National Park at East Glacier and remained active as a wood-carver until near the time of his death in 1971.

Shortly after I came to Montana in the spring of 1941 to become the first Curator of the Museum of the Plains Indian on the Blackfeet Indian Reservation, I learned that Russell's art continued to have a marked influence on Blackfeet Indians. While I was readying that museum for an early summer opening, Rose K. Brant, then Regional Superviser of Education for the Bureau of Indian Affairs, suggested that we needed an Indian-designed poster to advertise the new museum. She volunteered to interest Indian high school children from several reservations to submit designs for such a poster. I could then select the one that seemed to be most suitable.

When the designs arrived I was dismayed to find that all of the best executed bore illustrations that were obviously copies of Charlie Russell's Indians. So we abandoned the competition, and I arranged to have a striking poster designed by Victor Pepion, the more mature Indian artist, who had developed his own decorative style and who had been chosen to paint the four murals in the lobby of the new museum. It proved so popular that all copies of it were distributed even before the museum opened.

Looking back on the art of Charlie Russell some sixty years after his death, it seems to me that this artist's appreciation of the subjects he most liked to portray was best expressed in one of his paintings now exhibited at the Montana Historical Society. Titled *Charlie Russell and His Friends* [FIG. 24], this work was painted as a Christmas gift for his friend Malcolm Mackay in 1922, at a time when Russell was in full possession of his unique interpretive powers. There sits Charlie on his favorite horse and clad in cowboy togs, with one arm outstretched as if to introduce his friends to the viewer—friends who are represented as *both* cowboys and Indians on horseback. The human figures are placed in a vast panoramic setting of Montana plains, with Square Butte in the middle distance, and the Rocky Mountains—the Indians' Backbone of the World—in the background. Cowboys, Indians, and Montana—these were Charlie Russell's favorite subjects.

# NOTES

1. This sketchbook was published by its former owner, R. D. Warden, under the title *C. M. Russell Sketchbook* (Bozeman, Mont., 1972).

2. Charles Reymershoffer of St. Louis was an early student of Wimar's art. Russell's letter to him, bearing the date of its receipt as 8-24-1907, is reproduced in *Gateway Heritage*, 3 (Winter 1982–83). Wimar's painting *The Buffalo Hunt*, to which Russell referred in his letter, appears in color on the cover of that issue.

3. Frederic G. Renner, *Charles M. Russell, Paintings, Drawings, and Sculpture in the Amon G. Carter Collection* (Austin,Tex., 1966), 45. On that same page appears a photograph of Russell's wife, Nancy, posing as Keeoma, wearing an Indian dress, her hair in braids, and holding a long-stemmed Indian pipe.

4. Frank Bird Linderman, *Recollections of Charley Russell* (Norman, Okla., 1963), 53–56.

5. Linderman, *Recollections*, 57–66.

6. More than a dozen artists who had opportunities to participate in or to witness a buffalo hunt created paintings of mounted Indians hunting buffalo. Of them all, the one that seems to be closest to portrayal of the action as described to me by elderly Indian informants was another of Wimar's paintings titled simply *The Buffalo Hunt* (1860). See John C. Ewers, "Fact and Fiction in the Documentary Art of the American West" in *The Frontier Reexamined*, ed. John Francis McDermott (Urbana, Ill., 1967).

7. The pad saddle collected by Captain Howard Stansbury in 1849 is pictured in John C. Ewers, "The Horse in Blackfoot Indian Culture," *Smithsonian Institution Bureau of American Ethnology*, Bulletin 159 (Washington, D.C., 1955), plate 2a.

8. William Clark's reference to York as a "fat man" did not appear in print until Ernest Staples Osgood published *The Field Notes of Captain William Clark 1803–1805* (New Haven, Conn., 1964), 119.

9. Bodmer's drawing of a well-dressed Blackfeet woman was reproduced in William H. Goetzmann, *Karl Bodmer's America* (Lincoln, Nebr., 1984), FIG. 258.

10. Southern Plains Indian artists' ways of picturing cattle are illustrated in John C. Ewers, "Spanish Cattle in Plains Indian Art," *Great Plains Journal*, 16 (1977), 66–76.

11. Russell's *Brother Van Hunting Buffalo with the Indians* was reproduced on the cover of the Autumn 1972 issue of *Montana*.

12. Renner, *Charles M. Russell*, FIGS. 57, 64, 68, 72.

13. Charles Wimar's *The Attack on the Emigrant Train* was executed from a literary reference while he was a student in Dusseldorf, before he traveled among the Plains Indians. He placed the white defenders in the center foreground. Ewers, "Fact and Fiction," 66–67, FIG. 5.

14. This letter is reproduced in Frederic G. Renner, ed., *Paper Talk: Illustrated Letters of Charles M. Russell* (Fort Worth, Tex., 1962), 81.

# The Conservatism of
# Charles M. Russell

J. Frank Dobie

ONE CANNOT IMAGINE Charles M. Russell living in a world without
horses. If the wheel had never been devised, he could have lived
content. The steamboat had carried traders and trappers up the Mis-
souri River and become a feature in the pageant of the West before
he was born; he accepted the steamboat, respected it. When in 1880,
at the age of sixteen, he went to Montana, he traveled by the railway
to its end and then took the stage. The Far West was at that time still
an unfenced and comparatively unoccupied expanse of grass and
mountains; he accepted and respected the steam engine as one of its
features. As it hauled in plows, barbed wire and people, people,
people, he would, had he had the power, have Joshuaed the sun to a
permanent standstill.

The Russell genius was averse to change. No single collection of
his great art could be regarded as a full document on the evolution
of transportation in the West; although in his fertile life span he
came close to this. Such a series would include the old Red River
cart drawn with such casual care in his *Pen Sketches* (about 1899).
Other able drawings and paintings, except that of the Pony Express,
focus upon conveyances, progressing from dog travois to railroad
train, that stress incident and effect upon human beings rather than
the transports themselves.

Including the transports, Russell did document the Old West.
Plains Indian or frontiersman dominates countless paintings. Russell
never generalized. In any Russell picture of horses, for example, a
particular horse at a particular time responds in a particular way to

a particular stimulus; in the same way, his man made objects are viewed under particular circumstances. Here the steamboat and railway train are interesting through the eyes of the Indians whom they are dooming, very much as in one of Russell's paintings a wagon, unseen, is interesting for the alarm that sight of its tracks over prairie grass gives a band of scouting warriors [see *First Wagon Trail*, FIG. 30]. He was positively not interested in anything bearing mechanical evolution.

C. M. Russell's passionate sympathy for the primitive West welled into antipathy for the forces relegating it—and for him automobiles and tractors expressed those forces. He never glimpsed, much less accepted, "the one increasing purpose" in evolutionary processes that enables the contemporary Texas artist, Tom Lea for example, to comprehend with equanimity and equal sympathy the conquistador riding the first horse upon an isolated continent and the airplane that, more than four hundred years afterwards, bridges continents. Each a distinct man and a distinct artist, Tom Lea is at home in a cosmopolitan world of change, whereas Charlie Russell was at home only in a West that had ceased to exist by the time he arrived at artistic maturity. Tom Lea grapples intellectually with his world, is a thinker; Charlie Russell evaluated life out of instinctive predilections. Vitality, that "one thing needful" to all creative work, shows constantly in the work of both.

Russell's opposition to change was but the obverse of his concentration upon the old. His art can be comprehended only through an understanding of his conservatism. It was not the conservatism of the privileged who resent change because change will take away their privileges. It was the conservatism of love and loyalty.

Before he died in 1926, the airplane was changing the world; he dismissed it as a "flying machine." He was fond of skunks, a family of which he protected at his lodge on Lake McDonald, but his name for the automobile was "skunk wagon." His satisfaction in a cartoon he made showing mounted Indians passing a broken-down skunk wagon is manifest [*Skunk Wagon*, FIG. 29]. His forward-looking wife Nancy—to whom Russell's career as a serious artist was largely owing—would say to him, "Charlie, why don't you take an interest in something besides the past?" "She lives for tomorrow and I live

for yesterday," he said. For a long time he refused to ride in an automobile; he never did put a hand on a steering wheel. "You can have a car," he often said to Nancy, "but I'll stick to my hoss; we understan' each other better." At the World's Fair, in 1903, at St. Louis, the place of his birth and boyhood, he passed by the exhibitions of Twentieth Century progress and found kinship with a caged coyote "who licked my hand like he knew me. I guess I brought the smell of the plains with me."

"Invention," he wrote to a friend, "has made it easy for mankind but it has made him no better. Machinery has no branes." He resented the advent of the electric lights as deeply, but not so quietly, as Queen Victoria. He once called the automatic rifle a "Goddamned diarrhoea gun"—and I wonder how he would have spelled it. The old-time sixshooter and Winchester rifle were good enough for him. In the physical world he was a fundamentalist. It began going to hell for him about 1889, the year that Montana Territory became a state with ambitions to develop. One time Nancy got him to make a speech at a kind of booster gathering. The toastmaster introduced him as a pioneer.

Charlie began: "I have been called a pioneer. In my book a pioneer is a man who comes to a virgin country, traps off all the fur, kills off all the wild meat, cuts down all the trees, grazes off all the grass, plows the roots up, and strings ten million miles of bob wire. A pioneer destroys things and calls it civilization. I wish to God that this country was just like it was when I first saw it and that none of you folks were here at all."

About this time he realized that he had insulted his audience. He grabbed his hat and, in the boots and desperado sash that he always wore, left the room.

A string of verses that he wrote to Robert Vaughn concludes:
"Here's to hell with the booster,
The land is no longer free,
The worst old timer I ever knew
Looks dam good to me."

Russell's devotion to old times, old ways, the Old West did not come from age. It was congenital. Even in infancy he pictured the West of Indians, spaces and outlanders and knew that he wanted it.

Only when he got there did he begin to live. When he was forty-three years old, he looked at the "sayling car lines" (elevated) of New York and set down as a principle of life that the "two miles of railroad track and a fiew hacks" back in Great Falls were "swift enouf" for him. From Chicago in 1916 he wrote his friend and neighbor A. J. Trigg: "It's about thirty-two years since I first saw this burg. I was armed with a punch pole, a stock car under me loaded with grass eaters. I came from the big out doores and the light, smoke and smell made me lonsum. The hole world has changed since then I have not. I'm no more at home in a big city than I was then an I'm still lonsum."

He wanted room; he wanted to be left alone; he believed in other people being left alone. His latest request was that his body be carried to the grave behind horses and not by a machine, and that is the way it was carried.

In one respect Charlie Russell was far ahead of his contemporaries, who generally said that the only good Indian was a dead Indian. He had profound sympathy for the Plains Indians. His indignation against sharks greedy for their land was acid. "The land hog is the only animal known that lives without a heart." He hated prohibition laws and all kinds of prohibitors; he hated fervidly white men who debauched Indians with liquor. He painted the women and children as well as warriors of several tribes, always with accuracy in physical detail and recognition of their inherent dignity. "Those Indians have been living in heaven for a thousand years," he said to cowman Teddy Blue, "and we took it way from 'em for forty dollars a month." When sometimes he spoke of "my people" he meant the Horseback Indians. He called the white man "Nature's enemy." The Indians harmonized with Nature and had no more desire to "conquer" it or alter any aspect of it than a cotton-tail rabbit.

Over and over, he pictured schooners, freight wagons, pack horses, Indian buffalo hunters, cowboys, Northwest Mounted Police, horse thieves, cow thieves, stage robbers and other horseback men. Bullwhackers, mule skinners, stage drivers and their contemporaries of the frontier were as congenial to him as "Nature's Cattle"—among which the coyote and the tortoise were in as good standing as the elk and the antelope and in better standing than a "Cococola soke." "He can tell

what's the matter with a ford by the nois it makes but he wouldent know that a wet cold horse with a hump in his back is dangerous."

The "increasing purpose" of man's development of passenger vehicles has been to achieve more speed. Charlie Russell has often been styled the artist of Wild West action. It is true that his range bulls lock horns and his Longhorn cows get on the prod, that his cowboys often shoot, that his cow horses are apt to break in two, that his grizzly bears are hungrier for hot blood than Liver-Eating Johnson; in short, that violence was with him a favorite theme. At the same time, no other picturer of the old West has so lingered in repose. He likes cow horses resting their hips at hitching racks or standing with bridle reins "tied to the ground"; his master-piece of range life is a trail boss sitting sideways on his horse watching a long herd stringing up a draw as slowly as "the lowing herd" of milk cows winds "o'er the lea" in Gray's *Elegy*. One of his most dramatic paintings is of shadows. The best thing in his superb story of a stampede, "Longrope's Last Guard," in *Trails Plowed Under*, is the final picture of Longrope wrapped in his blankets and put to bed on the lone prairie. "It sounds lonesome, but he ain't alone, cause these old prairies has cradled many of his kind in their long sleep."

In only some of the great paintings in the large C. M. Russell collection at the Historical Society of Montana, in Helena, does drama reside in fast or violent action. There is drama in all Russell art, but it is the drama of potentiality, of shadowing destiny, of something coming, of something left behind. Russell illustrated a little-known pamphlet entitled *Back Trailing on the Old Frontiers*. He was a great traveler in that direction; he was as cold as a frosted crowbar towards the fever for being merely, no matter how rapidly, transported, as afflicts so many Americans today.

If the Old West was important to itself, Charlie Russell was important also, for he was—in Art—its most representative figure.

If the Old West is still important in any way to the Modern West, Russell remains equally important. If the Old West is important to far away lands and peoples, Charles M. Russell is important. He not only knew this West, he felt it. It moved him, motivated him, and gave him articulation, as a strong wind on some barren crag shapes all the trees that try to grow there.

Sometimes Russell lacked perspective on the whole of life. Some-

times he overdid violence and action, particularly that brand demanded by appreciators of calendars. But he never betrayed the West.

When one knows and loves the thousands of little truthful details that Charlie Russell put into the ears of horses, the rumps of antelopes, the nostrils of deer, the eyes of buffaloes, the lifted heads of cattle, the lope of coyotes, the stance of a stage driver, the watching of a shadow of himself by a cowboy, the response of an Indian story-teller, the way of a she-bear with her cub, the you-be-damned independence of a monster grizzly, the ignorance of an ambling terrapin, the lay of grass under a breeze; and a whole catalogue of other speaking details dear to any lover of Western life, then one cherishes all of Charles M. Russell.

# Charlie's Hidden Agenda: Realism and Nostalgia in C. M. Russell's Stories About Indians

Raphael Cristy

~

betwine the pen and the brush there is little differnce but I believe the man that makes word pictures is the greater[1]—C. M. Russell

KNOWN AS THE "Cowboy Artist," Charles M. Russell (1864–1926) depicted late nineteenth-century life in Montana and, by extension, America's trans-Mississippi West in art that attracted international acclaim. In addition to his paintings, sketches, and sculptures, Russell also wrote and published several dozen stories and essays that demonstrate his adept way with words. Most of his writings appeared first in Montana newspapers and several books distributed regionally. Since his death in 1926 a few published volumes of his illustrated letters have expanded public appreciation for his personality and wit. Both the published stories and the letters reflect Russell's

exceptional skills as a humorist and raconteur, and Russell's published stories especially embody a personal and perceptive view of the American West. Yet these writings have been largely overlooked as sources for serious study by most literary and historical commentators in the decades since they first appeared in print.[2]

The narrative form of Russell's published works may have deterred serious consideration of their substance. At face value, his writings are unsophisticated and charming, written in seemingly uneducated rural prose with droll humor. On reconsideration, however, many of Russell's stories, which depict episodes from the West of the 1820s through the 1920s, show a keen awareness of a place undergoing rapid transformation as it emerged from the nineteenth century into the twentieth century. Russell's works reflect a subtle yet firm grasp of the magnitude of that change as he witnessed it during his lifetime.

Russell's casual writing style grew directly from his oral delivery. Numerous firsthand accounts testify to the memorable impact of Russell's storytelling in cow camps, saloons, bunkhouses, and ranch parlors. More than a decade after Russell's death, a fellow cowboy recalled, "At camp and elsewhere Charlie Russel was always the center of attraction. . . . Russel always had a meal time story and the boys circled around him as close as possible, eating with legs crossed, plate on knees."[3] Russell's own letters as well as what others said about him suggest that he used this same vernacular style when he spoke informally. When the mood suited him, Russell seemed to create amusing tales spontaneously, and he apparently told many more stories than he ever published.[4]

In 1903 Russell and his wife Nancy began annual excursions outside Montana to sell his art. At social gatherings in New York, Los Angeles, and other cities, he impressed celebrities and high-society urbanites with his yarn-spinning. As Will Rogers noted in the introduction he wrote for *Trails Plowed Under*, the posthumous anthology of Russell's stories: "Why you never heard me open my mouth when you was around, and you never knew any of our friends that would let me open it as long as there was a chance to get you to tell another one. I always did say that you could tell a story better than any man that ever lived."[5]

Russell's enthusiasm for storytelling carried considerable momentum when the right circumstances prevailed. Fergus Mead, Russell's second cousin, remembered that Charlie "never stopped talking—spinning yarns. Lots of 'em are in Trails Plowed Under and in his letters. . . . He was an articulate sun-of-a-gun."[6] Yet Russell told stories only if someone could get him to talk. When Russell did not sense a mutual understanding and appreciation for his western story subjects, he was reluctant to perform.

As shy as he sometimes was to tell stories, Russell also struggled to write, once complaining to actor William S. Hart that he was "average on talk," but if handed a pen and paper, "Im deaf an dum."[7] Nevertheless, after years of telling his stories aloud, Russell committed some of them to paper in the colloquial slang and informal style he had known and used throughout his life in Montana. In 1906 Russell contributed a story titled, "A Savage Santa Claus," to a special Christmas section of the Great Falls *Tribune*. Then, in 1907, 1908, and 1909, *Outing Magazine* published five of his more serious stories, and between 1916 and 1921 Russell wrote twenty stories for the newly formed Montana Newspaper Association (MNA).[8] Founded by W. W. Cheeley, H. Percy Raban, and O. F. Wadsworth, the MNA published editorial and advertising newspaper supplements in Great Falls from 1916 through 1942. In the 1920s, some two-thirds of Montana's more than 170 daily and weekly newspapers carried the supplement, which offered special emphasis on Montana historical subjects. Although the MNA received twenty contributions from Russell, getting the cowboy artist to write anything, it was said, was "like pulling teeth."[9]

From 1921 until his death in 1926, Charlie Russell gathered thirty-six stories and essays, including most of the twenty already published by the MNA, into two books, *Rawhide Rawlins Stories* (1921) and *More Rawhides* (1925). When the first *Rawhide Rawlins* book appeared in 1921, Montana was experiencing a severe economic depression and drought, which prompted Russell to tell a Great Falls newspaper reporter: "These are hard times for a lot of folks. . . . If this book is going to give anybody a laugh and make him forget his troubles for a while, I want the price low enough so that people to whom a dollar means a dollar will feel that they're getting their money's worth."[10]

At a time when Nancy Russell first demanded and received $10,000 for one of her husband's larger oil paintings, *Salute to the Robe Trade* (1920), Charlie purposely priced the *Rawhide* books at one dollar. Russell seemed to want "a lot of folks" in Montana to be able to read his stories. The year after he died, Nancy reissued all but one of her husband's *Rawhide* stories and nine other Russell tales in *Trails Plowed Under*.[11]

Russell showed no sign of having a national audience in mind when he constructed humorous stories to embarrass certain Montana friends. "An old trickster," according to writer William Kittredge, Russell recorded both amusing and serious local legends about unusual events happening to specific people. In the process he dramatized regional history and supplied cultural vitality to the national perspective of the American West.[12]

Particularly rich in social commentary are Russell's Indian stories. While most of his stories on other topics emphasize humor, Russell's tales about Indians, while not devoid of humor, tend to maintain a more serious tone. They also deliver significant historical information and, unlike the supposedly humorous *Wolfville* stories by Alfred Henry Lewis and writings by other westerners such as Bill Nye and Mark Twain, Russell never seems to have purposely demeaned Native Americans. In fact, Russell carefully challenged the racist assumptions of his Montana audiences. Even among his contemporaries, only E. C. "Teddy Blue" Abbott, Frank Bird Linderman, and a few others shared his outspoken, positive views of Indian people. Russell could even add blunt social commentary that he knew Montanans would read while holding much different attitudes toward Indians.[13]

Russell's writings about Indians then would seem to merit especially close attention because they provide the clearest expression of his sense of the negative impact of whites on the transformation of the northern West in the late nineteenth century. One Russell historian has observed that Charlie's paintings evolved over his lifetime "away from documentary realism to what might be called romantic realism grounded in nostalgia. His portrayal of the Indian is a case in point."[14] While some Russell enthusiasts debate the degrees of romance and nostalgia in Russell's work, the observation

does provide a reasonable construct for considering Russell's approach to Indians. Once, when informally illustrating George Bird Grinnell's history of the Cheyenne Indians, *The Fighting Cheyennes*, for example, Russell wrote: "The red man was the true American They have almost gon but will never be forgotten The history of how they fought for their country is written in blood a stain that time cannot grinde out their God was the sun their church was all out doors their only book was nature and they knew all its pages."[15]

Russell's strong sense of admiration for the Cheyennes and other Indian peoples began with his own family. His great uncles, William, Charles, George, and Robert Bent, who, along with Ceran St. Vrain, founded Bent's Fort in southeastern Colorado in 1834, "were the fairest manipulators of Indians in the history of the mountain trade and maintained an elsewhere unheard-of standard of honor in dealing with them." William Bent married the daughter of a Cheyenne chief, and George Bent, their son, provided information for Grinnell's Cheyenne books.[16]

Like most Americans of his time, Russell believed that Indian tribal and racial identities soon would disappear through subjugation, starvation, or assimilation. Unlike many of his contemporaries, he believed such a fate was unjust. "We stole every inch of land we got from the Injun," he wrote, "but we didn't get it without a fight, and Uncle Sam will remember him a long time."[17]

Two of Russell's letters expressed his dismay with the changes forced on the Indians by misguided government paternalism. He told fellow cowboy, Kalispell taxidermist, and Montana Fish and Game Commissioner Harry Stanford, "the only real American . . . dances under the flag that made a farmer out of him once nature gave him everything he wanted. now the agent gives him bib overalls hookes his hands around plow handles and tells him its a good thing push it along maby it is but thair having a hell of a time prooving it. . . . nature was not always kind to these people but she never lied to them."[18]

In a letter to United States Senator Paris Gibson, Russell used his dry wit to make a case against assimilation. "Speaking of Indians. I understand there is a man back in your camp Jones by name who has sent out orders to cut all the Indians hair if Jones is stuck

to have this barber work done he'd better tackle it himself as no one out here is longing for the job the Indians say whoever starts to cut thair hair will get an Injun hair cut and you known that calls for a sertean amount of hide."[19]

Charlie Russell's opposition to federal Indian policies was out of step with prevailing white attitudes in Montana. In *The Rocky Mountain Husbandman*, published in White Sulphur Springs near the Judith Basin where Russell worked as a cowboy in the 1880s and 1890s, Robert Sutherlin expressed editorial views toward Indians that constitute one local example. Sutherlin preached that Indians must be assimilated and their tribal structure and way of life destroyed.[20] An especially rabid editorial, titled "The Red Devils," appearing in the *Mineral Argus*, another Judith region newspaper, read in part:

> During the past summer small lodges of Bloods, Piegans and Crows have been prowling around the Musselshell, Judith and Missouri valleys, killing stock and stealing horses . . . the property and belongings of white settlers. . . . There is to be no further favoritism shown thieving red devils by the military authorities. . . . The "Noble (?) Red Man" will speedily realize that, if he desires to exist on this sphere, he must remain on the grounds set aside for his exclusive occupation. This is as it should be, yet the big-hearted, philanthropical, goggle-eyed, heathen converter and Indian civilizer of Yankeedom cannot understand it and will probably protest.[21]

Wyoming newspaperman Bill Nye, in sarcastic editorials, took journalistic racism to another level of anti-Indian rhetoric, especially when he wrote in 1879,

> As usual, the regular fall wail of the eastern press on the Indian question, charging that the Indians never commit any depredations unless grossly abused, has arrived. . . . Every man who knows enough to feed himself . . . knows that the Indian is treacherous, dishonest, diabolical, and devilish in the extreme. . . . He will wear pants and comb his hair and pray and be a class leader at the Agency for 59 years, if he knows that in the summer of the 60th year he can murder a few Colorado settlers and beat out the brains of the industrious farmers.[22]

In contrast with these prevailing white attitudes, Russell gently confronted local racism, as shown in his letter to Senator Paris Gibson:

the subject of conversation was the Indian question the dealer Kicking George was an old time sport who spoke of cards as an industry . . . the kicker alloued an Injun had no more right in this country than a Cyote I told him what he said might be right but there were folks coming to the country on the new rail road that thaught the same way about gamblers an he wouldent winter maney times till hed find the wild Indian would go but would onley brake the trail for the gambler [23]

Racial dislike in early twentieth-century Montana focused with special intensity on small wandering bands of Chippewa and Cree Indians who collected in squalid camps on the outskirts of Helena, Great Falls, and other towns. To aid the destitute Indians who were suffering during an especially severe winter, Russell helped launch a local relief fund by making a candidly impromptu announcement for the Great Falls *Tribune*:

It doesn't look very good for the people of Montana if they will set still and see a lot of women and children starve to death in this kind of weather. . . . Lots of people seem to think that Indians are not human beings at all and have no feelings. These kind of people would be the first to yell for help if their grub pile was running short and they didn't have enough clothes to keep out the cold, and yet because Rocky Boy and his bunch are Indians, they are perfectly willing to let them die of hunger and cold without lifting a hand. I know that the majority of people of the state are not that way, however, and if they are called upon they will be glad to help the Indians out. [24]

Russell's public participation in the relief effort was uncharacteristic. Despite the extroverted and comic storytelling side of Russell's personality, he lived a relatively private life, seldom expressing political or religious attitudes outside his household. Charlie's statement in the *Tribune* and his public gesture of dropping the first money into the hat reflected a special intensity of concern for the landless Indians. On this occasion, Russell felt sufficiently moved to take a public stand and then write privately to United States Senator Henry L. Myers

urging support for the establishment of the Rocky Boy's Reservation near Havre.

> A friend of mine Frank Linderman has been trying to get a bill passed for a strip of land for the Chippaway and Cree indians. These people have been on the verge of starvation for years and I think it no more than square for Uncle Sam, who has opened the West for all foreigners, to give these real Americans enough to live on. . . . I understand that Senator Dixon is fighting the indian bill. Mr Dixon has the earmarks of a man that was never hungry in his life. I would like to lead the Senator to the Chippaway camp right now with the temperature ranging from 10 to 30 degrees below zero and show him what real starvation meant. And if he has anything under his hide like a heart he would change his talk.[25]

Russell also supported Linderman in his political and bureaucratic struggle against Washington inertia and Havre real-estate boosters. With a note of encouragement to his friend and a copy of the letter to Senator Myers, Russell included his own political cartoon of an obese capitalist "Land Hog" preventing an Indian family from crossing into the United States from Canada. "Frank its hard work this letter writing for me so I am sending this sketch to show how I feel about the Indians question of course I apologise to the whole hog family . . . but the land hog dont come in the same class[.]"[26]

Charlie Russell's infrequent and typically private efforts on behalf of Indian welfare reflected neither a lack of concern for Indians nor some protective reflex for his public image and art sales. Adverse public opinion in Montana would have made no significant dent in Russell's artistic stature, and his pro-Indian sentiments were already well-known locally. By 1913 exhibits of Russell art arranged by Nancy in New York and other major cities had boosted the price of his paintings well beyond the means of most Montana people who might be offended by pro-Indian political efforts. Russell simply led a life of artistic tunnel vision. His actions on behalf of Indians in his time reflected less an indifferent cynic purging his own "social guilt," as one art critic has speculated, and more a compassionate yet preoccupied artist responding impulsively to immediate human suffering.[27]

Charlie Russell's actions supporting the Cree and Chippewa demonstrated his belief that Indians needed to adapt to white American society. Nevertheless, his Indian stories consistently expressed admiration for the least assimilated Indian—the traditional warrior—forced to live within a reservation but cooperating in few other ways with white authorities. Such appreciation did express a form of nostalgia. Nevertheless, Russell's vision of Indians was not too idealistic or "goggle-eyed." He showed a serious awareness of the lethal violence often associated with old nomadic tribal ways. In his story, "The War Scars of Medicine-Whip," Russell started a narrative about a deadly clash between Blackfeet and Sioux warriors with a description of the battle's instigator: "That old savage is the real article, an' can spin yarns of killin's and scalpin's that would make your hair set up like the roach on a buck antelope."[28]

Although he used racist language common at the time, Russell loaded a negative term like "savage" with an ironic sense of cautious respect. The story's cowboy narrator acknowledges that, in certain circumstances, this old warrior would be his mortal enemy. Russell's use of "savage" in "The War Scars of Medicine-Whip" and other stories suggests an inverse meaning, much the way he used "gentlemen" when referring to the hunters who annihilated the wild buffalo.[29] Charlie Russell could respect the unassimilated warrior's independence and loyalty to his native culture while not necessarily wanting to be his best friend. "I admire this red-handed killer," he wrote in the "War Scars" tale.

> The Whites have killed his meat an' taken his country, but they've made no change in him. He's as much Injun as his ancestors that packed their quivers loaded with flint-pointed arrows, an' built fires by rubbin' sticks together. He laughs at priests an' preachers. Outside his lodge on a tipod hangs a bullhide shield an' medicine bag to keep away the ghosts. He's got a religion of his own, an' it tells him that the buffalo are comin' back. He lights his pipe, an' smokes with the sun the same as his folks did a thousand winters behind him. When he cashes in, his shadow goes prancin' off on a shadow pony, joinin' those that have gone before, to run shadow buffalo. He's seen enough of white men, an' don't want to throw in with 'em in no other world.[30]

Most Americans believed that "it was necessary to obliterate all vestiges of native cultures" and make Indians into an imitation of white people.[31] Even the more compassionate Indian sympathizers advocated the sacrifice of Native American cultures and religions, believing that Christianity alone could save Indians from total destruction. For Charlie Russell, forcing Indians into an alien way of life was a futile exercise that would destroy a valuable culture. In his dry-eyed brand of nostalgia, Russell's writings expressed appreciation for anyone who resisted or fell victim to the unstoppable momentum of the transitional frontier.

Through periodic contacts with Indians, Russell accumulated information that appeared in his art as well as his stories. His use of this information showed an understanding of the complex and conservative Indian social relationships that did not readily embrace outsiders. Russell generally spoke with cautious modesty of his own direct experiences with Indians. "My Indian study came from observation and by living with the Blackfeet in Alberta for about six months. I don't know much about them even now; they are hard people to savvy." Russell's narrator for the essay, "Injuns," known only as "Murphy," warned, "if I told only what I know about Injuns, I'd be through right now."[32]

Russell's portrayal of Medicine-Whip's situation on the reservation, for example, was not an attempt to write documented history. Nevertheless, the details of characterization, setting, and narrative style are consistently authentic and could represent Blackfeet oral history despite the absence of any Medicine-Whip (or other Indian names associated with Russell stories) among registered (American) Blackfeet or (Canadian) Blood tribal name records. "Whether or not Medicine-Whip ever existed," Canadian historian Hugh Dempsey has noted, "the adventure Russell recounted could easily have been told to him, as he said, while he was in camp along the Bow River."[33]

In another mixture of fact and fiction, Russell's narrative, "The Trail of the Reel Foot," first appearing in 1916, was based on accounts of a Ft. Pierre, South Dakota, half-blood Indian, Clubfoot George Boyd. Boyd's two frostbite-damaged feet had been amputated from instep to toes and left moccasin tracks in the snow that

confused Gros Ventre warriors during the winter of 1864–65.[34] In Russell's innovative version of the story, the encounter between white and Indian cultures is complicated by the fur trapper's completely reversed clubfoot. "His right foot's straight ahead, natural; the left, p'intin' back in his trail." Russell crafted a humorous scenario out of the irony of Indian confusion with unusual footprints in the snow.

At first the humor seems based on a patronizing attitude toward Indian superstition, which attributes the opposing footprints to "two one-legged men travelin' in opposite directions."[35] Later, when Sioux warriors see Reel Foot's actual physical defect, they respect his condition as an honorable wound, suffered probably in battle or torture, and abstain from killing him. Russell showed how the Sioux cultural attitude respecting human disfigurement differed from the ridicule and disgust typically found in the author's audience. Russell's narrator, Dad Lane, articulates that unsympathetic attitude in a joke. "I never do look at him without wonderin' which way he's goin' to start off."[36] In contrast, Sioux values about disfigurement spare Reel Foot's life. Russell's presentation of the humanistic nature of dangerous Indian warriors in a humorous context contradicted the white stereotype of bloodthirsty Indian "braves" and exposed one of the differences between Indian and white cultures.

Interracial marriage between white men and Indian women also generated considerable controversy in proper white society of both nineteenth and twentieth centuries, but provided Russell with yet another means of defending Native cultural differences. Many white men in interracial marriages experienced diminished stature in white culture from the earliest years of the fur trade well into the twentieth century. Mountain men who took Indian wives, according to one historian, were the ones "the settlers hated the most, alleging against them every villainy that should be alleged against Indians." In 1937 a Montana woman gossiped in a letter to a Russell researcher, "I think I told you I saw James Willard Schultz in Great Falls at the Rainbow [Hotel] . . . . He impressed me as the sort of man who would love his Indian wife the best because he would like the servility."[37]

As a young man, Russell was not above light-hearted racial ridicule combined with self-depreciation. In 1888 Charlie and his pal

Phil Weinard won first prize at a Helena costume party with Weinard dressed as an Indian man and Russell decked-out as his "squaw." Three years later, while still working as a cowboy, Russell wrote to a friend concerning an earlier opportunity to marry an Indian woman: "I had a chance to marry Young [L]ouse's daughter he is blackfoot Chief  It was the only chance I ever had to marry into good famley  but I did not like the way my intended cooked dog and we broke of[f] our engagement." In this private letter, Charlie joked about romance with an Indian woman by referring to cooking dog meat, knowing that the Blackfeet religiously avoided eating dog. Apparently, he assumed that his friend would appreciate the absurd lie.[38]

Russell dealt more directly with the sensitive topic of interracial marriage in his story, "How Lindsay Turned Indian." In his opening words narrator Dad Lane disagrees with the social stigma for interracial marriages. "Most folks don't bank much on squaw-men, but I've seen some mighty good ones doubled up with she-Injuns."[39] By the end of this lengthy yarn, Lindsay's adventures among the Blackfeet raised his stature beyond the negativity commonly associated with the "squaw-man" label.

Russell also used humor to make his audience more receptive to harsh conditions in the lives of Indian people. He reflected on the famine suffered by many northern Plains Indian communities in the final quarter of the nineteenth century. In "Finger-That-Kills Wins His Squaw," for example, the story's main character appears when some cowboys, including the narrator, deliver a herd of government cattle for distribution to the Blackfeet.

> There's an old Injun comes visitin' our camp, an' after he feeds once you can bet on him showin' up 'bout noon every day. If there's a place where an Injun makes a hand, it's helpin' a neighbor hide grub, an' they ain't particular about quality—it's quantity they want. Uncle Sam's Injuns average about one good meal a week; nobody's got to graze this way long till a tin plate loaded with beans looks like a Christmas dinner.[40]

Here Russell accommodated the typical racist assumption that Indians are helpful or willing to work only when the time comes to

put away food. Then he presented the blunt verbal picture of people suffering starvation at the whim of the government.

More troubling than food shortages, "Curley's Friend" tells of an attempted massacre. In 1924 a grim narrative appeared in MNA weekly newspaper inserts about some cowboys on horse and cattle reprisal raids against local Bannack Indians on Montana's southwestern ranges in 1878. Occasionally the cowboys killed their opponents—men, women, and children—and dropped their bodies down an abandoned mine shaft to hide the grisly evidence. The journalist revealed a flippant attitude about the murdered Indians by stating: "The cowboys returned the fire with the result that all of the Indians including the squaws, were soon in shape to be "snaked" [roped and dragged behind a horse] to the graveyard." Since that day the writer said, "The old shaft is the sepulchre of a dozen or more Bannack braves, as well as a few squaws and pappooses."[41]

A year later "Curley's Friend" appeared in Russell's *More Rawhides.* Curley tells of how he happened to interrupt forcibly a fellow cowboy's systematic shooting of a peaceful group of Bannack men and women. Disturbed by his companion's cold-blooded killing of Indian women who were begging for their lives, Curley forces the other cowboy to stop shooting, confiscates his gun, and earns himself a mortal enemy. Rather than bragging, Russell's narrator tells his story to explain why his life was spared at a later time by a Bannack war party. Apparently, the leading warrior recognized Curley and let him go free in the midst of lethal raids and skirmishes that left four other whites dead.

Russell's challenge was to deliver this story, in person or in print, to Montana audiences who may have sympathized more with the murderer than with Curley. To gain their trust and attention, Russell's narrator/hero could not be too compassionate for the Indian victims for fear of being rejected as a "big-hearted, philanthropical, goggle-eyed, heathen converter." So Russell had Curley disclaim, "I ain't no Injun lover, . . . but I'm willin' to give any man a square shake." By the end of his tale Russell was ready for Curley to negate a basic tenet of frontier bigotry: "I heard that all good Injuns were dead ones. If that's true, I'm damn glad the one I met that day was still a bad one."[42]

Through storytelling, Russell manipulated popular assumptions and attitudes about Indians to place his divergent ideas subtly in the minds of his audience. Despite being the least polished of his stories, "Curley's Friend" raised the issue of genocide and provided a model for the individual initiative required to stop it. Curley's erratic story sequence, similar to the inconsistent flow of events in an impromptu oral narrative, as well as the complete absence of references to the multiple killings hidden in the old well, suggest Russell did not rely on the newspaper account for his story. Nevertheless, whether "Curley's Friend" came directly from Russell's imagination as a response to atrocities in the Bannack outbreak of 1877–78, or, more likely, originated from the actual storyteller/protagonist, Russell purposely brought his audiences face-to-face with the unpleasant dark side of transforming the frontier into "civilized" society.

Russell used characters who bridged native and white cultures in yet other stories. One example is "Dad Lane's Buffalo Yarn," a story that also exposes the grossly unromantic side of buffalo hunting. The story has two narrators—Long Wilson and Dad Lane. Russell's first narrator, Long Wilson, describes how the professional buffalo hunters did their bloody killing, slaughtering dozens of animals at a time.

> Whenever one tries to break out of the mill, there's a ball goes bustin' through its lungs, causin' it to belch blood, an' strangle, an' it ain't long til they quit tryin' to get away an' stand an' take their medicine. Then this cold-blooded proposition in the waller settles down to business, droppin' one at a time an' easin' up now an' agin to cool his gun, ... These hide hunters 're the gentlemen that cleaned up the buffalo.[43]

Following Long Wilson's description of buffalo destruction, Dad Lane tells of his survival with an Indian partner who has a dual identity. Raised with white people, the Indian uses the anglicized name of Joe Burke. Just under the surface of his white man's clothes and language, however, resides his Indian identity, Bad Meat. Burke, or Bad Meat, proves to be a good partner. When he and Dad Lane must fight for their lives with a war party, Bad Meat sheds his white clothes. "When it's light I'm surprised at Bad Meat's appearance,"

Charles M. Russell, *The Chief Fired at the Pinto #2*, 1926, pen and ink. This drawing illustrated Russell's story, "The Ghost Horse," in *Trails Plowed Under* (1927).
MHS MUSEUM, HELENA, MACKAY COLLECTION

Dad Lane says. "Up till now he's wearin' white man's clothes, but this morning' he's back to the clout, skin leggin's, an' shirt. . . . He notices my surprise an' tells me it ain't good medicine for an Indian to die with white men's clothes."[44]

Bad Meat helps Dad Lane survive both the battle and near-starvation on a burned-over range. Russell shows that Indian companionship and know-how have the highest value in life-or-death situations. In "Dad Lane's Buffalo Yarn," Russell emphasized the brutal destruction of the buffalo as well as the value of native cultural persistence in the face of compulsory assimilation.

The ultimate cultural bridge between the Indian and white worlds in Charlie Russell's stories is not a human but rather a horse. Russell's story "The Ghost Horse" directly connects the days of the Indian's buffalo range and the white man's cattle business. The animal hero, an actual horse ridden by Russell throughout his eleven years as a cowboy and pampered for thirteen years after that, was written for the 1919 Great Falls High School yearbook, *Roundup Annual*. The writing style lacks all of the rural "cow camp" slang that Russell expressed in other stories. Rather, he wrote in "contemporary" English, possibly to communicate directly with his younger audience.

The story follows the life of a horse raised by Crow Indians to be a buffalo runner, stolen by the Piegan Blackfeet, and sold to a young cowboy. The narrative dwells on the horse's Indian days, but when the horse finally becomes the cowboy's property, "Paint," as he is then called, encounters cattle herds and a raucous new town. Near the story's end, Russell shifts the narration to reflect Paint's viewpoint entirely. Tied outside a saloon, the horse witnesses a fatal gunfight. "Paint knew then," the story says, "that the white man was no different from the red. They both kill their own kind."[45]

In another story, titled "Finger-That-Kills Wins His Squaw," Russell simply used the harsh racism expressed by some of his narrators to set up his white audience for his version of human equality. "That story that Dad Lane tells the other night 'bout his compadre getting killed off," Russell has narrator "Squaw" Owens explain in his tale,

> sure shows the Injun up, . . . Injuns is born bushwackers; they believe in killin' off their enemy an' ain't particular how it's done, but prefer gettin' him from cover, an' I notice some of their white brothers play the same way. You watch these old gun-fighters an' you'll see most of 'em likes a shade the start in a draw; there's many a man that's fell under the smoke of a forty-five—drawn from a sneak—that ain't lookin' when he got it.
>
> I've had plenty experience amongst Injuns, an' all the affection I got for 'em wouldn't make no love story, but with all their tricks an' treachery I call them a game people.[46]

"Squaw" Owens, like the hero in "The Ghost Horse," helps Russell cultivate the attention of his white Montana audience with a wary attitude toward a supposedly inferior and devious race. Nevertheless, his comparisons actually describe a ground-level sense of racial equality. Disguised in the racist language of his narrators, Russell's Indian stories provided entertaining propaganda that celebrated the validity of the endangered cultural life of American Plains Indians.

Russell's celebration of Indian cultures grew from an impulse that is easily categorized as nostalgic, a wish to return to a former home or a sentimental wish for a time gone by. He began one story, titled "Dunc McDonald," for example, with: "Like all things that

happen that's worth while, it's a long time ago."[47] In contrast with the spontaneous emotion in his letters to Harry Stanford and others, Russell's stories frequently reflect a more disciplined consideration of earlier times. Russell's Indian stories are not mere wishes for an idealized past and a vanishing race, but instead use nostalgia with a purpose. His tales carefully contradicted the prevailing attitudes of his fellow westerners, who responded to Indians with disgust or condescension more often than with sympathy. The "romantic realism" that some historians perceive in Russell's paintings appears in the artist's Indian yarns less as nostalgic regret than as depiction of harsh realities within which Russell may provide a moral of racial and cultural toleration.

Interpreting the imagery in Charlie Russell's art has been a popular sport since he created his paintings. A recent Smithsonian exhibit and catalog have attracted controversy with strong interpretations of the political content of works by western artists, including Charles M. Russell. One historian argued that Russell purposely chose "to portray warring Indians as ruthless, bloodthirsty mobs" in works that "suited Russell's need to show the 'animal' quality of Indians in combat." A routine reading of Russell's story, "Trail of the Reel Foot," might have softened this exaggeration of Russell's views toward Indians. The association of Russell with anti-Indian and pro-western expansionist attitudes, moreover, is simply incorrect.[48] Russell's own voice clearly states his sympathy and respect for native peoples.

Charlie Russell's tales about Indians radiate his concern for the human impact of social changes in the transitional nineteenth-century West. While he lacked the political temperament of a Frank Linderman, Russell effectively used his artistic talent and ingenuity to form mildly subversive literature about local people and events. Russell's stories argue implicitly for tolerance of intermarriage between Indians and whites, for respect for cultural distinctiveness, and for appreciation of mixed-blood people. The stories also portray the loss of buffalo-based Indian societies and the cultural damage caused by government-mandated assimilation. While attempting to entertain with his stories, Russell did not shirk the unpleasant issues of Native American suffering because of land theft, starvation, and

murderous violence. Without indulging in emotional hand-wringing over the injustice of the Indian peoples' circumstances, Russell provided subsequent generations with an honest perspective, on an individual level, of some of the consequences of accelerated social change in the American West.

## NOTES

1. CMR to Sgt. Ralph Kendall, n.d., in Charles M. Russell, *Good Medicine: Memories of the Real West* (Garden City, N.Y., 1929), 77. CMR and many of his quotable contemporaries routinely made spelling, punctuation, and grammar errors in their informal correspondence. Except for editorial clarifications within parentheses, each quotation is cited as originally written.

2. An exception is Robert L. Gale, *Charles Marion Russell*, Boise State University Western Writers Series, no. 38 (Boise, Idaho, 1979).

3. Al P. Andrews to James B. Rankin, [May 3, 1938], Rankin Papers.

4. A few versions of Russell's unpublished stories also survive in published accounts of other people. See, for example, "Tales Charley Told," in Frank Bird Linderman, *Recollections of Charley Russell*, ed. H. G. Merriam (Norman, Okla., 1963), 18–28; Con Price, *Memories of Old Montana* (Hollywood, Calif., 1945), 148–50; and Con Price, *Trails I Rode* (Pasadena, Calif., 1947), 89–102. Fergus Mead to Rankin, May 10, 1938, Rankin Papers.

5. Will Rogers, "Introduction," in Charlie M. Russell, *Trails Plowed Under* (Garden City, N. Y., 1927), xiv.

6. Mead to Rankin, May 10, 1938, Rankin Papers.

7. CMR to William S. Hart, June 29, 1902, in *Good Medicine*, 30.

8. CMR wrote the following articles for *Outing Magazine*: "Mormon Murphy's Misplaced Confidence," 50 (August 1907), 555; "How Lindsay Turned Indian," 51 (December 1907), 337; "Dad Lane's Buffalo Yarn," 51 (February 1908), 514; "Finger-That-Kills Wins His Squaw," 52 (April 1908), 32; "Longrope's Last Guard," 52 (May 1908), 176.

9. Austin Russell, *C.M.R.: Charles M. Russell, Cowboy Artist* (New York, 1957), 198. Original editions and microfilm copies of many Montana Newspaper Association (hereafter MNA) supplements are on file at the Montana Historical Society Library, Helena, Montana.

10. Michael P. Malone and Richard B. Roeder, *Montana: A History of Two Centuries* (Seattle, Wash., 1984), 216, 217; "New Book by C. M. Russell Filled with Humor," unsigned article, MNA, distributed October 31, 1921.

11. Seventeen stories with a foreword are collected in C. M. Russell, *Rawhide Rawlins Stories* (Great Falls, Mont., 1921). Nineteen stories and essays with a preface are collected in *More Rawhides* (Great Falls, Mont., 1925). Three stories published in MNA inserts were not reprinted in either of these two

books. *Rawhides* story, "Johnny Sees the Big Show," was omitted from *Trails Plowed Under.*

12. William Kittredge, "Desire and Pursuit of the Whole, The Politics of Storytelling," *Montana,* 42 (Winter 1992), 11.

13. Alfred H. Lewis's books include *Wolfville* (New York, 1897), and *Wolfville Days* (New York, 1902), *Wolfville Nights* (New York, 1902), *Wolfville Folks* (New York, 1908). E. C. Abbott and Helena Huntington Smith, *We Pointed Them North: Recollections of a Cowpuncher* (1939; reprint, Norman, Okla., 1989). Frank B. Linderman's books include *Indian Why Stories* (New York, 1915), *Pretty-Shield: Medicine Woman of the Crows* (1932; reprint, Lincoln, Nebr., 1972), and *Plenty-Coups: Chief of the Crows* (1930; reprint, Lincoln, Nebr., 1962).

14. Brian W. Dippie, *Looking at Russell* (Fort Worth, Tex., 1987), 62.

15. Russell, written on illustration, in *Good Medicine,* 127.

16. Austin Russell, *C.M.R.,* 19, 20; David Lavender, *Bent's Fort* (1954; reprint, Lincoln, Nebr., 1972), 396 n. 4; Bernard DeVoto, *Across the Wide Missouri* (Boston, 1947), 373; George E. Hyde, *A Life of George Bent: Written from His Letters* (Norman, Okla., 1968), viii.

17. Russell, "Injuns," *Trails Plowed Under,* 28.

18. CMR to Harry Stanford, May 8, 1925, in *Good Medicine,* 53.

19. CMR to Paris Gibson, February 4, 1902, in *Good Medicine,* 71.

20. Frank R. Grant, "Embattled Voice for the Montana Farmers—Robert Sutherlin's Rocky Mountain Husbandman" (Ph.D. Diss. University of Montana, 1982), 132.

21. "The Red Devils," Maiden (Mont.) *Mineral Argus,* September 10, 1885.

22. Bill Nye, "The Annual Wail," *Bill Nye's Western Humor,* ed. T. A. Larson (Lincoln, Nebr., 1968), 11, 12.

23. CMR to Gibson, February 4, 1902, in *Good Medicine,* 70, 71.

24. Verne Dusenberry, "Montana's Displaced Persons: The Rocky Boy Indians," *Montana,* 4 (Winter 1954), 1; *GFT,* January 10, 1909; Celeste River, "A Mountain in His Memory, Frank Bird Linderman: His Role in Acquiring the Rocky Boy Indian Reservation for the Montana Chippewa and Cree . . ." (master's thesis, University of Montana, 1990), 146, 207.

25. CMR to Henry L. Meyers, C. M. Russell folder, box 1, file 25, Linderman Collection, Museum of the Plains Indian, Browning, Montana.

26. CMR to Frank B. Linderman, file 5, box 4, Linderman Collection, Mansfield Library, University of Montana, Missoula.

27. Peter H. Hassrick, *Charles M. Russell* (New York, 1989), 130.

28. Russell, "The War Scars of Medicine-Whip," *Trails Plowed Under,* 177, 178.

29. Russell, "Dad Lane's Buffalo Yarn," ibid., 42.

30. Russell, "The War Scars of Medicine-Whip," ibid., 180.

31. Robert H. Keller, Jr., *American Protestantism and United States Indian Policy, 1869–82* (Lincoln, Nebr., 1983), 3, 150, 151.

32. Al. J. Noyes, *In the Land of Chinook; or the Story of Blaine County* (Helena, Mont., 1917), 131; Russell, "Injuns," *Trails Plowed Under*, 25.

33. Hugh Dempsey, "Tracking C. M. Russell in Canada, 1888–1889," *Montana*, 39 (Summer 1989), 6, 14 (reprinted in this volume). The American Blackfeet and Canadian Blood tribes share a language and much culture. Russell used both terms when referring to the Indians he visited near High River, Alberta, in 1888.

34. Russell, "The Trail of the Reel Foot," *Trails Plowed Under*, 17. "When the Gros Ventre Indians Trailed a 'Bad Medicine' Track . . .," unsigned, MNA, distributed December 24, 1924, and "Clubfoot Trail Puzzled Indians," unsigned, MNA, distributed February 21, 1938. For Clubfoot George Boyd's version of the incident see "Mon Tana Lou" Grille, "General Nelson A. Miles' Pursuit of Sitting Bull During Winter of 1876 . . . ," MNA, distributed May 9, 1935.

35. Russell, "The Trail of the Reel Foot," *Trails Plowed Under*, 18, 20.

36. Ibid., 18.

37. DeVoto, *Across the Wide Missouri*, 376; Cassandra O. Phelps to Rankin, February 5, 1939, Rankin Papers.

38. Phil Weinard to Rankin, January 4, 1938, Rankin Papers; Russell to "Friend Charly," May 10, 1891, in *"Paper Talk": Charlie Russell's American West*, ed. Brian W. Dippie (New York, 1979), 20; Russell, "The War Scars of Medicine-Whip," *Trails Plowed Under*, 185.

39. Russell, "How Lindsay Turned Indian," *Trails Plowed Under*, 133.

40. Russell, "Finger-That-Kills Wins His Squaw," ibid., 121, 122. See Helen B. West, "Starvation Winter of the Blackfeet," *Montana*, 9 (Winter 1959), 2.

41. Russell, "Curley's Friend," *Trails Plowed Under*, 57; "Horse Prairie Cowboys' Private Cemetary," MNA, distributed December 22, 1924, and a later version on March 14, 1938. The 1938 version was rewritten to reflect a less mirthful attitude toward Indian victims.

42. "The Red Devils," 2; Russell, "Curley's Friend," *Trails Plowed Under*, 57, 64.

43. Russell, "Dad Lane's Buffalo Yarn," *Trails Plowed Under*, 41, 42. See also James A. Dolph and C. Ivar Dolph, "The American Bison: His Annihilation and Preservation," *Montana*, 25 (Summer 1975), 15.

44. Russell, "Dad Lane's Buffalo Yarn," *Trails Plowed Under*, 47.

45. Russell, "The Ghost Horse," ibid., 91, 99; Karl Yost and Frederic G. Renner, comps., *A Bibliography of the Published Works of Charles M. Russell* (Lincoln, Nebr., 1971), 21, item 41. See also, "The Pinto," MNA, distributed June 30, 1919, and June 3, 1922.

46. Russell, "Finger-That-Kills Wins His Squaw," *Trails Plowed Under*, 121.

47. Russell, "Dunc McDonald," ibid., 15.

48. Alex Nemerov, "Doing the 'Old America': The Image of the American West, 1880–1920," *The West as America: Reinterpreting Images of the Frontier 1820–1920*, ed. William Truettner (Washington, D.C., 1991), 299–300.

# Bad Pennies: A Study of Forgeries of Charles M. Russell Art

F. G. Renner

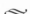

SEVENTY YEARS AGO, Charley Russell was known to a few acquaintances as the kid who drew interesting pictures of Judith Basin Roundup scenes. As his skill and fame grew in the years that followed, Russell paintings became known to practically everyone with even a remote interest in the Old West, mostly from the hundreds of them published on calendars, as colored prints, and as magazine and book illustrations. Readers of these pages are familiar with some of his finest canvasses which have been reproduced from paintings in the Montana Historical Society's own collection and used as illustrations in this magazine.

It is less well known that there is a thriving business in the manufacture of forgeries of Russell"s work. A dozen or more have been offered for sale to the Historical Society of Montana. It is believed that all of Russell's admirers and collectors should know some of the information that is available about this dishonest business. It needs publicity if it is to be stamped out.

In general, there are five categories of "fake" Russells.

First are the outright copies in oils of some of Russell's more important paintings. Such copies are even larger than the original painting, although the forger may not know this. Others are copies of minor water color sketches. The first appeared as magazine or book illustrations. These may be not much larger than the illustration and they are sold as the original from which the reproduction was made.

"The Empty Saddle (forgery)." COURTESY GINGER RENNER

"Cowboy on a Horse (forgery)." COURTESY GINGER RENNER

The second kind of forgeries are paintings or drawings of western subjects in which the attempt is made to copy Russell's style, with Russell's signature forged on them. These may be in oil or water color, or even pen sketches. The painting may be of an Indian buffalo hunt, a cowboy on a bucking bronco, or a similar action scene of the early West. Practically all of these are uniformly bad—so filled with outright mistakes that Russell would not have made, that few of them would deceive anyone at all familiar with a genuine Russell. (See reproduction of the crude forgery "The Empty Saddle" and crayon-pastel "Cowboy on a Horse.")

The third category includes paintings by other artists, with the original signature painted out and Russell's substituted. A few of these are fine paintings but the style of the artist is usually so foreign to Russell's that is immediately evident what they are.

In addition to these, a number of Russell prints have been painted over with water color and sold as original paintings. And finally, there has been some unauthorized recasting of Russell bronzes.

There have been quite a number of outright copies of well-known Russell paintings. Most of these have been done in oil, probably because an oil painting that can be sold as a "Russell" will bring roughly twice as much as one of similar size and quality in water color. Since most Russell paintings are in private hands, rather than in public museums, the forger resorts to the use of a readily available colored print or lithograph as his model. This is often his give-away.

The quality of such copies varies tremendously. Many of the paintings of this kind are too crude to fool anyone moderately familiar with Russell's work. The colors are usually harsh and there are minor discrepancies that can be readily detected by comparison with the print. A few of them, however, are well executed duplicates by a highly skilled, if dishonest draftsman. Most of them have one quality in common, a flat and lifeless appearance that makes them look like copies. This is apparently due to the inability of the forger to capture the skilled handling of depth and perspective that characterizes much of Russell's work.

One of these, "Lassoing Wild Horses," along with a couple of equally-spurious Remingtons, was once sold to a prominent citizen of Fort Worth, Texas. A discerning fellow-collector who saw the

painting speedily recognized it as a not-too-well-done copy of *Wild Horse Hunters*. The purchaser decided to take no immediate action but to wait until the dealer who sold him the paintings made his next trip to Fort Worth. When the dealer showed up with some more paintings for sale a few months later, the client demanded his money back— a mere trifle of $19,000. The dealer was in a tight spot. He didn't dare admit the paintings he had sold were no good, so he explained that he couldn't return the money as it had been spent. The client wasn't especially perturbed, nor was he bluffing. He merely called the club where the dealer was staying and instructed the manager not to let him check out or to leave town until given the word. The story that came out later was that the dealer was there five days until his wife was able to wire him the money and get him out of hock. Incidentally, this collector has since acquired the real original and it is now one of the important pieces in his collection.

A painting called "The Mad Cow" on the other hand, which was sold by the same gallery for a reputed $8,500 a number of years later, had few of the usual discrepancies. The proportions and details revealed by a comparison of the photographs of the forgery and the original painting of *The Bolter* were so close that is was apparent the forger could have used a reflector, throwing the print on a screen (in this case his canvas) and carefully painting in the exact outlines of the cowboy dropping his loop over the horns of the running steer. Examination of the painting itself, however, left no doubt as to what it was. The canvas was sparking white and the paint was still freshly soft, although presumably done nearly forty years earlier. The forger, never having seen the original, also made the mistake of copying the colors of the print too closely. What he didn't know was that the bluish print he had obviously used as his model was off-color. The original painting has no such bluish cast, but is in soft browns and yellows.

There are three such copies of the famous *Bronc to Breakfast* [FIG. 14]. As most readers of this magazine know, the original of this painting is a water color and is owned by the Historical Society of Montana, having been acquired as a part of the outstanding Mackay collection.

The first forged copy of this painting was an oil and turned up, unsigned, in the hands of a San Francisco dealer about six years

after Russell's death. It has since acquired a counterfeit Russell signature and can be purchased as "an original painting of the Old West by Charles M. Russell," in case anyone is interested.

The second forgery of *Bronc to Breakfast* was also in oil, and not a very good one. By the time this was sold the location of the original was pretty well known; so the dealer had to make some explanation of the existence of the two paintings. His story was that his oil was the real masterpiece, while the watercolor was merely Russell's "working sketch."

The third forgery was called "A Bronc Before Breakfast" and has an even more interesting story connected with it. This painting—so the published account goes—"is an original water color copied from the large oil painting owned by Dr. Phillip Cole of Tarrytown, New York." It is true that Dr. Cole, a former Montanan and one of the earliest collectors of Russell"s work, had a Russell painting of the same general subject called *The Camp Cook's Trouble* which showed a bronco bucking through a camp fire. However, the position of the horse, the rider, the number of figures around the chuckwagon, in fact nearly every detail was totally different. It is coincidence, indeed, that a copy of *The Camp Cook's Trouble* should turn out to be so nearly identical with the well-known print of the completely different *Bronc to Breakfast*. Perhaps it is the same kind of coincidence that is responsible for the fact that 25 of the 107 Russell forgeries of record can be traced to the same dealer.

Other colored prints of Russell paintings that have been copied in oils and sold or offered for sale as originals include *Capturing the Grizzly, A Crow Chief, Crow Burning Sioux Buffalo Range*, (the original of this one is also a water color), *The Disputed Trail, In Without Knocking, Last of the Herd, The Navajos, Roping the Grizzly, A Strenuous Life, The Sun Worshipers, The Warning Shadows, When Tracks Spell Meat*, and *Where Ignorance Is Bliss*.

Some mention should probably be made also of the so-called "murals," consisting of copies of Russell's paintings that still adorn the walls of many Western bars and similar places, painted there by itinerant artists. While few, if any, of these were painted with the intent to defraud, they are still forgeries, even though some of them carry the facsimile of Russell's signature. Such copies of Russell's work

can still be seen in the present cocktail lounge of the Shirley-Savoy Hotel in Denver, Colorado, and in one of the older restaurants in Portland, Oregon.

No discussion of Russell forgeries would be complete without some mention of the "famous Eugene Field collection." That this well-known man of letters was supposed to have been a Russell collector became known about 1940 when Wichita, Kansas, was found to be almost plastered with phony Russells and Remingtons. As the story has been reported, it seems that in the late 1930s, and perhaps shortly thereafter, two characters from Chicago were involved in the disposal of the Eugene Field library. Not making money fast enough to suit them, this pair conceived the scheme of increasing the values of their books by adding inscriptions by famous people on the fly-leaf, autographs of "A Lincoln," for example, and similar "improvements" that would appeal to rare book collectors.

With the growing interest in Russell and Remington, they graduated to hiring "original" water color sketches by these artists painted in such books as John Clay's "My Life on the Range," Parkman's "The Oregon Trail," and many others. One of these rarities was Hamlin Garland's "The American Indian" which was shown with great pride by the man who had purchased it. What made this book so remarkable was that Remington must have come back from the grave to paint the sketch inside the front cover, since he died fourteen years before the book was published.

In addition to such works of art, this pair sold a great many paintings as "Russells from the Eugene Field Estate." Some of these were attempts to duplicate sketches that had appeared in "Good Medicine," Russell's own book of illustrated letters; and in "Trails Plowed Under." Others were larger water colors, and an occasional oil of western subjects with Russell's signature forged to them.

Joe De Yong, who probably knows more about Russell's style of painting than any man alive, saw several of the paintings from the "Eugene Field collection" and pronounced them the work of a shallow and ignorant crook. One of these paintings was called "Going to Town," and showed four mounted cowboys shooting off their six-shooters against a most un-Russell-like green background. It was signed with the Russell signature and dated 1924. De Yong lived

with Russell in 1924 and stated positively that no such painting was painted, nor such title used. As he expressed it, "The painting wasn't even a plausible copy of Russell's men, horses, background, color scheme, style of drawing, nor manner of using a brush. It was simply a so-called western by some mediocre, small calibre, chisler whose best skill is expressed in a poor forgery of Russell's signature."

One pair of water colors that were reported to have been purchased "from the Eugene Field collection" is still a puzzle. These paintings were copied from genuine Russells, each of them showing a modern rodeo rider trying to stay aboard a bucking bronco.

Neither of the originals from which this pair was copied has ever been published and the only known photographs of them are the ones Mrs. Russell had, and the ones in the files of the writer. The only conclusion possible is that somewhere, sometime, the forger had the opportunity to see the originals themselves, and made his copies from them.

One of the characteristics of many of the "Eugene Field Russells" is the "fairy-like quality" of the paintings—a baby-blue silk neckerchief on the cowboy, instead of the ten-cent red bandana that Russell would have painted—a delicately checked shirt that might have come from Marshall Fields but never from the Utica General Store—the Russell signature in bright scarlet or orange, and most of the colors in pastel shades. The very prettiness of the paintings damns them for what they are. There is no record of how many such forgeries there are in existence. Twenty-three have been uncovered and there are probably others.

Little is known about the people who have copied or painted all the known Russell forgeries but it appears certain that only a very few such paintings have come from the brush of either well-known or reputable artists.

One small oil with a Russell signature on it has turned up that was undoubtedly painted by Berninghaus, the late and highly-respected Saint Louis artist. Two others, black and white water colors, could only have been done by Dan Muller the author and illustrator of "Chico of the Cross UP Ranch." It can be taken for granted that neither of these reputable artists were aware that their paintings had gotten into the hands of someone who had changed the original signature to that of Russell.

A number of years ago, three oils, painted and signed by Olaf Seltzer, the fine Montana artist who still lives in Great Falls, were offered for sale in New York. A few months later, the same paintings were seen in other galleries; but by this time Seltzer's name had been painted out and Russell's substituted, undoubtedly without Seltzer's knowledge. One of these paintings was unsold for several years. Finally a leading New York dealer made a comment about it that reveals a good deal of the philosophy about forgeries held by some individuals. He said, "It's too bad the blank Gallery is trying to sell that Seltzer painting as a Russell; but if they are going to do it, they ought to make it convincing and put the price up around $7,000. Trying to sell it for a measly $3,500 merely spoils the Russell business for the rest of us."

Another painting done by another artist and re-signed with Russell's signature depicts a herd of buffalo stampeding through a camp. One man is shown shooting at the buffalo with a rifle, another is trying to frighten them off with a six-shooter, while a woman and child cower at the side of an up-turned wagon. The painting, "The Stampede," a subject that Russell wouldn't have painted, is a typical "western." The artist is unknown but it certainly was not Russell, despite the forgery of his signature in the corner.

"The Stampede (forgery)." Courtesy Ginger Renner

"Overland Trail (forgery)." COURTESY GINGER RENNER

In contrast, a horrible daub was recently offered for sale to the Historical Society of Montana by an obscure San Francisco dealer. This painting is on flour sacking or some such material and shows a group of cattlemen meeting four settlers in a mountain pass. One of the settlers is mounted on a mule and there are two ox-drawn wagons in the background.

No one who had even a casual acquaintance with Russell's work would have any doubts but that the signature on this painting was a forgery.

Aside from the few paintings on which the signature has been changed, most of the forgeries of Russell's work have undoubtedly been done by obscure artists, expressly hired for, or motivated by the same purpose, and in each case for the same reason: to defraud the public.

Most C.M.R. fans are familiar with 16 splendid pen sketches by Russell known collectively as "The Western Types." Five of these, *Buffalo Man*, *Halfbreed Trader*, *The Scout*, *The Stage Robber*, and *The Trapper* are in the Historical Society collection. Several sets of prints of these sketches have been colored over with water color and

sold as original Russell paintings. One Arizona collector who owned such a set for many years, had them examined by an artist friend. He was certain that they were originals and was highly indignant when they were pronounced to be prints. The collector had to see copies of the undoctored ones before he was finally convinced. Three other well-known prints of pen sketches by Russell which have been colored and sold as "originals" are "The Trail Boss," "The Christmas Dinner," and "First American News Writer," the first two of which were originally reproduced in Russell"s own book, "Pen Sketches."

Two other groups of pen sketches signed C. M. Russell have come to light in recent years, one of them around Calgary, Canada. Apparently they have been done by two different artists, if the perpetrators can be dignified by this term. The tight and cramped drawing on some of them and the dense black shading in others bear little resemblance to Russell's free and easy style and they are unquestionably forgeries.

Of the fifty authentic Russell bronzes, those the artist himself had cast, only two are known to have been tampered with. Shortly after Mrs. Russell's death in 1941, the writer was called upon to determine the authenticity of one of them, a bronze called the *Buffalo Hunt*. There wasn't much question but that the bronze was a copy since there was known to be only nine of them and this was one of several additional ones that a New York dealer had suddenly offered for sale. The problem was to prove it. One way to do this was to compare the measurements of the bronze with those of the original model, then in California in the possession of the executor of Mrs. Russell's estate. When this was done the bronze was found to be smaller than it should have been. This was evidence that it could not have come from the original model but was a copy, probably from another bronze.

The problem appeared to be solved. Before leaving Mrs. Russell's home, however, the measurements of the four other *Buffalo Hunt* bronzes still in the possession of the estate were checked. The calipers revealed that one of these was also a forgery. Such a thing seemed impossible, but there was the evidence.

The estate files revealed the clue that apparently explained the presence of the second forgery in Mrs. Russell's own collection. It

was found that the same New York dealer who had sold several *Buffalo Hunt* bronzes had once been an agent for Mrs. Russell and had handled a large number of bronzes, including *Buffalo Hunt*. The correspondence also indicated that she had had a great deal of difficulty with this particular individual and finally terminated their arrangements and ordered the bronzes in his possession turned over to a new agent, a reputable gallery. There seems little doubt but that this person had several copies of the *Buffalo Hunt* bronze made when the original was in his possession. In any event, the records showed that he turned over one of them to the new agent, the same forgery this gallery unsuspectingly returned to the estate when all the bronzes were called in after Mrs. Russell's death.

In recent years, ten additional castings have also been made of the bronze, *Will Rogers*, the famous cowboy humorist and friend of Russell. These are recognizable by their "fuzziness" or loss of detail, when compared with the original bronzes.

A third bronze of pony express riders changing horses is also reported to bear a forgery of Russell's signature. From the photograph of it, it certainly bears no resemblance to Russell's work, nor is there any copyright record of it in Russell's name.

The first doubtful Russell came to light twenty years ago. The title of this painting had a more authentic ring to it then the painting itself. It was called "When Guns Were Trump" and showed a group of mounted cowboys in front of a saloon—a poor imitation of that great Russell painting, *Smoke of a 45*. The signature was an inept forgery and one of several other features that convicted the painting was that the saddle blanket on one of the horses had been put on with the fold to the side. A range-man like Russell, of course, would never make a tinhorn mistake like that.

This painting was sold to a man in Santa Barbara, California. He was so proud of it that he put it on display, where it was seen by Mrs. Russell (at that time living in Pasadena). She quickly pronounced it a forgery.

This, however, was not the first Russell forgery. The first one was not only made, but was published before any reproduction of an authentic Russell appeared in print, 68 years ago. Russell "fans" know that the first Russell painting to be published was *Caught in the Act* [FIG. 26] which is now owned by the Montana Historical

Society. This painting was reproduced first in the May 12, 1888 issue of *Harper's Weekly*.

The earliest forgery of Russell's work beat this record by almost two months. It was a pen and ink sketch of an Indian squaw with a papoose on her back and three youngsters and a dog riding the travois trailing behind her pony. Other details included a colt out in the lead, a dog in the foreground, and seven tepees and two sets of bare lodgepoles in the distance, all plainly copied from an oil painting by Russell titled *Indians Moving Camp*. This forgery appeared under the title of "Crow Indians on the Move," on page 1 of the *Northwest Illustrated Magazine* in the March issue of 1888.

Other pen and ink sketches, copied from other oil paintings by Russell, appeared in subsequent issues of this same magazine. In some instances the words "after a painting by C.M. Russell" followed the title; in others no credit was given.

The question is often raised as to whether Russell ever painted two identical paintings; or ones so close in subject and treatment as to appear practically alike. One art dealer known to have handled many forgeries often tried to persuade his customers that Russell made this a common practice. If true, it would of course confuse a lot of people and make it that much easier to dispose of fraudulent copies. But it is not true.

At one time it looked like there was such a pair of paintings. Many years ago, two very interesting photographs of work obviously by Russell, turned up. They both showed General Phil Sheridan and his guests, Grand Duke Alexis and Buffalo Bill, in the stirring action of a buffalo hunt. The human figures and their mounts were identical, as was the landscape and the small bunch of buffalo the hunters had cut off from the main herd. About the only difference was that a buffalo calf was missing in one painting and there was some variation in the foreground.

Even the "experts" were certain the Russell had done both paintings. It was equally certain that C.M.R. wouldn't deliberately have made a second painting so nearly like the first one. He was too much the creative artist to dream of copying his own work. The matter was so intriguing that Mrs. Russell was asked if she remembered the paintings and if there was any explanation.

Charles M. Russell, *Running Buffalo* (unaltered version), 1918, oil on canvas.
PHOTOGRAPH COURTESY THE GILCREASE MUSEUM, TULSA, OKLAHOMA

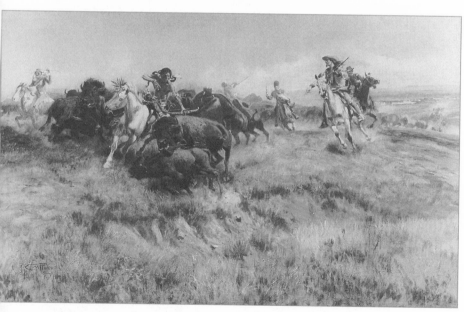

Charles M. Russell, *Running Buffalo* (altered version), 1918, oil on canvas, 0136.2266.
FROM THE COLLECTION OF THE GILCREASE MUSEUM, TULSA, OKLAHOMA

Mrs. Russell's story solved the mystery. The original painting, she said, had been done on commission for a wealthy New Yorker. When he received the completed oil he was displeased with certain details and returned the painting to her husband with the demand that they be changed. The collector didn't like the idea of hunters converging on a buffalo cow and calf—he thought a magnificent old bull would be more appropriate! He was offended also because the animal was slobbering, the painting plainly and accurately showing the saliva stringing back from the buffalo's mouth.

Russell's reaction was typical: "He'd be damned if he'd change the sex of the buffalo—they were after meat and not a stringy old bull. As for the slobbering—that's what buffalo did when they had been run some distance, and that wouldn't be changed either!" But with some grumbling Russell finally did agree to paint out the buffalo calf and he also changed the foreground, slightly, to compensate for the different composition. That was all. The collector had no choice but to accept the painting with these minor modifications. The explanation of the two photographs, of course, was that they were of the same painting, before and after it had been changed.

Russell did paint many of his favorite subjects time and again. There are records of well over forty Indian buffalo hunting paintings and a dozen or more variations of two or three cowboys trying to rope a "ringy" steer that has broken away from the herd. Occasionally too, Russell would do a subject in oil, and then try something quite similar in water color, or even in pen and ink. In none of these cases, however, is the treatment identical and in some cases only the subject matter is the same. The Indians in one painting will be armed with lances, and with bows and arrows in another, or there will be a variation in the number or position of the Indians or cowboys, sizes will vary and the composition may be entirely different. Out of over two thousand oils, water colors and pen sketches which have been recorded, no two are identical. Where such a pair has turned up, experts have invariably pronounced one of them a deliberate forgery.

One of the many authentic touches that characterizes Russell's meticulous work are the typical brands he usually painted on the shoulder, ribs, or hip of his animals. This brand is one of a number

of things to look for in examining a painting about which there may be some question. The seventy-five to a hundred different brands Russell used were not just any kind of a mark. They were the real ones that belonged to existing outfits whose animals he painted, as proven by a painstaking check of the official records of the Montana State and County Livestock Associations. True, there has been a forgery or two where the perpetrator was smart enough to copy the brand on his animals from one Russell had used, consequently, the fact that the brand is "right" doesn't necessarily mean that the painting is authentic. But if the brand is one that was never used by an old-time Montanan, it should, at least, give cause for immediate suspicion that the art form is a phony.

Another point to look at is the Russell signature on the painting. Most people who know something of his work, including the forgers, are familiar with the typical signature on the colored prints. What many do not know is that Russell experimented with his signature, just as he did with the rest of his painting and that he used five distinct styles of signatures; each during a definite and known period of his career. Lacking this information, the forger of an oil called "The Wagon Train" dated his painting 1893, and added a type of Russell signature that the artist didn't use until 1897 and later.

Perhaps the worst blunder is a portrait of a cowgirl signed "Chas Russell," an appellation that Russell despised and which he certainly never used in signing his paintings.

There are fake paintings where the forger has shown a cowboy wearing an exaggerated style of hat favored by Hollywood and of a period that Russell scorned. In other forgeries, the paint has been laid on with an interlacing, basket-like effect, entirely foreign to the Cowboy Artist's manner of working in any medium at any period of his life. Other frequent mistakes in such details as the knot of a hackamore or the riggin' of a saddle are ample proof that the forger was not only unfamiliar with Russell, but ignorant of the West.

It is to be hoped, too, that none of the readers of this article have a Russell painting with "curled tails" on any of the nines that happen to be in the date, near his signature. There are a few such paintings. It is certain that they are not authentic. Russell's nines were always made with a straight line.

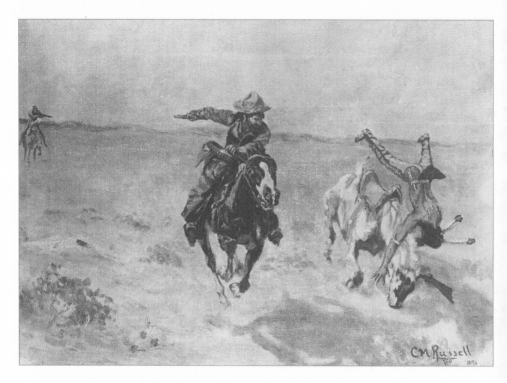

"A Close Call (forgery)." COURTESY GINGER RENNER

With the vast fund of information now available in the way of photographs, reproductions, copyright records, and complete descriptions of practically all of Charles Marion Russell's work, there is little excuse for being taken in by a forgery. Anyone contemplating becoming a Russell collector should definitely give considerable study to the man and his work. They will find it both fascinating—and rewarding!

# CMR: The Cowboy on Canvas

Lee Silliman

ACCORDING TO WEBSTER, style is the "characteristic mode of presentation, construction, or execution in any art." Charles M. Russell's thousands of admirers—the writer included—can testify to his appealing "characteristic mode of presentation." Yet, surprisingly little has been written about Russell's style and his development as an artist. How did other artists influence him? What were his basic color schemes and composition patterns? What types of special effects did he employ? What techniques did he use? Exploring the answers to these questions should increase our appreciation of his artistic genius. The reader should realize, of course, that the following generalizations cannot be applied to every one of Russell's hundreds of paintings.[1]

The stagecoach which deposited Charles M. Russell at Helena, Montana Territory, in 1880 did not exactly bring him to a budding art colony. Earlier artists who had depicted the Montana frontier—Karl Bodmer, John Mix Stanley, George Catlin, William J. Hayes, and others—were trained elsewhere, visited Montana to make sketches and returned East to complete and exhibit their work.

Apart from a few unprofitable art lessons as a boy in St. Louis, Russell largely trained himself in the wilds of Montana. When asked why he did not study abroad, then the fashion among aspiring American artists, Charlie replied, "I don't see how a Dutchman or a Frenchman could teach me to paint things in my own country."

Russell's paintings of the 1880s were in the primitive style—simple, mural-like representations which lack the detail and perspective of his later works. In the painting *Bucking Bronco*, the figures could almost have been pasted onto the background.

Gradually his paintings improved, particularly after he quit the range in 1893 to become a full-time artist. His marriage in 1896 further accelerated the transition to more detailed and realistic works. To keep the wolf from the door he painted more pictures, especially watercolors, in the first four years of his marriage than in any other four-year period. And as his paintings increased in quantity, they improved in quality; the effects of persistent practice are particularly evident in his watercolors. His colors changed from muted grays and browns to more vibrant blues, greens, and ochres. Perhaps Russell's watercolors of this time are superior to his oils because the semi-transparent quality of watercolors permits lighter tonal values and brighter colors. He reduced the number of figures in the composition, while drawing each with more detail. The classical rocking horse pose, with the horse's fore and hind legs simultaneously extended, slowly gave way to realism.

Whether these improvements reflect the direct influence of another artist cannot be determined. Yet, it does seem certain that Russell profited at this time from the comments and criticisms of other artists and art editors. On his trips East he met Charles Schreyvogel, the famous painter of army life in the West; John Marchand, another Western artist; Frank Schoonover and Philip Goodwin, illustrators of the Howard Pyle school; and Will Crawford, a leading pen and ink artist. Russell did apparently borrow occasional details from his predecessor Karl Bodmer.[2] Because of the constructive criticism of his artist friends, Russell began correcting the mistakes he had been unable to see.

By 1905 the Cowboy Artist was receiving between two and four hundred dollars per painting—a testimony to his maturing talents. He was now entering his prime period—roughly from 1905 to 1920—when some of his most famous paintings would be produced. At least three aspects of Russell's art in this period should be examined: composition, color, and technique.

## Composition

OF FUNDAMENTAL importance to every painting is composition. The various elements which draw the viewer's attention must balance in

a pleasing manner. After years of experimentation Russell settled upon a triangular arrangement of the main figures. As a rule, the dominant character is nearest to the foreground and the supporting figures behind and toward the background. The resulting composition is like a wedge or a "V" with the center of attention at the apex and the secondary figures leading back into the distance. For instance, in *Rattlesnakes Rattle, But Cows Wring Their Tails*, the recalcitrant longhorn, the roping cowpuncher, and the background rider delineate a triangle on the sagebrush flat. Another excellent example of the wedge pattern is found in *Men of the Open Range* [FIG. 7]. While these two paintings are outstanding illustrations of this pattern, the vast majority of Russell's pictures are skillfully based on this grouping.

Why the wedge? Russell found it a useful technique for conveying perspective and depth. One of the points must be closer to the viewer, which is not necessarily the case when figures are strung out like a chorus line across the picture. Compare the three-dimensional effect in *Work on the Roundup* to the flatness of *Cowboy Camp During the Roundup*. In most pictures, as demonstrated by the riders in *Carson's Men*, there is a progression in the prominence of the main subjects. Frequently coupled with the less prominent subjects are other minor figures to help define the wedge and give perspective to the painting. The fleeing buffalo herd and the distant wagon circle in *Meat for the Wagons* aid in shaping the triangle as do the scattering packhorses in *When Horses Turn Back, There's Danger Ahead*.

Russell used a variety of techniques to draw attention to the commanding figure of the scene. The central figure, for instance, is often framed by a lighter background. A fine example of this eye-catching contrast is provided by *Lewis and Clark on the Lower Columbia* [FIG. 13]. Captain Lewis and Sacajawea almost blend in to the background, but the stalwart Chinook Indian, in bold relief against the pink mist, immediately attracts one's notice. (This painting is interesting for another related reason. It is one of a number of paintings in which the viewer would normally expect the famous personage to dominate the scene but Charles Russell chose to focus prime attention upon the Indian. He often depicted history from the viewpoint of the Indian.)

Whether it was a clear sky, a swelling cloud, a haze of dust, or a patch of snow, Russell often conveniently shows a light area behind the main figure's head. A related tendency is the occasional strip of background light to silhouette the legs of the horses or other animals. This light, perhaps provided by a glistening stream, clouds of dust, or distant sun-reddened hills, helps to define the action and position of the horses. *Jumped* and *Men of the Open Range* illustrate.

The artist's careful employment of detail and color intensity also focuses attention on the principal subject. Usually the nearest and largest figure is drawn with greater distinctness than the other figures. This clarity was achieved by painting it in greater detail and with more vibrant colors. On the other hand, the supplementary figures are not as precise and are relatively subdued in color. In *Smoke of a .45* the center cowboy is spotlighted by his size, detail, and color. By comparison, many of Russell's earlier pictures, such as *Bronc in Cow Camp* [FIG. 16], do not show selective use of detail and color tones to build up a principal figure.

When Russell began painting in the 1880s, he frequently bisected his pictures with a horizontal line across the scene. Years later he criticized his nephew for the same mistake: "Don't do that! Don't divide a picture in layers like a cake."[3] Experience had taught Russell the value of interrupting the monotony of a level horizon with rolling hills, flat-topped buttes, and majestic mountains fading into the hazy distance.[4] Beyond the land is the expansive blue-green sky, sometimes layered with billowy cumulus clouds. Besides the beauty added to the picture—and Charlie's Montana is truly beautiful—the background gives important perspective to the scene. The distant view is rendered in light tones to make the transition from ground to sky unobtrusive, so as to complement rather than compete with the horses and riders. Particularly well-developed backgrounds are found in *Meat for the Wagons* and *Toll Collectors* [FIG. 8].

Russell came to understand, as well, that the foreground plays a vital part in creating a three-dimensional impression. His early paintings often portray cowboys or Indians on a nearly featureless ground. In time Charlie learned to fill in the void of a large plain foreground with knots of bunchgrass, clumps of blue sagebrush, and exposures of earth and rock. Many times a diagonal line, such as a game trail,

or a wagon road adds to the sense of depth by uniting the foreground with the background. An example of this line is found in *Men of the Open Range*.

## Color

ALONG WITH HIS OTHER artistic attributes, Charles Russell was a superb colorist. He combined colors harmoniously, realizing that the color balance is as basic to a good painting as is compositional balance. By 1900 he had discarded the dark tonal values in favor of lighter color schemes. Many of his paintings are light green and ochre with pink overtones; toward the end of his career he used deeper greens and blues. Perhaps he is most noted for his blues and purples which give so many pictures a cool crisp air.

It is intriguing to note that Russell incorporated patches of red into almost all of his pictures. Never large nor radiant enough to attract much attention, the red area is just substantial enough to spice the picture. For illustrations, note the red saddle blanket and sash in *Meat for the Wagons* and the red headband and canoe decorations in *Lewis and Clark on the Lower Columbia*.

A trademark of many of Russell's Indian paintings is the use of a white horse for the central horseman. Prior to 1905 he often drew the spotted pinto, but numerous later works feature a white horse commonly painted with red symbols and designs. Such paintings as *His Wealth* and *Toll Collectors* are examples. Why Russell had such a preference for white horses is not clear. His own favorite horses included Monte, a pinto; Red Bird, a sorrel; and the almost white Grey Eagle. The Blackfoot Indians, the tribe Russell usually portrayed, reserved no special status for the white mount. In fact, according to the ethnologist John C. Ewers, "no other color of horse was as popular with the old-time Blackfoot as was that of the pinto. Many men were proud to be seen riding a two-colored horse."[5] Perhaps Russell wished to make the principal Indian conspicuous; a white horse, flanked by darker ones, draws notice to its rider.

Charlie once remarked that he and Frederic Remington "saw the same country, but not the same colors, and that's all the difference of light."[6] Russell recognized that the color and intensity of

the light striking an object determine its color. Particularly after 1910 he consciously manipulated light to achieve special effects in his paintings. The use of a light area to emphasize the main character has already been mentioned. In paintings like *Surround* ("The Last of the Herd") and *In the Wake of the Buffalo Runners* shafts of golden sunlight heighten the feeling of nobility and drama. A comparison of *Buffalo Crossing the Missouri* (1899) to *When the Land Belonged to God* (ca. 1914 [FIG. 6]) illustrates what Charlie learned about the use of light and composition. In the former painting the light source is diffused and contributes little to the impact of the picture. On the other hand, *When the Land Belonged to God* is more than a historical record of buffalo migration; because of Russell's controlled use of light and color, it is a dramatic idealized representation of that once-commonplace event. The Cowboy Artist may have been subtly influenced by the French Impressionists, but he would never admit to such a fact, for he had only contempt for the newer schools of art. He once wrote Bill Krieghoff that he saw a painting at a "futurist" exhibition in London that "looked like an enlarged slice of spoilt summer sausig" and another that "represented the feeling of a bad stomach after a duck lunch an it mighty near turned mine."[7]

Russell may very well have discovered the potentials of light through experience and experimentation. Around 1916 Russell, Frank Linderman, and several others took a float trip down the Missouri River. Away from buildings, trees, and smokestacks, they witnessed sunrise and sunset over the Missouri River Breaks.

Joseph Kinsey Howard describes the phenomenon: "As the sun descends the hot wind dies and then comes the miracle of color, purple and yellow and flame and unnamed mutations, merging at last in a golden haze over the muddy Missouri, suddenly transformed into a ribbon of silver."[8]

Such play of color and light may have inspired Charlie Russell to include the splendor of a Montana sunset in so many paintings. However, the excursion was not the only influence, as Austin Russell claims, because Charlie was painting beautiful sunsets four or five years before 1916. At any rate, many would agree with Austin that "those ruddy glowing sunsets with Indian figures . . . have more magic in them than all his previous pictures."[9]

# Technique

THROUGH THE YEARS Russell developed his own technique for painting a picture. The first step was a rough sketch. Many a quiet evening was devoted to hours of drawing and redrawing an idea, although few examples of such studies remain today. Sometimes he would use the old technique of viewing his picture in a mirror to detect bad drawing or poor composition.

When satisfied with a composition he would resketch it upon a high quality canvas and put on a coat of primer oil to lay out the approximate color scheme. Then, with generous amounts of paint, he would develop the picture in detail. Not only did Russell use considerable pigment in his oil paintings, he sometimes applied watercolor so thickly it is difficult to distinguish them from oils. That his practice was contrary to normal usage of watercolor, a transparent medium, did not bother Charlie Russell!

Since he did not paint from a detailed preliminary drawing, Russell often made changes as he progressed and sometimes several changes were in order. Said Frank Linderman about the magnificent buffalo painting *When the Land Belonged to God*, "I saw him myself paint a dozen buffalo bulls into the picture. I feel certain that fifty bulls must have temporarily led that particular herd."[10] A midcourse change is still evident in the head of a background horse in the famous oil *In Without Knocking*. This ability to build his picture as he painted is one reason why his works appear so spontaneous and alive.

Occasionally Russell modelled for himself in a mirror or persuaded a friend to pose, but usually he relied upon his vivid imagination and memory to paint the subjects of his pictures. For background scenery Russell referred to his keen memory and to sketches drawn on the spot. As a rule, Charlie painted several paintings simultaneously so as to be able to leave a painting when problems brought him to a standstill and to return later with a fresh outlook. This fact accounts for the six or more unfinished works at the time of his death.

The years after 1920 marked the twilight of the Cowboy Artist's career. Sickness, advancing age, and encroaching civilization began to produce a certain bitterness in the artist. Said Austin Russell, "And

once in a while there began to creep into his words a new hardness, almost bitterness, and a new note of cynicism—not about people, but about the world."[11]

As failing health slowed him down, his output of pictures was somewhat reduced. He painted fewer of the rough-and-tough action scenes that had made him famous, preferring instead the nostalgic picture story. Such paintings as *Laugh Kills Lonesome* and *Men of Open Range* are romantic expressions of the artist's love for an earlier time. Many people regard the sentimental pictures of Russell's later period among his best works.

Charles M. Russell has come a long way from the time when his pictures were worth a drink at the bar. One of his oils is now appraised at a quarter of a million dollars. To Russell the cost of success was measured in years of continual practice with sometimes very modest results. In time his artistic achievements were considerable; with the improvement of his composition and color schemes he became a superb realist. His paintings record not only an exciting frontier; they chronicle the growth of one of America's greatest artists.

## Notes

1. Paintings mentioned which are not reproduced in this book may be found in the Charles M. Russell books by Harold McCracken and Frederic Renner.

2. John C. Ewers, *Artists of the Old West* (Garden City, N.Y., 1965), 231–32.

3. Austin Russell, *C.M.R.: Charles M. Russell, Cowboy Artist* (New York, 1957), 224.

4. From 1898 to 1901 Russell frequently placed an imposing butte or mountain squarely behind the central figure.

5. John C. Ewers, "The Horse in Blackfoot Indian Culture," *Smithsonian Institution Bureau of American Ethnology*, Bulletin 159 (Washington, D.C., 1955), 55.

6. Austin Russell, *C.M.R.*, 203.

7. Charles M. Russell, *Good Medicine* (Garden City, N.Y., 1929), 62.

8. Joseph Kinsey Howard, *Strange Empire* (New York, 1952), 339.

9. Austin Russell, *C.M.R.*, 221.

10. Frank Bird Linderman, *Recollections of Charley Russell* (Norman, Okla., 1963), 95.

11. Austin Russell, *C.M.R.*, 241.

# PART FIVE

~

# A Few Words from Our Sponsor

N O ONE EVER SPOKE for Charles M. Russell as well as he spoke for himself. His contemporaries always considered his way with a story a natural gift. "You never heard me open my mouth when you was around, and you never knew any of our friends that would let me open it as long as there was a chance to get you to tell another one," Will Rogers wrote. "I always did say that you could tell a story better than any man that ever lived."[1] Irvin S. Cobb, who made his living telling stories, agreed:

> Charley's chief forte was in storytelling and in coining homely epigrams. America knows him as the only rival Frederic Remington had as a painter of the vanished border country, but some of us knew him—and still mourn him—as probably the greatest repositor and expositor of the frequently ribald but always racy folklore of forgotten mining camps and plowed-under cattle trails that ever lived. Some of his deftly fabricated yarns, part fact, part fable . . . are classics and deserve to be. The pity is there is none left who can render them as Charley did. . . . He hunkered on his heels and let wisdom seep out of the squeezed corner of his lips like sugar dripping from a sugar tree.[2]

After Russell's death, two books brought his gift to the world: *Trails Plowed Under*, a collection of his stories, and *Good Medicine*, a collection of his letters. Today, Russell is a beloved western icon as much for what he said as what he showed in paint and bronze.

Writing never came easy to Charlie Russell, but it seemed a natural extension of his art. "I have always liked to tell stories with the brush so have tried in a way to keep memories' trails fresh . . . for those who loved the old west," he stated in 1921. "I still love the West . . . as I love an old horse, for what she was."[3] His stories were love letters as well. Russell published his first in 1897, within a year of marrying Nancy, and, enticed by the promise of a book of his "Line Camp Yarns," contributed eight more to *Outing* in the years 1907–8.[4] Subsequently, he began writing humorous sketches for a locally produced weekly Montana Newspaper Association insert

in 1916, and by 1917 had adopted the byline Rawhide Rawlins. Most of his tales were collected in two booklets, *Rawhide Rawlins Stories* (1921) and *More Rawhides* (1925), which served as the basis for *Trails Plowed Under*. But several strays never made it between covers, and two are reprinted here. The first, Russell's report on all the doings at the second annual Great Northern Montana Stampede in Havre, "Rawhide Rawlins on Montana Stampedes; What Cowboy of Old Range Days Saw at the Big Show at Bull Hook," was published in the insert for July 30, 1917. Perhaps it was considered too topical for reprinting, or perhaps Russell chose to let sleeping dogs lie since one of the featured performers that year, "Long George" Francis, was subsequently convicted of horse theft and, after eluding the law for nearly a year and a half, froze to death on Christmas Eve 1920 just before he was to begin serving his jail sentence.[5] Readers today will find much to enjoy in Russell's characteristic observations on the perils of rodeoing. The second selection, "Cinch David's Voices" (October 29, 1917), is a typical Rawhide Rawlins comic sketch, long overdue for reprinting.

"Hunting and Trapping on the Judith with Jake Hoover; When Lonely Trading Post Stood on Site of Lewistown" originally appeared in a Montana Newspaper Association insert in June 1917. This reminiscence of Russell's first year in Montana was reprinted in 1918 in *Roundup*, the Great Falls High School annual, as "A Slice of Charley Russell's Early Life." Its deep-felt nostalgia underscores its anti-progressive message: "No king of the old times could have claimed a more beautiful and bountiful domain." Russell was blunter when he told Joe De Yong about "a dim wagon road" leading into the Judith Basin: "goes thro a canon & if he [Russell] ever got a chance he'd like to blow the dam cliff down & cover the road so you could only get in with a pack horse."[6]

No *Russell Roundup* would be complete without the short autobiographical statement "A Few Words About Myself." Scrawled in pencil on three pages of lined paper, it outlines Charlie Russell's philosophy of life. First published as a preface to *More Rawhides* and reprinted in *Trails Plowed Under*, it remains as fresh and appealing today as when he wrote it. "Nothing I ever read in the western tongue and philosophy," a friend observed, "can hold a candle to that."[7]

It is one thing to read Will Rogers or Irvin S. Cobb praise Russell's storytelling gift; it is something else to actually experience Russell painting word pictures on paper. He moved effortlessly from humor to sentiment in his inimitable prose, creating funny, loving tributes to the "west that has passed."

## Notes

1. Will Rogers, Introduction to Charles M. Russell, *Trails Plowed Under* (Garden City, N.Y., 1927), xiv.

2. Irvin S. Cobb, *Exit Laughing* (Indianapolis, Ind., 1941), 402.

3. NCR to J. H. Chapin, February 21, 1921, quoting CMR, Britzman Collection. The note prefacing "Four Paintings by the Montana Artist, Charles M. Russell," *Scribner's Magazine*, 70 (August 1921), 146, paraphrased Russell's statement: "Mr. Russell loves the West and will keep alive through his canvases the stories of the old West and his own time. The four story-telling pictures [that follow] are typical of his work to-day." The year before, the catalog of an exhibition at Babcock Galleries in New York sounded the same refrain: "Mr. Russell says that his pictures would drive the impressionist into hysterics, yet we must not lose sight of the fact that regular folks still like story telling pictures." Babcock Galleries, "Paintings of the West," reprinted in *El Palacio*, 8 (July 1920), 236.

4. *Outing* published five of the stories Russell submitted, but no book; nevertheless, "Yarns of the Line Camp" was the genesis of *Trails Plowed Under*. For a full discussion, see Brian W. Dippie, "Introduction to the Bison Books Edition," Charles M. Russell, *Trails Plowed Under: Stories of the Old West* (Lincoln, Nebr., 1996), v–xix.

5. See Gary A. Wilson, *Tall in the Saddle: The "Long George" Francis Story, 1874–1920* (Havre, Mont., 1989).

6. Joe De Yong to his father, January 27, 1918, De Yong Papers, Oklahoma City.

7. Joe Scheuerle to NCR, April 10, 1927, Britzman Collection.

# Rawhide Rawlins on Montana Stampedes; What Cowboy of Old Range Days Saw at the Big Show at Bull Hook

C. M. Russell

"THE OLD WEST has passed," says Rawhide Rawlins to the gang assembled in the cigar store, "and the grangers have pretty nearly turned the country grass side down, but I'm glad to know that there are men like Allard on the Flathead, Buchanan at Miles City, and Johnny Maybee and Long George at Bull Hook, who still have enough love for the west not to allow people to forget the life of the old cow days. I hope Kalispell, Havre, Miles Town, Missoula and other places in Montana keep pulling off these shows as long as there are snaky hosses and men with sand to ride 'em.

"It's been some time since I had visited Bull Hook, or Havre, as they call it now," continued Rawhide, "and if it wasn't for the Bearpaw's and old Book Hook Butte, I'd never a-knowed her. Them old hills is still there, but it looks like they'd moved since I saw them. It may have been the home-made booze they handed us in the old days that made the scenery look different then, but there is sure some change. I saw more automobiles in Havre this trip than there used to be people in old Chouteau county.

"I took in that stampede, and they pulled something worth while. It was a saying in old times that it took a strong back and weak head to make a bronc twister. The cow days has gone, but judgin' from what I see at Havre, they're still breeding strong backs, and I'm glad of it. An old Injun told me that bravery lived in the heart, not the head. If my red brother is right, bronc riders must be all heart above their flanks.

"This Long George is built for bear hunting. If a grizzly would take after him, all George has got to do is raise one leg, and Mr. Bear thinks he's up a tree. When I first sight George, he's about two blocks off, standing in a crowd, and the way he looms up above other humans, I think he's hossback, but when I get near I'm sure surprised; he's only standin' on his hind legs.

"Besides bein' fast with a rope, George is a bull-dogger—his home is among a steer's horns. Most bull-doggers just spur up agin the cowbrute and grab some horns, and maybe they upset Mr. Steer and maybe the cowboy gits dragged 'round awhile an' the steer wins. But George ain't satisfied with horn holts; he wraps himself about three times around Mr. Longhorn's head an' goes to sleep. Sometimes this longhorn goes bounding off, but as he can't see, hear nor breathe, he soon lays down. Now I don't know the rules of the game, but I'm betting if you asked the steer, he'd say George cheated.

"There was good enough ropers in that tying match, but them Spanish steers are travelers, an' with forty feet start, they've said good-bye to all but fast hosses.

"I see one of them git sore and start for Mexico, an' the gait he's goin' it won't take him long. He's pushing the landscape back of him plenty when a movie man shows up in his track. Mr. Movie stands his ground, thinkin' Longhorn will turn to the right, but not him. He ain't got no regard for law and order, and catching the movie man in the short ribs with the round of his horn, he leaves him layin' like a suit of cast-off clothes. He's mighty still, and it looks like he's work for the undertaker. But he don't cash in, although he tells a friend that he's close enough to the pass on the big divide to hear harp music and angel voices mighty plain.

"Another time a twister rides a steer till he quits pitching, an' then steps off like he's quittin' a street car. This easy dismounting makes the steer sore, and just to prove he ain't a streetcar, and the track he's travelin' ain't nailed down, he turns it into a foot race. In less than two jumps it's easy to see that Mr. Twister's takin' second money, an' if it hadn't been for his chap-belt it would have been a sure case of the golden gates ajar. As it is he throws this cowpuncher high enough so he's got a good view of Chinook and Big Sandy, with a glance at the Sweet Grass hills thrown in.

"Among the ropers, Maybee Johnny ain't there on a tie-down! But the steers have a notion that he is. It don't look much of a trick to upset one of them longhorns, but keepin' him upset is what bothers the tie man. This breed of cattle appears to have legs all the way 'round, and with an animal built this way, it's hard to tell when he's down. Johnny sure knows cows, but he can't tell his hoss nothin', an' between them they make a good team.

"Speakin' of hosses, Long George has got one, too. Some say it was the hoss that learned George all his tricks. Anyway, he's a real cow hoss.

"There was a kid there that didn't look to be more'n a dozen years old that rode a little black steer that did some fancy twistin'. Every time it hit the ground its whole hide loosened. But the little feller stayed and was rakin' him every jump.

"They had a bunch of snaky hosses, but they had good riders to fork 'em. One twister wants to hang up a bet that he can ride a hoss named Hightower and scratch him every jump while he looks back at the grandstand. But if he saw the grandstand from Hightower's back, it must have been a mirage, for it wasn't where he was lookin, and the only scratchin' he done was with his finger nails. Even that didn't save him. His hat didn't come down till after the show.

"When I knew cows there was plenty of cowboys, but I don't remember any she-ones. But since they got she congressmen, it seems right enough to have she-cowpunchers, and if our congresslady's as good in the capitol building as these gals are in the middle of a hoss, she'll do till something better comes along.

"Fanny Sperry Steele is the real thing. I've seen her ride at many contests and never yet saw her grab leather. She rides lean, with loose feet and scratches 'em.

"Amony the scary things they had was a fightin' steer. Judgin' from the length of his horns and his fightin' ways, his father died south of the Mexican line, but his dad never wore hame-tips on his horns. That's where this steer was handicapped. You can bet, too, that the man that killed his daddy in a bull ring was no kin to the so-called Mexican bull fighter that met this steer in Havre.

"This fightin' steer made 'em all climb the fence. The only one that stood his ground was the dummy, and the way that long horn worked him over showed he wasn't joshing."

# Cinch David's Voices

C. M. Russell

≈

"Speakin' of Missouri's squeaky voice, did any of you ever hear of a feller called Cinch David?" inquired Rawhide Rawlins.

"This Cinch has got all kinds of voices. He may be talkin' one minute below his belt; the next thing his voice is comin' from under his hair. I never heered him sing, but if he ever did it wouldn't be no quartet; it's a whole choir.

"One time me an' Joe Contway's night-herdin' beef. It was over in the Lone Tree country, an' we're holdin' about fifteen hundred head. There's a cold, drizzlin' rain comes up this night, hittin' the herd before they get their beds warm. There ain't enough wind with it to keep 'em driftin' in any one direction, so these steers start to scatter, spread and walk out of the country. After Joe an' me's ridden pretty hard for a while we see there's no chance of holdin' 'em, an' knowin' there's hosses tied to the wheel in camp, Joe goes for help.

"'Tain't long till he's back, an' I can hear all kinds of men singin' and hollerin'. It's so dark you can't recognize nobody, but now and then I can see a rider agin' the sky-line. Towards mornin' we get 'em bunched an' they quiet down. It's about this time I ride on to Joe.

"'How many men did you bring out,' says I.

"'Only one,' he says.

"'One,' I says, 'I'd bet I heard twenty different voices.'

"Joe laughed. 'Them was all Cinch David's,' he says.

"Another time Cinch is comin' out of the mountains with an empty wagon and a team of broncs he's been breakin'. This pair of snakes get the bulge on him an' start hittin' the high places, finally turnin' the

wagon plump over with Cinch jailed under the bed. Of course the broncs pull the pin an' start for Arizona with the double-tree.

"With the heft of the runnin' gear and bed on him, Cinch stands a good chance of starvin' to death as he can't lift this off him an' there's no chance to 'badger' out. While he's layin' under there, studyin' ways to escape, he hears the hoofs of a hoss and the sing-ing' of a human. This is old Charlie Ferris, an Irish prospector from Yogo, who's been down the river and is returnin' happy. In his saddle pocket is a quart of joy-bringer that Ed. Morris has staked him to at Utica. About half of this is under Charlie's hide an' he's singin' 'Bold Brennan on the Moor.'

"Charlie's worked up till he thinks he's ridin' the highways of old Ireland with Dick Turpin. He's awakened from this day-dream by voices that he can't locate. He's a little superstitious an' sure be-lieves in spooks, claimin' that while he's never seen any himself, his people in Ireland have all seen plenty of banshees and hobgoblins. When he first hears them voices he thinks he's kicked into a nest of 'em, but pretty soon he sees this wagon layin' wheels up, an' he finally decides that all these calls of distress is comin' from under.

"As he listens, one feller in a deep voice calls: 'Help us out of here.'

"Another voice, high an' squeaky, yells: 'Lift the box!'

"Still another shouts: 'You ain't goin' to let us starve to death, are you!'

"Old Charlie, sittin' on his hoss, has been countin' the voices. He figures there's anyhow eight—perhaps ten men under the wagon-bed, an' although he's far from stingy and would cut anything he had in two once, the idea of dividin' what's left of the quart with this band of thirsties is too strong for his liberality.

" 'What kind of min are ye, askin' for help?' he inquires, addressin' the wagon box. 'If tin of ye can't raise that wagon ye're not worth savin',' and he spurs on up the gulch.

"Cinch is rescued later by a couple of men that know his outfit."

# A Slice of My Early Life

C. M. Russell

~

I WAS FIFTEEN YEARS OLD, a pilgrim, when I first met Jake Hoover, and a man never needed a friend worse than I did.

Jake was still a young man, but he had spent many years in the mountains; a hunter, trapper, prospector, and an all-around mountain man. I had come to Montana a few months before with a man much older than I was, and we did not get along well together. He did not understand a boy's nature and was not backward about telling me that I was no good. He finally told me that I could not live in Montana, but he didn't call the turn, for I'm here yet and still living.

One day I quit him and went to a man who had promised me a job herding horses, but when I reached the stage station, which was near the present town of Utica, I found that my supposed friend, the man whom I had just left, had beaten me out of the job by telling the station man that I wasn't worth my grub. The station man said that he did not want a kid of that sort around, so there was nothing for me to do but drift. All I owned in the world was a brown mare and a pinto pony. I rode the mare and used the pony to pack my bed, which was very light. With no money or grub, life did not seem joyful, and I felt mighty blue, but leaving the stage station I rode a short distance up the Judith River and made camp. While I was wondering where my next meal was coming from, a rider with several pack horses appeared and made his camp on the river near mine. I recognized him as Jake Hoover, whom I had seen several times. After getting his packs off he strolled over to my camp and looked it over.

As I remember him then, Jake Hoover was of medium height, with thick, curly brown hair which he wore quite long, a mustache

and several months' growth of beard. His eyes, gray and deep-set, saw everything at a glance. He was seldom afoot, but when he walked, travelled with his toes out. He wore a light, soft hat, blue flannel shirt, duck pants and boots. His spurs were short-shanked, with broad heel bands. He never used a cartridge belt, but instead a plain leather strap on which he hung a knife scabbard holding two butcher knives. His cartridges were always carried in a pouch either in his pocket or hanging under his belt. His gun was a .44 Winchester rifle which he packed across his saddle in front of him in a horn sling, but in a game country he carried it loose in his hands. His gun and cartridges were both kept slick with bear grease, and he could empty a Winchester faster than any other man I ever knew, never taking it from his shoulder once he started shooting.

After surveying my camp, Jake asked: "Where do you keep your grub?"

"I ain't got none," I answered.

Then I told him my troubles. He listened until I was through, and while I was talking I couldn't help feeling that he would be my friend.

"Well," he said, "if you want to, you can come with me, but trade that mare off as soon as you can." He explained that mares were a nuisance in the mountains because they would lead horses out of the country.

Jake was a skin hunter, but not wasteful, as he sold his meat to the few scattered ranchmen that lived along the Judith river. He had just got rid of a load of deer and elk meat, and was now returning to his mountain home on the South Fork of the Judith.

Early next morning we broke camp and started for the mountains.

The Judith Basin in those days was thinly settled. Where Lewistown stands today was Reed's Fort, a trading post owned by Bowles and Reed. Philbrook was then known as the Lower Crossing, and a man of the name of Bill Clegg ran a saloon there. Utica did not exist then, and the principal settlement on the Upper Judith was the mining camp of Yogo, which was then a year or two past its glory, but was still inhabited by a few miners and prospectors. Pig Eye Basin was then the home of Red Mike who ran a trading post; Ettien brothers, and Babcock and David. That was all the population. A man named Gaver also had a small ranch on the foothills near the river.

As we rode along I had a chance to size Jake up, and he told me something about himself. He rode a horse that he called by the beautiful name of "Guts," a heavy set bay with a stripe in his face, as good a mountain horse as ever traveled a trail. Morg, Sherman, and Buck were pack horses—all typical western cayuses.

That afternoon we entered the South Fork of the Judith. At that time there was no wagon road into it. A few trees felled across the lower canyon made Jake's fence. Shut off from the outside world it was a hunter's paradise, bounded by walls of mountains and containing miles of grassy open spaces, more green and beautiful than any man-made parks. These parks and the mountains behind them swarmed with deer, elk, mountain sheep and bear, besides beaver and other small fur-bearing animals. The creeks were alive with trout. Nature had surely done her best, and no king of the old times could have claimed a more beautiful and bountiful domain.

To me, a boy lately from the east, riding by Jake's side through a country like this seemed like a chapter from one of my favorite romances of the Rocky Mountains.

Jake's cabin was situated at the other end of the first big park, close to the creek. This cabin was the work of mountain men, made with an axe and an auger and not a nail in it. Instead, wooden pegs

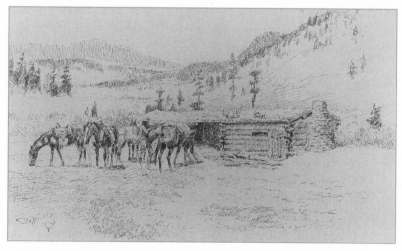

Charles M. Russell, *Where I Learned the Diamond Hitch—The Old Hoover Ranch on the South Fork of the Judith*, 1917, pen and ink. Wiley T. Buchanan III Collection

and pins were used. The roof and floor were of dirt, with a stone fireplace. There was, in reality, two cabins joined together by a shed, the second cabin being used as a hidehouse. There was but one window, composed of three panes of glass, set lengthwise in the logs. In the main cabin, besides the fireplace, was the bunk made of poles, filled with fir bows. There was also a rough table made of pine poles, hewed flat on the upper side. A stool or two of the same rough make about completed the furniture. To a man who loved the mountains nothing more was needed.

Since then I have been in the best hotels in Europe and America, but no food they produce could touch that that came from Jake's frying pan. The latter, with coffee pot and camp kettle in which beans and dried fruit were cooked, completed the kitchen equipment. He could make better bread in a frying pan than high price chefs can in a modern range.

As I have said, Jake was a all-around mountain man, and knew more of nature's secrets than any scientists that I have ever happened to meet.

Although I never was a hunter myself, I have been with Jake on many hunts. He had no more fear of a bear than I would have of a milk cow. On one of our trips he killed four together, and the noise they made was not a peaceful song. I, myself, had a tree picked out and had spotted the limb I would sit on, but in the midst of the excitement, when one bear fell not more than twenty feet away from him, Jake looked about as startled as if he was grinding coffee.

Old timers who ought to know claim Jake was the best hunter in Montana. He knew the ways and habits of all the wild creatures in the mountains. In those days I was a youngster with fairly keen sight, but Jake would see game where there was nothing visible to me, and he was always right about it. Sometimes I wouldn't see the animal until he had fired at it, and he seldom missed.

Jake was very fond of animals, and had many pet deer around his cabin. He used to put out salt to attract them, but I never knew him to kill a deer at a lick or near his home. He also had a colony of beaver above his cabin where he often went in the evenings to watch them work. He told me many hunting stories, and I remember one bear story, particularly. Jake said he was prospecting, and upon re-

turning to his camp one evening he found that a Silver Tip had visited him and a pair of gum boots were missing. Jake declared that all that summer and fall he saw gum boot tracks in the mountains, and as there was no sign of camps or other humans, he said it must have been a bear wearing the boots.

# A Few Words About Myself

C. M. Russell

∾

THE PAPERS HAVE BEEN KIND to me—many times more kind than true. Although I worked for many years on the range, I am not what the people think a cowboy should be. I was neither a good roper nor rider. I was a night wrangler. How good I was I'll leave it for the people I worked for to say—there are still a few of them living. In the spring I wrangled horses, in the fall I herded beef. I worked for the big outfits and always held my job.

I have many friends among cowmen and cowpunchers. I have always been what is called a good mixer—I had friends when I had nothing else. My friends were not always within the law, but I haven't said how law-abiding I was myself. I haven't been too bad nor too good to get along with.

Life has never been too serious with me—I lived to play and I'm playing yet. Laughs and good judgment have saved me many a black eye, but I don't laugh at other's tears. I was a wild young man, but age has made me gentle. I drank, but never alone, and when I drank it was no secret. I am still friendly with drinking men.

My friends are mixed—preachers, priests, and sinners. I belong to no church, but am friendly toward and respect all of them. I have always liked horses and since I was eight years old have always owned a few.

I am old-fashioned and peculiar in my dress. I am eccentric (that

is a polite way of saying you're crazy). I believe in luck and have had lots of it.

To have talent is no credit to its owner; what man can't help he should get neither credit nor blame for—it's not his fault. I am an illustrator. There are lots better ones, but some worse. Any man that can make a living doing what he likes is lucky, and I'm that. Any time I cash in now, I win.

# Credits

PART ONE. RUSSELL IN THE PRESS

"A Diamond in the Rough," Helena *Weekly Herald*, May 26, 1887

"Life on the Range," Helena *Daily Independent*, July 1, 1887

"The Cowboy Artist," Helena *Daily Herald*, September 21, 1888

Untitled note, Livingston *Post*, June 30, 1892

"Our Cowboy Artist," Great Falls *Tribune*, April 28, 1893 [from the Anaconda *Standard*]

"Russell, the Cowboy Artist, and his Work," Butte *Inter Mountain*, January 1, 1903

"Cowboy Artist St. Louis' Lion," Helena *Daily Independent*, May 13, 1901

"Prefers Ulm to New York as Place of Residence," Great Falls *Tribune*, February 16, 1904

"Russell Scorns Film Cowboy and Santa Barbara Climate, But City Claims Him as Son," Great Falls *Tribune*, February 17, 1923

Arthur Hoeber, "Cowboy Vividly Paints the Passing Life of the Plains," New York *Times*, Magazine Section, March 19, 1911

"Russell, Noted Cowboy Painter, Leaves Past for Minneapolis," Minneapolis *Tribune*, December 9, 1919

"'Just Kinda Natural to Draw Pictures, I Guess,' Says Cowboy Artist In Denver to Exhibit Work," *Rocky Mountain News* [Denver], November 27, 1921

Will Rogers, syndicated column, Los Angeles *Examiner*, April 27, 1924 [McNaught Syndicate, Inc.]

PART TWO. REMEMBERING RUSSELL

Frank B. Linderman, "Charles Russell—Cowboy Artist," *Outlook*, 145 (April 13, 1927), 466–68

Irving S. Cobb, "Fortunate Friendship," *Montana*, 8 (October 1958), 73–75, from the Lewistown, Montana, *Democrat-News*, December 16, 1934.

Wm. Bleasdell Cameron, "The Old West Lives through Russell's Brush" and "Russell's Oils Eye-Opener to the East," *Canadian Cattlemen,* 13 (January, February 1950), 11, 26 and 26–27, 34.

Joe De Yong,"Modest Son of the Old West," *Montana,* 8 (October 1958), 90–96

Wallis Huidekoper, "The Story Behind Charlie Russell's Masterpiece: 'Waiting for a Chinook,'" *Montana,* 4 (Summer 1954), 37–39

Carter V. Rubottom, "I Knew Charles M. Russell," *Montana,* 4 (Winter 1954), 16–25

George Coffee, "Home Is the Hunter," *Montana,* 7 (April 1957), 32–36

Vivian A. Paladin, "Charlie Russell's Friends," *Montana,* 34 (Summer 1984), 14–23

PART THREE. CHARLIE RUSSELL—LADIES' MAN

Ginger K. Renner, "Charlie and the Ladies in His Life," *Montana,* 34 (Summer 1984), 34–40 and 53–61

Elizabeth Greenfield, "The Cowboy Artist as Seen in Childhood Memory," *Montana,* 14 (January 1964), 38–44

Verne Linderman, "The Big Lonesome," *Christian Science Monitor,* November 20, 1942

Jessie Lincoln Mitchell, "C. M. Russell—The White Indian," *Montana,* 10 (January 1960), 3–13

Helen Raynor Mackay, "Good Medicine," *Montana,* 7 (April 1957), 37–39

[Nancy C. Russell], "Close View of Artist Russell," Great Falls *Tribune,* March 1, 1914

PART FOUR. RECAPTURING RUSSELL:
INTERPRETIVE AND BIOGRAPHICAL STUDIES

John Taliaferro, "The Curse of the Buffalo Skull: Seventy Years on the Trail of a Charles M. Russell Biography," *Montana,* 46 (Summer 1996), 2–17

Hugh A. Dempsey, "Tracking C. M. Russell in Canada, 1888–1889," *Montana,* 39 (Summer 1989), 2–15

John C. Ewers, "Charlie Russell's Indians," *Montana,* 37 (Summer 1987), 36–53

J. Frank Dobie, "The Conservatism of Charles M. Russell," *Montana*, 2 (April 1952); reprinted *Montana*, 8 (October 1958), 57–63

Raphael Cristy, "Charlie's Hidden Agenda: Realism and Nostalgia in C. M. Russell's Stories About Indians," *Montana*, 43 (Summer 1993), 2–15

F. G. Renner, "Bad Pennies: A Study of Forgeries of Charles M. Russell Art," *Montana*, 6 (April 1956), 1–15

Lee Silliman, "CMR: The Cowboy on Canvas," *Montana*, 21 (January 1971), 40–49

PART FIVE. A FEW WORDS FROM OUR SPONSOR

[C. M. Russell], "Rawhide Rawlins on Montana Stampedes; What Cowboy of Old Range Days Saw at the Big Show at Bull Hook," Montana Newspaper Association Insert, July 30, 1917

[C. M. Russell], "Cinch David's Voices," Montana Newspaper Association Insert, October 29, 1917

Charles M. Russell, "A Slice of My Early Life" [1917], *Montana*, 8 (October 1958), 12–16

C. M. Russell, "A Few Words About Myself" [1925], *Montana*, 8 (October 1958), 72

# Index